SHAKESPEARE BY McBEAN

MANCHESTER
1824

Manchester University Press

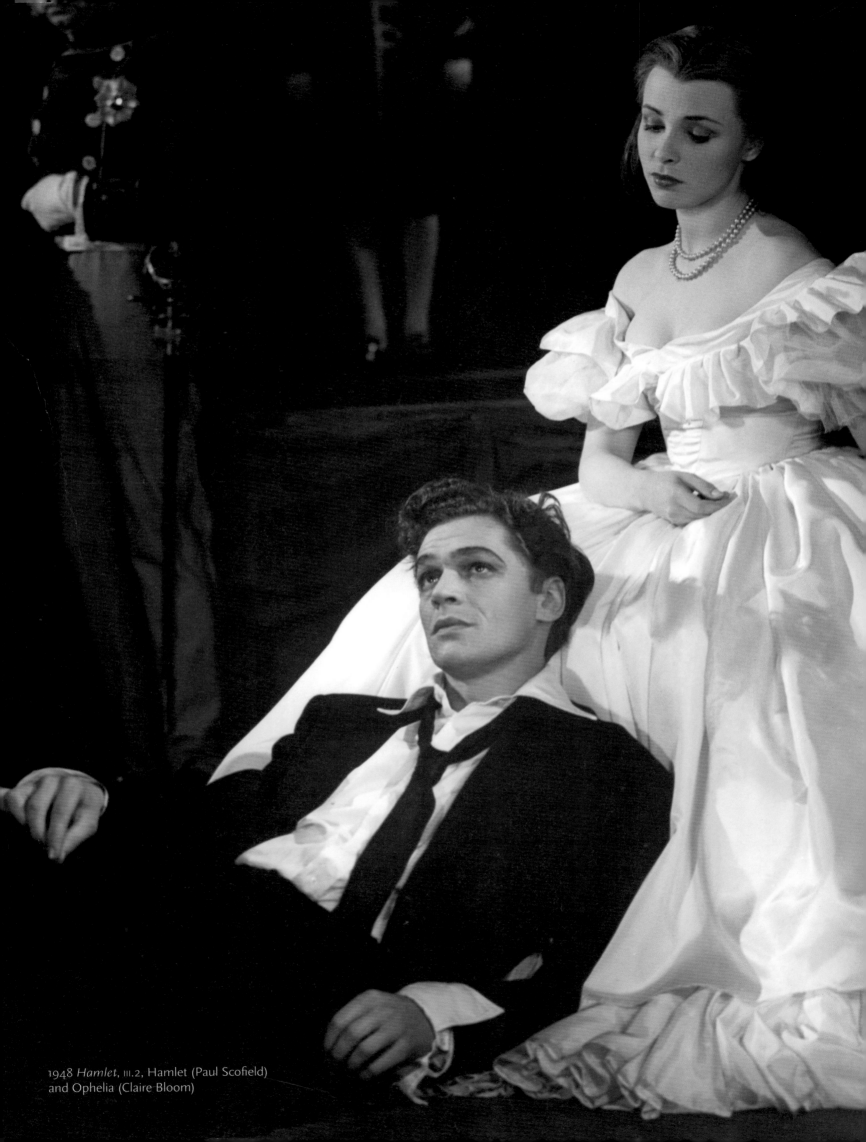

1948 *Hamlet*, III.2, Hamlet (Paul Scofield)
and Ophelia (Claire Bloom)

SHAKESPEARE BY McBEAN

ADRIAN WOODHOUSE

With a foreword by
Gregory Doran
Artistic Director, Royal Shakespeare Company

Manchester University Press

Published by Manchester University Press
Altrincham Street, Manchester M1 7JA

www.manchesteruniversitypress.co.uk

British Library Cataloguing-in-Publication Data
A catalogue record for this book is available from
the British Library

ISBN 978 1 5261 2701 3 paperback
First published 2018

Designed and typeset by axisgraphicdesign.co.uk
Printed in Great Britain by Cambrian Press

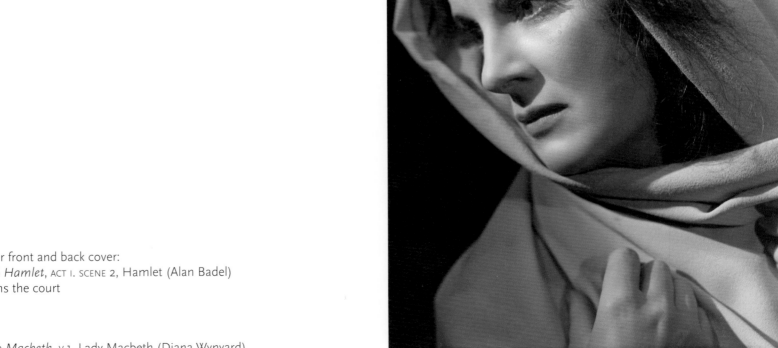

Inner front and back cover:
1956 *Hamlet*, ACT I. SCENE 2, Hamlet (Alan Badel)
shuns the court

>

1949 *Macbeth*, V.1, Lady Macbeth (Diana Wynyard)

iv

Contents

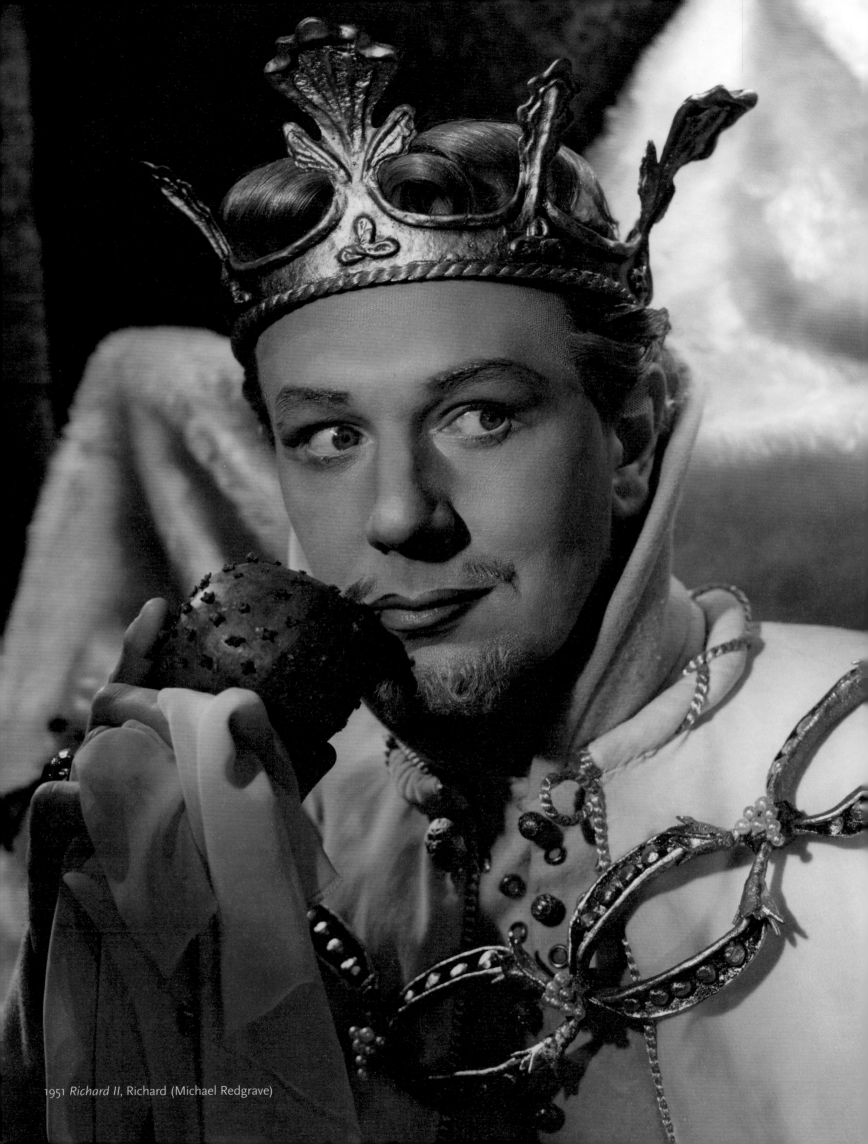

1951 *Richard II*, Richard (Michael Redgrave)

Foreword:
Angus McBean, 'an original'

"And so in spite of death, thou dost survive, In that thy likeness still is left alive."
Shakespeare: *Venus and Adonis*

Angus McBean is a sculptor in light and shadow and silver bromide.

His stylish portraits of actors performing in every single Shakespeare play, at Stratford-upon-Avon and elsewhere, tumble us back into another world, of poise and glamour and artifice. Our guide through this photographic journey is the effortlessly knowledgeable Adrian Woodhouse. He gives us not only a detailed survey of the changing fashions of Shakespeare production over two decades in the postwar era but a moving insight into the developing art of an original genius, who defined his age.

McBean's own life is affectionately chronicled, from humble beginnings in Monmouthshire, to his arrest during the war, and imprisonment for four years with hard labour, on charges of illegal homosexual activity; his re-engagement with the theatre community, following a photo shoot for the 1945 Stratford production of *Antony and Cleopatra*, with 'Yankee' Claire Luce as the Egyptian queen; his spectacular assumption into the pantheon of theatrical greats, as the iconic theatre photographer of the 1950s; and his eventual fall from favour under the new Stratford regime of Peter Hall. Then in a happy coda, he goes on to snap four young men called The Beatles, and a new chapter begins.

The ground covered, and the change in acting styles during that period, is perhaps nowhere better demonstrated than by looking at McBean's portrait of the young Paul Scofield, playing Pericles in Nugent Monck's 1947 production, and the same actor playing King Lear for Peter Brook in 1962.

The revolution in artistic sensibility is immediately evident when you contrast the poised camp of Robert Helpmann's King John, or Michael Redgrave's Richard II (what a lot of eye makeup!) to the brave new world of Peter Hall's new Royal Shakespeare Company. We move from an illusory world of painted cloth and canvas to a world of real materials, of leather and metal and wood.

Shakespeare plays seem always to be performed in their 'correct' period, ancient Roman, medieval or Renaissance, or inspired by Watteau or Van Dyck, with perhaps only one (Guthrie's 1959 *All's Well That Ends Well*) in contemporary modern dress. The priority of the experience, captured and enhanced by McBean, is to transport the audience to another time and place, rather than to connect forensically with our own.

This wonderful survey also quietly celebrates the craft of design, by artists like Leslie Hurry or Tanya Moiseiwitsch, or the all-female team known as Motley (Margaret 'Percy' Harris and her sister Sophie, and Elizabeth Montgomery Wilmot), who together designed many of the famous productions of this starry decade. Crucial to the creation of these illusions were lighting designers like Michael Northen, the first person in Britain to be credited as a theatre lighting designer, Julia Wooten and Peter Streuli, who was brought in by Glen Byam Shaw to be both chief stage director and lighting designer at Stratford for five seasons.

As one might expect from the 'arch-gossip' and former diary columnist of the *Evening Standard*, Adrian Woodhouse's account is peppered with fascinating insights and delicious detail: Godfrey Tearle playing Macbeth in 1949 at the age of 65, and his relationship with Fleance, the 17-year-old Jill Bennett; the breakdown of the relationship between Laurence Olivier and Vivien Leigh during their 1955 season; the 1958 *Hamlet* tour to Moscow when Coral Browne (Gertrude) met the spy Guy Burgess.

There are theatrical trivia aplenty: the first actress to play Ariel at Stratford (Margaret Leighton); the first use of dry ice at Stratford (in Michael Benthall's 1951 *Tempest*) and the disappearance of McBean's 'Swiss roll', a 140-feet photographic panorama, a 'Bardic Tapestry' created by McBean to celebrate 350 years of Shakespeare production, which used to hang in the dress circle foyer of the Shakespeare Memorial Theatre and is now lost.

Angus McBean's photographs, the theatre and the productions he captures, viewed from the perspective of our own times, seem like gems from a lost age, but this book manages to reverse that perspective and make them seem immediate, fresh, and innovative, and that, in itself, is a startling feat.

Gregory Doran
Artistic Director
Royal Shakespeare Company
2018

Introduction

The great photographer Angus McBean has been celebrated over the past fifty years chiefly for his romantic portraiture and playful use of surrealism. There is some reason. He iconised Vivien Leigh fully three years before she became Scarlett O'Hara and his most breathtaking image was adapted for her first appearance in *Gone with the Wind*. He lit the touchpaper for Audrey Hepburn's career when he picked her out of a chorus line and half-buried her in a fake desert to advertise sun-lotion. Moreover he so pleased The Beatles when they came to his studio that he went on to immortalise them on their first LP cover as four mop-top gods smiling down from a glass Olympus that was actually just a stairwell in Soho.

However, McBean (the name is pronounced to rhyme with thane) also revolutionised British theatre photography in the late 1930s. He himself thought that his greatest achievement lay in his photographs of Shakespeare productions, most particularly those created during his 17-year association with the company at Stratford from 1945. He was right.

As a recorder of Shakespeare Angus McBean is simply unequalled. He photographed every play in the canon, the most popular ones so many times that his final Bardic tally topped 160 productions. The 90 of these he shot at Stratford by themselves yielded nearly 3,500 images. Nevertheless there is far more than sheer numbers to his Shakespearean pre-eminence. McBean's 'genius' – the word applied to him by his admirer Lord Snowdon, who, ironically, had usurped his position as the most fashionable theatre photographer just before marrying into royalty – was to endow the hitherto staid portrayal of Shakespearean acting with an immediacy and excitement that can only be called sex-appeal.

It helped that McBean, a devourer of theatre from boyhood onwards, could never tire of Shakespeare: the romance of kings and queens, heroes and villains, magicians and clowns perfectly suited a man who practised his own form of parade and sorcery. He was also fortunate indeed that he fell into theatre photography by accident just as a seemingly golden age of British acting was beginning. However his own contribution was to give the outstanding stage performers of this era an enduring power that carried far beyond the confines of their playhouses.

Certainly, in a single session with a Yankee Cleopatra in 1945, he transformed the image of Stratford overnight, conjuring from the Prospero's cell of his small Covent Garden studio the dazzle of the West End into the West Midlands. (It is significant that the then Shakespeare Memorial Theatre began transferring its productions to London shortly afterwards.) In succeeding seasons, acknowledged since as the Stratford stage's 'renaissance', his black-and-white magic continued to endow this rebirth with a glamour that was crucial in its further rise to not just national but international pre-eminence.

Even as his photographs were created, McBean's Shakespeare became ubiquitous. Large display prints of his lustrous close-ups of the heroes and heroines crowded the foyers and stairwells of the Stratford theatre; their smaller versions, along with his almost cinemascopic stage panoramas, filled weighty Festival programmes, which could now be billed as souvenirs; dozens of different McBean images were sold as postcards by the thousand to be dispersed over the world; periodicals and annuals stuffed with his Stratford photographs jostled each other wherever books were sold; even the restaurant overlooking the Avon had its adverts shot by him. Most spectacularly of all he created for one SMT 'centenary' a photographic mural running round the theatre's circle foyer which measured 140 feet long and 8 feet high.

Now, almost six decades on from his last commissions for the then newly retitled Royal Shakespeare Company, the postwar years of its predecessor at Stratford simply *have* to be viewed through the camera eye of Angus McBean. At last, his glorious mid-1950s addition of colour to his sessions at Stratford can be fully appreciated for the first time: the poor quality of newsprint colour reproduction had inhibited wider circulation of his vivid images when they were being created.

How fortuitous it was, therefore, that such a perfect match of theatre and photographer began just as each needed a lifeline.

Angus McBean's self-portrait
Christmas card, 1954

3

PROLOGUE

By the time the Second World War was ending in Europe, Stratford appeared a drab backwater to the mainstream of Shakespearean productions. For all the SMT's brave new building, opened in 1932 to the modernist design of Elisabeth Scott, and its employment of radical director/designer Theodore Komisarjevsky, it was clear that the greatest Shakespeare performances of the 1930s and early 1940s were taking place beside the Thames or on film sets. Talents honed in the redoubtable Lilian Baylis's Old Vic – Edith Evans, John Gielgud, Laurence Olivier, Ralph Richardson, Peggy Ashcroft, Michael Redgrave, Alec Guinness and Anthony Quayle – found ready outlet thereafter in the West End for roles by the Bard without any need to tread the boards beside the Avon. While Olivier had not only transferred his Old Vic Henry V of seven years before magnificently to the screen in 1944 but also, during his own co-directorship with Richardson of the Old Vic company, had just given his famously corvine Richard III which would eventually follow Henry V and his 1937 Hamlet on to film.

Accordingly the Stratford theatre administration decided to appoint Sir Barry Jackson, adventurous founder of the Birmingham Repertory Theatre three decades before and founder with Bernard Shaw of the Malvern Festival, as next artistic director of its own annual season. However his predecessor, the actor-manager Robert Atkins, had already had the inspiration to engage Claire Luce, the blonde American film star and sometime dance partner of Fred Astaire who had become a wartime Forces' Favourite after she chose to remain performing in England, as lead actress for the 1945 season. Her performances as Beatrice, Cleopatra, Viola and Mistress Ford were well received and the US picture weekly *Life* even ran a spread on her residency in Stratford complete with some production photographs and the convenient fiction that she was staying in the town's venerable Shrieve's House. The production pictures had been taken, following the theatre's policy of favouring the home-grown, by the Stratford photographer Tom Holte, whose chief trade otherwise was snapping tourist views and old buildings.

The publicity surrounding Luce nevertheless did not fill the Memorial Theatre, perhaps understandably given competing distractions of the celebration of victory in Europe and the calling of a General Election. So in late June John Goodwin, young assistant to the theatre's 'press representative', Tom English, suggested to his boss that they might just have Miss Luce specially photographed by Angus McBean. When English contacted the studio, which McBean had set up only a few months previously in Endell Street just off Covent Garden Market, the photographer could not believe his luck. He certainly needed some: in the previous decade McBean, bald but impressively russet-bearded and who still spoke (belying the patronym of his only Scottish grandparent) with the slight Welsh accent of his native Monmouthshire, had experienced extraordinary professional triumph followed by devastating personal humiliation.

After moving to London aged 20 in 1924 McBean had gradually become known in theatrical circles for his two ways of making faces: dramatically posed and lit portrait photographs, which initially he took in the front room of his family's suburban bungalow and printed in its bathroom, and magnificent masks constructed of papier mâché or plaster. John Gielgud, just a few months his senior, could still recall fifty years later the sensations that McBean caused with his elaborate costumes and masks at riotous Old Vic Balls at the Albert Hall which raised money for the Baylis classical repertoires – *and* that McBean, who seemed to be able to make anything, had had his first paid theatre job in Gielgud's 1932/3 West End hit *Richard of Bordeaux* crafting two intricate metal dioramas of a Gothic townscape and the cast's 'medieval' shoes.

Over the next few years commissions for masks and props for various West End shows followed which earned McBean considerable praise. Actors, dancers and debutantes also trekked in increasing numbers for portraits to his West Acton bungalow, among them Stratford's 1932 Prince Hal, Gyles Isham, Diana Gould and Guinevere Grant who became respectively baronet Sir Gyles of Lamport Hall, Lady Menuhin, wife to the great violinist, and Lady Tilney, Mrs Thatcher's 'wardrobe mistress'. (Piquantly, Isham embarked on a necessarily discreet 12-year relationship with a young designer, John Lear, who was a lodger

in the McBean bungalow.) The reason was clear for those whose faces were their fortune. This photographer, who had a mantra 'Everyone wants to be beautiful', delivered exactly that: his mask-maker's understanding of physiognomy made him able to sculpt his sitters' faces with light and shade to glorious effect when his portraits were developed on silver-coated photographic paper.

McBean images began to appear in the 'shinies' (as the weekly society picture magazines were then known) after *The Sketch* used as a full-page frontispiece his self-portrait posed with his own articulated puppet of Mae West in her *Diamond Lil* costume. Then, following a period as assistant to the Mayfair society photographer Hugh Cecil, during which he took in his boss's absence the first known studio images of the Prince of Wales and Mrs Simpson together, McBean felt confident enough of this part of his face-making to invest like Cecil in a huge half-plate camera on a tripod, whose 5 by 4 inch glass negatives could be retouched to perfection. In June 1935 he opened his first proper studio in a basement in then run-down Pimlico.

However it was a mask commission early the following year which led to him bringing his big camera into the theatre and to a 31-year love-affair through the lens with one of the twentieth century's most fabled faces. No less than the actor/

composer Ivor Novello asked McBean to make him some technically rather taxing masks for a Regency-set frivol, *The Happy Hypocrite*, for which the star had chosen as his onstage love interest 22-year-old Vivien Leigh, whose beauty had a few months previously caused a sensation when she made her West End debut. Novello was so much struck with the reference photographs which McBean made, along with a usual life cast, in order to model the masks that he invited their creator to take production shots at the traditional photo-call a few days before opening night alongside the long-established Stage Photo Company (SPC). 'We Welsh boys must stick together,' said the star, only half in jest.

McBean did as he was bid and, although the show was a flop, it was *his* dramatic close-up images which were blown up to be posted as huge prints outside His Majesty's Theatre, which were distributed in hundreds by Novello's veteran press agent, William Macqueen-Pope, and which achieved the never equalled feat of appearing, credited to McBean, as frontispiece of all five 'shinies' in the same week. His ravishing close-ups of Leigh did not achieve wide circulation because the society magazines, like the monthly *Theatre World* which put a McBean of the lead star on its cover, had Novellomania. However a new career was born for the photographer and the young actress decided that she had found her favourite image-maker.

Within weeks McBean was engaged to work on the second of Novello's huge Drury Lane Theatre musicals, *Careless Rapture*. For this the photographer began his practice of watching a full dress rehearsal where he noted down the particular stage-actions he wanted to be repeated the next day at the traditional, sometimes four-hour-long, photo-call for any new production. Other shows in 'Popie's' care followed, including a spectacular US musical revue *Transatlantic Rhythm* in which McBean captured his first Broadway and Hollywood stars as well as demonstrating a particular gift for photographing black performers. Always, instead of relying, like the SPC and other theatre photographers of the time, on existing stage lighting which he could see produced a deadening or flattening effect when subjects were viewed through camera lenses, he brought his own

Vivien Leigh in
The Happy Hypocrite, 1936

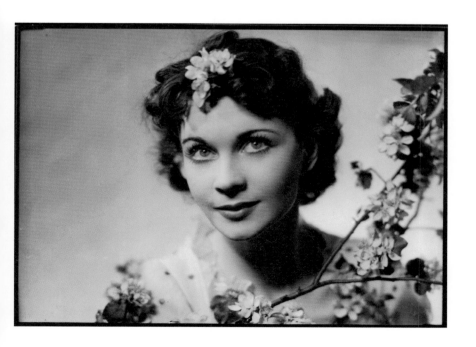

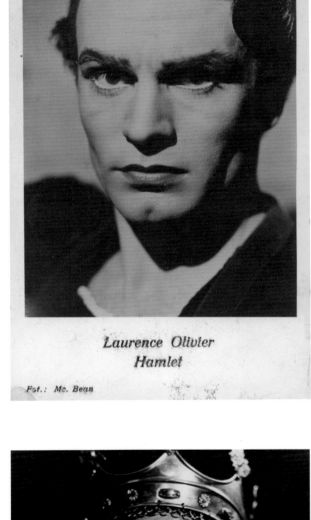

Edith Evans in *As You Like It*, 1936

Laurence Olivier in *Hamlet*, 1937

lights up on to the stages. With these to help him he could also dare to zoom in on the actors' faces for Hollywood-style close-ups that were perfect for attention-grabbing display outside the theatre or for publicity in the 'shinies'. Almost overnight McBean, of whom the SPC's owner soon wailed that he had put his company out of business, made British theatre photography not just a routine record but a carefully crafted part of every drama.

Even more to his personal satisfaction, but to the initial horror of Lilian Baylis who thought the 'shinies' far too frivolous to represent her productions properly, he wheedled his way into his beloved Old Vic alongside its usual photographer, Debenham. Here, after capturing the season's *The Country Wife* and *The Witch of Edmonton* which starred Edith Evans, he photographed his first Shakespeare production: *As You Like It* with Evans and the rising Michael Redgrave which transferred to the West End. His pictures endowed the pair with a glowing beauty which was somehow all the more fitting since the 48-year-old Rosalind was having an ill-concealed affair with her Orlando even though he was nearly twenty years her junior and his wife, Rachel Kempson, was also a member of the company.

Thereafter McBean was given freer rein at the Old Vic, even being allowed to re-block the stage moments he wished to capture in order

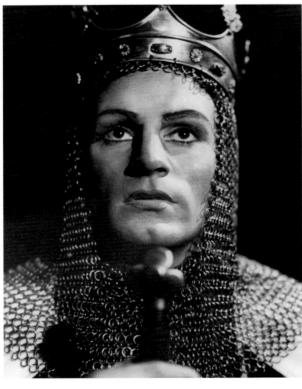

Laurence Olivier in *Henry V*, 1937

to achieve a better picture. Thus he recorded Laurence Olivier's *tour-de-force* of playing Hamlet, Henry V, Sir Toby Belch and Macbeth that season, and the photographer would later claim that he 'never took a better picture' than one of his smouldering close-ups of Olivier as Hamlet. When that summer the actor repeated the role at Elsinore Castle (with Vivien Leigh now taking on Ophelia) the photographer was delighted to be asked by a Danish company to have the image made into a postcard; and, having already begun to send out self-portrait Christmas cards as a handy form of advertisement, he went on to use his own postcard-sized prints of the Olivier close-up as his 1937 greeting. (The flattered Olivier soon commissioned McBean to take pictures of himself, his wife the actress Jill Esmond and their baby son in the marital home. At almost the same time Leigh, at the photographer's suggestion, paid the first of many visits to the Pimlico studio to model hairstyles for a leading West End *coiffeur*.)

While capturing another lauded but now forgotten Prince of Denmark of the summer of 1937, the actor-composer-poet Christopher Oldham Scaife, at the director Michael Macowan's Westminster Theatre, McBean encountered for the first time the 23-year-old Anthony Quayle and his beautiful wife, Hermione Hannen, who were playing Horatio and Ophelia. Both soon joined the Old Vic company where the sudden death of Baylis in November 1937 prompted a handsome memorial book the following spring illustrated only by McBeans: specially commissioned images of backstage scenes or personnel at the theatre in Waterloo accompanied a selection of production shots of not only the plays the photographer captured there but also some of the ballets at Baylis's other venue, Sadler's Wells. McBean recorded at the Old Vic later in 1938 director Tyrone Guthrie's *Othello*, in which Olivier as Iago stole all the notices from Ralph Richardson's Moor, and Guthrie's modern-dress *Hamlet* which made the name of Alec Guinness. Further Shakespeare productions McBeaned that year were Macowan's modern-dress *Troilus and Cressida* in the West End, featuring Robert Harris, Max Adrian and others in black tie or evening gowns lolling on a white grand piano, and a more conventional but commercially disastrous attempt at *Henry V* by Novello who

swapped the habitual *lederhosen* of his Drury Lane musicals for the hero-king's chain-mail.

By now McBean, less than three years after he took up the genre, was the country's leading theatre photographer with Shakespeare his particular speciality, as witnessed by his sublime image of Jessica Tandy's Princess Katherine in the Old Vic *Henry V*. However his *réclame* was much increased by his emergence, again almost by accident, as the country's best-known, home-grown surrealist: an idea of posing sitters after the manner of the fashionable painter William Acton, who portrayed society beauties as classical busts in surreal landscapes, took off spectacularly when McBean's photograph of Beatrix Lehman, then

Christopher Scaife in *Hamlet*, 1937

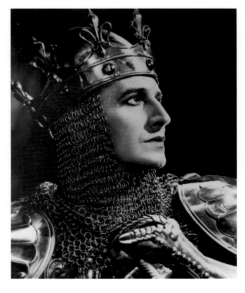

Alec Guinness in *Hamlet*, 1938

Ivor Novello in *Henry V*, 1938

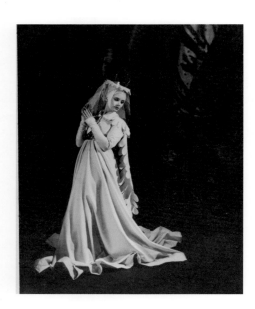

starring in Eugene O'Neill's *Mourning Becomes Electra*, appeared full-page in *The Sketch* in December 1937. A weekly series in the magazine first 'Actonising' then 'surrealising' actresses, along with the occasional comic actor or debutante, ran on until the spring of 1939 and gained McBean huge publicity, as well as imitation, nationally and internationally.

The photographs, which shamelessly plundered, often for comic effect, surrealism's lexicon of ruins, disembodied heads and limbs or desert sands and infinite vistas, were created using elaborate sets in McBean's small studio and sometimes took days to achieve. Pamela Stanley, in full crinoline and parasol of her West End role in *Victoria Regina*, sat atop a large mound of specially ordered sand with an elaborate but empty plaster frame dangling in front of her face. Vivien Leigh had a plaster dress moulded on to her body by the photographer and his assistants for hours so that she could come back when the dress dried and be presented as the goddess of dawn floating in clouds (actually artfully lit cotton-wool stuck on to the garment). Diana Wynyard, with her perfect Greek profile, was similarly plastered before being half-buried with ruined columns about her in the sand, which had proved rather too difficult to remove from the studio and thus was used again and again. The sitters in the series, like the public, never failed to be pleased: the famously bald *farceurs* Alfred Drayton and Robertson Hare adored the image of their heads

lying on sand alongside some ostrich eggs and a stuffed baby ostrich; Flora Robson told McBean years later that her portrait, showing her emerging like some exotic creature through the crust of a desert wilderness, was her favourite picture of herself; while Peggy Ashcroft, who travelled to the Pimlico studio in 1938 with her Portia trial scene robes from a West End production of *The Merchant of Venice*, in 1983 declared the same about her 'surreal' image.

Scarcely surprisingly McBean never found time to go to Stratford to see Shakespeare there, despite his friend Isham's return to the company to play Henry VIII and Prospero in 1938. Though in summer the following year, after a hectic six months in the West End which included production shots and 'surreal' double-exposure posters for the celebrated *The Importance of Being Earnest* starring Edith Evans and John Gielgud as well as the British premiere of *Design for Living*, the photographer travelled to Buxton Opera House to capture an Old Vic-bound *Romeo and Juliet* starring the film heart-throb Robert Donat and Constance Cummings. Donat soon had a close-up from the session made into a postcard which he distributed to fans, and other stars did likewise with their favourite McBeans: Vivien Leigh was still giving away in the mid-1950s a 1938 image of herself in a big black hat which she had despatched to Hollywood when hoping to be cast as Scarlett O'Hara. (The picture, originally a *Bystander* magazine frontispiece, also happened to be the photographer's own favourite out of his entire *oeuvre*.)

The onset of war in Europe initially closed the London theatres but they quickly reopened, enabling McBean to photograph Gielgud's first Lear at the Old Vic just as his surreal work was achieving mass circulation. His Christmas cards and a specially made image of Olivier's 1938 Old Vic Coriolanus, which put a small cut-out of the actor in costume against familiar McBean props and cotton-wool clouds, were featured at length in the popular pocket magazine *Lilliput* while the weekly *Picture Post* in February 1940 ran a cover story on McBean called 'How to Photograph a Beauty'. This showed across several pages how he created an image of the actress Diana Churchill's disembodied head lying on a lino-clad

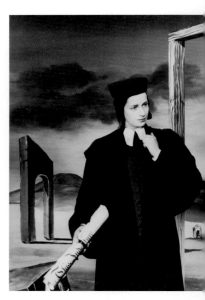

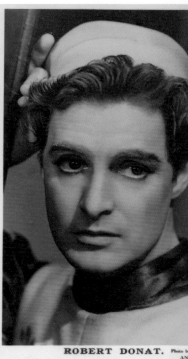

Jessica Tandy in *Henry V*, 1937

Peggy Ashcroft 'surrealised' as Portia, 1938

Robert Donat in *Romeo and Juliet*, 1939

Gyles Isham, 1940

kitchen floor and the feature was much publicised elsewhere – even in Germany where the Nazis mistakenly trumpeted the sitter as 'the wayward daughter' of the new British Prime Minister.

After the Blitz began, the photographer, declared unfit for armed service, moved out of London to set up a makeshift studio in an uncle's Georgian house in Bath and relinquished his Pimlico base to his sometime assistant John Vickers, newly embarked in practice himself. From Bath McBean was still able to travel the country where productions were either on extended tours, like the *King John* of the now bombed-out Old Vic, or on their way into the West End, like *The Doctor's Dilemma* directed by Olivier and starring his now wife, Vivien Leigh. One magnificent portrait session, taken during a brief visit to the capital and his former studio, assumed particular poignancy: the Guyanese-born dance-bandleader Ken 'Snakehips' Johnson sat for McBean but before the pictures could be used the 28-year-old was killed on his bandstand in a night-time direct-hit on Leicester Square's fashionable Café de Paris.

Then in November 1941, after apparently some months under police observation, the famous photographer was arrested at his uncle's house. Homosexual acts were then illegal and it seems that the coincidental location of a well-known café in the centre of Bath, where McBean and a number of other men used to meet, near the wartime HQ of naval intelligence had

engendered official paranoia about homosexuals. After ruthless interrogations and searchings of personal papers, McBean and a further six men (all younger, some of them in the services and one with a girlfriend who also went to the café) were charged with committing homosexual acts. The photographer's theatre work dried up immediately, though professional and personal contacts remained touchingly loyal: Isham, now an army officer with a dashing McBean close-up to mark his commission, was among the 'rather grand friends', as the photographer called them, who wrote him letters of support during his four months on bail. Two days before his trial opened, the Oliviers defiantly used a McBean-credited close-up of Vivien Leigh as Mme Dubedat, which her new husband would claim as *his* favourite picture of her, on the programme cover for *The Doctor's Dilemma* at the Theatre Royal, Haymarket; and they insisted too that McBean's name appear prominently under his display prints outside the theatre throughout the revival's 18-month run.

The photographer and his co-accused pleaded guilty but, after a day at Winchester Crown Court on 6 March 1942 in front of no less than the Lord Chief Justice, Viscount Caldecote, McBean was sentenced to four years' imprisonment with hard labour, by far the harshest punishment meted out and 'twice as long as Oscar Wilde's' as he thereafter was wont to quip. Lurid newspaper coverage of the trial caused anguish for his mother and sister before he endured a particularly

Ken 'Snakehips' Johnson, 1941

shaming ordeal when, shackled wrist and ankle to a gang of other prisoners, he was led across Waterloo Station en route to Wakefield Gaol as rush-hour crowds stared. However, according to letters sent to his best friend, now his brother-in-law, he endured his sentence and its long hours of arduous manual work in south Yorkshire fields with remarkable good humour.

On release in September 1944, three months after his fortieth birthday, McBean reckoned he would be unlikely to find work either in the theatre, where Vickers, who remained in his former Pimlico premises, had taken over his West End and Old Vic eminence, or with the wide-ranging sitters for his studio portraiture whom he had attracted previously. Nevertheless he returned to London determined to start anew somewhere more convenient for the West End and found – a stone's throw from the upper end of Shaftesbury Avenue in one direction and from the detritus and denizens of the flower, fruit and vegetable markets of Covent Garden in the other – a bomb-damaged shop. He took a very cheap 21-year lease and laboriously restored the building to serve as a studio with accommodation above. In April 1945, as Allied Forces were fighting their way into Berlin and the Stratford Festival season was opening, he began business again but portrait sitters were slow to arrive. Then Stratford's Tom English telephoned.

ACT I: 1945–48

It was arranged that Claire Luce, who was actually living in a suite in the Savoy Hotel a few hundred yards from McBean's new base, should be portrayed in her Cleopatra role and would attend Endell Street with three of her Egyptian costumes, wigs and head-dresses. Beforehand McBean not only had his friend the painter Roy Hobdell, who had provided many of the backdrops for the *Sketch* surreal series, limn a night-time scene complete with obelisk and moon, but also mocked up the poop of a Nile barge and coaxed a young Jamaican dancer, Berto Pasuka, to do duty as Nubian slave-oarsman for the session. Luce, who in between shots puffed on cigarettes as McBean's assistant recorded in some informal snaps, gamely allowed herself to be directed by the photographer into the hieratic poses that he wanted but which naturally

Claire Luce in McBean's studio, 1945

did not reflect the actual course of the *Antony and Cleopatra* production that he himself had not seen. The results, dramatically shadowed images of the svelte, full-lipped Luce, which might be dubbed hyper-real rather than surreal, were remarkable, with the inclusion of Pasuka lending an extra exotic, even erotic, edge.

The Stratford publicity team were delighted and they and McBean were even more so when *Tatler* took three of the pictures and blazed Luce across a double-page spread on 11 July 1945. 'I was back,' the photographer opined later and indeed theatre and portrait work flooded in as if he had never been away. At Sadler's Wells he took production shots of Britten's new opera *Peter Grimes*, starring Peter Pears, whom everyone in the business knew to be the composer's lover; actors like Robert Morley wanted to be McBeaned in costume even though the West End productions in which they were appearing had not been; and he rapidly became house photographer not only to the most influential West End production company, H.M. Tennent, but also to the Royal Opera House. Sir Barry Jackson, when he took control at Stratford that October for the 1946 Festival season, needed no persuading by English and Goodwin that the Memorial Theatre ought to employ McBean on a permanent basis.

Sir Barry's declared theme for his first season was 'youth'. This he signalled by his employment of a 21-year-old *wunderkind* fresh from Oxford University, Peter Brook, as one of the six different directors for the season's plays, and also of a 24-year-old Birmingham Rep alumnus, Paul Scofield, to be a leading actor alongside the established Robert Harris, Valerie Taylor, Ruth Lodge and David King-Wood. Though, clearly in order to be politick, the Stratford snapper Holte was used to record the opening play, *The Tempest*, as well as *Cymbeline* and *Henry V*, McBean quickly became the Festival's favoured photographer. He was commissioned to take the production shots of Brook's *Love's Labour's Lost*, *As You Like It*, *Measure for Measure*, *Macbeth*, the season's non-Shakespeare, *Dr Faustus*, and was eventually asked to do a special session with Scofield's Henry V in order to augment the rather pallid images of the latter from the hapless Holte.

The new SMT photographer, who once more could afford colourful tweed suits and shirts tailored to his own design, began a routine through the months of the Festival which was unvarying until he was finally persuaded a decade later to acquire a car. After a train up from London with his assistant, equipment and lights, he watched a dress rehearsal of the next play, stayed overnight and then – following the schedule of shots he wanted to achieve which he posted up at the theatre first thing the next morning – took his photo-call before entraining back to the capital. In Endell Street he and his staff would develop the glass negatives and produce prints for despatch back within another day to the publicity office, from which choices would be made both for multiple 10 by 8 inch prints for newspapers or magazines and the display images at the theatre. It is significant that, now a photographer favoured by the 'shinies' had been engaged by the SMT, even the worthy local magazine *Shakespeare Pictorial* which dutifully chronicled the Festival offerings among academic articles, this year reinvented itself as *Stratford-upon-Avon Scene* which was filled with McBean images.

The hit of the 1946 Festival was undoubtedly Brook's directorial debut beside the Avon whose gorgeous Watteauesque costumes and settings by Reginald Leefe were particularly suited to

McBean's eye for picturesque re-arrangements and his romantic *chiaroscuro*. The star of the season equally undoubtedly was Scofield and this was underlined by McBean's images of him which could by turns endow his thoughtful Henry V with heroic handsomeness or his Don Armado in *Love's Labour's Lost* with an ennui which one critic likened to that of 'an over-bred and beautiful old borzoi'. The pairing of Scofield as Oliver in *As You Like It* with his wife, Joy Parker, who was playing Celia, also brought about the first of countless Stratford shots where McBean ensured that the heads of an embracing couple were on a perfect diagonal across his picture. Certainly he seemed equally at home whether he was illumining the precise *quattrocento* elegance of the *Measure for Measure* from Stratford's first American director, Frank McMullan, or capturing the dark cauldron of the Jacobean *Macbeth* directed by his own old acquaintance Michael Macowan.

The actors too felt particularly at ease with McBean because many of them had worked with him previously: Harris, Lodge and Taylor had been in front of his camera many times in the West End; King-Wood had appeared in Isham's celebrated 1934 Oxford University Dramatic Society production of *Dr Faustus* for which McBean made masks; even Scofield had been photographed by McBean as a teenager. Four decades later the actor recalled with affection and considerable perspicacity not only his own delight at encountering McBean once more but also the respect that the photographer, for all his troubles of a few years previously, commanded from the Stratford actors:

He generated a sense of excitement in the theatre and the company when he arrived to photograph a production. He was an original, even picturesque, man in personal appearance and had a manner containing both extreme sweetness and chilly professionalism. His concentration was so total, to the point of being electric, and was perhaps the reason why his posed photographs had the quality of lively performance. The actors were on their toes because Angus was there. Few photographers have this effortless authority – with little talk, just a few gritty barks. He photographed me in a production at the Westminster Theatre during the

war (I was a student) and he seemed not to have changed at all – swift decision and movement, a hint of mockery, the sudden overwhelming niceness, the fleeting impression of an almost monkish austerity and suddenly the gust of Pan-like laughter. A wonderful man.

The 'lively' quality that McBean brought to his first Festival Season's photographs was remarked upon at the time by observers like Lester Taylor, editor of *Stratford-upon-Avon Scene*, so it was little surprise that for the 1947 Festival the newcomer, not Holte, was engaged to photograph all five new productions which were added to the three, including *Love's Labour's Lost*, repeated from the previous season with some recasting. The fresh faces on the SMT stage included Beatrix Lehmann, McBean's first 'surreal' sitter who most recently had been establishing a repertory company funded by the new Arts Council in war-damaged Coventry. She was another leading actress at a Festival who was new to Shakespeare and the first of her varied roles was the Nurse in the hugely anticipated *Romeo and Juliet* directed by Peter Brook which opened the slightly lengthened season.

Shortly before McBean travelled to photograph this first production his newly taken conventional close-up of Lehmann appeared as welcome free publicity across half a page in *The Sketch*. However it was rather Brook's casting of the winsome, 19-year-old Daphne Slater, barely months earlier a Gold Medal winner at RADA and newly signed in a blaze of publicity to a seven-year film contract by the producer Herbert Wilcox, which had crowds queueing from the early hours or bicycling from London for the gallery seats. (In the event critics were fiercely divided about Brook's cutting of the play as well as about the verse speaking of Slater and Laurence Payne's Romeo, which paled beside the spell-binding Queen Mab speech from Scofield's Mercutio.) Small wonder then that McBean, who brought out in his 'action' shots the picturesqueness of the miniature castellated city walls, towers and arcades by which designer Rolf Gerard rendered Verona, contrived a full-length image of Slater gazing at the 'light through yonder window' while also backlighting her face to endow her with movie-star radiance. Within three weeks of opening night this occupied a full page in *The

Sketch*, the first of many such in the 'shinies' which McBean's photographs of Stratford actresses would achieve. The photographer was to reiterate many times in the next fifteen years his pose of a single SMT performer, sometimes standing within an arch or similar framing scenery but always shot from below, which gave them heroic, even godlike status.

For magazine editors, now filling their pages also with McBean's London play, opera and ballet photographs, his ability to make Shakespeare productions look like fashion plates or Old Masters (the image of Payne's Romeo alone by a cut-out tree is clearly indebted to a famous Nicholas Hilliard miniature) was indeed manna. So *Twelfth Night* with multicoloured Carolean kit that one unkind wag compared to Butlin's holiday camp uniforms, a *Richard II* sprigged with flowers throughout, *The Merchant of Venice* starring Lehmann with sets and costumes from Veronese paintings chosen by the season's other young director, Michael Benthall, and even the production of *Pericles*, with its stark silhouettes and candy-stripes designed by Sir Barry himself, occupied for week after week multiple chunks of the print media which made up the nation's habitual visual stimulation before universal television ownership. Even the doughty *Stratford-upon-Avon Scene*, which had to record that summer the accidental drowning in the Avon of 18-year-old Albert Forster three days before he was about make his debut with the SMT in minor roles, started aping *Theatre World* and put McBean production shots on its cover rather than stolid images of the theatre building from the local photographers.

Sir Barry, who saw the commercial and publicity advantage to be gained from taking the Festival to London for a period once its season in Warwickshire ended, also had his press team create a special programme featuring McBean images of various productions by the time that *Richard II*, for which Robert Harris's king had won great plaudits, and *Twelfth Night*, featuring Lehmann's Viola and Scofield's Aguecheek, moved with *Romeo and Juliet* for the autumn months to His Majesty's Theatre in the West End. Henceforward the 'Festival Souvenir' was an annual feature which served also as an

Peter Brook, 'Eminent Man of the Theatre', *Tatler*, 1947

ongoing testimonial to the talent of the house photographer. McBean himself meanwhile made Peter Brook appear through a drop-curtain of his *Romeo and Juliet* press-cuttings in a new surreal series, created this time by double-exposure or scissors and paste, of 'eminent men of the theatre' which he began for *Tatler* that summer. (The import of the accolade for Brook can be gauged by the fact that the young director appeared third in the series after the doyen of theatre critics, James Agate, and Ivor Novello.) Production shots of *Twelfth Night* even graced the magazine *New Writing* whose editor, John Lehmann, was brother of Beatrix. Clearly the SMT was 'hot'.

So it was perhaps a surprise to the public to discover as the 1948 season was opening that Sir Barry, who was deploying six new productions with inspired choices of performers or directors and a recast *Merchant of Venice* for a longest-ever Festival, was not going to have his own three-year contract extended by the theatre's governors. Once again the season's leading actress, one of McBean's own favourite sitters Diana Wynyard, was new to Shakespeare though she had had an impressive stage and film career. The other featured ladies included Claire Bloom, a 17-year-old discovery of Michael Benthall who was himself to direct the first three of the new productions. Joining Scofield at the head of the actors' list were a diverse quartet who had variously been photographed by McBean before: the Australian-born ballet-dancer/actor Robert Helpmann; Esmond Knight, who despite eye surgery was nearly blind from wartime injury; Anthony Quayle, who was also to direct *The Winter's Tale* and *Troilus and Cressida*; and 63-year-old, sometime Hollywood stalwart Godfrey Tearle, whose father had been one of the earliest directors at the Festival in the nineteenth century. Tearle was also to direct himself in the last play for 1948, *Othello*.

The popping eyes of Helpmann as both the wicked king who murders his nephew, Prince Arthur, and Shylock appeared to great effect in the McBeans of the first two well-received plays, *King John* and the revived *Merchant of Venice*. Wynyard's beauty in the Sophie Federovitch costumes for the latter production ensured that two different images of her Portia were full-page in *Tatler* and

Robert Helpmann, 'Eminent Man of the Theatre', *Tatler*, 1948

The Sketch for consecutive issues. However, it was Benthall's decision to alternate Helpmann, who during the war had both danced and played Hamlet in London, and Scofield as the Prince of Denmark in a powerfully cast production – Wynyard as Gertrude, Quayle as Claudius, Bloom as Ophelia and Knight as the gravedigger – clothed in mid-Victorian dress and ablaze with candles which generated the most excitement and the most striking of the images of the season. Though Scofield was the Stratford gallery's swoon-maker, it was Helpmann, also posed by McBean in his studio for *Tatler*'s 'eminent men of the theatre' series against a giant copy of the first page of the Hamlet text, who gathered greatest publicity. Eventually an image of him as King John on his throne was chosen to be the first in a series of picture postcards of Stratford leading players that the SMT decided to offer to theatregoers. (McBean's study of Scofield's Hamlet with candles became, after considerable demand, fourth to go on sale following postcards of Wynyard and Tearle.)

Benthall's final production, a riotous *The Taming of the Shrew* starring Wynyard and Quayle, proved extremely popular, perhaps because audiences – among them in July a Gloucestershire country-house party including Princess Margaret – enjoyed the spectacle of the exquisite actress as the termagant first with a whip and then being slung over Petruchio's shoulder after their wedding.

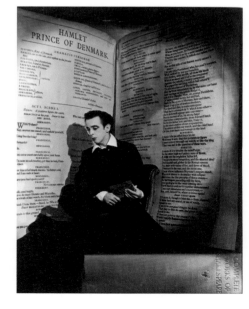

Of Quayle's own two directorial efforts, the Byzantine Empire-style *The Winter's Tale* with Knight as a tormented Leontes to Wynyard's sensitive Hermione won the most critical plaudits that year, while his *Troilus and Cressida*, which pitted dreamily romantic Trojans against neo-fascist-garbed Greeks, clearly stood him in good stead with the governors of the theatre: Quayle was named as Sir Barry's successor even before the season had ended. Tearle's impressive *Othello* earned points likewise for its director-star and also concluded an extraordinary year for Stratford in the 'shinies' when the rather heavy-jawed 'Moor' became, thanks to a McBean close-up, a *Tatler* pin-up.

ACT II: 1949–52

Quayle assumed artistic control at the Memorial Theatre through the winter months of 1948/9 while the Stratford stage was filled with various touring offerings from West End managements in association with the Arts Council. These included a Shaw revival and new plays from Terence Rattigan and Christopher Fry which brought to Avonside names like Flora Robson and John Gielgud as well as a mesmerising young actor, Richard Burton, whom Gielgud had picked to appear with himself, Claire Bloom and Pamela Brown in his own direction of Fry's *The Lady's Not for Burning*. Spurred surely by a House of Commons debate of proposals to establish after the planned 1951 Festival of Britain a specially built National Theatre on the south bank of the Thames, Quayle had been set challenges to make the SMT Festival more profitable while *also* extending its reach. So he planned five new productions, a repeat of *Othello* and a trimming back in the length of the season so that the company could make a first international transfer with a tour the following winter of Australia and New Zealand. (Recently knighted Laurence Olivier and his lady, Vivien Leigh, had just led the way by taking the Old Vic company Down Under for a theatrical progress that was triumphal despite the fact that the productions offered were three or more years old.)

Quayle had been a McBeanophile from the time they first met at the Westminster Theatre in 1937 (his second wife, the actress Dorothy Hyson,

and her mother, Dorothy Dickson, moreover had been surrealised in *The Sketch*) and he ordered an expansion of both the SMT's souvenir brochures and its postcard series. He explained his enthusiasm three decades later with typically salty candour:

> There have been a few good theatre photographers but Angus was the only great one. He did marvellous work at Stratford, just look at the way he made crowd and fight scenes seem alive and on a personal level he was very good for me. He took my favourite picture of myself onstage [in 1955's *Titus Andronicus*, see below]. When, like me, you have a face like a bum, you need an Angus.

Despite *Macbeth* having been in the repertory only three years previously in Jacobean dress, the new Festival chief chose to direct it himself in an early medieval setting of barbarism and necromancy a-shiver with furs and sheepskins all of which were brilliantly caught in McBean's studies of Wynyard's tortured Lady Macbeth and Harry Andrews's commanding Macduff. As in 1946 the three witches were played by men but some discretion had to be drawn over the other gender-blind casting, at the insistence of Tearle who played the thane of Glamis, of a 17-year-old blonde newcomer, Jill Bennett, as Banquo's son, Fleance: Bennett, who would become a fine actress and fourth of the five wives of the playwright John Osborne, was already Tearle's mistress. Another Stratford newcomer, who also stood out with his blond hair but would remain for the next three years taking on ever-larger roles, was a young actor called Robert Hardy.

A joyous *Much Ado About Nothing*, directed by Gielgud and starring Wynyard and Quayle as the sparring wits in gorgeous Piero della Francesca-style costumes designed by the Spanish artist Mariano Andreu, was not surprisingly the year's greatest success. The Benthall productions, *A Midsummer Night's Dream* using Mendelssohn's music and *Cymbeline*, though lusciously set by James Bailey and Leslie Hurry in High Renaissance and High Gothic respectively, could not compete with the audiences' fun at seeing Beatrice and Benedick so willingly duped into love. However, Tyrone Guthrie's *Henry VIII* more than held its own with Quayle looking so uncannily

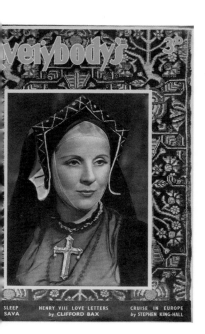

Diana Wynyard in *Henry VIII*,
Everybody's, 1949

like the Tudor monarch in his swollen later years
that it was natural that McBean had him assume
the pose of the famous Holbein image which
was quickly thereafter plastered across shiny
and newsprint pages. The production achieved
two more publicity coups for the SMT: Guthrie's
image, leaning intensely towards McBean's camera
amongst fire buckets and backstage impedimenta,
filled a page in *The Sketch*; and Wynyard's Queen
Katherine became the cover-girl of an issue of
the popular *Everybody's* magazine which inside
devoted a double-page spread to Henry VIII's love
letters illustrated with still more McBean shots of
the production. It would be hard to imagine any
equivalent publication on present-day supermarket
shelves devoting such space, let alone a cover, to a
Shakespeare play at Stratford.

That autumn, perhaps emboldened by the
august drama critic/scholar Ivor Brown who used
a McBean portrait of himself set before a blown-
up version of the First Folio's frontispiece as the
cover of his new book on Shakespeare, the SMT
general manager George Hume commissioned
the photographer to supply special signed prints
of the season's leading players. These were
endowed with fine calligraphic titles on their
mounts, handsomely framed and hung up not
outside the theatre to draw audiences in but
across the public areas within for those audiences
to admire year after year. Stratford's era of actor
as icon had arrived, and Hume wrote McBean
a note of congratulations and thanks. Almost
contemporaneously the photographer happened
to launch another face which in time became
even more celebrated as a twentieth-century icon.
Commissioned to do one of his 'sand pictures', as
the advertising agency dubbed them, of a pretty
girl to promote a sun-lotion, he selected a young
chorus girl he had noticed while photographing
a small West End revue. Having softened Audrey
Hepburn's then unforgiving fringe and style of
makeup, McBean posed her with bare shoulders in
a seemingly infinite desert (actually a sand strewn
table top and a few favourite props) in which she
appeared to dwarf ruined classical columns behind
her. The haunting image of Ozymandian beauty
went into chemists' shops across the land, caught
the eye of a casting agent and Hepburn, mindful
always of McBean's role in her ascent to Hollywood

stardom, even invited him to her first wedding.

By the time the SMT's 1949 company set off
by air (following their seaborne scenery) for their
Antipodean tour of *Macbeth*, in which Quayle was
taking over the title role, and *Much Ado About
Nothing*, the Festival director had already made
his plans for 1950 which would grab headlines.
Not only had Gielgud been persuaded to direct
once again but the 'First Gentleman of the
English Stage', as the actor had been dubbed by
James Agate as sly reproof to the knighthood
bestowed on Olivier, was also to join the company.
Peggy Ashcroft and Gwen Ffrangcon Davies
along with the 19-year-old Barbara Jefford were
to be the leading ladies. Moreover Quayle had a
carefully negotiated royal surprise to announce on
returning from the sell-out Australasian tour.

Though there were to be only three entirely
new productions in a nearly seven-month season
to accompany revivals of *Henry VIII* (this time
with Ffrangcon Davies as Queen Katherine and
Jefford as Anne Boleyn) and *Much Ado* (with
Gielgud and Ashcroft replacing Quayle and
Wynyard) it was revealed that the King, Queen
and Princess Margaret would visit the town
and then the theatre to watch a matinée of the
first of the revivals. Though purists sniffed
that it was a pity that the first visit by reigning
monarchs to the SMT should be to a play not
attributed entirely to Shakespeare, the prospect
of the royal occasion somewhat overshadowed
the first production, another *Measure for Measure*
just four years after the last. However under the
direction of Peter Brook (fresh from staging the
West End premiere of Jean Anouilh's frothy *Ring
Round the Moon*, starring Scofield as twins and
bedecked with a breathtaking set by Oliver Messel)
this was a far darker version somehow suited
to the Lententide of its March opening. Both
Gielgud's austere Angelo and Jefford's fearless
Isabella received formidable coverage in the wide
distribution of McBean's production shots, and the
photographer's studio portrait of the young actress
appeared within days of the first night as a *Sketch*
frontispiece captioned 'Stratford's New Star'.

In the event the Prime Minister, Clement
Attlee, stole a march on the royal party by arriving
nine days earlier with his wife and children to
see a performance of *Henry VIII*, to have dinner

with SMT personnel till midnight in the Falcon Hotel and to read on his return journey to No. 10 an advance copy of that week's *The Sketch* which featured full-page a McBean of Ffrangcon Davies with attendant ladies. Nevertheless the royal visit on sun-filled 20 April more than lived up to what had been expected of it. After taking in the Town Hall, the Birthplace – where the King, a grandfather for eighteen months, said of the infamous babyminder 'We might have one for Charles' – and Holy Trinity, the visitors were greeted at the theatre by Mr and Mrs Quayle. They had a detailed tour backstage, watched a rehearsal of the first scene of the next production, *Julius Caesar*, and His Majesty, when walking past some dressing rooms and spying the Garter insignia laid out for Quayle to wear when portraying his much-married predecessor, showed his host how this should be arranged and worn. After lunch in the restaurant they took their places in an improvised royal box in the first two rows of the circle into which the MPs for Warwick and Stratford, Anthony Eden and John Profumo, were invited.

The prologue and epilogue of the play were spoken specially for this occasion by Gielgud and Harry Andrews so that they could be included in the day's events. The performance was also distinguished in its final scene of the coronation of

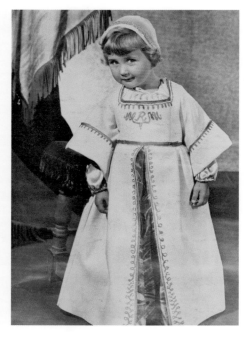

Anne Boleyn by the fact that Quayle carried in his arms not a doll to represent Princess Elizabeth but his own month-old daughter, Jenny, while his two-year-old daughter Rosanna, garbed in white and gold, played Princess Mary. The former never murmured during her first stage appearance but her sister delighted the audience during the speech by Andrew Cruickshank's Cranmer by pointing to her father and exclaiming, with projection that carried to the gallery, 'There's Daddy'. Not surprisingly Rosanna Quayle was photographed in her costume by McBean shortly afterwards and appeared full-page in various magazines. The photographer repaid the theatre the favour: when he named Diana Wynyard as one of the ten most beautiful women he had ever pictured, he chose to show the close-up of her as Hermione in *The Winter's Tale* which had become the second of the theatre's production postcards.

Julius Caesar, directed by Quayle assisted by Michael Langham, with Cruickshank in the title role, Gielgud as Cassius and Quayle as an almost self-effacing Mark Antony, was featured large that June in *Everybody's* magazine which chose to use for its cover the craggily noble features of Harry Andrews as Brutus. To the company's delight the venerable playgoer's magazine *Theatre World*, whose coverage of plays at Stratford had previously been cursory even though it had been an ardent consumer of McBeans from the beginning of the photographer's career, then devoted much of its July issue to three of the Festival's productions, putting on its cover, somewhat to Quayle's discomfiture, his Antony in the heroic pose he had been made to strike by McBean.

When Gielgud, whose second acclaimed *King Lear* at the Old Vic in 1940 had been McBeaned, took the role for a third time in a production directed by both himself and Quayle, it barely mattered that some critics were unmoved and gave acting laurels to 'The Three Sisters' – Cordelia, Regan and Goneril played by Ashcroft, Ffrangcon Davies and Maxine Audley. The McBeans of Gielgud's old king nevertheless commanded more picture pages that summer (including a full-page in *Tatler*) as did the images of him and Ashcroft in the recostumed and recast *Much Ado*. So too did a double exposure of Quayle and the Memorial Theatre building with a headline 'The Man of

Rosanna Quayle in *Henry VIII* for Stratford's royal visit, 1950

Anthony Quayle, 'The Man of Stratford', *Tatler*, 1950

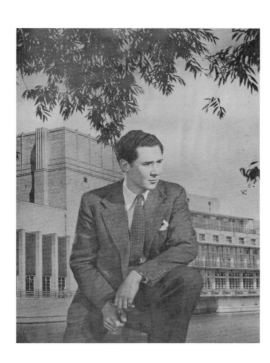

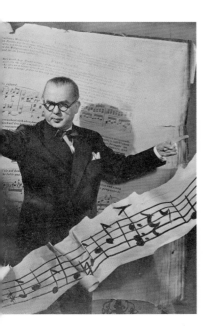

Leslie Bridgewater, *The Sketch*, 1950

Stratford' as well as another piece of McBean trickery which showed the theatre's director of music Leslie Bridgewater wreathed in strips of his autograph scores. It was symptomatic of the esteem in which the photographer's images were held by his subjects that Gielgud chose to give a large display print signed by McBean of the full-length image of himself used by *Tatler* to Robert Hardy, with whom he struck up a friendship that was to last until his death. Hardy particularly treasured the image with its signed dedication 'To Bob Hardy in memory of our good times together, John Gielgud, Lear, Stratford 1950': it was still in his possession at *his* death in 2017.

Quayle's policy of dispersing SMT performances more widely continued. After the season ended, the cast of *Measure for Measure* took off for a tour to Berlin and three other German cities with Cruickshank replacing Gielgud as Angelo. Quayle himself reunited with Wynyard, in the original costumes for their roles, to give a gala charity performance of *Much Ado About Nothing* at the Theatre Royal, Drury Lane. Then through the winter months, while alterations were made to the auditorium which *inter alia* provided an extra 135 seats, a hardback record of the 1948–50 seasons was produced with forewords by Ivor Brown and Quayle preceding an unprecedented assembly of photographs by McBean. The book

sales so exceeded expectations that it was decided to produce such an album every three years and it was significant that the Old Vic company, for whom McBean began taking pictures again at just this time, decided that it too should have such a volume to celebrate its productions.

The year-long, nationwide Festival of Britain, inspired by Prince Albert's Great Exhibition of a hundred years earlier, defined 1951 and accordingly Quayle invited Michael Redgrave and Richard Burton to join the company for the first four of the history plays, a sequence not attempted at Stratford for half a century. Quayle and Redgrave would direct the quartet and Sir Barry Jackson, at the Birmingham Rep once more, neatly arranged that his theatre would carry on the history cycle with the *Henry VI* plays and *Richard III*. The Festival season would then be completed with *The Tempest* directed by Benthall.

The designs by Tanya Moiseiwitsch for Stratford's histories ingeniously used the same sets for all four plays but her costumes for *Richard II* in particular drenched Redgrave's exquisite King and Heather Stannard's Queen Anne in such a profusion of fake ermine and velvet that it was hard to determine which of the onstage pairing occupied more picture pages in the magazines. Stannard, 'discovered' a year previously by Olivier for his West End production of the latest Christopher Fry play, was an especial favourite of 'the shinies' but Redgrave, caught by McBean in close-up at the fateful moment Richard takes the crown from off his own head, filled the cover of *Theatre World* in what was now becoming the magazine's detailed coverage of the Festival every July. Quayle's Falstaff in the two parts of *Henry IV*, acknowledged as the finest for generations before and since, provided McBean with one truly memorable close-up which quickly became popular in the theatre's postcard series.

However there was no question that the SMT audiences' new pin-up was Burton, whose new wife Sybil Williams had also joined the company to play Lady Mortimer in *Henry IV, Part 1* and assorted wenches or nymphs thereafter. His roistering Prince Hal who couldn't wait for the crown of his father – played by Harry Andrews – grew into a more than usually thoughtful Henry V and the glamour he projected across the

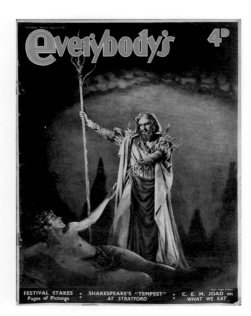

in full costume and makeup to join hands with Burton in a unique curtain call which was mirrored bibliographically at the end of the year when the scholar John Dover Wilson and critic T.C. Worsley combined to produce a McBean-filled book, *Shakespeare's Histories at Stratford, 1951*.

Despite the company's success in achieving record audience figures and the commercially beneficial revival in January 1952 at the Phoenix Theatre in London of the hugely popular *Much Ado About Nothing* starring this time Gielgud paired with Wynyard, Quayle warned shortly before his next season of the need for financial prudence given the costs of mounting productions which sometimes received just 30 performances. So a recast *The Tempest* was scheduled for a second run using two new leads of the company who were both making their SMT debuts: Ralph Richardson replacing Redgrave as Prospero with Margaret Leighton taking on Ariel, apparently the first time the part had been played by a woman on the professional stage. However Quayle would open the season in the title role of the first of two productions directed by Glen Byam Shaw, *Coriolanus*, which had not been staged at Stratford in a generation, and *As You Like It*. Gielgud was to direct yet another *Macbeth* and George Devine do likewise with Ben Jonson's *Volpone*, for both of which Richardson would assume the title roles. As well as Leighton, who had begun her career as a teenager with her local, the Birmingham Rep, and was also to take on Lady Macbeth, Quayle had attracted a wide-ranging group of established and new featured players: Michael Hordern, the Irish actress Siobhan McKenna, the Lithuanian-born Laurence Harvey, already a rising star of British films though aged just 23, and the American-born Mary Ellis, whose talents as an actress were matched by her abilities as a singer, which had in the 1930s made her the favourite performer of King George V.

In the event the first night of *Coriolanus*, into which Ellis recalled thirty years later she had been coaxed to play Volumnia by Quayle and Byam Shaw over 'an expensive lunch in the [London] Carlton Grill', fell barely five weeks after the sudden death of George VI, Stratford's royal visitor of just eight months previously. Ellis recalled later also that a funereal pall of cold and dreary weather which persisted into March was lightened by the arrival

footlights was preserved in the pictorial record thanks to the considerable artifice of his compatriot photographer. McBean's lighting, along with the attention of his retouchers in Endell Street, smoothed almost into damask Burton's notoriously pitted cheeks in all the heroic close-ups with crowns and swords while emphasising the actor's eyes which, so one critic gushed, brought 'a cathedral' on to the stage.

The impact of Burton, who made a handsome swain to Hazel Penwarden in both *Henry V* and *The Tempest*, was nevertheless more than matched by Redgrave's Prospero in the latter play where the striking design fusion of Inigo Jones and Afro-Caribbean created by Tasmanian-born Loudon Sainthill filled the stage even before the climatic masque with candles, multicoloured drops and palms. Benthall's decision to use dry ice for the first time at Stratford was not always so happy: the mist created for some of the early performances in the run quite engulfed actors and sets for far too long. Nevertheless McBean's fog-free production shots once again took the fancy of *Everybody's* magazine, which placed Redgrave with his Ariel, played by Alan Badel, on the cover and gave the play its centre-spread in one of its August issues. However the Stratford stage was owned most definitely that year by the three kings. So, following the final performance of the season which happened to be of *Henry V*, both Redgrave's Richard II and Andrews's Henry IV reappeared

Glen Byam Shaw, 1953

of McBean to photograph the production before it opened. She had been another of his favourite sitters ever since he had made her the second in his surreal series for *The Sketch* and she repaid the compliment: 'Being photographed by Angus was always such fun. I always looked forward to it. He was so charming and always put you at your ease.'

The mood at Stratford certainly lifted too after enthusiastic notices for the play, in the spare but heroic proportions of arches and pillars designed by Motley, within which Quayle's 'lout with a lion's heart' and Harvey's Aufidius both attracted acclaim. Though Richardson in the revived *Tempest* did not fare so well with the critics, *As You Like It*, in a highly stylised Arden also designed by Motley, became the hit of the season in no small measure because of the chemistry onstage between Leighton as Rosalind and Harvey playing her Orlando. This was reflected in the tenderly romantic pictures of the couple by McBean and it was soon evident to Ellis and other members of the company that 30-year old Leighton, who was wont to arrive at rehearsals on a bicycle 'as fresh as the daffodils and appeared to exist on nothing but lettuce leaves and lemon juice', and Harvey, who at the start of the season had been the beau of another of McBean's favourite sitters, 45-year-old Hermione Baddeley, were falling for each other offstage. (Leighton would indeed eventually divorce her husband, the Austrian-born publisher Max Reinhardt, and marry her Stratford co-star.) The production of *Macbeth* offered no such *divertissements* and the McBean images of it could do little to help along a production which attracted reviews that were less than enthusiastic for its leading man, cordial for its leading lady and good only for the minor players like Harvey's Malcolm. Nevertheless *Theatre World*, beguiled by the chance to show off its favourite photographer's costume pictures, put Richardson and Leighton's Macbeths by McBean on the cover of its July round-up of the Festival.

ACT III: 1953–56

Quayle conceived ambitious plans for the 1953 season which would see the twenty-first birthday of the 1930s Memorial Theatre building. He asked Glen Byam Shaw to share directorship of the Festival with him so that he could split the

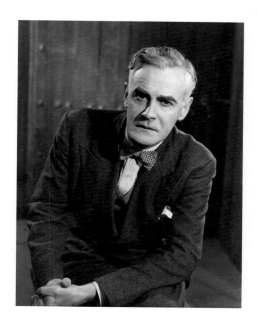

company in two for the year of the coronation of Elizabeth II. He himself would lead one half in a 37-week tour of 11 cities in the Queen's furthest dominions, New Zealand and Australia; in this he would reprise his Falstaff in an otherwise recast *Henry IV, Part 1* of two years previously along with a recast *As You Like It*, for which he would take on Jaques, and a brand new *Othello* directed by and starring himself. This last play would then come back to be given beside the Avon for the following year's Festival. All three productions were therefore captured by McBean and given public performances for a week at Stratford in December 1952 and the touring players were treated the following month to a starry farewell party at Claridge's Hotel in London in advance of embarking for the southern hemisphere. The touring players' progress through the two countries was triumphant and bore witness also to another match hatched in the Forest of Arden: Barbara Jefford, who had returned to the company to take over the role of Rosalind as well as playing Desdemona and Lady Hotspur, and Terence Longdon, who was playing Oliver and Prince Hal, were married in Christchurch, New Zealand, in March with appropriate jubilations.

Meanwhile Byam Shaw's home team, as the company which opened in Stratford that month was inevitably dubbed, began a larger repertoire with some familiar big names. Michael Redgrave, Peggy Ashcroft and Harry Andrews returned to

lead the Avonside players out first in a rapturously received *The Merchant of Venice* staged by Dennis Carey, then director of the Bristol Old Vic. He brought with him its prolific 28-year-old designer, Hutchinson Scott, and though the latter was surely too young to have seen the 1938 production at London's Old Vic in which Ashcroft also played Portia it was striking how similar his costumes for her were to those she had worn 15 years earlier. This had the eerie effect that in McBean's new photographs of Ashcroft in the trial scene she looked barely any older than his *Sketch* surrealisation of her earlier Portia.

Carey's other import from the Bristol theatre, its 23-year-old composer-in-residence Julian Slade, proved to be even more significant for British theatre history even though his incidental music for *The Merchant of Venice*, which was heard seven months later on the radio when the BBC broadcast a recording of the production, has – like his brief connection to Stratford – long been forgotten. In 1954 Slade would dash off in a few weeks for the Bristol Old Vic a little musical about an old piano found in a street. He titled it *Salad Days* from the famous line spoken by Ashcroft in her second 1953 Festival role, Cleopatra.

Before Byam Shaw came to direct her and Redgrave's Antony, his stab at *Richard III* with Marius Goring as the last Plantagenet monarch proved to be the least popular of the season's plays. McBean's images perhaps reflected little enthusiasm for his subject even though Goring had been a professional friend since appearing in *The Happy Hypocrite* 17 years earlier. However the photographer's engagement with his subject matter, like that of the critics, was restored with *Antony and Cleopatra*, which brought out the majestic passion of its two leads. Ashcroft, perhaps not a natural Cleopatra and forced to bear invidious comparisons with Vivien Leigh's Egyptian queen in the Oliviers' McBeaned West End production only two years before, was to considerable surprise endowed by Byam Shaw and his designers Motley with fair skin and red hair. These certainly helped deflect attention from the fact that Rachel Kempson as Antony's abandoned Octavia was more classically beautiful than this serpent of the Nile but McBean ensured that Ashcroft eventually trumped even memories of Leigh's Cleopatra when she took to

her throne for the death scene for which Motley gloriously borrowed their setting from the final frames of Cecil B. de Mille's 1934 film version.

Goring recovered his own standing with both McBean and the critics when playing Petruchio to Yvonne Mitchell's Katerina in *The Taming of the Shrew* and the Fool to Redgrave's *Lear*, both productions directed by George Devine. The designs by the rumbustious artist Robert Colquhoun for the latter play were as monumental as the performance of its star, and no less than Ivor Brown indicated sonorously as the season neared its end that Stratford was now quite the equal of the West End. *Theatre World*, conscious that it was about to face competition from October from a new monthly magazine for theatre-lovers called *Plays and Players*, concurred and by holding over its Stratford coverage until August was able to squeeze in photographs of all five of that season's productions behind a cover of Redgrave and Ashcroft as the Nileside lovers.

Amidst such heavyweight stuff it was a relief for the photographer to do a bit of his old camera trickery to celebrate the coming of age of the Stratford theatre building: at the request of the publicity office McBean produced a whimsical image of the Festival director, actually still on his Antipodean tour, and the season's two leads blowing out 21 candles on a cake decorated with miniature figures of themselves. This appeared in various publications and then, after the production of *Antony and Cleopatra* closed the 1953 Festival on the last day of October and reopened four days later for a six-week run at the Prince's Theatre on Shaftesbury Avenue, the Redgraves demanded that Stratford's image-maker should produce a Christmas card for their family in the manner of his own famous ones. After some discussion the Redgrave parents and their two younger children, Corin and Lynn, trooped into his Endell Street studio, which was barely yards from the Prince's, and were photographed in Victorian clothes after the fashion of a nineteenth-century formal portrait for the front flap of their seasonal greeting. Then 16-year-old Vanessa, who couldn't get away from her school for the first session, was portrayed in similar costume skating in a fake winter landscape, at the time one of McBean's favourite backdrops, for the reverse.

Anthony Quayle and cast in
Othello, Plays and Players, 1954

During the course of the sell-out run at the
Prince's McBean also had the satisfaction of being
asked by the SMT to photograph the illuminated
front of its temporary London home at night-
time with five of his display photographs in the
glass cases stretching round the corner site of
the theatre. He wished he had been asked to do
the same in the first weeks of 1954 when the
production, along with his photographs in the
front-of-house displays and souvenir programmes,
went on to play to packed houses in The Hague,
Amsterdam, Antwerp and Brussels in barely eight
days and then settled in Paris for a week at the
Théâtre des Champs Elysées. The performance
in this last and vast berth, though hugely popular
with French audiences, was savaged by Parisian
critics to such an extent that there was much
British newspaper comment about the reviews.

In Stratford the rest of 1954 proved to be a
year of more modest ambitions. Anthony Quayle,
having returned with his touring company only
the previous November, deemed it right that Byam
Shaw, who had been deputising for him while he
was away, should now share directorship of the
Festival. The pair also announced that, instead of
importing established or big names, the company
would this season make a virtue of developing the
talents of actors under 30 or those whom it had
been nurturing previously. As planned, Quayle's
Antipodean *Othello*, with Jefford also repeating
her ravishing Desdemona, would open the season
followed by *A Midsummer Night's Dream* and
Romeo and Juliet, a recast *The Taming of the Shrew*
and then *Troilus and Cressida.*

Since there was some recasting of the *Othello*,
notably Raymond Westwell who had been promoted
from his role on tour as Rodorigo to Iago, McBean
did a second set of production shots just as another
hardback pictorial record of the Stratford stage was
launched covering 1950–52 and which contained
his images of the show taken before it had set
off for the Antipodes. For his second photo-call
for Quayle's jealous Moor he added a wholly new
element: encouraged by improvements in colour
film and processing he essayed some colour
images with a small camera alongside his usual
large one on its tripod. In the event he deemed
suitable for the publicity office only a single
colour transparency, a duplicate of his black-and-

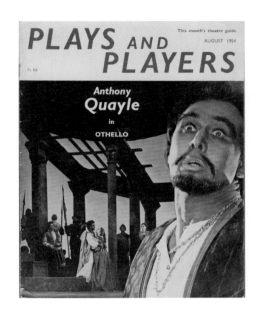

white close-up of Othello and Desdemona in the
bedroom scene which he contrived to pose in
similar fashion every time he photographed the
play; and he did not repeat the experiment in the
new chromatic medium at Stratford for the rest of
the year. However a mark had been put down and
that summer he got the measure of the different
lighting requirements for working onstage in colour
while photographing *After the Ball*, Noel Coward's
West End musical version of *Lady Windermere's
Fan*. Emboldened also by the demands of *Plays and
Players*, for whose larger format he had taken to
montaging two black-and-white negatives in order
to display on its cover both a full-stage image of
a production and a close-up of its star, he spliced
together in his studio two such images from *Othello*
for the cover of the new magazine's extensive
August spread on the Festival productions.

The production of *A Midsummer Night's Dream*
by George Devine with designs by Motley was
undoubtedly the critical and popular hit of the
season. As McBean's photographs showed, the
comedy, with Quayle's Bottom sporting a bottle-
brush wig when he was not 'transformed', was
particularly delightful though the other mechanicals
were none too happy with the close-up effects of
the raw garlic which the Festival director took to
eating later in the run apparently for health reasons.
Among these mechanicals were Leo McKern and
James Grout as well as a young actor, Ian Bannen,
who made a well-received Stratford debut as Flute.

Byam Shaw's choice to direct *Romeo and Juliet* and bring back Laurence Harvey was bold if not downright cheeky. The heart-throb had spent some of his time away from Stratford over the previous 18 months filming in Verona itself the role of the ardent young Montague in a visually luscious Technicolor adaptation of the play by the Italian director Renato Castellani which was to be premiered in a few months' time at the Venice Film Festival (it duly won the Best Film prize). The casting opposite Harvey of blonde Zena Walker, who though she had now only turned 20 had joined the SMT at the end of 1952 to play Phebe in the touring *As You Like It*, was just as popular: like Margaret Leighton she was a 'local' girl who had had her first break when only 16 at the Birmingham Rep. Walker and actors in the lesser parts, like Keith Michell's Tybalt, stole the notices from Romeo but that seemed hardly to matter with the audiences who doted on Harvey. McBean, whose close-up of the lovers adorned that August's cover of *Theatre World*'s Festival coverage, noted succinctly thirty years later: 'Laurence was a very pretty gentleman so people forgave him a lot.'

The photographer himself got away with his own bit of cheek before taking his photographs of the last scene of the play. As a treat for his septuagenarian mother he had brought her with him and his assistant for the *Romeo and Juliet* trip so that she could see how he worked at Stratford. Cherry McBean accordingly sat in the stalls through the photo-call and then, while actors and stage-hands were readying the concluding few poses of the session, her son called her on to the stage and shot off a picture of her sitting on the corner of Juliet's tomb with one of his own light-stands beside her.

Critics had their faith in the Festival sustained with the recast *The Taming of the Shrew*, starring Michell and Barbara Jefford, which was regarded as a great improvement on the previous year's offering, and McBean's photographs reflected the gusto which the pair brought to the roles. However, reservations about Harvey's verse-speaking and that of Muriel Pavlow cast opposite him surfaced again in Byam Shaw's direction of *Troilus and Cressida*, for which McBean repeated his splicing together of two negatives to give a single striking image of Troilus and Michell's

stentorian Achilles watching Cressida's seeming faithlessness with Diomedes. Despite Quayle's geriatric cherub of a Pandarus stealing almost every scene he graced, the most praised aspect of the production was the designs by Malcolm Pride recorded handsomely by the photographer who was himself beginning to be feted for his sets: that spring the well-known 'art-house' Academy Cinema on London's Oxford Street had reopened lavishly redecorated to the designs of McBean at the behest of his friend who owned it.

After such a relatively disappointing season with home-grown talent, which had seen a 22-year-old called Ian Holm appear for the first time in 'page' and other tiny roles, the co-directors determined that they should corral theatrical royalty to recover the SMT's reputation. Byam Shaw, who had been a close friend of Laurence Olivier since they had acted together two decades previously, spent a weekend at the Oliviers' country house, Notley Abbey in Buckinghamshire, and persuaded Sir Laurence and his now double Oscar-winning wife to forsake the West End, Broadway and film sets in which they could apparently do no wrong to lead a home company in three of five new productions at Stratford. The trio of plays to showcase both stars – who had just had great success in the West End with their own production of Rattigan's *The Sleeping Prince*, photographed as ever by McBean – were decided as *Twelfth Night*, *Macbeth* and the gory *Titus Andronicus* which Stratford had never dared give before. This, unlike the other two plays, was *terra nova* also to Olivier. Gielgud, who had joined Olivier as a knight of the stage since last playing Benedick, would direct the Oliviers in *Twelfth Night* and then set off in June from Brighton for an SMT away company tour of Europe and Britain, including a further two months in the West End. He was to be in partnership once more with Ashcroft in yet another outing of his hugely popular *Much Ado About Nothing* along with his fourth essay of Lear (with no fewer than three actresses – Ashcroft, Claire Bloom and Mary Watson – sharing the role of Cordelia). This was to be directed by George Devine with designs by the Japanese-American artist Isamu Noguchi.

The reach for the stars had the desired effect: immediately the programmes were announced

at the beginning of 1955, press coverage about the Oliviers taking up residence in Stratford exploded and continued unabated through the year while demand for ticket sales hit record levels. There were half a million applications for the eighty thousand tickets in what would be an almost nine-month season since the away company would finish its tour with three weeks beside the Avon in late November and December. The sheer glamour that the Oliviers brought to the Festival was unquestionable: just before their first rehearsals began they had been on adjacent lots at Shepperton Studios, Olivier finishing off his film of *Richard III* for release at the end of the year and Leigh on last takes for the film of Rattigan's latest success *The Deep Blue Sea*, in which she had usurped the role of Hester from Ashcroft who originated the part in the West End. Indeed, no sooner had the couple moved into a rented riverside house outside the town, than they had McBean visit them to take, as he did so regularly in his own studio, fresh sets of 'straight' publicity pictures – while also having this sitting photographed in turn by a crew from the French weekly *Paris Match*. This published a picture spread of McBean with his tripod camera directing Leigh in poses on a very ordinary sofa, thus promoting even across the Channel the opening of *La Nuit des Rois*. (The headline for the coverage was 'Dans le cité de Shakespeare Vivien sera reine et Sir Laurence le roi'.)

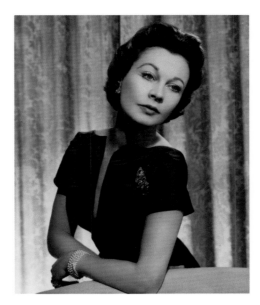

McBean photographing Vivien Leigh, *Paris Match*, 1955

Vivien Leigh in the Oliviers' rented Stratford cottage, 1955

For all the Oliviers' insistence that they were to be treated as ordinary members of the company the force of their fame – and also, quite unknown to their adoring public, the disintegration of their marriage – was hard to deal with. In rehearsals for *Twelfth Night* Gielgud found himself undermined by Olivier whose constant playing for laughs, both in character as Malvolio and out, and pulling rank eventually led to the director being forced to absent himself from some days of rehearsals. As Angela Baddeley, Mrs Byam Shaw, later put it: 'Larry was a bad boy about it. He was very waspish and overbearing with Johnny and Johnny became intimidated and lost his authority.' It was indicative of Olivier's meddling in dramatic proceedings that he paid the young Australian actor Trader Faulkner, who was playing Viola's twin, Sebastian, £5 to hold a full-on kiss with Leigh in their rediscovery scene for several seconds longer than necessary on opening night. (This was done, it seems, to spite Leigh's lover, Faulkner's compatriot and mentor Peter Finch, who had recently resumed an on-off affair with her.)

McBean's photo-call was by contrast the usual model of calm control by the photographer, who delighted in pandering in his close-ups once more to Olivier's taste for facial prosthetics and in reworking a favourite device for the shipwreck scene where Leigh's spotlit Viola is surrounded by a darker circle of sailors. The photographer now also had sufficient measure of his new medium of colour to produce some luminous images of Leigh with Keith Michell's Orsino. The best of these was picked to adorn the glossy cover of the June *Warwickshire and Worcestershire Magazine* and made a display all too rare in its time of high-quality colour reproduction. A black-and-white image of Olivier's Malvolio in nightshirt with candle eventually adorned the cover of *Plays and Players* that same month and became one of no fewer than eight images from the 1955 season which joined the SMT's postcard series.

The notices, delayed for almost a fortnight because there was a newspaper strike, were distinctly mixed for Olivier's clowning and poor for Leigh which served to send the actress into one of the manic phases of her mental instability. However, while audiences and critics salivated as they waited for the Oliviers' turn as the

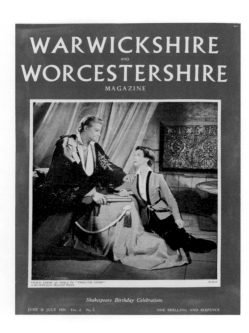

Macbeths, there was a happier response to the second production, the then rarity *All's Well That Ends Well*. This had a director, Noel Willman, new to Stratford who chose to bring back to the company the Spanish artist Mariano Andreu to design gorgeous Louis XIII costumes and sets. A watercolour for one of these promptly emblazoned the cover of the enlarged Festival brochure, which Quayle and Byam Shaw decided the special year merited, and the opulent finished products were given lavish power by McBean in both his black-and-white and colour sets of photographs. (Intriguingly the theatre's stage and lighting director Peter Streuli took his own snapshots of McBean at work in the photo-call 'directing' some of the actresses while McBean's assistant held one of the stands for his lights. McBean would later

use one of these snaps to illustrate an article he himself penned for a photo magazine.)

In choosing the Scottish play Byam Shaw once again found his Stratford selection in competition with a film version: *Joe Macbeth*, a British-American production which set the story in 1930s Chicago gangland with twentieth-century language, had just been finished and would be released even before the Festival was over. Moreover the strains in the Olivier marriage were now all too evident to the SMT company: Finch had taken a room in the town and among other activities was, to Byam Shaw's fury, also rehearsing Leigh in her Lady Macbeth. Indeed, as Quayle would later tell one of the actress's biographers, by the time the production opened in June – the day after the away company under Gielgud and Ashcroft began their tour with *Much Ado About Nothing* – the Oliviers were spitting graphic insults at each other under their breath while on stage together.

Though the critics, unaware of such viperish real-life drama, were warm to Olivier but divided about his consort's performance, Leigh commanded all attention in the production images. The designer Roger Furze, who had been a favourite with the couple for some 15 years, gave her a dark-red wig and serpentine green gown enabling McBean to produce what has become the defining image of the actress's brief Stratford career, and indeed of the whole of this *annus mirabilis* for the SMT, when he portrayed her going up a Glamis staircase with daggers in hand. Moreover he conveyed in another image something which did not travel far across the footlights: Leigh's remarkable feat of playing the whole of her mad scene completely cross-eyed. In later years he greatly rued that, though some of his colour shots in the session of lesser characters like Maxine Audley's Lady Macduff with her children were ravishing, he achieved only one colour image of the leading couple that satisfied him, and his transparency of this, which he sent to *Plays and Players* for what turned out to be woefully poor reproduction on the cover of its October issue, was lost thereafter.

No such fate befell production pictures of *The Merry Wives of Windsor* in which Quayle once again gave his fat knight under the direction of Byam Shaw, this time against delightful wintry

Keith Michell and Vivien Leigh in *Twelfth Night*, *Warwickshire Life*, 1955

The Oliviers in *Macbeth*, *Plays and Players*, 1955

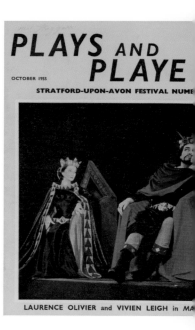

McBean directing his photo-call for *All's Well That Ends Well*, 1955

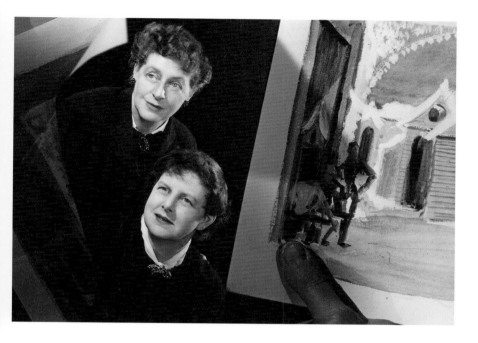

Sophie and Margaret Harris, the Motley designers, 1955

the play's action calls with long scarlet ribbons after the fashion of some Oriental theatre. He even carried his stylisation front-of-house by demanding that the programme covers should be black instead of the usual red and that McBean use colour film very sparingly during his photo-call lest any such images should give too luxurious an impression of the production. Lady Olivier promptly had herself captured glamorously in costume and character by another, now anonymous, photographer whose images found their way into *Paris Match* and other Continental colour weeklies. Despite ensuring that in his own pictures 42-year-old Leigh remained lovely, even after suffering Lavinia's various mutilations, McBean rightly reckoned that his finest image from the session was a heroic full-length solo of Quayle as Aaron the Moor which joined the postcard series. 'The devil got all the best pictures in that play as well as the best lines' he joked later.

designs by Motley. One full-stage colour image was used at the end of the year as the SMT's own Christmas card and the black-and-white photographs of the frozen Thames in the play were particularly popular in press coverage. The irony was that outside the theatre it was high summer and the manically merry queen of that Stratford season was hosting midnight punting parties on the Avon with picnics in its meadows. She invited all members of the company to these, but only the younger ones, like Faulkner and another young compatriot of his, Ron Haddrick, respectively Malcolm and one of the murderers in *Macbeth*, dared attend. Olivier recorded in his memoirs later that his wife's Stratford revels left him so exhausted that he took to fleeing their rented house for Notley Abbey 60 miles away or spending nights in his theatre dressing room 'rather like some old actor who can't pay his rent'. Leigh, however, would be up again, apparently bright as a pin, after barely two hours' sleep.

Such abandon was a somehow fitting counterpoint to the season's final offering, *Titus Andronicus*, for which Peter Brook had been asked to direct Olivier as Titus and Leigh as Lavinia, the Roman general's raped and amputated daughter. The sometime *wunderkind* chose also to produce, with assistants, the music and designs and his most striking effect in the latter respect was to replace the streams of stage-blood for which

Despite the misgivings beforehand, the reception for the production on opening night and afterwards was tumultuous and the rest of the season continued to see a procession of the Oliviers' famous friends visiting the SMT until the final night when the American entertainer Danny Kaye and his composer wife Sylvia Fine were in the audience to see *Macbeth*. Fine snapped Olivier leaving the theatre for the last time even as the backstage staff were making preparations to

Laurence Olivier after the last performance of *Macbeth*, 1955

receive, only a few days later, Gielgud and the away company who had most recently been toiling through weeks in Newcastle, Edinburgh, Glasgow, Manchester and Liverpool. It had become painfully apparent through this company's extensive tour that, although *Much Ado About Nothing* (photographed yet again in this incarnation by McBean) remained an SMT winner, *King Lear*, saddled by director Devine and his designer Noguchi with costumes and sets which seemed to meld Kabuki with Sci-Fi and which critics and audiences alike ridiculed, was very much the also-ran. Stratford's house photographer was secretly relieved that he had been not able to take the production shots because the company had set off for Europe before he could do so; the visual record of the play was thus made in Amsterdam by a local photographer there, Maria Austria. However when the SMT issued as a postcard one of the Austria studies of Gielgud with a great half-circle of false beard suspended from his chin and what one critic called 'an upturned lamp-stand' on his head, this was wrongly credited on its verso to McBean. Stratford images and the bearded photographer were clearly indivisible in many minds.

After such a starry season (1955 has been described as the zenith of the SMT's existence) the following year would inevitably seem tamer but Quayle and Byam Shaw made clever choices in programming and casting which saw no fall-off in bookings. Alan Badel, who after playing the Fool to Gielgud's previous Lear had moved on to roles as diverse as Romeo at the Old Vic and Richard Wagner on film, returned to Stratford to open proceedings in April as Hamlet under the direction of another returnee, Michael Langham, who was just about to succeed Tyrone Guthrie as commander of the Shakespeare Festival in Stratford, Ontario. It happened that Badel was one of the mere handful of actors, out of the thousands he worked with, for whom McBean had an active dislike but nothing can be discerned in his handsome tenebrous pictures of this Prince of Denmark, whose angular features chimed with the stark black minimalist settings for Elsinore by Michael Northen. It helped that the much-praised Gertrude and Claudius were played by two of the photographer's favourite subjects, Diana Churchill, who was making her Avonside debut,

and Stratford stalwart Harry Andrews. He also used to even greater effect his device of montaging a close-up of Badel with a full-stage shot featuring the Prince's mother and stepfather.

Barely were those prints dry for delivery to the theatre's publicity office than the photographer was back in Stratford for his photo-call for another *The Merchant of Venice*. This was directed by Margaret Webster, the last member of a British theatrical dynasty who had had her greatest successes on Broadway, and starred two other newcomers to the SMT, Emlyn Williams and Margaret Johnston. While dramatic black-and-whites of Shylock and Portia in close-up and in the trial scene came so easily to McBean, he now proved just as adroit at reproducing in colour Alan Tagg's ravishing settings and costumes in tones of candyfloss and marshmallow. As usual young actors new to the company also found him generous in featuring them handsomely: in this case it was 23-year-old Prunella Scales, whose Nerissa was described by one reviewer as 'a pretty midget'.

Byam Shaw's choice to stage, so soon after Quayle's version, yet another *Othello* was designed to give Andrews the lead role at Stratford he had for years deserved but it had to contend with memories of a slew of very recent productions: Burton and John Neville had just been alternating the Moor and Iago at the Old Vic photographed by McBean; BBC television had barely six months previously broadcast a lauded version with another black American singer-actor, Gordon Heath, directed by Tony Richardson; and Orson Welles's film starring himself had, after nearly five years of delay, finally been released in Britain in February. McBean was personally pleased with his session before the play's warmly praised opening in May but a little surprised that *Plays and Players* afterwards would not use his own choice of a close-up of Andrews looming over Margaret Johnston's Desdemona for its cover but instead selected a solo image of Williams's Iago.

By then the photographer had derived much satisfaction in the lavish use of his photographs in the Festival's souvenir brochure for the season. Its frontispiece was a montage by Suzanne Ebel, a talented advertising executive and long-time partner of the company's now head of publicity, John Goodwin, of some of McBean's photos from

Montage by Suzanne Ebel in
Festival brochure, 1956

the previous seven years. Another page displayed
in miniature all his 33 images (as well as the
Maria Austria of Gielgud wrongly credited to him)
which had been made into SMT postcards. The
brochure also contained an image that made him
smile at the time but proved to be a professional
omen: the portrait of the latest *wunderkind*, the
25-year-old Peter Hall, who was temporarily
forsaking his captaincy of the Arts Theatre in
London to direct Stratford's next production,
had been taken by Hall's 26-year-old Cambridge
contemporary Anthony Armstrong-Jones. The
latter on leaving university had been sent to
McBean by his uncle, the designer Oliver Messel
who knew the photographer well, in the hope
that the young man might be employed as an
assistant. McBean, with some regret, had turned
him down because he didn't then have a vacancy.
So Armstrong-Jones had been apprenticed
instead to society photographer Baron, and was
now just beginning to make an independent
name for himself not only as a portraitist using a
conventional large-format tripod camera but also,
using a small automatic camera, as photographer
of rehearsals at the Arts and at the Royal Court
Theatre, where George Devine was then starting
the English Stage Company.

With a nod back to Peter Brook's debut at
Stratford, Hall was engaged to direct *Love's*

Labour's Lost and he not only brought with him
from the Arts Theatre Geraldine McEwan to play
the Princess of France but also coaxed back to the
SMT the designer James Bailey who had been
making a name for himself in the West End and
across the Atlantic. Conscious of the effect created
by the gorgeous Watteauesque settings of Brook's
production a decade earlier, Bailey devised for Hall
and the cast, which included Badel as Berowne
and Andrews as Don Armado, an exquisite,
Navarrese castle setting with the usual *boscage* of
the park reduced to a few stylised rose-bushes in
pots, and costumes that might have come straight
out of a Clouet miniature. These looked pretty
enough in McBean's black-and-whites but in
colour were sensational, with the photographer's
portrayal of the final act's 'Muscovites' in the latter
medium providing a minor comic masterpiece.
More than one observer voiced the opinion that it
was a shame that the production, which opened in
early July, could not have had a longer run.

By the time that Quayle came to direct *Measure
for Measure* for its mid-August opening he had
made it quietly known to Byam Shaw that this was
to be his last with the SMT: through the previous
winter he had played Marlowe's Tamburlaine
for Guthrie's Stratford Festival in Canada and
on Broadway to Tony award-winning acclaim
and he now wished to free himself from the
cares of theatre administration to concentrate
on his own acting and directing. For McBean
the choice of Williams as Angelo in Quayle's
Avonside swansong was *déjà vu*: he had captured
the Welsh actor in the role in 1937 at the Old Vic,
with Isabella played by Angela Baddeley, and
in many West End performances since. When
the production opened there were widespread
complaints that Tanya Moiseiwitsch's designs and
the stage-lighting were far too dark but this is not
evident in the visual record: McBean of course
brought his own lights which penetrated the
murk and he produced handsome sets of images
in black-and-white and colour featuring Anthony
Nicholls as the Duke and Johnston as Isabella
alongside Williams.

The outgoing Festival director was not quite
done with the SMT for, even as Byam Shaw
was announced as taking the helm solo, it was
publicised also that Quayle, Olivier (who was

just about to rejuvenate his career by appearing in John Osborne's *The Entertainer* at the Royal Court Theatre), Leigh and most of the original cast of the 1955 *Titus Andronicus* would embark in May 1957 on a six-city Continental tour before playing five weeks in the West End. The advertising material for their progress was naturally emblazoned with McBean's affecting image of the Oliviers in the final scene, and that winter the photographer, already with an ambition to record every play in the Shakespeare canon, was pleased that he could capture another rarity, *Timon of Athens*, when this was staged at the Old Vic with Ralph Richardson in the title role. (A few months later the same theatre also gave McBean a third chance to photograph *The Comedy of Errors*, another play that was never staged at Stratford during his years there.)

ACT IV: 1957–59

For 1957 Byam Shaw unashamedly continued what he believed in at the SMT: bringing big names to the company. This meant not only a return for both Peggy Ashcroft, who the previous year had been made a Dame, and Gielgud but also a summer visit by the Queen and Prince Philip to see his opening production, *As You Like It*. Apparently HM had never seen the play, and the coincidence that she had just honoured its star was too much to resist for the royal diary planners. They also slotted a whistle-stop tour of the Shakespeare Birthplace garden into the visit's schedule before the royal couple would sweep through the town in their motorcade to have lunch in the theatre restaurant with the SMT board and their wives, the Byam Shaws and the local MP John Profumo with his film-star spouse, Valerie Hobson.

The vision that Byam Shaw had of Arden appeared similar to that of Quayle's production in the year that the Queen ascended the throne; indeed Motley once again did the designs. So it was not surprising that McBean used many of the self-same poses that he had used five years before although now he was able in his colour images to do full justice to the Harris sisters' clever use of reds, greens and browns. He was certainly vocal in dismissing unkind wags, who sniggered

that Ashcroft was 44 and Richard Johnson, her Orlando, was 15 years younger, by reminding them that at the Old Vic two decades previously the Edith Evans-Michael Redgrave gap had been 20 years; that hadn't showed in his photographs so neither would this one. He was right and the production, in which Ashcroft's Rosalind shone brilliantly after the nightmare of a sore throat for the opening performance, and with Jane Wenham making a particular mark as Celia, was the most popular of the season – further justifying its choice as the royal play on 14 June.

Douglas Seale, who had been a member of the 1946 and 1947 SMT companies and had since succeeded Sir Barry Jackson as head of the Birmingham Rep, had made a name for himself directing Shakespeare's histories and he did not disappoint with his choice of *King John* for the next production in which Robert Harris returned to Stratford in the title role. Designer Audrey Cruddas provided lavish colour and opulent costumes which were meat and drink to McBean in both his media while his use of *chiaroscuro* enhanced the darkness of the Arthur storyline. If *Julius Caesar* directed by Byam Shaw disappointed the critics, who felt that Alec Clunes and Richard Johnson as Brutus and Antony respectively were underpowered, the production shots mostly seemed flat as well, including a half-length of Clunes with Joan Miller as his Portia which graced the cover of July's Stratford round-up issue of *Plays and Players*. However McBean was proud that he nevertheless produced one of the finest of his Stratford 'action' shots when deploying his central spotlit figure in a darker circle device for the death at the hands of the Roman mob of luckless Cinna the Poet, played by John Murray Scott.

Hall's next endeavour for the company, *Cymbeline* with Harris in the title role of the ancient British king, Ashcroft as Imogen and Johnson as Posthumus, was blessed in its designs by Lila di Nobili which married Gothic and Renaissance. Ivor Brown rightly noted in his habitual resumé of the season for the triennial hardback record that the play should properly be called *Imogen* and McBean's concentration on images of Ashcroft, Harris and Johnson was rewarding in both black-and-white and colour: his close-up of Imogen in straw hat for her journey

to Wales became a popular item in the postcard series. Advance expectations of the season's final production, in which Peter Brook would direct Gielgud in *The Tempest* as well as essaying its designs and music, were higher still: even before it opened in August, the H.M. Tennent management undertook to transfer the play to a limited run in the West End. McBean, who created a montage for the Festival souvenir brochure of some of his many images of Gielgud, worked his own magic again to make the actor a pin-up in the production shots and made light also of Brook's idiosyncratic costume for Brian Bedford's Ariel and unflattering garb for Johnson and Doreen Aris as Ferdinand and Miranda.

The brochure also contained as its frontispiece a quite different sort of McBean: an advertisement featuring his close-up of Olivier holding between the third and fourth fingers of his left hand one of the cigarettes to which the actor had just been persuaded to lend his name in return for a handsome advance against royalties (set at tuppence per thousand packs sold) and five hundred packs of twenty for distribution to friends every year. The photographer, who ensured through retouching a perfect curl of smoke from the ash on the cigarette-tip, had been delighted to receive £100 (nearly £3,000 in today's value) for the commission which was nearly ten times his

usual charge for a studio portrait sitting. Olivier in the first year of the contract alone received nearly £4,000 and was still receiving substantial sums from 'my fags' well into the 1960s.

The seven-week, money-spinning run for *The Tempest* in the West End from 5 December 1957 turned out to be at the huge Theatre Royal, Drury Lane: nine years previously Gielgud had given Prospero there in a starry matinée performance of just Acts 4 and 5 from the play to raise funds for the rebuilding of RADA. McBean was also able to reflect that his pictures had also been front of house for the last complete Shakespeare production at the theatre, Ivor Novello's ill-fated *Henry V*. Then, fortuitously for his own Shakespearean tally, McBean was able to photograph during the 1957/8 winter the Old Vic company's productions of the rarely performed three parts of *Henry VI* in which Barbara Jefford appeared to magnificent effect as Queen Margaret.

For his own 1958 season Byam Shaw decided that he would first lead the Festival productions with new names and afterwards bring in more established ones. Thus Dorothy Tutin, who as a 21-year-old had taken over the role of Hero in the brief 1952 West End incarnation of the much-loved Gielgud-directed *Much Ado About Nothing*, joined the company fully to take on Juliet, Viola and Ophelia. Her Romeo, under Byam Shaw's own direction of the opening play, was Richard Johnson and, amidst the sumptuous Renaissance costumes and sets by Motley, McBean ensured that the pair made perhaps the most glamorous, star-crossed Veronese the SMT ever presented. Small wonder one of his black-and-white images of the couple became the company's most popular SMT postcard of the season while his colour shots of the lovers evoked by turns the etherealism of de Chirico landscapes and the hyperreality of Dali portraiture. By way of complete contrast the photographer had fun with his close-up of Angela Baddeley as the Nurse, carefully blacking out on his glass negative some of her front teeth in order to increase the comic effect. He had further fun in producing, at the request of publicity officer Goodwin, a montage of 39 little cut-outs of his photographs of Stratford performers, which could wind in a giant 'S' down the front cover of the season's souvenir brochure, as well as a 'straight'

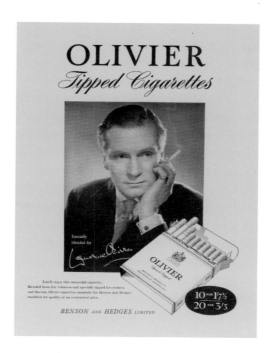

Olivier cigarettes advertised in Festival brochure, 1957

plumped for lavish Van Dyck costumes which suited the pertness of the two leading ladies particularly well. Tutin, who had already been photographed by McBean in West End roles which followed her SMT Hero, knew of his meticulous concern to make the best picture in his photo-calls and later remembered some discomfort during their *Twelfth Night* session: 'In the shipwreck scene he asked me to hold my head for some time at an angle that was very uncomfortable so that my hair [a wig] hung down in a way that he said made me seem vulnerable. I didn't argue.'

There was initially some surprise that Byam Shaw chose to direct another *Hamlet* only two seasons after SMT's last one but his intention was to give the season's biggest name, Michael Redgrave, the chance at last to play the Dane on the professional stage. (The actor had taken the role in a production he also directed while a master at Cranleigh School in the early 1930s before being Laertes to Olivier's 1937 Prince at the Old Vic when the latter memorably stepped forward at one curtain call to announce 'Ladies and Gentlemen, today a great actress has been born, Laertes has a daughter' to harbinger the arrival of the infant Vanessa.) At 50 Redgrave was not only decades older than the age usually assumed for Hamlet but also nine years older than Googie Withers who was playing his mother and almost twice the age of Tutin playing Ophelia. This proved no impediment to the much-lauded production, designed once again by Motley, and the striking images in black-and-white as well as colour achieved by McBean for the June opening. It was perhaps the enthusiasm for this *Hamlet* which finalised an invitation from the Russian government for the company to visit Leningrad and Moscow as soon as the Festival was over and, with the offer of financial assistance from the Arts Council to facilitate the trip, this was accepted.

The SMT's own invitation to Tony Richardson to direct *Pericles* for a July opening was an expression of modest daring by Byam Shaw: Richardson was one of the Angry Young Men at the Royal Court Theatre under George Devine and had made his name directing *Look Back in Anger*, *The Entertainer* and another seven plays there. Johnson took on the title role with McEwan as Marina and, surely inspired by Richardson's latest Court offering,

photograph for the back cover of a table laden with lobster, fruits and wines to advertise the theatre's Riverside restaurant.

Tutin's Viola in *Twelfth Night*, which opened a fortnight after her Juliet, was under the direction of Hall, who cast his previously favoured Geraldine McEwan as Olivia, along with the Stratford newcomer Michael Meacham as Orsino, Mark Dignam as Malvolio and Johnson as Aguecheek. With di Nobili once more his designer, the director

Front cover of Festival brochure, 1958

Still life to advertise SMT's Riverside restaurant, 1958

Barry Rekord's gritty Jamaican play *Flesh to a Tiger*, the key Chorus role was part-sung part-intoned by the Trinidadian singer-actor Edric Connor, who thus became the first black performer to appear on the SMT's stage. The Stratford favourite Loudon Sainthill, who had also worked on *Flesh to a Tiger*, was designer for the play's maritiming and brothel-creeping, which some of the audiences found hard to understand, but there was no mistaking their delight, and that of McBean, in Angela Baddeley's veritable gargoyle of misrule as the Bawd.

Even greater delight descended upon the banks of the Avon with Douglas Seale's direction of *Much Ado About Nothing*, indeed so much so that there were complaints throughout its short life that so joyous a production should only have opened at the end of August when it could by itself have sold out the entire season. Seale, now transferred from Birmingham Rep to London's Old Vic, chose to place Withers and Redgrave as Beatrice and Benedick in a mid-nineteenth-century fashion-plate Messina, realised by Tanya Moiseiwitsch with Motley corsets, crinolines and 'cherry-bum' uniforms for all the waltzing, parading and gulling while petite parasols and giant sunshades were twirled almost as much as the gentlemen's moustaches. McBean's multitude of happy images in both colour and black-and-white reflected the general joy which saw critical near-ecstasy not only for the two leads but also for McEwan's sprightly Hero and the comic pairing of Patrick Wymark and Ian Holm as Dogberry and Verges.

Accordingly the company set off for its four-week tour to Leningrad and Moscow, which included Christmas and New Year, in high spirits to give the first three of the season's productions. Since Withers was committed elsewhere, her role as Gertrude was taken by Coral Browne who accordingly became principal player in an extraordinary coda to the 1958 season, a minor real-life drama which was itself eventually fictionalised. After a Moscow performance of *Hamlet* the spy Guy Burgess, who was living out his days in the Russian capital after fleeing the West seven years earlier, barged drunkenly backstage. Handed on by his original target, Redgrave, to Browne, he enlisted her help in getting him a suit and shirts made in and sent

to him from London because he could find no sartorial satisfaction in his place of exile. She complied, despite encountering opposition initially from various Savile Row tailors that she should be pandering to the demands of a notorious traitor. Twenty-five years later the incident was turned by Alan Bennett first into a TV play, starring Browne as herself and Alan Bates as Burgess, then adapted to be one-half of a successful West End double bill, *Single Spies*, in which Browne was played by Prunella Scales.

Barely had the Russian tour ended than Byam Shaw was able to announce the momentous programme he planned for 1959, the hundredth season since the opening of the first permanent Memorial Theatre and which he declared would also be his last. He had coaxed Paul Robeson and Charles Laughton to cross the Atlantic to play Othello and King Lear respectively (with Bottom thrown in for the latter as well) while Olivier was to return to play Coriolanus, and Dame Edith Evans would make her Stratford debut as his Volumnia along with the Countess of Roussillon in another *All's Well That Ends Well*. To celebrate the centenary John Goodwin, mindful of the favourable response to McBean's 'S' montage for the cover of the 1958 Festival brochure and also of the photographer's much-publicised murals for a new ballroom below London's Academy Cinema, asked him if he could make a panorama of Shakespearean performances from the time of Elizabeth I for display in the theatre.

The challenge was exactly what the photographer loved and he came up with what might be called his Bardic Tapestry: a procession of images from 350 years culled from museums, archives and his own files which he spliced together seamlessly so they could be blown up by the firms he used for his studio backdrops or murals to form an extraordinary panorama 140 feet long and 8 feet high. This was printed on canvas and suspended from a track running round the walls of the dress circle foyer so that, when necessary, it could be rolled up and stored away. The task, which took McBean *inter alia* to the British Museum to photograph the Marquess of Salisbury's First Folio, so inspired him that he insisted on doing it for nothing more than the cost of canvas and printing – though the

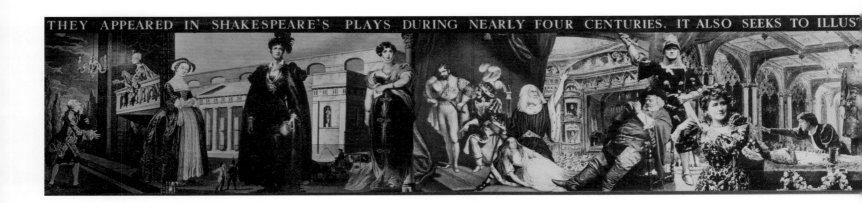

THEY APPEARED IN SHAKESPEARE'S PLAYS DURING NEARLY FOUR CENTURIES. IT ALSO SEEKS TO ILLUS'

grateful SMT, which garnered much publicity by the panorama and used it in miniature to accompany the chairman Sir Fordham Flower's history of the theatre and its site in the season's bumper brochure, gave the photographer an extra £50 at the end of the year. 'They called it The Shakespeare Panorama, I called it the Swiss Roll,' he recalled later. Sadly, all trace of this commission has apparently now vanished.

Such a fate for the Panorama, not only the largest photographic assembly McBean ever produced but also a remarkable commemoration of Shakespearean performance history fully five years before the great quatercentenary exhibition staged on the opposite bank of the Avon, was perhaps foretold in the casual casting aside during the SMT's own centennial of the photographer who had served it so well. Tony Richardson, who was directing Paul Robeson in *Othello* with another American import, Sam Wanamaker, playing Iago and Mary Ure as Desdemona, asked his friend Armstrong-Jones to take the production shots as he had for his plays at the Royal Court Theatre. The results from the small Armstrong-Jones automatic camera in final rehearsals under standard stage lighting were, as usual, grainy and reduced all of Loudon Sainthill's elaborate sets to mere black backgrounds. In addition, however, Richardson insisted on his friend taking formal close-ups of most of the cast with his larger camera.

McBean, who despite not giving Armstrong-Jones a job eight years earlier had remained on friendly terms with him and had only recently visited his East End studio, was therefore merely bidden by the publicity office to photograph

Robeson, Wanamaker and Baddeley's much-praised Emilia, in their costumes. From these he managed to place one close-up of the Hollywood star on the May cover of *Plays and Players* and another eventually graced the cover of the trade journal *Kodak World*. However all official photographs of the production otherwise – in that year's souvenir brochure, in the hardback record of the years 1957–59 and the latest postcard in the SMT series – were those of the aspirant to McBean's theatrical crown, credited as 'Tony Armstrong-Jones'. No one could have guessed then that just over a year later the 29-year-old would achieve a real coronet on marrying Princess Margaret.

For director Tyrone Guthrie, who decided to stage *All's Well That Ends Well* in the dated modern-dress appropriate to a military colonial outpost of a quondam Great Power, there was

Part of the Shakespeare Panorama, 1959

Tyrone Guthrie rehearsing *All's Well That Ends Well* on the SMT stage, 1959

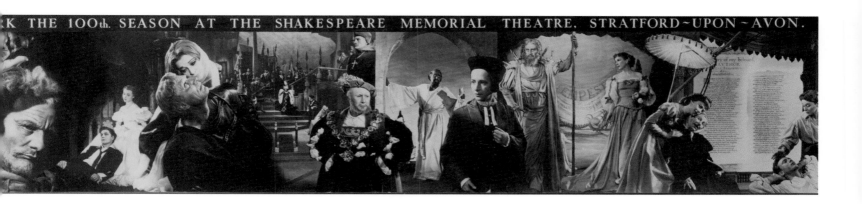

nevertheless no question that he would use McBean who had been recording his productions for over two decades. The resulting images deftly captured in both black-and-white and colour the comedy of the scenes of the soldiery in their khaki shorts, which one wag in the first night audience was heard to compare to the then-popular TV show *The Army Game,* as well as the formality of the various royal or noble courts in suits or evening dress. Certainly McBean made with his study of Dame Edith's Countess one of his favourites of all the many photographs he had taken of the actress since 1936. In retrospect, though, he wished he had paid more attention to a tall 21-year-old actress, who had joined the SMT that year to play assorted wenches and citizens but later in the run of *All's Well* stepped in at an hour's notice to take over the part of Diana and played it for a week of performances. Her name, fortuitously, was Diana Rigg.

By the time that Hall came to rehearse Laughton and the cast of *A Midsummer Night's Dream* as a lordly revel in a late Elizabethan great house designed by di Nobili it had been announced that the director would, barely a few months after his twenty-ninth birthday, succeed Byam Shaw as head of the Festival in 1960. Although he brought the Australian-born fashion photographer Alec Murray, a friend of his wife, the actress Leslie Caron, into some of his costume rehearsals to shoot images for the Festival brochure, the publicity office deemed it politic that di Nobili's elaborate sets should not be reduced to mere blackness for the permanent record. So McBean took his usual photo-call which captured in a single shot of Laughton with ass's ears and

hoofs, perhaps the most comic image of his entire time at Stratford, as well as the exuberance of the production's cast which included Robert Hardy and Mary Ure as Oberon and Titania, Ian Holm as Puck, Vanessa Redgrave as Helena and Albert Finney as Lysander.

Hall's second production of the year gave Olivier, now about to be formally cut adrift from Vivien Leigh, a second crack at Coriolanus 21 years after his first at the Old Vic. Though the principals were much praised by the critics McBean found the settings and costumes so murky that he could not make enough impression even with his own lights to produce colour full-stages of the most dramatic set-pieces which fully satisfied him; and he was also less than happy with his black-and-whites save for a close-up of a cowled Olivier. No such problems affected the lucid, in every sense of the word, *King Lear* with which Byam Shaw bade farewell to the SMT. McBean, who had first photographed Laughton to great effect in 1937 as Captain Hook in *Peter Pan* at the London Palladium, coaxed another fine set of images from the actor about whose switchback moods Mrs Laughton, Elsa Lanchester, had warned him during that first encounter where she was playing Peter Pan. There was, however, one sticky moment at the beginning of the Stratford photo-call during the first scene with Lear enthroned. McBean's assistant, deputed by the publicity office to take some candid images with a small automatic camera while the session was in progress, was spotted by the star moving about behind McBean and his tripod. Laughton broke pose and thundered: 'Young man, what do you think you are doing?' 'Photographing you, Mr Laughton,'

the assistant replied. 'Yes, photographing Charles Laughton, actor, when you *should* be photographing King Lear. I can't have this stealing of these candid camera shots.' Despite murmuring that he had been instructed by the theatre to do so, the assistant thought it wiser to stop. Some days later, however, the images of Charles Laughton, actor, were passed for issue by the 60-year-old star as well as those of King Lear.

The presence of the Hollywood actor had also been enough to enable Byam Shaw to negotiate a most handsome parting gift to the SMT and to many of its 1959 company. The week after the Festival ended a huge production team from the US television company NBC descended upon Stratford to film the production of *A Midsummer Night's Dream* for broadcasting in North America in a 90-minute condensed version the following autumn. The screening was additionally to be introduced by a short travelogue from Laughton around Stratford and Warwickshire which would undoubtedly do wonders for the local tourism for years to come. Indeed it was estimated that the single broadcast, to be sponsored by the Ford Motor company which undertook to limit its advertising during the play's duration to just one half-way break, would be seen by 40 million people, eight times the number of visitors to the SMT in its previous hundred years, and would represent something of a thank you to the American public which had contributed two-thirds of the money for rebuilding the theatre after the 1926 fire.

ACT V: 1960–62

The resulting financial benefit to the SMT certainly helped pay for major alterations that winter to the theatre's stage commanded by Hall, which included a noticeable thrust, a rake and a 26-foot revolve, while also enabling the incoming Festival director to gamble on leasing a permanent outlet in London for the company for both the transfer of Stratford productions and the regular staging of non-Shakespeare plays. The alterations alone, as critic Penelope Gilliatt (soon to succeed Mary Ure as yet another Mrs John Osborne) noted perspicaciously in the 1960 souvenir brochure, would mean major changes to the settings of

future Stratford productions thus ending what she dismissed as 'interior-decorative' designs. She trumpeted too Hall's choice not only to give his six productions for the new season a theme as early, middle and late comedies but also to impose a homogeneity on their directions by himself or three kindred directorial spirits. She lauded also his decision to feature alongside Ashcroft and Tutin actors whom she described as 'irruptive newcomers' to Stratford: these were players who had mostly made their name in George Devine's Royal Court, Hall's own Arts Theatre tenure and Joan Littlewood's Theatre Workshop, Stratford-at-Bow. It was perhaps small wonder that Harry Andrews, after being likened in Gilliatt's essay to a 'landlord's fixture' at Stratford, decided to withdraw from starring as Leontes in *The Winter's Tale* on what was announced as his doctor's orders.

McBean quickly felt the effects of the new directorial broom. Hall decreed that for his first production, the rarely performed *The Two Gentlemen of Verona*, he would have David Sim, who had once shared a studio with Armstrong-Jones and had similarly photographed Royal Court plays, so he didn't need McBean's services. It was only when the latter, once more mindful for the posterity of his own recording of Shakespeare, protested to a sympathetic Goodwin that it was the one play in the canon he had never yet photographed, that the publicity officer was able to prevail upon Hall to let Stratford's now veteran cameraman watch a final rehearsal and take some shots in a much abbreviated photo-call. 'I don't think Peter Hall liked me,' McBean said sadly in later years. 'And he, perhaps quite rightly, felt that I was old-fashioned and wanted somebody new. There was certainly no time to be spared for photo-calls like there had been – and I suppose that dislike is a two-way affair. I'm afraid I didn't like the Peter Hall management.'

Given the circumstances it was scarcely surprising that McBean produced just twelve undistinguished images of the play which were barely circulated. However Goodwin, recognising with his long experience of reproduction of pictures in magazines and in the Festival brochures, that Sim's grainy and very black pictures would not suit his own purposes, persuaded Michael Langham, director of

The Merchant of Venice which followed, to make time for a full photo-call for McBean as well as Sim's presence during dress rehearsals. Langham, who had admired McBean's portrayals of his own previous SMT productions, agreed and the older photographer produced a magnificent set of images. These more than did justice to the designer Desmond Heeley's eighteenth-century settings and costumes as well as Tutin's Portia and the sensational Shylock of 27-year-old Peter O'Toole while also conferring import on actors in lesser roles like Patrick Allen, Dinsdale Landen and Jack McGowran. Goodwin gratefully used as many as he could in the souvenir brochure alongside Sim's images and chose a McBean of O'Toole to become an SMT postcard.

The new Festival director continued to make his point by inviting Zoe Dominic, another photographer who had become known through her work at the Royal Court, to shoot through rehearsals of the revival of his 1958 *Twelfth Night* of the Van Dyck costumes in which Tutin reprised her Viola. So although McBean was given a photo-call which produced felicitous images of the Malvolio of Eric Porter, who had last been at Stratford as a 16-year-old in 1945, and the rest of the new cast, which included Ian Richardson as Aguecheek, it was the Dominic pictures which went into the souvenir brochure and became a postcard. The presence of Ashcroft to play Katerina to the Petruchio of O'Toole in *The Taming of the Shrew* directed by Hall's Cambridge contemporary John Barton, nevertheless ensured that McBean, who had first encountered the actress in a West End extravaganza for which he made props in the very same year in which O'Toole was born, was once again given his head.

Thereafter Barton, who had joint directorial responsibility with Hall for the succeeding *Troilus and Cressida*, counselled that their production, which mostly took place in the designer Leslie Hurry's octagonal sandpit on the central revolve, needed the clarity of McBean's pictures too. His faith was amply rewarded when the photographer, who was allowed also to shoot in colour for the first time that season, produced memorable sets of images of this most unconventional Ilium and its cast which included Tutin's Cressida, O'Toole's Thersites, Max Adrian's Pandarus, a

rapidly promoted Diana Rigg as Andromache and the beauteous Elizabeth Sellers as Helen. (Since Adrian had actually made his name taking the same part in the 1938 modern-dress production, McBean gently reminded the Stratford co-directors that the visual record of that celebrated version of the play was his own.) Indeed, after capturing Porter and Sellars to great effect as Leontes and Hermione in director Peter Wood's *The Winter's Tale*, endowed by the French designer Jacques Noel with striking classical costumes and dangerously spiky royal crowns, the photographer nursed hopes that he would not be entirely swept aside as Hall's plans for expansion now came to fruition.

McBean was thus more than pleased by the seemingly calculated accolade of photographing Donald McWhinnie's production of *The Duchess of Malfi*, in which Ashcroft took the title role and Adrian the Cardinal: after playing for a week in Stratford it became the company's opening production on 15 December 1960 at the Aldwych which had been chosen as the permanent West End base. He also took publicity pictures in his studio only a few hundred yards north of the Aldwych of Hall and Caron, who was appearing in her husband's direction of *Ondine*, second production at the new venue. Then, following the announcement on 20 March 1961 that the Queen was giving the SMT a new charter renaming it the Royal Shakespeare Theatre, housing what would henceforward be the Royal Shakespeare Company, McBean was commissioned by the publicity office to photograph all personnel employed by the new royal godchild in its twin locations.

Accordingly he set up his camera in the dress circle of the Aldwych to capture an assembly on the stage of the actors appearing in the productions there (centred on Ashcroft and Gielgud who would eventually be taking the leads in *The Cherry Orchard*) as well as the musicians and backstage staff. Thereafter he made a special trip to Stratford do the same from the dress circle of the new RST only to discover that he was expected to include in the background of this group portrait also all the staff of the restaurant, café, wardrobe and the company's administrative departments. His care to light these latter correctly so they would have their due received no recognition: when the group portraits appeared in the souvenir brochure, along

with night-time shots he had taken of the outside of the Aldwych Theatre with illuminated marquee announcing its new residents, the images were not credited to McBean. He received scant notice too when he created a montage of the kings and queens of England for the programme cover for John Barton's Shakespearean anthology, *The Hollow Crown*, which was given regular slots at the Aldwych following great enthusiasm for its one-night-only appearance at Stratford the previous year.

Through the course of 1961 McBean found himself required or his images used in stop-start fashion. He was not invited to photograph the first production, *Much Ado About Nothing*, in which Geraldine McEwan and the Canadian actor Christopher Plummer cavorted as a Napoleonic Wartime Beatrice and Benedick, but he was bidden to the second, *Hamlet*, starring Ian Bannen who in the seven years since his Stratford Flute had enjoyed a succession of roles in British films. However McBean's particularly fine pictures in both black-and-white and colour of Peter Wood's production in romantic Hurry sets, which featured McEwan as Ophelia and Sellars as Gertrude, mostly took second place to images produced by Sim or Stratford-based Gordon Goode who first had been allowed into SMT rehearsals three years earlier. In part Bannen, whose Prince was mauled by the critics, was to blame: he rejected the most striking of the black–and-white close-up McBeans of himself because he disliked the photographer's portrayal of his nose in the most darkly shadowed of all the images.

The similarly striking McBean black-and-white or colour images of William Gaskill's *Richard III*, starring Plummer hunched in magnificent malignancy below the designer Jocelyn Herbert's giant sun of York, achieved rather greater currency in RST publications and as a postcard. Then the joyous McBeans of *As You Like It*, in which Vanessa Redgrave scored a triumph as Rosalind opposite Bannen's Orlando, once again were not used though images of the production from younger photographers were. Hall's *Romeo and Juliet* – star-crossed in every sense since his choice of the Pakistani-born RADA graduate Zia Mohyeddin as Romeo had to be replaced by South-African-born Brian Murray just six days before the

Aldwych Theatre company personnel, 1961

RST company personnel, 1961

Ian Bannen in *Hamlet*, not passed for publication, 1961

first night in August and Sean Kenny's ambitious set, which rose, fell and spun, was ridiculed by the critics – nevertheless provided McBean a chance to show he was just as good at capturing violent action as well as the grace of Dorothy Tutin's reprise of Juliet or the clucking humour of Dame Edith's Nurse. It was somehow appropriate that what turned out to be the last of his Stratford postcards should be an image of the Great Dame with her fan since her imperturbability and quick thinking, and those of Max Adrian playing Friar Laurence, in the face of a malfunction of the Kenny set has entered RSC lore. One night Dame Edith was revolved by mistake into a scene in Friar Laurence's cell. Adrian paused, blessed her, she curtsied and walked off with immense dignity whereupon the Friar continued with his lines.

McBean was not asked to photograph the Stratford season's final offering, in which Gielgud essayed *Othello* for the first time under the direction of Franco Zeffirelli, and in retrospect he was relieved. (The production, during whose rehearsals the normally temperate Gielgud grew exasperated by both the mercurial director and his Iago, played by Bannen, was regarded as so great a disaster that plans to transfer it to the Aldwych were abandoned.) Nevertheless, having been bidden to the London venue to take portraits of Plummer and Porter as Henry II and his turbulent priest in Jean Anouilh's *Becket* for use in *Plays and Players*, McBean was gratified to be asked back there at the end of the year to take a full set of production shots of *The Cherry Orchard* with Ashcroft and Gielgud.

In the retrenchment that followed at Stratford in 1962 – out of the six productions two were revivals with new casts, the 1958 *A Midsummer Night's Dream* and the 1960 *The Taming of the Shrew* – the photographer did not receive a summons until the very last offering that November: *King Lear*, in which Brook directed Scofield as the maddened monarch with Irene Worth, Patience Collier and Diana Rigg as his daughters. McBean suspected that his commission was the result of requests from both Brook, who had also designed the simple but striking sets, and Scofield, whom he had most recently photographed to great effect in the West End production of *A Man for All Seasons* which the actor had just left after its Tony award-

winning transfer to Broadway. Though McBean shot only in black-and-white, he took more images of this *King Lear* than of any other play during his association with Stratford. The tally was somehow appropriate to Scofield's performance, hailed not only as the greatest Lear but also the finest performance ever on the SMT/RSC stage, even though Brook's rehearsals tested the actors to the limit. Rigg who cheerfully claimed she was 'the tallest Cordelia in the world' – indeed, her height was accentuated by her dark auburn hair being piled up on her head like a cottage loaf – recalled that Brook's final rehearsal went on till three in the morning before the opening 14 hours later and *still* she felt she didn't get the role right until five weeks into the run.

The memory of the long *Lear* photo-call lingered. The Canadian-born Worth, who had visited McBean in his studio for a magnificent portrait sitting when she first appeared in England at the Old Vic in 1951, said subsequently: 'Angus photographed me about a dozen times in twenty years and he never took a photograph of me that I didn't like. He was such a genius with lighting – and retouching.' Alec McCowen, who was playing the Fool, recalled the 1962 Stratford encounter when he was in the last play which McBean ever recorded 26 years later:

I had been photographed by Angus before [in the West End] but I have never worked with any other photographer who made it all *so* easy. Angus knew exactly what he wanted. We went through the play in the proper order, we assumed our positions for the lines he had noted down, he made very slight adjustments to his lights or us and then – click – he was done and we went on with no fuss to the next shot. I wish I had been photographed by Angus more often but it's something to have been in *that* play which was the last he did at Stratford.

Indeed, there were no further new commissions for McBean from the Royal Shakespeare Company, although there was an irony that his photographs of the Scofield *King Lear* heralded and then emblazoned the RSC at every location visited during the play's worldwide travels over the next two years: in the course of a sell-out run at the Aldwych in 1963 the production hopped across the Channel for a stint in Paris then in the

quatercentenary year of 1964 it made a 16-week British Council-funded tour of Germany, the Iron Curtain countries and North America. However McBean postcards continued to be sold in the RSC's theatre shop into the 1970s and a glorious selection of the photographer's exquisitely printed large display prints of Stratford stars continued to hang in their frames on the walls of the foyers and main staircase of the RST. When these were finally taken down they joined the other thousands of prints McBean had supplied to the SMT/RSC which had been carefully preserved in the theatre's archive and which have been made available to scholars and researchers ever since.

With the coming of digital reproduction the wider dissemination of McBean's images from Stratford has been made even easier and there is a further fine irony that, for those productions in his last years at Stratford where pictures from other photographers were favoured by the management at the time, it is now with very few exceptions the McBeans which have been chosen as the definitive visual record of those same productions. Moreover McBean images have spread from being just Stratford postcards to adorning a whole multitude of merchandise in the RSC shop. It is thus possible to buy, for example, the Oliviers as the Macbeths on crockery, cushions, scarves and even umbrellas while Burton's Prince Hal and Gielgud's Prospero now gaze out from fridge magnets.

EPILOGUE

When his employment at Stratford ended McBean, typically, was not minded to mope. The opening of a new theatre in Chichester under the artistic direction of Olivier brought him regular work in Hampshire to replace what he had lost in Warwickshire. Moreover, through his commissions photographing productions at the Royal Opera House, Sadler's Wells and Glyndebourne, he had fallen into taking portraits in his studio for LP covers, first in black-and-white then in colour. From 1959 this line of employ had moved away from capturing opera or singing divas like Maria Callas, Joan Sutherland and Shirley Bassey to include pop-stars like Tommy Steele, Cliff Richard, Helen Shapiro and many lesser names in the huge new youth record market.

Thus it was that, less than three months after photographing Scofield's Lear, McBean received in his studio in Endell Street a new pop-group, of whom he had not heard, called The Beatles. They got on well, the foursome signed his studio visitors' book after he had taken pictures for the EP they were releasing and a month later he was asked by EMI to go to its Soho HQ to take further colour photos for the group's first LP, *Please, Please Me*. There had been some discussion that the group should be photographed walking down the central staircase of the modern office building but McBean insisted that he wanted the four in an ascending diagonal smiling down at his small Hasselblad automatic camera from over a first-floor railing of the staircase as he lay on the ground of the well below. The set-up was an adaptation of one of his favourite poses: a line of heads which he had used to happy effect in Stratford's 1955 and 1960 *Twelfth Night* and 1959 *All's Well That Ends Well*. Thus it was that a McBean image, credited to him as was EMI's custom, came to adorn the cover of the record album which has sold worldwide then and since in hundreds of millions in various incarnations. (The Beatles themselves, recognising the iconic significance of the image, had the photographer return to the EMI building in August 1969 to recreate the pose at what turned out to be the close of their career together. When EMI left the building for new offices, Paul McCartney acquired the piece of handrail over which The Beatles had peeped.)

The continuing faith that Olivier placed in McBean's pictures also meant that the photographer had even more regular visits to the Old Vic from October 1963 when the venue became temporary home of the new National Theatre for whom Olivier promptly poached John Goodwin, Stratford's longtime head of publicity. Accordingly McBean captured the NT's first production, *Hamlet* with O'Toole, and during his photo-call scooped up a short, black velvet rehearsal cloak that the actor discarded and ever afterwards used it as the cloth for covering his own head when looking through the back of his big camera while taking his shots. He also recorded other classic plays in the new NT's repertoire including the remarkable *Othello* in which Olivier triumphed.

Peter O'Toole and Rosemary
Harris in National Theatre
Hamlet, 1963

Laurence Olivier and Frank
Finlay in National Theatre
Othello, 1964

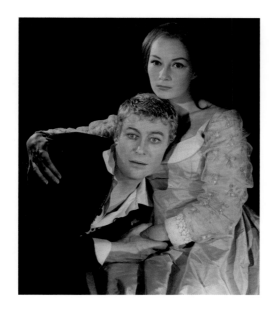

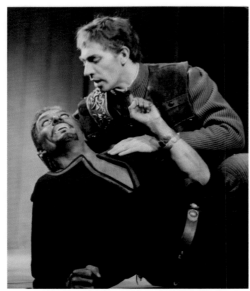

Laurence Olivier presenting
McBean with his sixtieth
birthday cake, 1964

of flashbulbs, paid handsome tribute to their
longtime friendship despite their disastrous first
meeting in the Motley studio in the West End in
November 1935, when he himself had just started
a season alternating Romeo and Mercutio with
Gielgud. (McBean, failing to recognise the young
actor huddled in a corner seeking solace after poor
notices for his Romeo, had said he was waiting
until Gielgud took over the part six weeks later
before seeing the play.) Olivier recounted:

> I fled into the night my tears frozen in horror on
> my cheeks. Shortly after that he [McBean] began
> to photograph me … and I have been perfectly
> happy, and I shall always be perfectly happy, to
> allow what shreds of immortality I'm allowed to
> rest in the hands of Angus McBean. If any of you
> by any chance have nursed a wish to see *Othello*
> and by some chance have not managed to get a
> seat, don't bother – look at the photographs here –
> it's much better.

The exhibition was perhaps the high-water
mark in McBean's career. He continued to take
photographs at the NT and to work for EMI but
the lease on his Endell Street studio expired and,
though he set himself up in a new one in less
centrally located Islington, he increasingly spent
more time restoring the Elizabethan country
house in Suffolk he had acquired a few years
previously. While big stars remained faithful to
him (in 1966 Richard Burton insisted that he
should travel to Oxford to photograph him in
the OUDS production of *Dr Faustus*, in which
Elizabeth Taylor was taking the mute part of
Helen of Troy) his general theatre business began
to drop off markedly. More theatre managements
wanted to save time and costs by resorting to
those photographers who could work through
rehearsals and had taken McBean's place at
Stratford. Concurrently, as the mass outlet for
black-and-white production photographs of the
clarity and tonal variety that McBean achieved
virtually disappeared with the extinction of the
old 'shinies', greater pictorial coverage of plays in
newspaper reviews and previews now meant that
younger photographers' images of grainy white
faces in all-black backgrounds were actually more
suited to the inferior reproduction standards of
newsprint.

When the Kodak Gallery in London offered
him an exhibition of photographs to mark his
sixtieth birthday in June 1964 it seemed to
McBean entirely appropriate, since this was the
Bard's quatercentenary, that he should turn his
negatives of his Shakespeare photographs over to
the gallery's curators for them to make a selection
and to print up what they considered to be the best
of the thousands of images. The show, *William
Shakespeare: The Complete Plays Photographed
by Angus McBean*, was opened by Olivier who,
as well as presenting the photographer with a
cake in the shape of a camera nestling on a bed

A hip operation, his sixty-fifth birthday and a degree of financial contentment – after McBean sold, at Olivier's suggestion, his black-and-white negatives of theatre, opera and ballet productions as well as some portrait subjects to Harvard University Library's Theatre Collection – encouraged the photographer to retire in 1971. (The sum paid by Harvard was equivalent to £350,000 at today's prices but came to seem paltry in 1977 when Cecil Beaton's archive achieved a valuation twenty times higher.) Unfortunately a third of the almost forty thousand McBean glass negatives acquired by the US university (they weighed over four tons) were damaged in transit or shortly thereafter. Among these losses were the complete sets of images of eight Stratford productions between 1946 and 1960 as well as the portraits for the Aldwych Theatre *Becket*.

McBean himself compounded this destruction of his posterity: when he finally left his Islington studio he smashed his remaining four tons of negatives of portrait sitters whom he thought of little consequence since they hadn't been wanted by the Harvard personnel. Thus was lost his record of subjects as various as fellow photographer Bill Brandt, aristocratic beauties like the Marchioness of Reading and Princess Lee Radziwill, Kamila Tyabji, the first Muslim woman to go to Oxford and to practise at the London Bar, and a teenage chorus boy in *South*

Pacific at the Theatre Royal, Drury Lane, called Larry Hagman who later found international fame in *Dallas*.

The photographer swiftly had reason to regret his smashing session. His work, seemingly dated just a decade earlier, came back into fashion with collectors and scholars a generation younger than his late 1950s–60s detractors. In 1976 he was given a retrospective exhibition in York, which transferred the following year to the foyers of the new National Theatre building, and his vintage prints began to be acquired by the National Portrait Gallery. In 1980 he travelled out of Europe for the first time to attend a selling exhibition of his photographs in Australia and was even persuaded to photograph a Sydney production of *Oedipus Rex*. After the 1982 publication of a selection of his work in a book which bore a glowing foreword by Lord Snowdon, he was coaxed out of retirement to shoot pictures in Paris for two French fashion magazines. Then in 1985 his favourite picture, the *Bystander* frontispiece of Vivien Leigh which the actress sent to Hollywood in 1938, was used by the GPO as a stamp.

Angus McBean smashing his negatives in Islington, 1974

Vivien Leigh stamps, 1985

As he progressed through his ninth decade McBean's extraordinary professional Indian summer continued. Working from a borrowed studio in a Southwark warehouse belonging to a new young assistant he was in demand again as a portraitist, shooting Deborah Kerr for a revival of *The Corn Is Green* as well as luminaries like the film director Derek Jarman and fashion priestess Vivienne Westwood and various music stars. He travelled to Japan and around Britain for repeated exhibitions of his work and in 1987 and 1988 he photographed two West End productions for director John Dexter: *Portraits*, a new play by William Douglas Hume, and a revival of T.S. Eliot's *The Cocktail Party*, which starred respectively Keith Michell and Alec McCowen.

In the summer of 1988 McBean also visited Stratford for the first time in a quarter of a century to see the RSC's archive of his black-and-white prints and colour transparencies and was delighted to discover how well these had been looked after. During three days he spent reviewing his SMT/RST work and making a first selection from it, the idea was born that there should be a book of his Stratford pictures to follow a volume, then in production, of his photographs of Leigh. *Vivien: A Love Affair in Camera*, which contained McBean's memoir of the actress, was published in 1989 when his projects also included a first trip to the US to take pictures for another fashion magazine and a colour portrait sitting with Dame Peggy Ashcroft in her own house. Sadly McBean became ill while in North Africa that winter and, following complications, he died in Suffolk the day after his eighty-sixth birthday in 1990 – just as the RSC's gallery was about to mount a small retrospective of his Stratford images.

This volume is therefore a fulfilment thirty years on of Angus McBean's own intentions for what he deemed to be his finest achievement. I hope he would approve.

ACKNOWLEDGEMENTS

Adrian Woodhouse would like to thank the following for being so generous with their expertise and time which were essential to the production of *Shakespeare by McBean*: Kevin Wright of the RSC, who maintained belief in the book at all times, and his colleague Carolyn Porter, who laboured long to digitise most of the photographs; Sylvia Morris, formerly of the library and archives at the Shakespeare Birthplace Trust, and the present staff there whose insight and efficiency when handling the RSC McBean images in their care made final selection from them so smooth; Dale Stinchcomb of Harvard University Library, who happily has expunged memories of his institution's previous handling of its own McBean collection; the late Roger Howells, whose enthusiasm for this book was sadly not to be rewarded by seeing it in print; Matthew Frost of Manchester University Press who needed no second bidding before commissioning the book and has been properly punctilious about its text; Alan Ward of Axis Graphic Design whose ideas for the book's appearance have been so inspired; Greg Doran, whose perspicacious foreword is also blush-making; and Richard Hill, who over many years has made Angus McBean a special subject while chasing down and marshalling photographs or ephemera with a persistence that never flags.

NOTE ON ILLUSTRATIONS

All the main images are the copyright of the RSC, save those of: *Comedy of Errors*, and *The Two Gentlemen of Verona*, which are by courtesy of the negative owners, Harvard University Library Theatre Collection; *Antony and Cleopatra*, 1945, *Henry VI, Parts 1, 2* and *3*, and *Timon of Athens*, which are the copyright of Adrian Woodhouse.

All the images within the Introduction are the copyright of Adrian Woodhouse, save those of: Glen Byam Shaw, Sophie and Margaret Harris, the personnel of the Aldwych and the Stratford theatres and Ian Bannen as Hamlet, 1961, which are the copyright of the RSC.

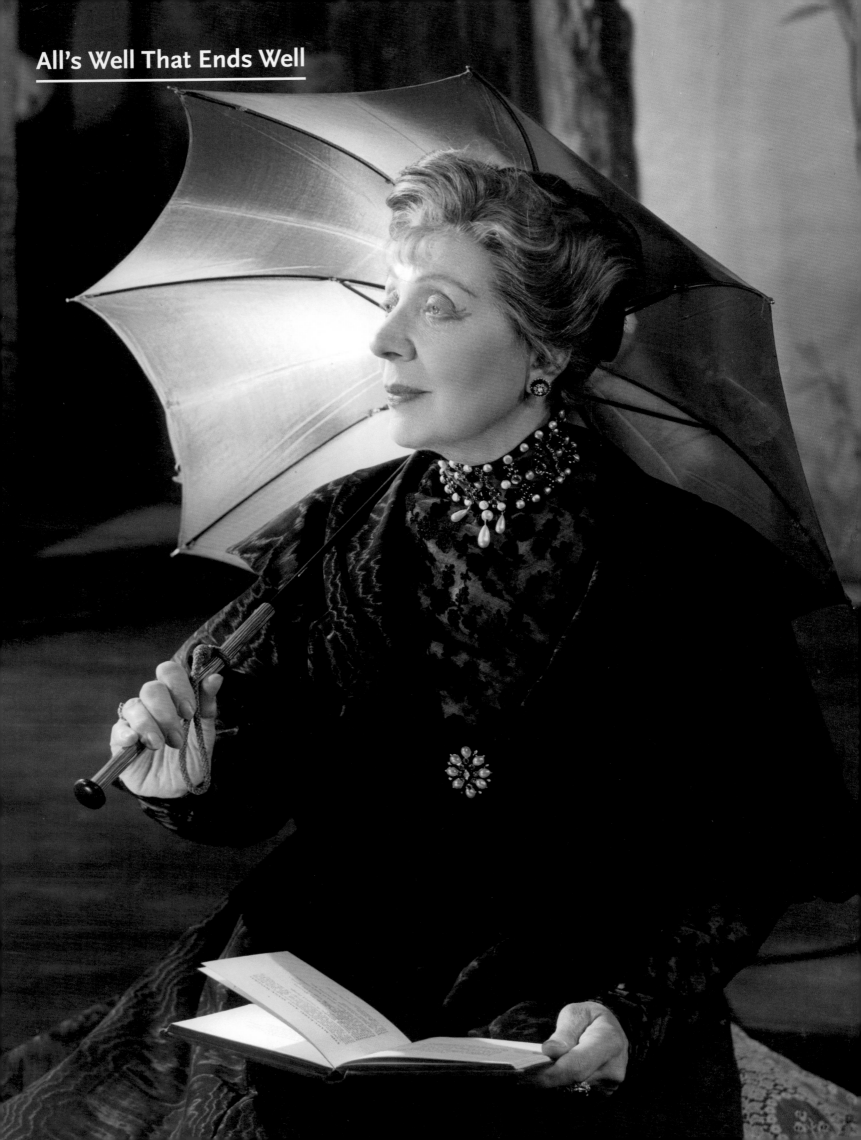

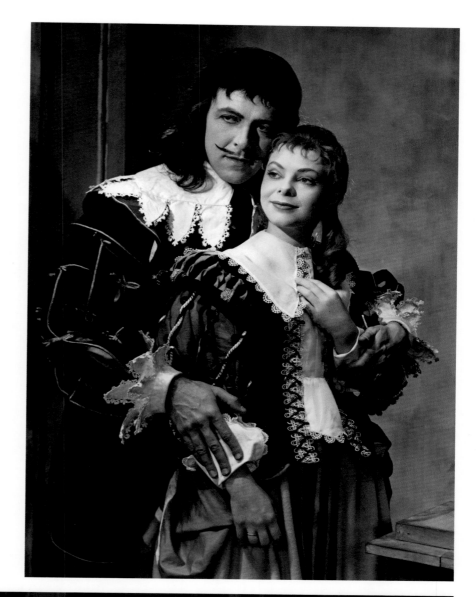

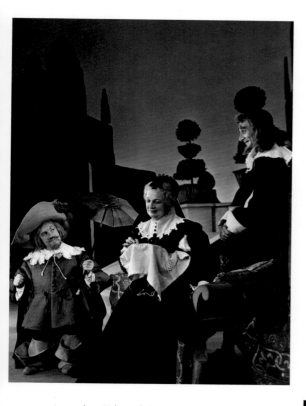

1955, I.3, Lavache (Edward Atienza),
the Countess of Roussillon (Rosalind
Atkinson) and Rinaldo (Geoffrey
Bayldon

IV.2, Bertram (Michael Denison) woos
Diana (Jill Dixon)

II.2, Parolles (Keith Michell)
demonstrates his swordsmanship,
note McBean's lamp

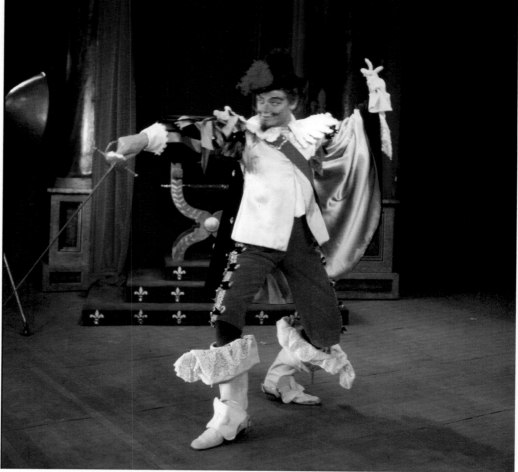

<

1959, The Countess of Roussillon
(Edith Evans)

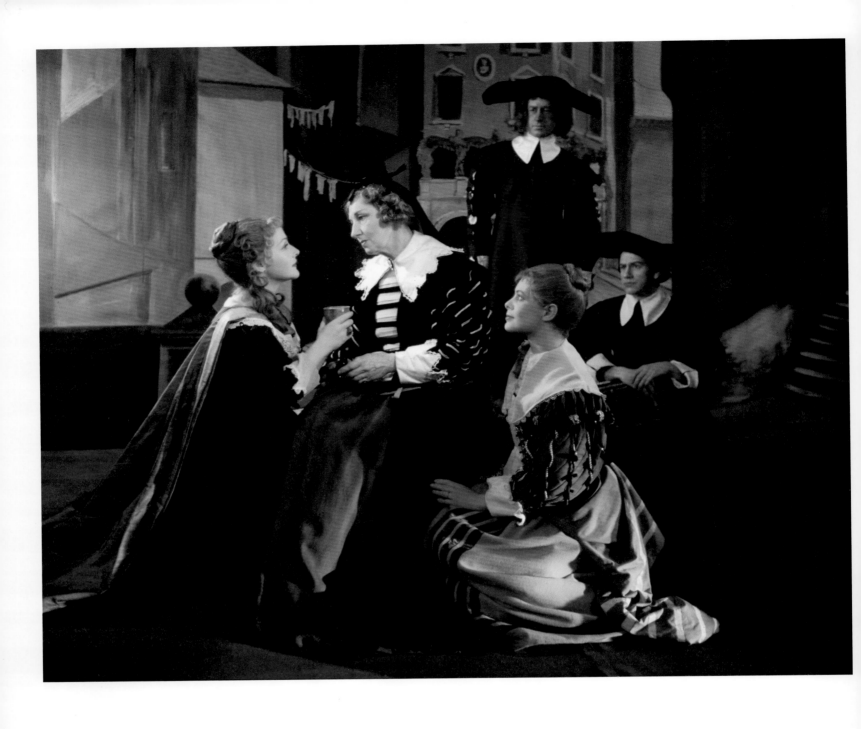

1955, III.5, Helena (Joyce Redman), the Widow of
Florence (Nancy Stewart), Diana (Jill Dixon) and
Mariana (Dilys Hamlett)

1959, IV.1, Parolles (Cyril Luckham) observed by the
Florentine lords (top to bottom – Nicholas
Hawtrey, Peter Woodthorpe and Paul Hardwicke)
before his ambush

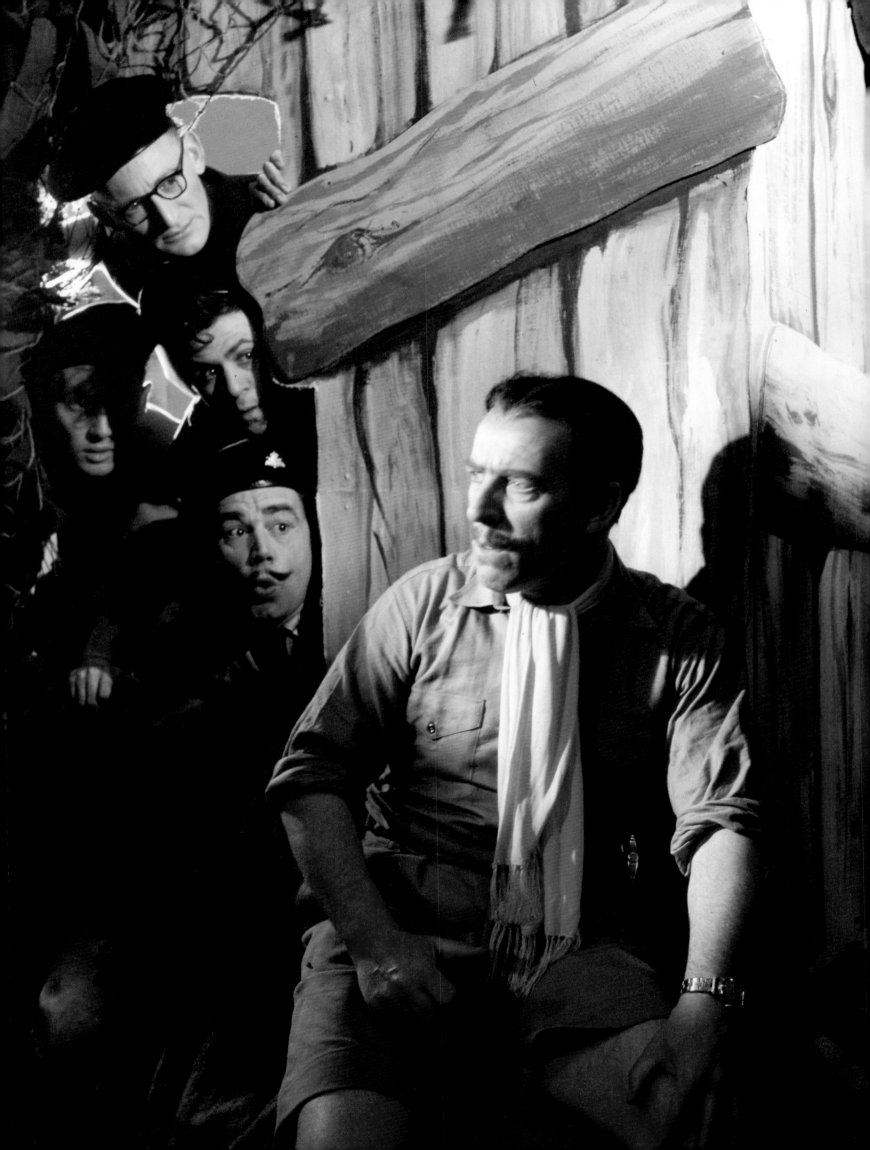

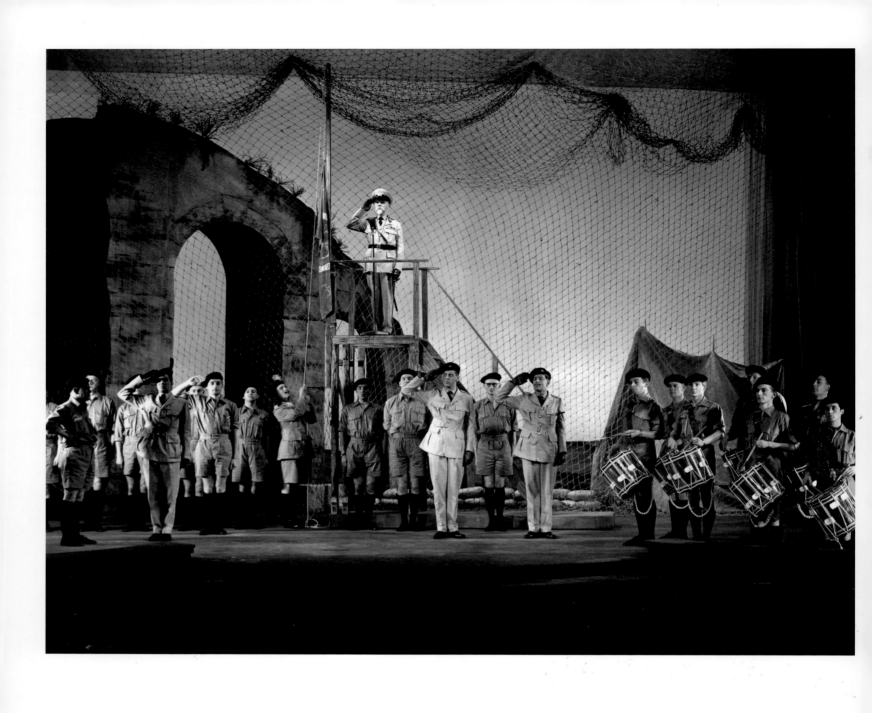

1959, III.3, review of the Florentine troops

IV.4, Helena (Zoe Caldwell)

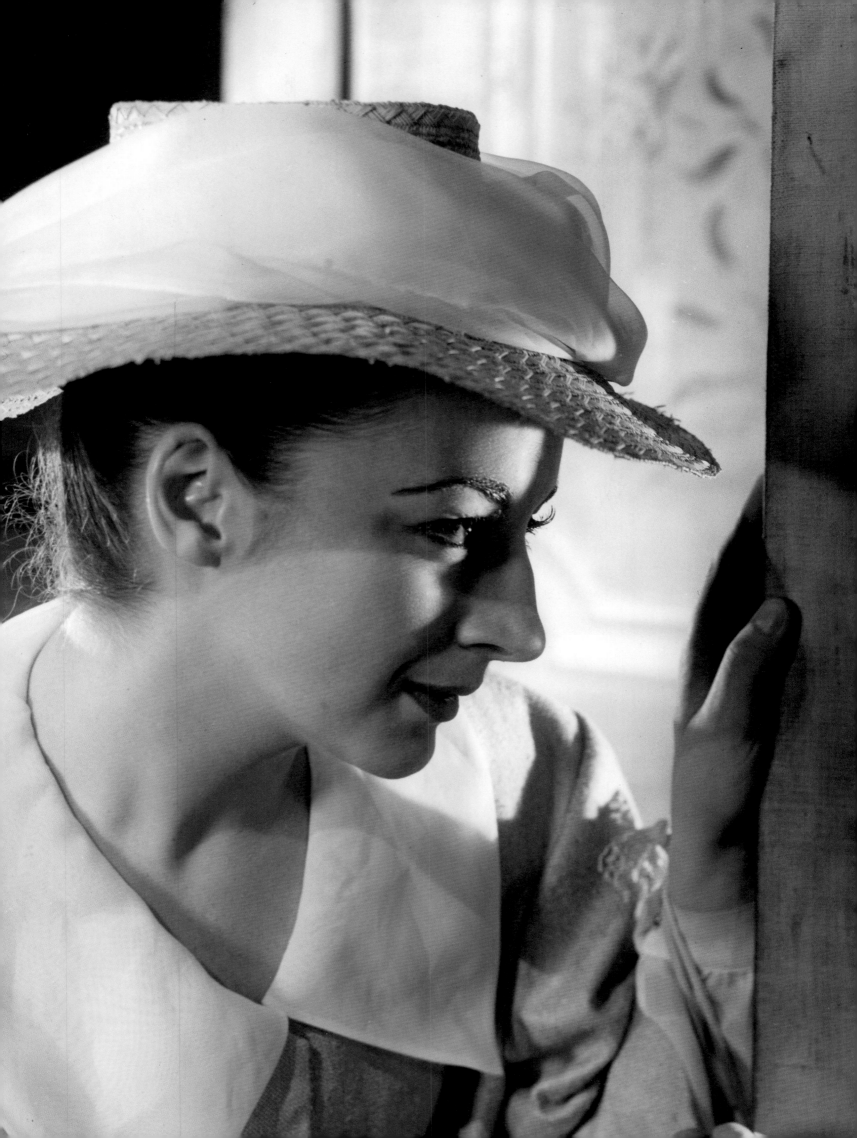

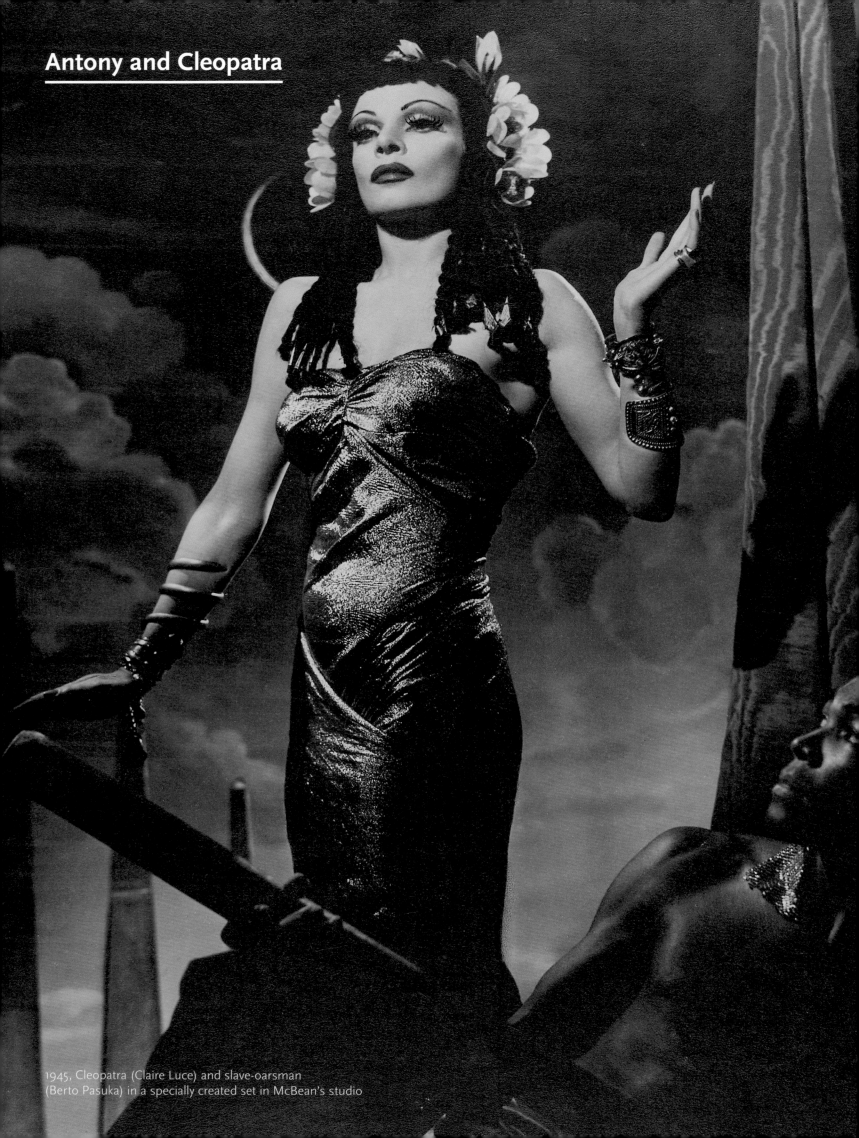

Antony and Cleopatra

1945, Cleopatra (Claire Luce) and slave-oarsman
(Berto Pasuka) in a specially created set in McBean's studio

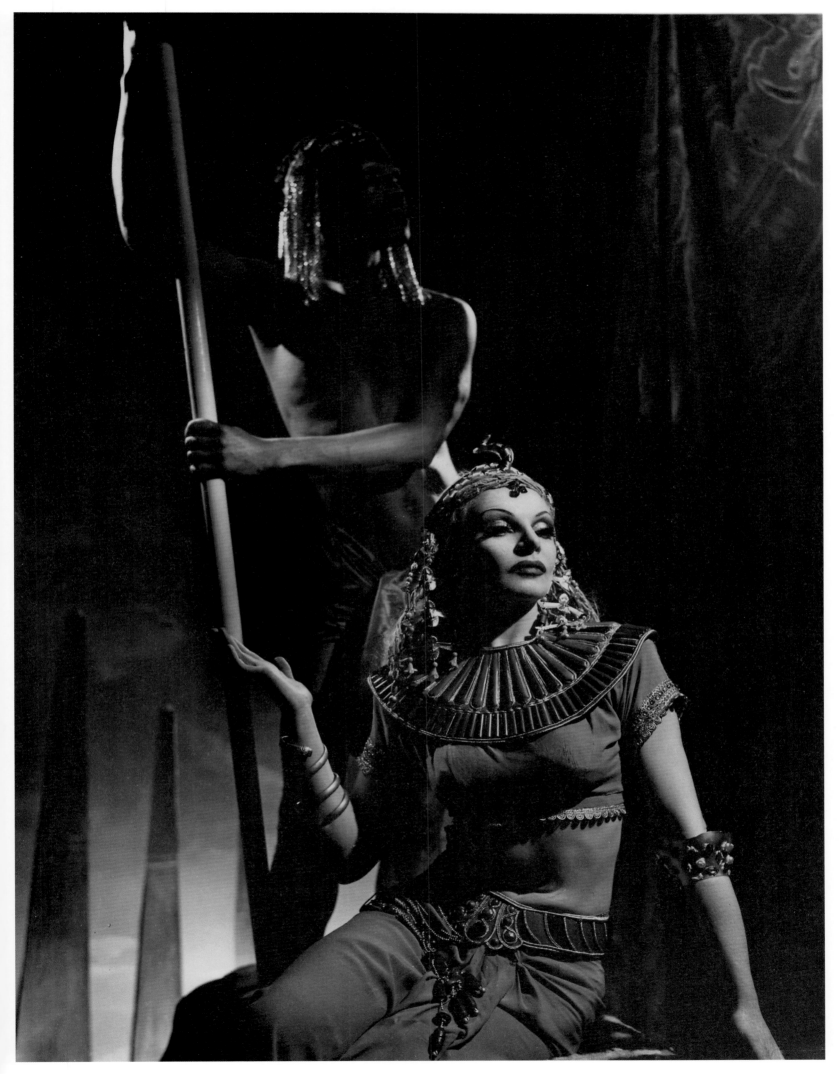

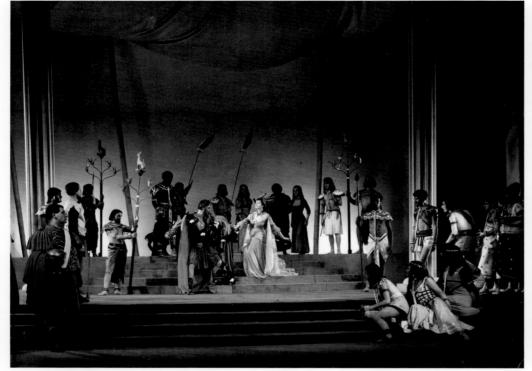

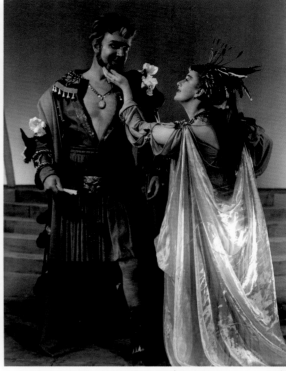

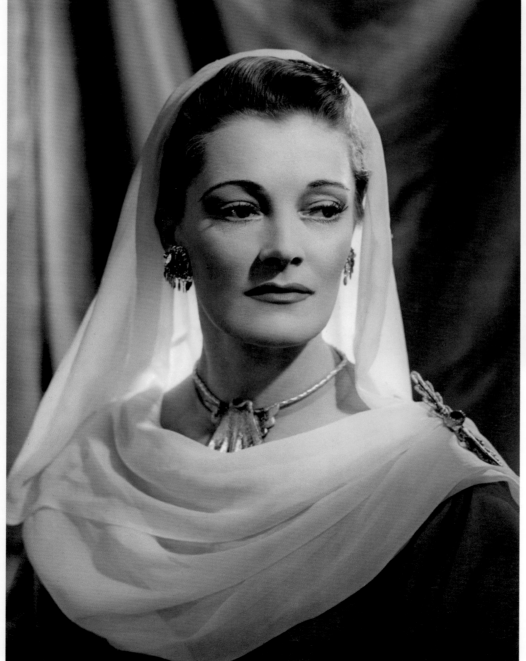

1953, I.1, Antony (Michael Redgrave) and Cleopatra
(Peggy Ashcroft) and the Egyptian court

I.1, Antony and Cleopatra

II.3, Octavia (Rachel Kempson)

II.5, Cleopatra

>

v.2, Charmian (Jean Wilson), Cleopatra and Iras
(Mary Watson)

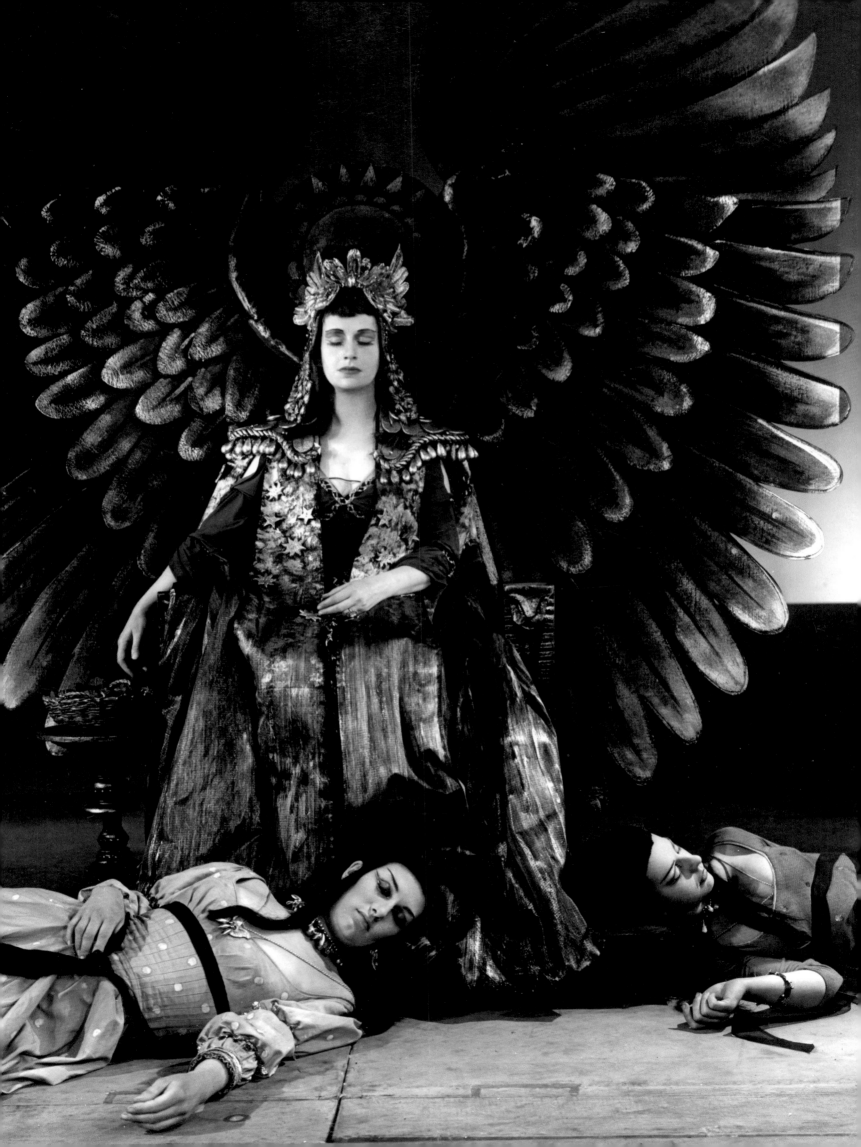

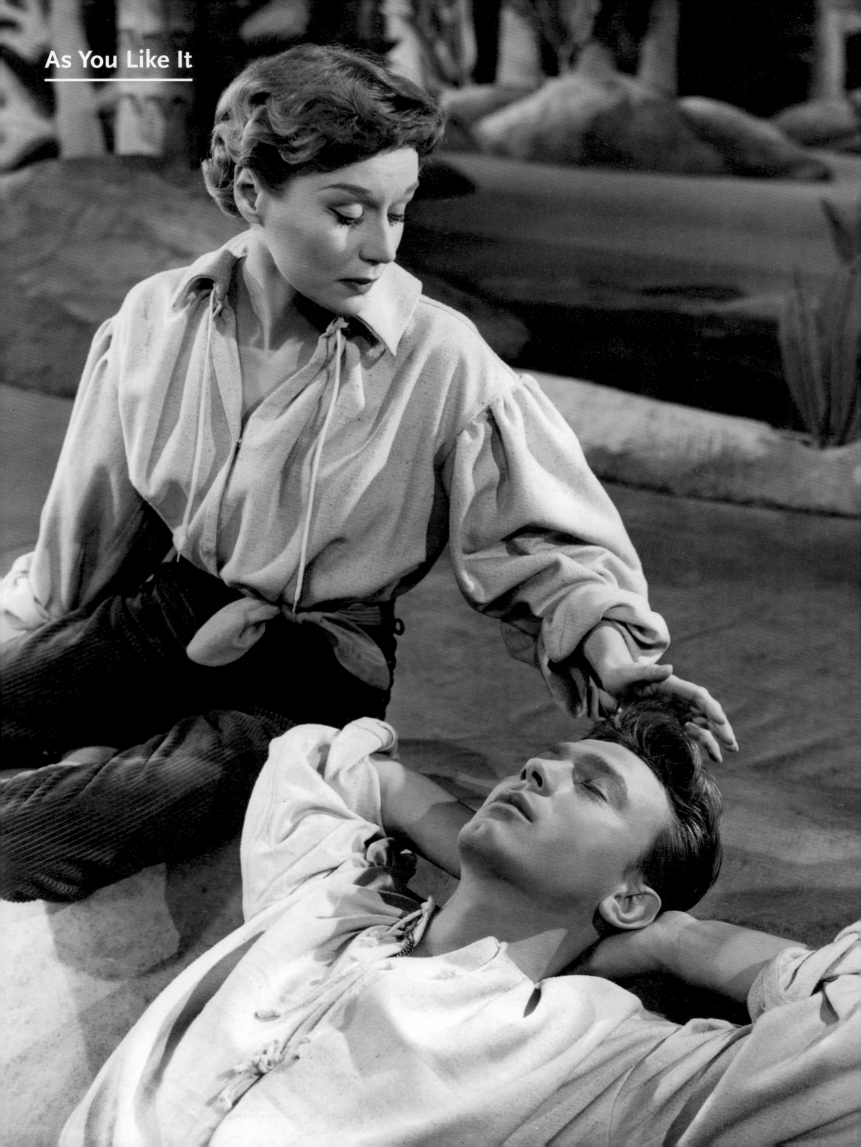

1946, I.2, Touchstone (Hugh Griffith)

IV.3, Oliver (Paul Scofield) and Celia (Joy Parker)

1952, II.7, Jaques (Michael Hordern)

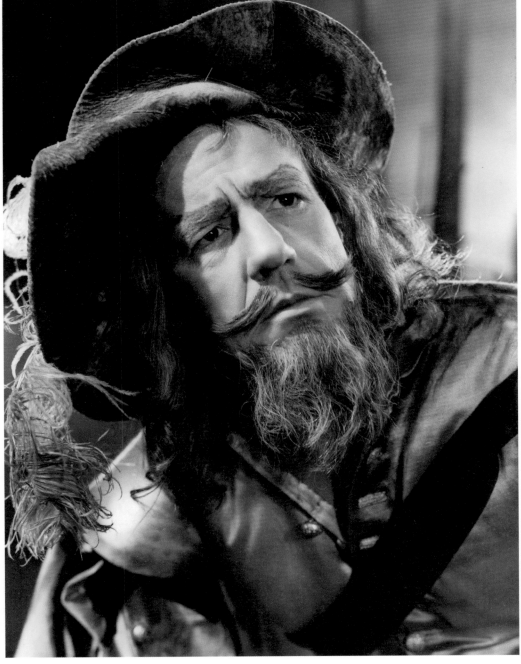

<
1952, III.2, Rosalind (Margaret Leighton) and Orlando
(Laurence Harvey)

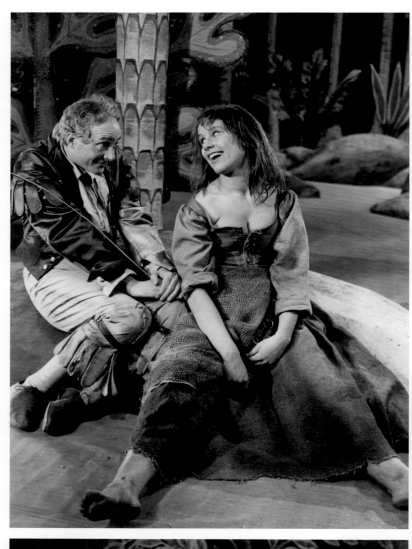

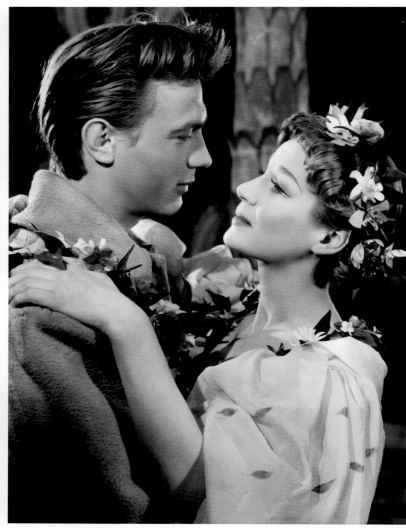

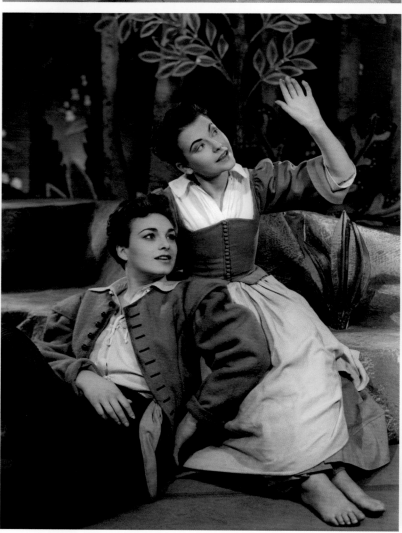

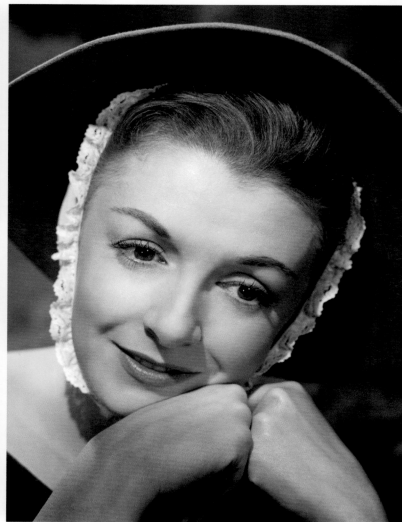

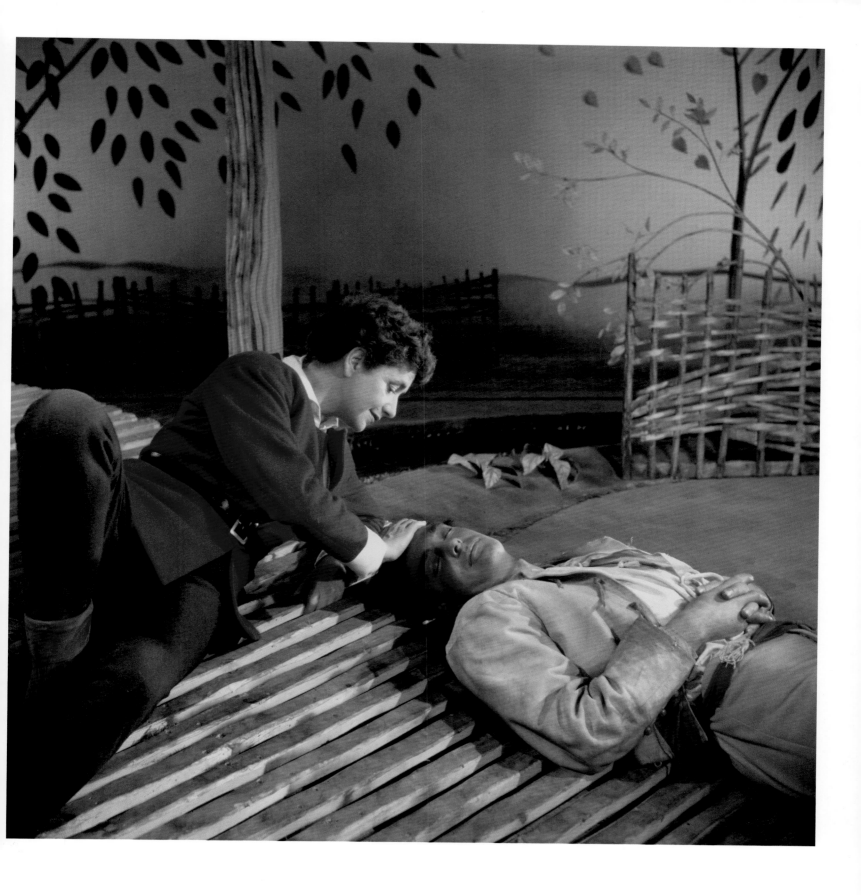

<

1952, III.3, Touchstone (Michael Bates) and Audrey
(Jill Showell)

v.4, Rosalind (Margaret Leighton) and Orlando
(Laurence Harvey)

1953, v.4, Rosalind (Barbara Jefford) and Celia
(Charmian Eyre)

1957, Celia (Jane Wenham)

1957, III.2, Rosalind (Peggy Aschcroft)
and Orlando (Richard Johnson)

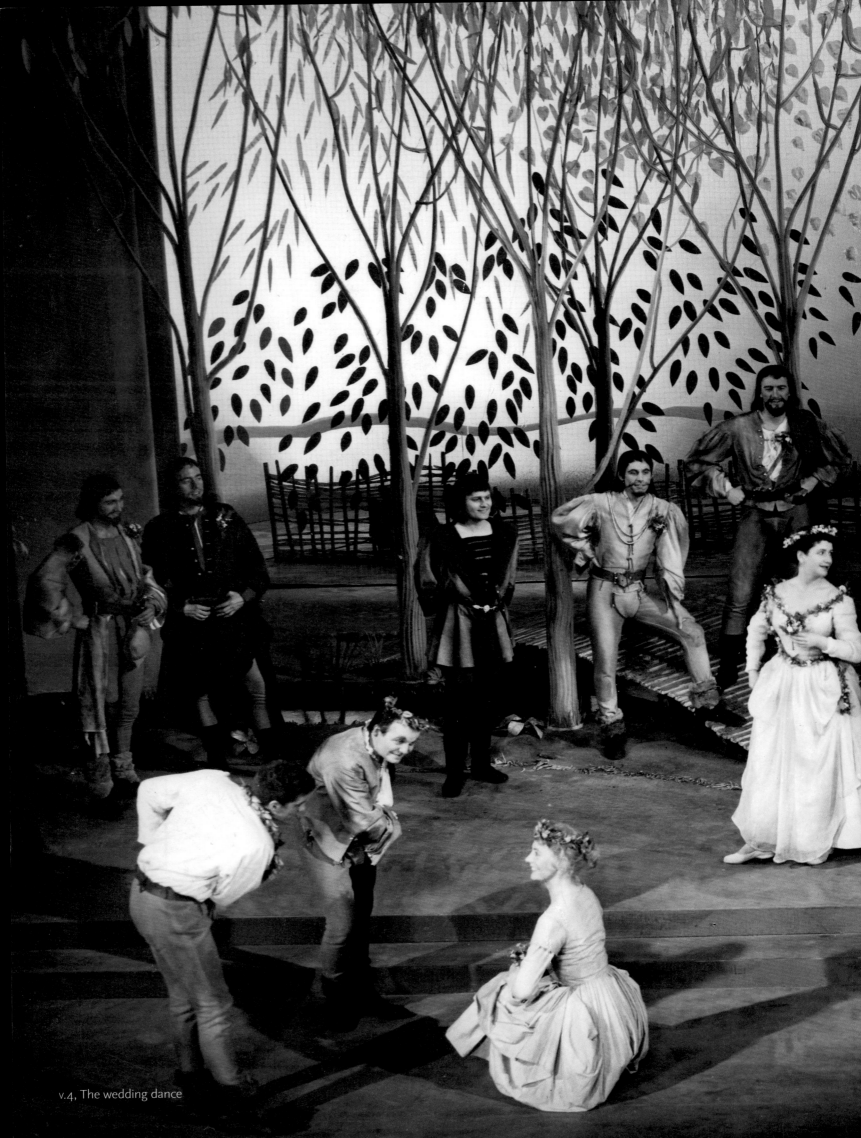

v.4, The wedding dance

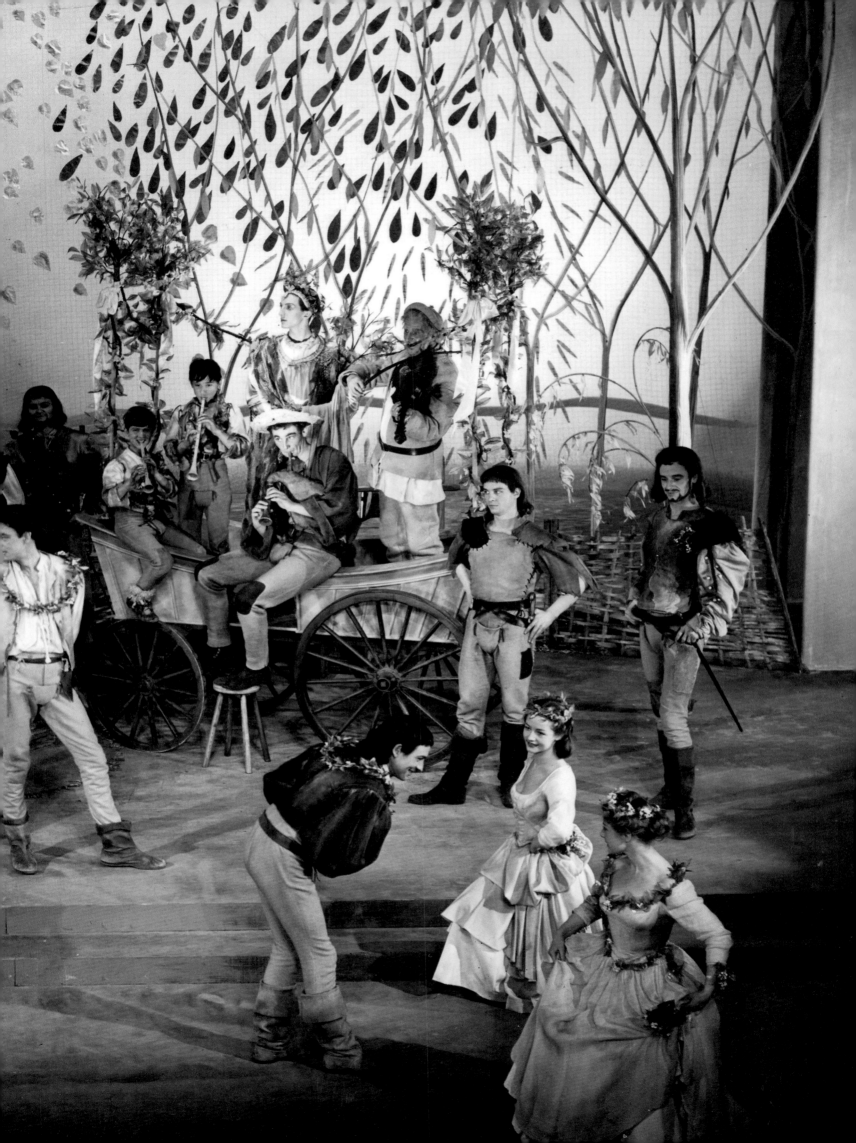

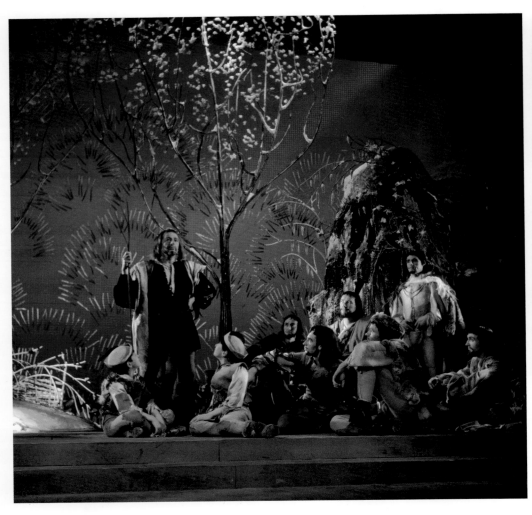

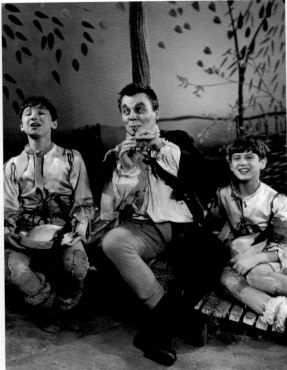

1957, I.3, Touchstone (Patrick Wymark) and pages (Peter Whitmarsh and Michael Saunders)

II.7, Jaques (Robert Harris) and the woodland court

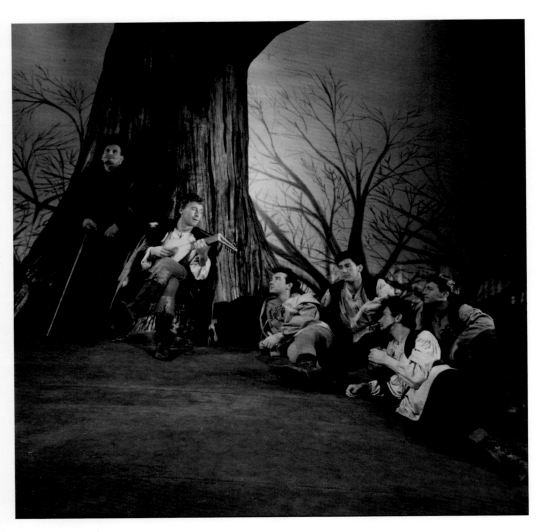

1961, II.5, Amiens (Eric Flynn) sings to the woodland court

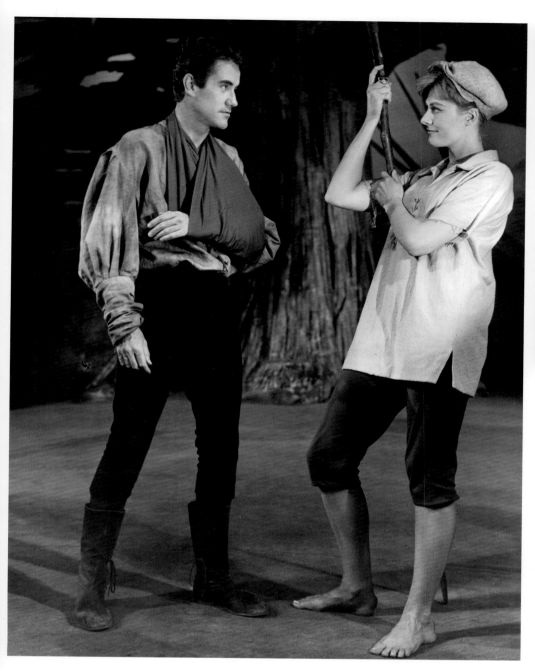

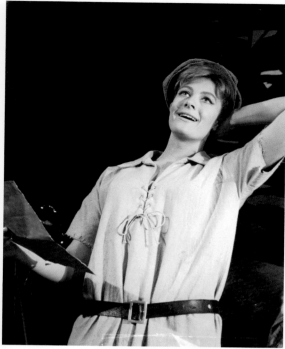

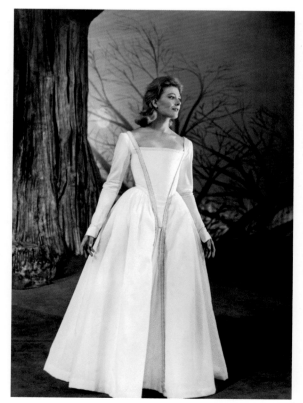

1961, III.2, Orlando (Ian Bannen) and Rosalind
(Vanessa Redgrave)

III.2, Rosalind

V.4, Rosalind

The Comedy of Errors

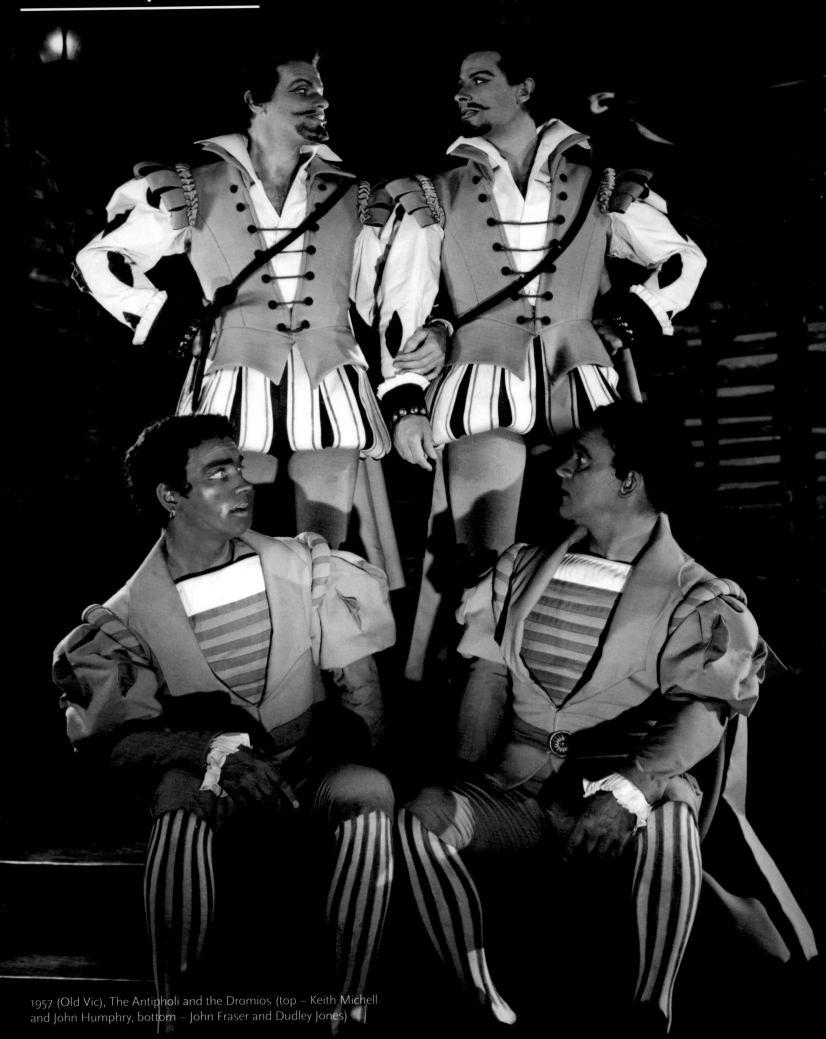

1957 (Old Vic), The Antipholi and the Dromios (top – Keith Michell and John Humphry, bottom – John Fraser and Dudley Jones)

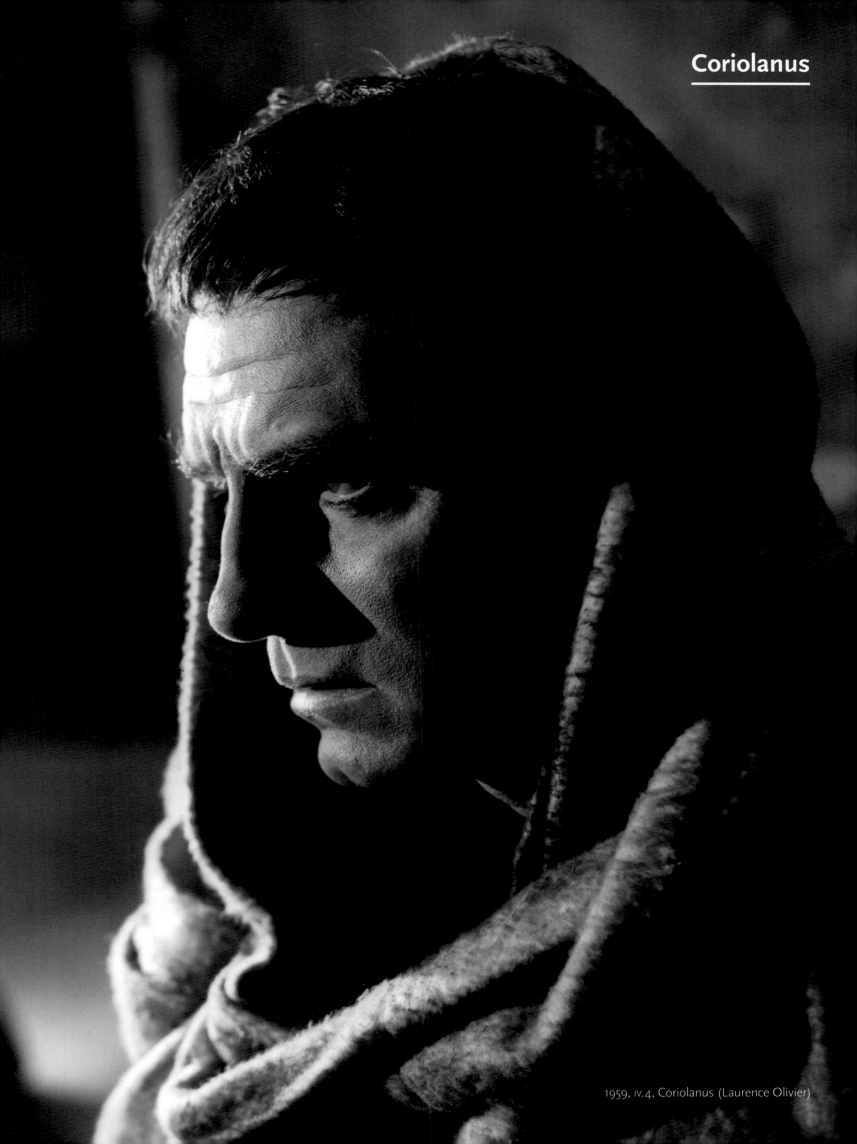

1959, IV.4, Coriolanus (Laurence Olivier)

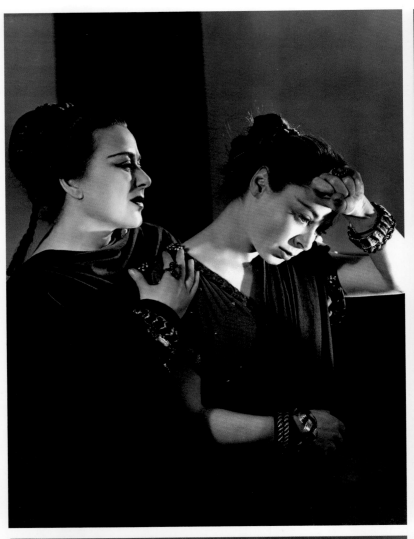

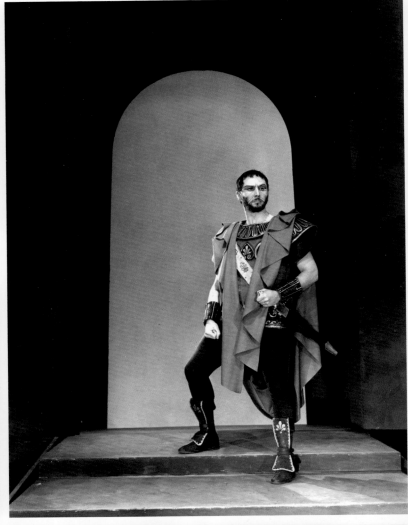

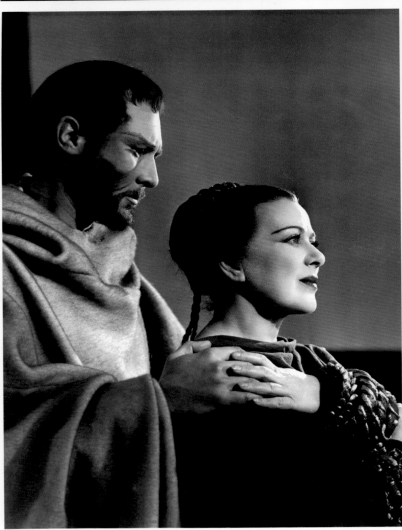

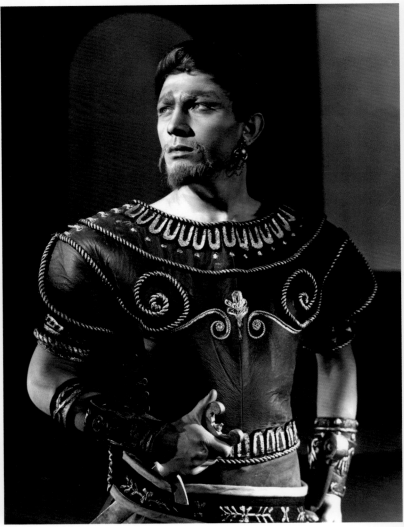

<

1952, I.3, Volumnia (Mary Ellis) and Virgilia (Siobhan McKenna)

III.1, Coriolanus (Anthony Quayle)

IV.1, Coriolanus and Volumnia

IV.4, Aufidius (Laurence Harvey)

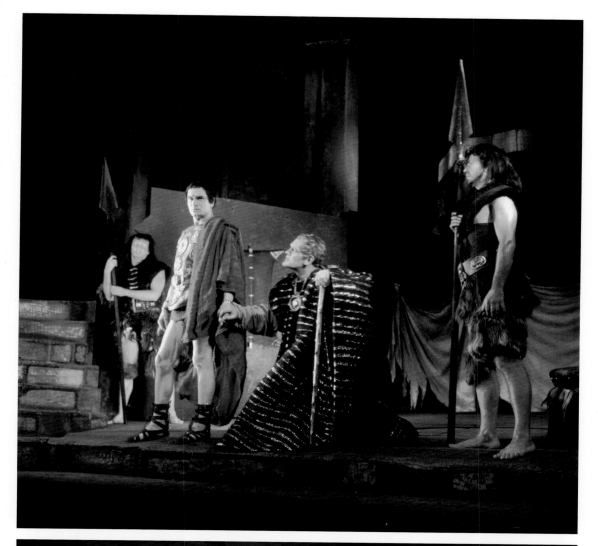

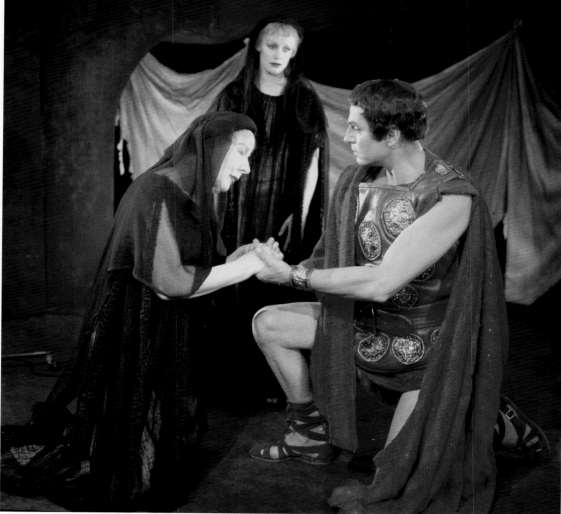

>

1959, V.2, Menenius (Harry Andrews) pleads with Coriolanus (Laurence Olivier)

V.3, Volumnia (Edith Evans) and Virgilia (Mary Ure) plead with Coriolanus

FOLLOWING PAGE

V.6, Coriolanus is killed by the mob and Aufidius (Anthony Nicholls)

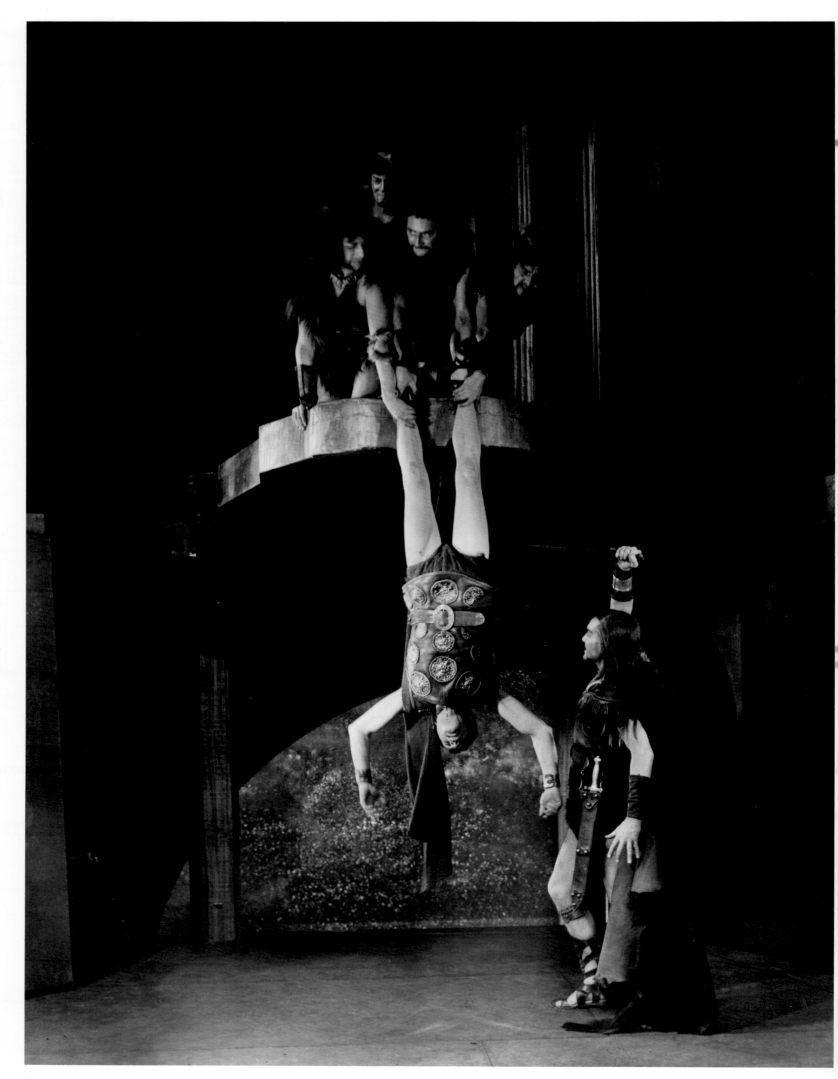

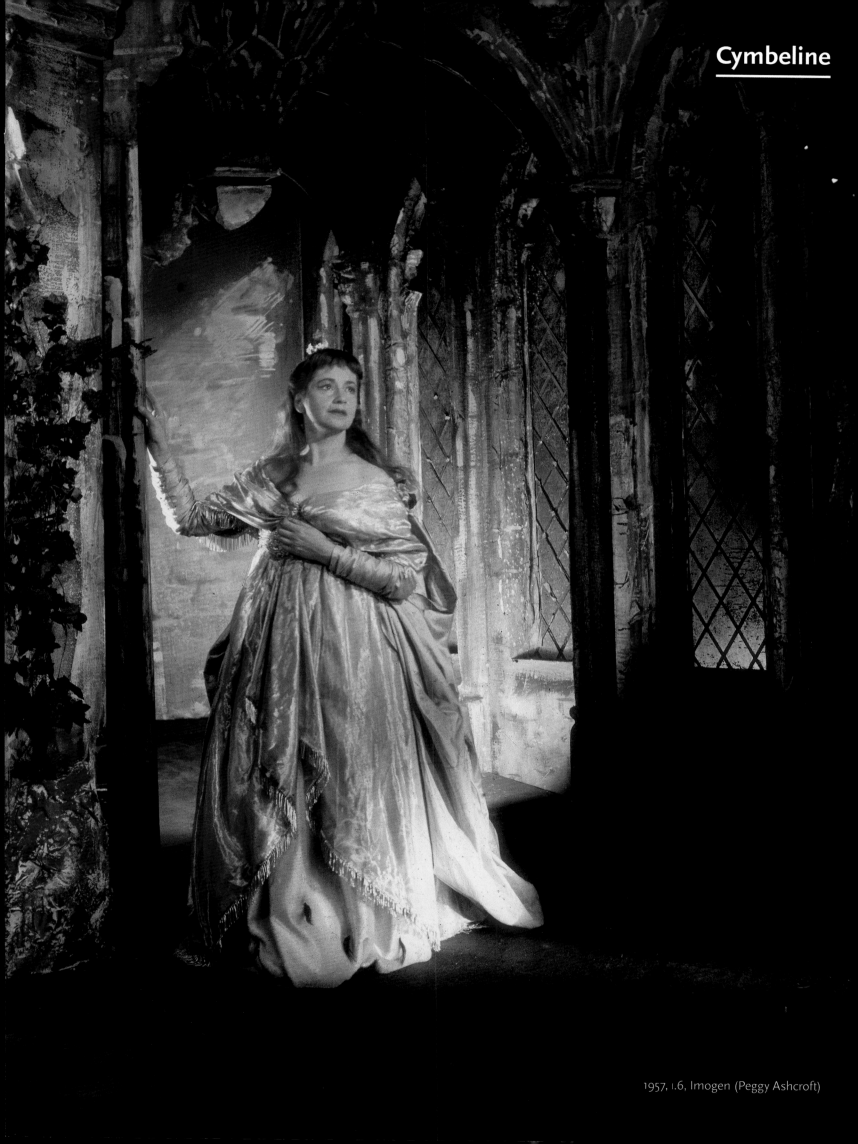

1957, I.6, Imogen (Peggy Ashcroft)

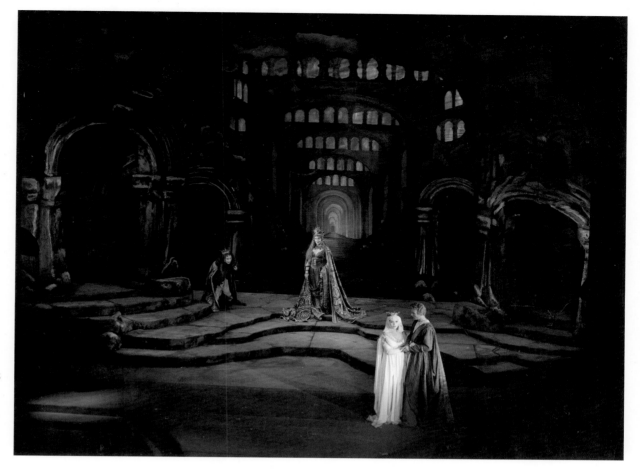

1949, v.4, Jupiter (Robert Shaw) appears to Posthumus (Clement McCallin)

I.1, The Dwarf (Timothy Bateson), the Queen (Wynne Clark), Imogen (Kathleen Michael) and Posthumus (Clement McCallin)

III.1, Cymbeline (Leon Quartermaine)

III.5, The Queen, Cloten (William Squire) and the Dwarf

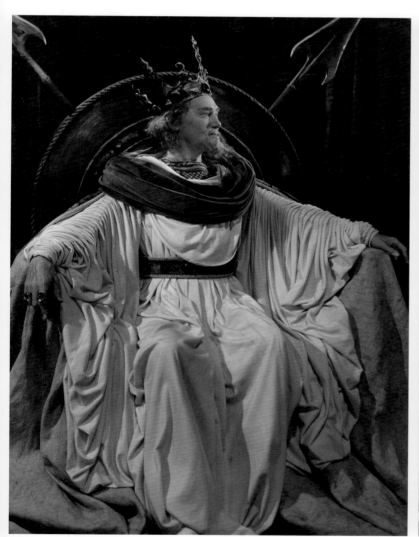

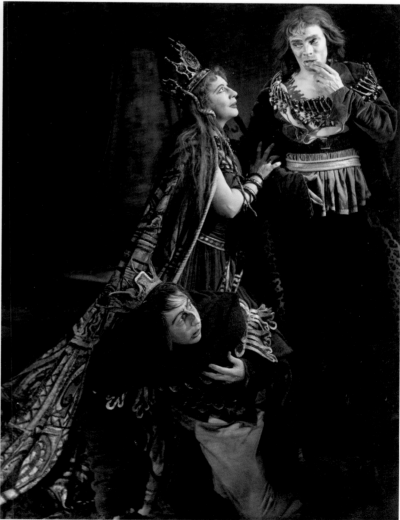

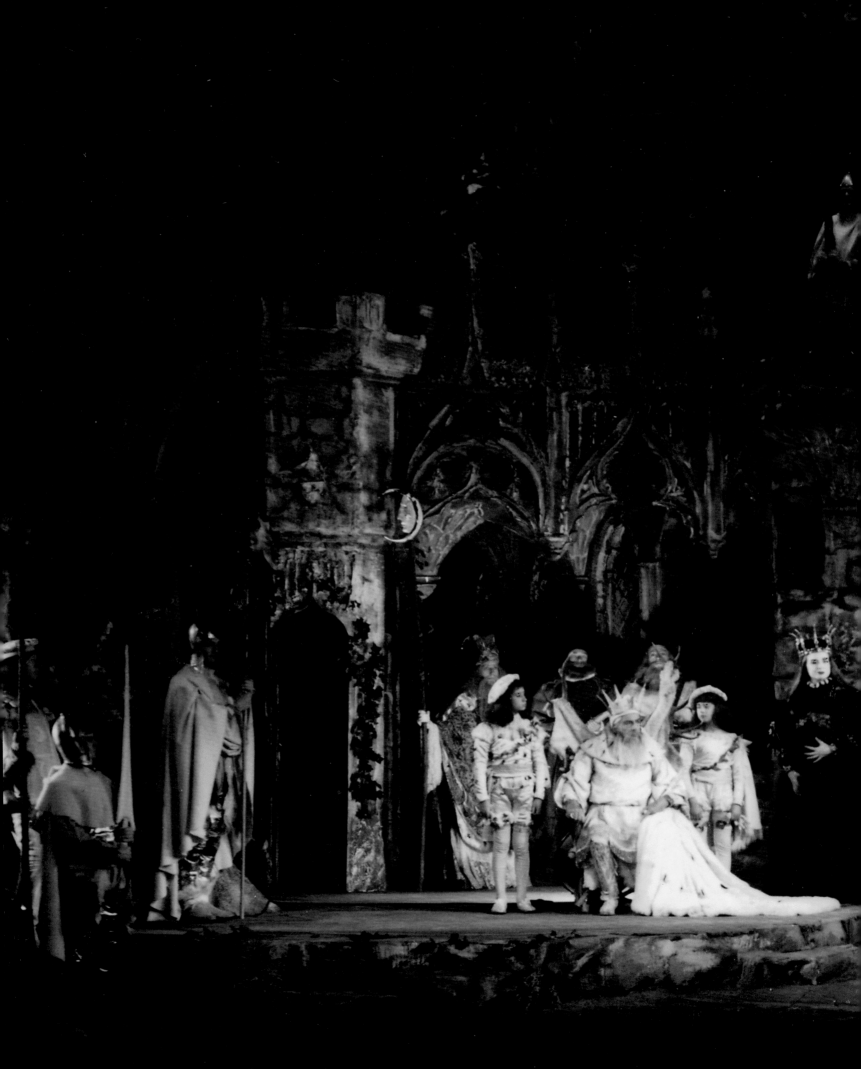

1957, III.1, Cymbeline (Robert Harris) refuses to pay tribute to Caesar

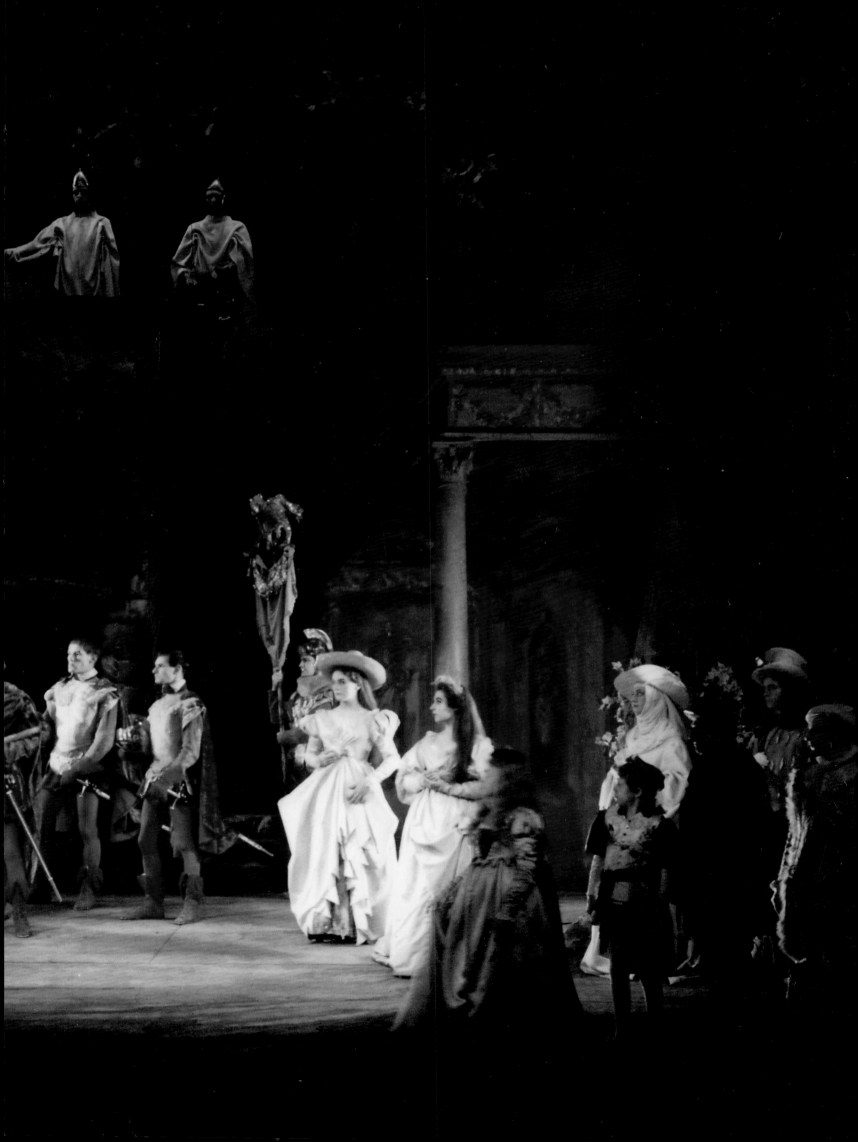

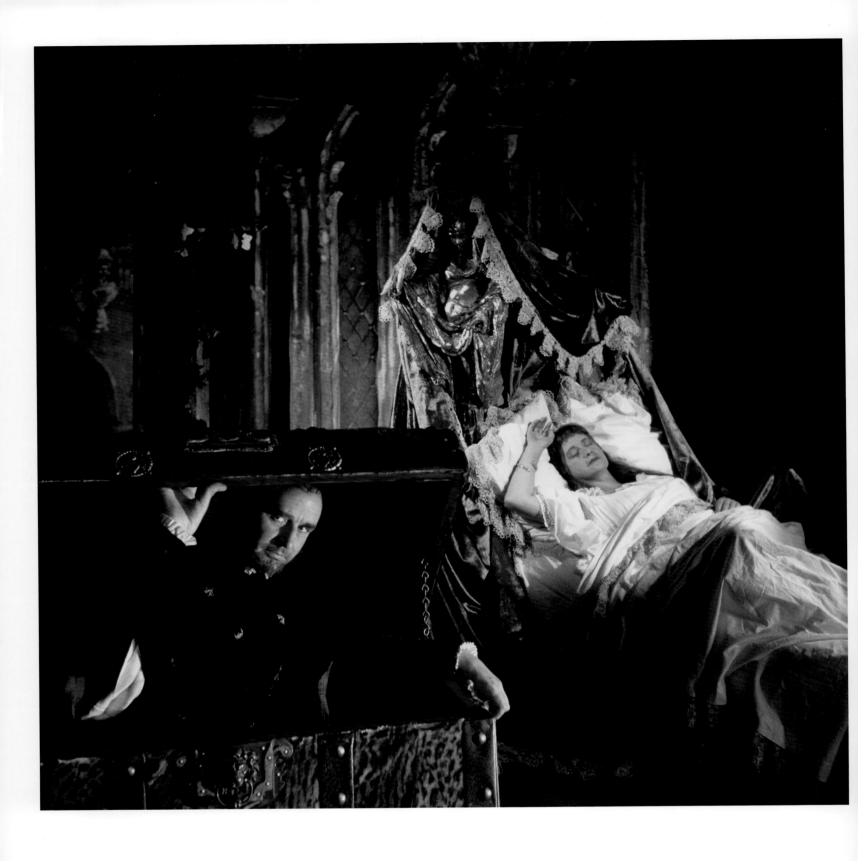

1957, II.2, Iachimo (Geoffrey Keen) and Imogen

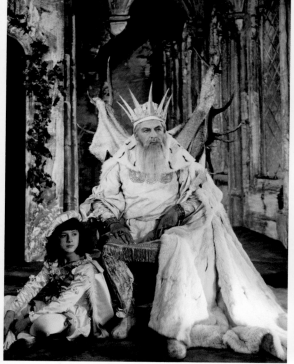

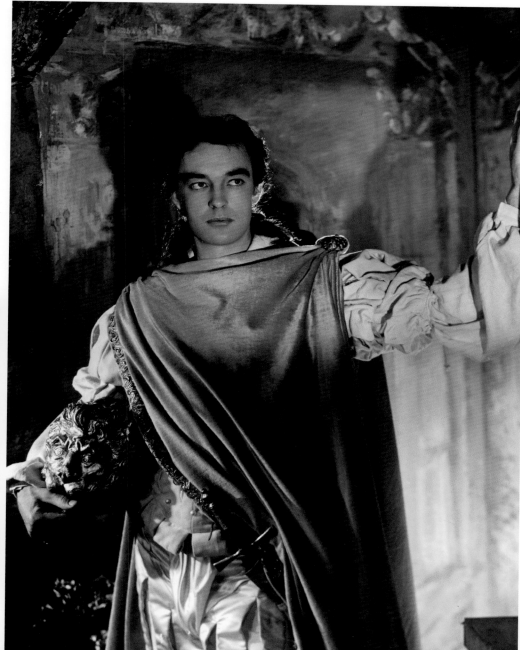

III.1, Cymbeline and page (Michael Saunders)

III.5, Posthumus (Richard Johnson)

III.6, Imogen

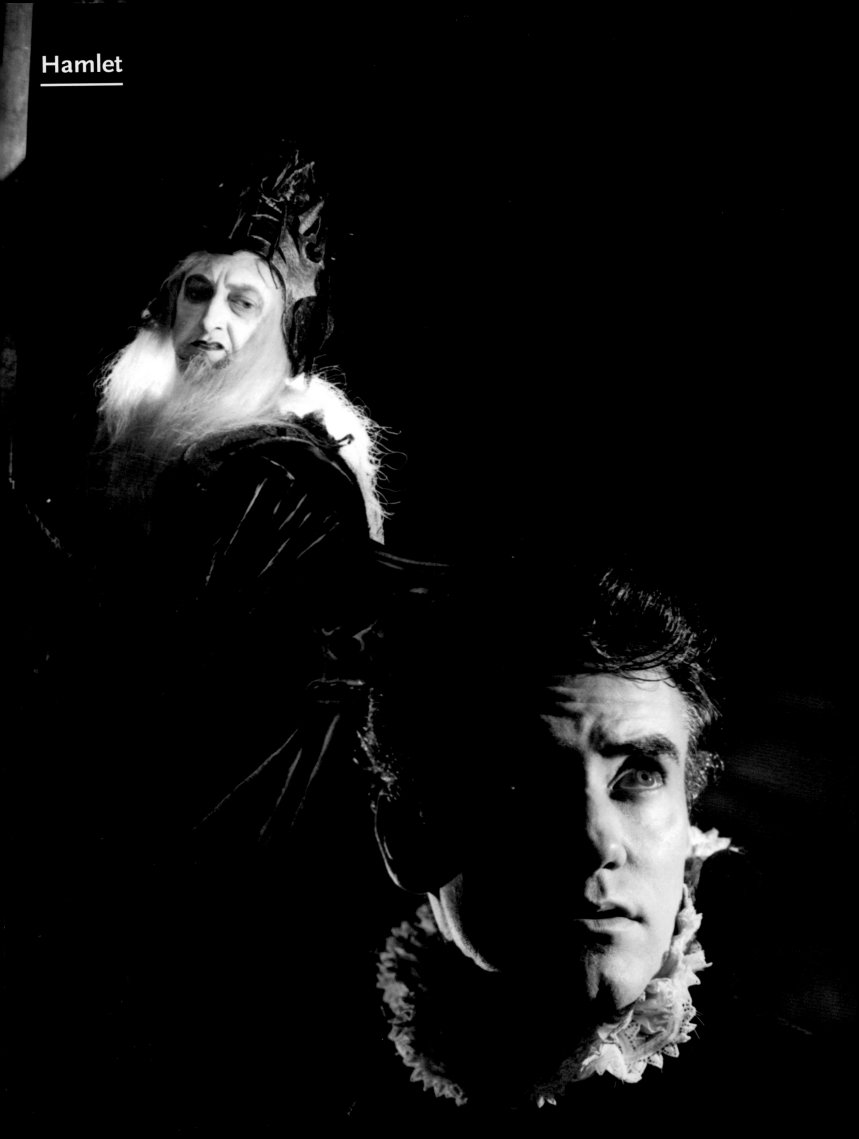

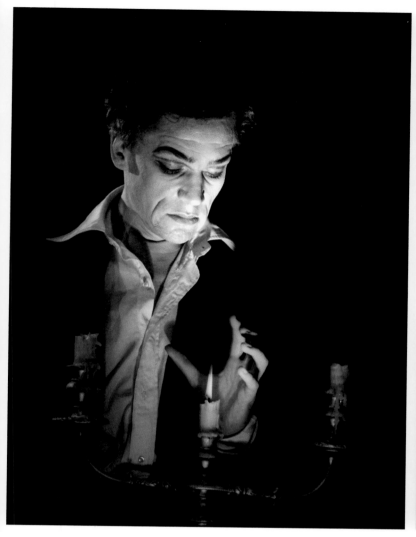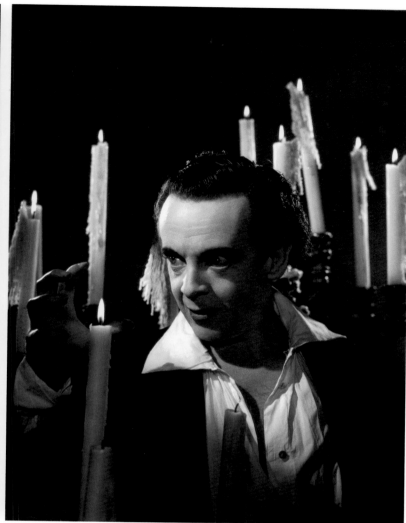

1948, III.1, Hamlet (Paul Scofield)
III.1, Hamlet (Robert Helpmann)
III.2, The court just before
'The Mousetrap'

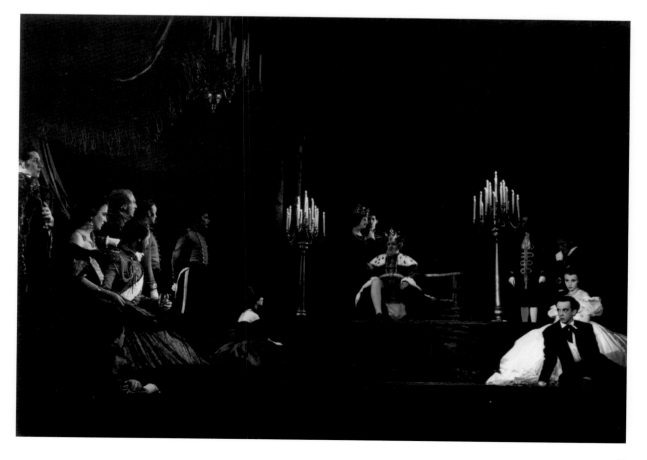

1961, I.5, Ghost (Gordon Gostelow)
and Hamlet (Ian Bannen)

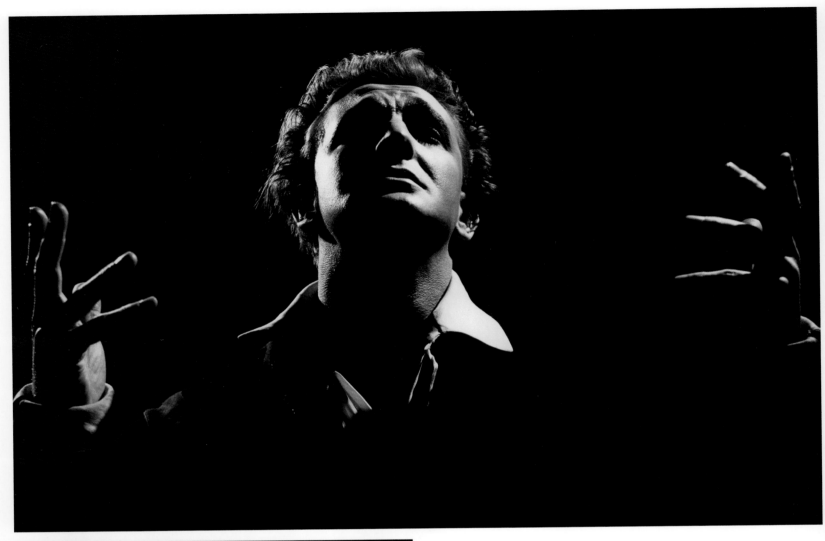

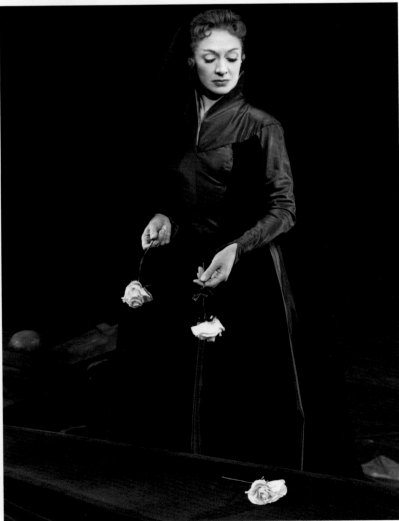

1956, III.1, Hamlet (Alan Badel)

v.1, Gertrude (Diana Churchill)

v.2, Claudius (Harry Andrews) and Hamlet

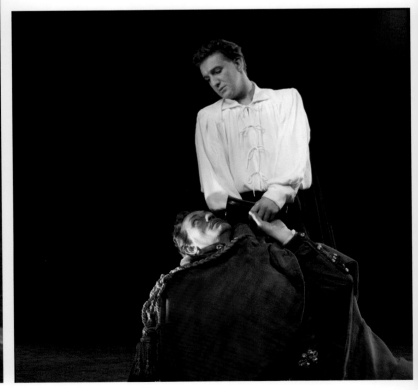

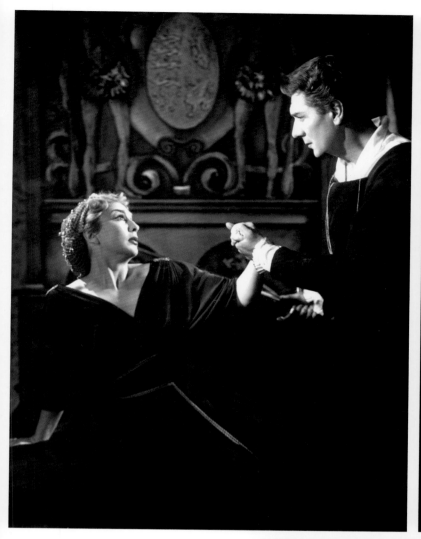

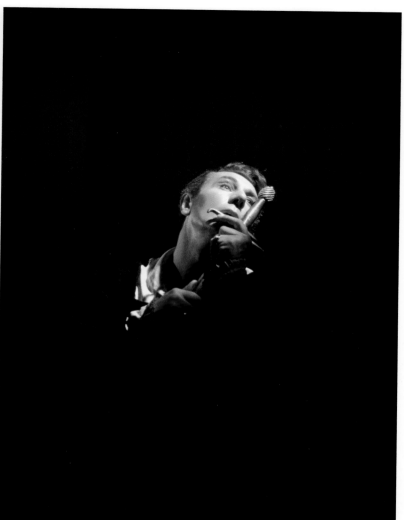

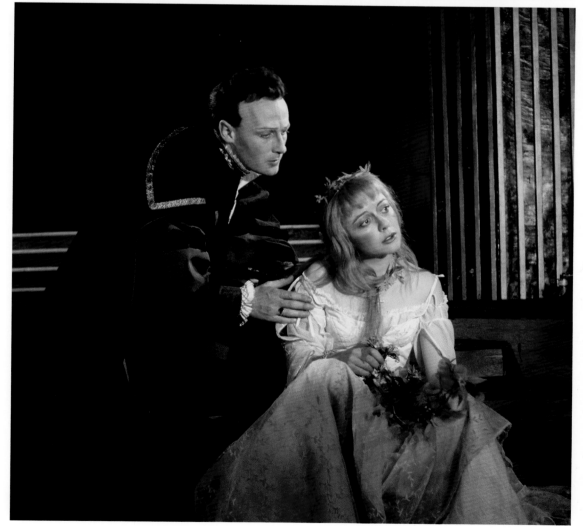

1958, III.4, Gertrude (Googie Withers)
and Hamlet (Michael Redgrave)

IV.4, Hamlet

IV.5, Laertes (Edward Woodward) and
Ophelia (Dorothy Tutin)

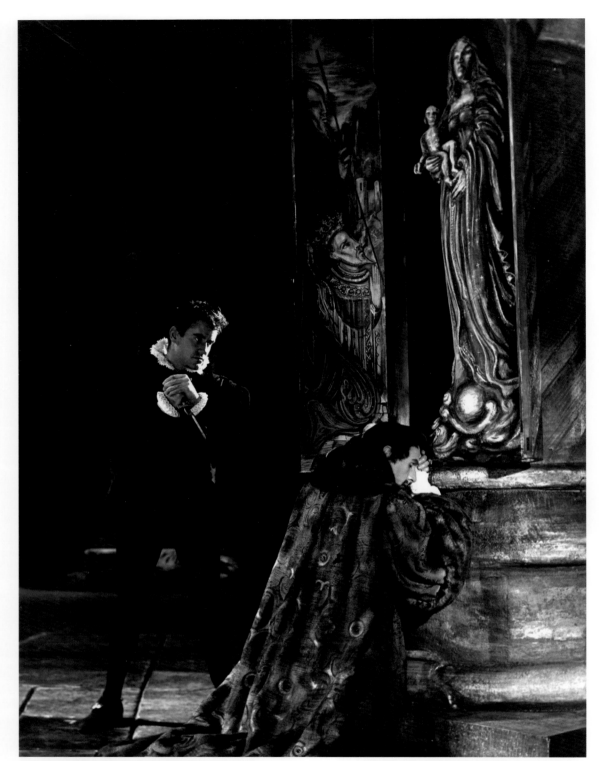

1961, III.3, Hamlet (Ian Bannen) and
Claudius (Noel Willman)

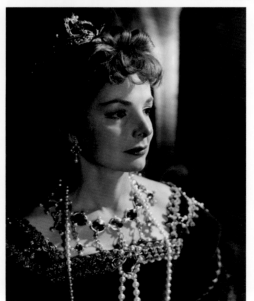

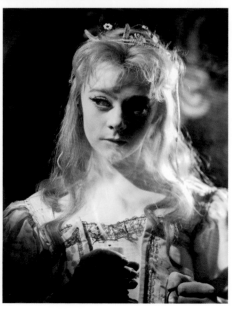

IV.1, Gertrude (Elizabeth Sellars)

IV.5, Ophelia (Geraldine McEwan)

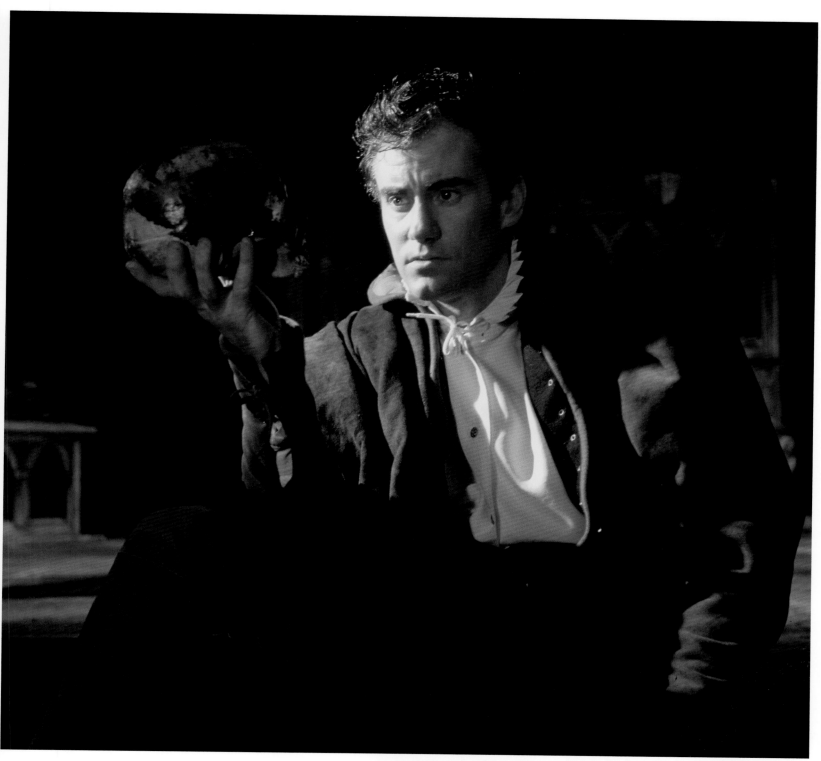

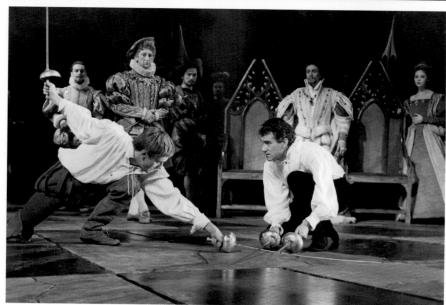

v.1, Hamlet and 'poor Yorick'

v.2, Laertes (Peter McEnery) and Hamlet

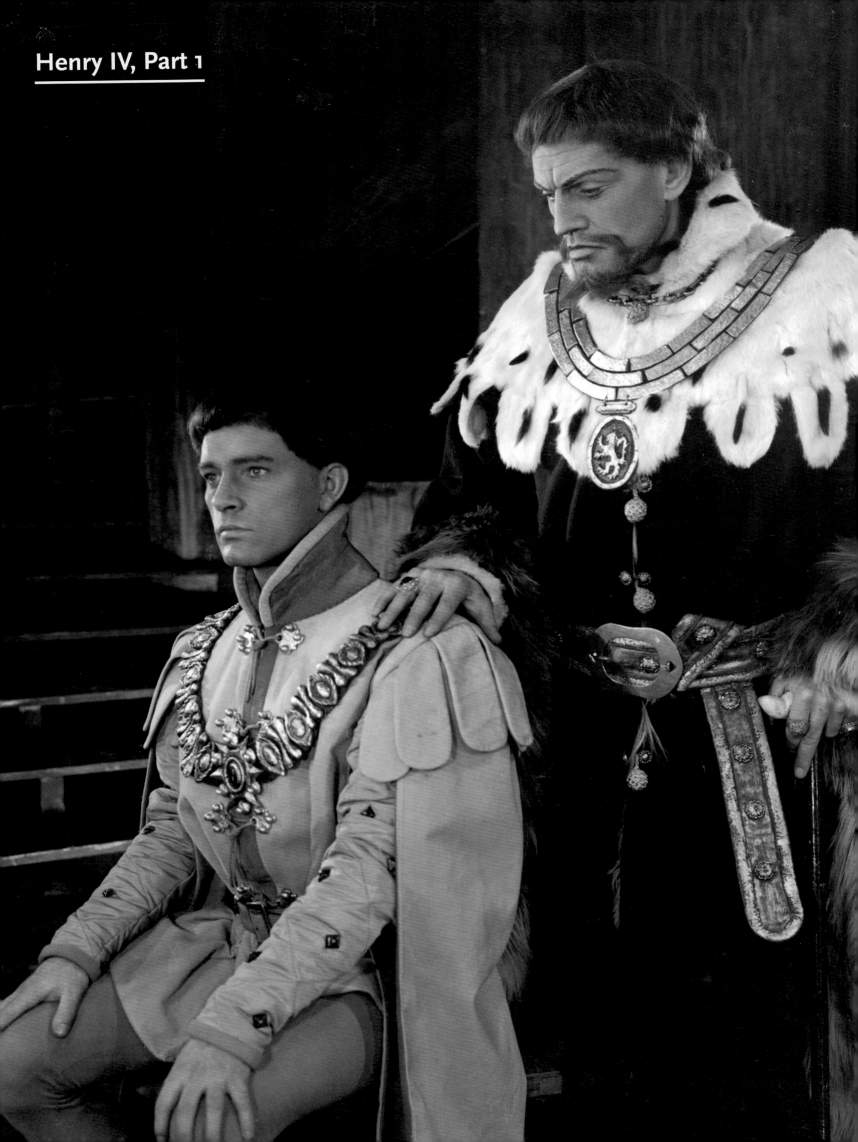

Henry IV, Part 1

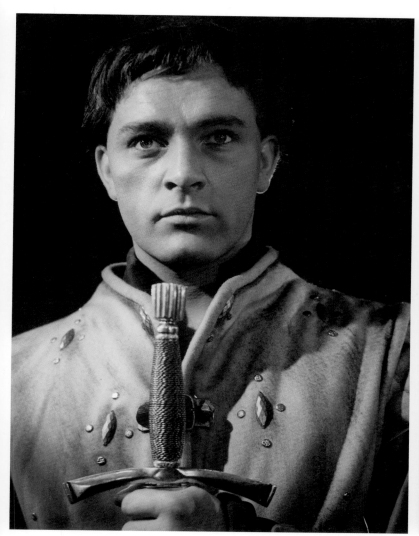

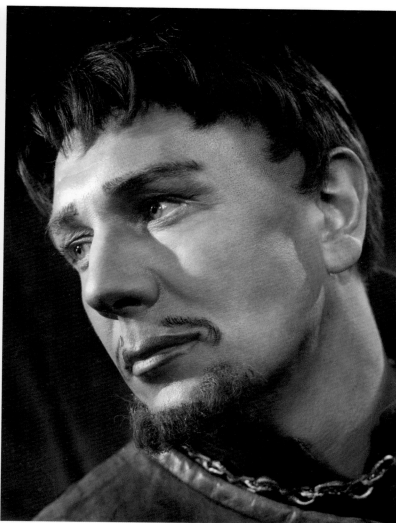

1951, I.2, Prince Hal
(Richard Burton)

II.3, Hotspur (Michael Redgrave)

III.3, In the Boar's Head

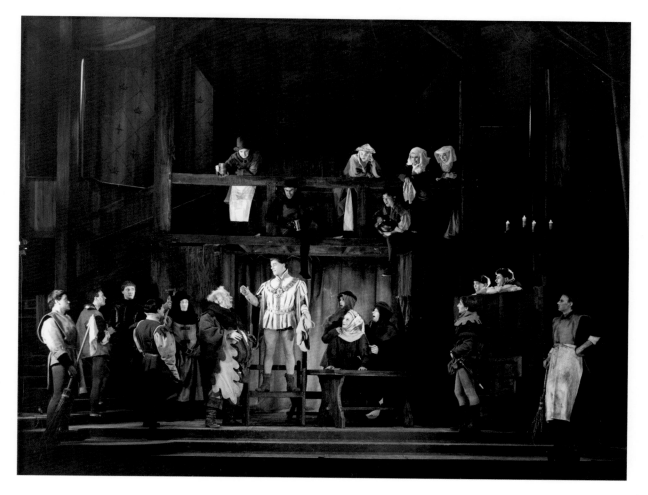

<
III.2, Prince Hal and Henry IV
(Harry Andrews)

FOLLOWING PAGE

V.4, Falstaff (Anthony Quayle)
with Hotspur's body

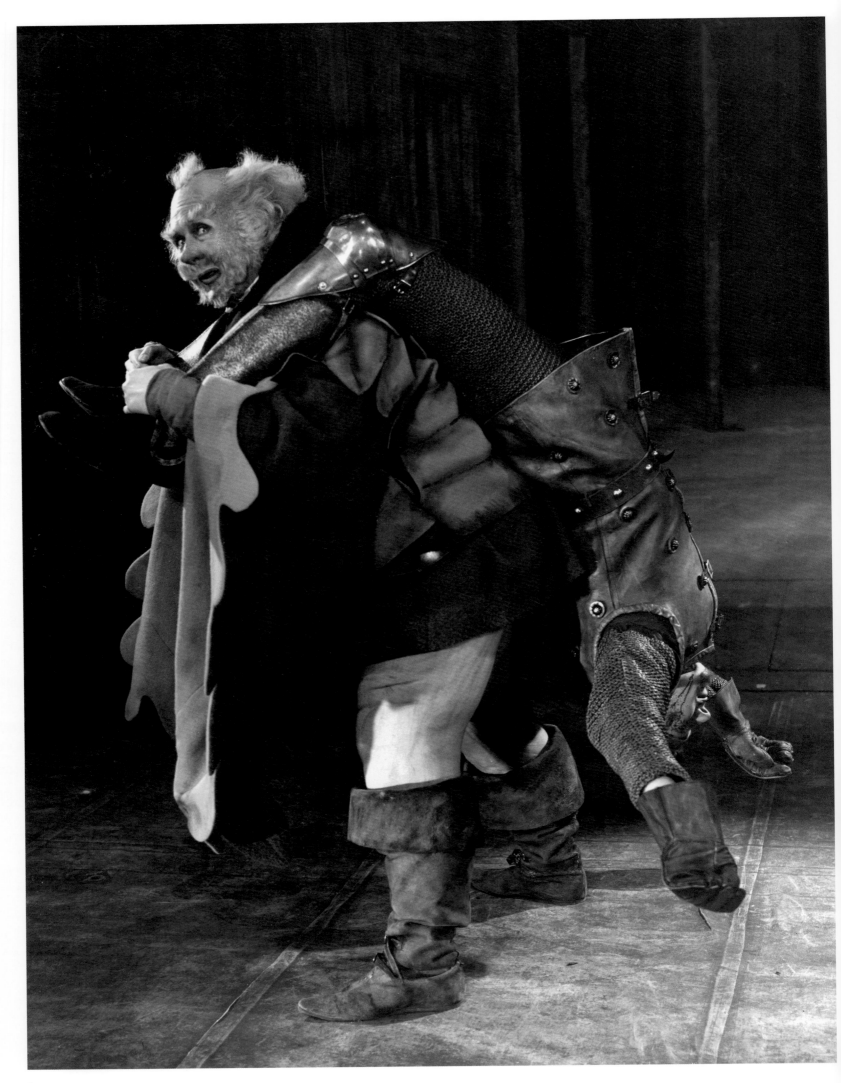

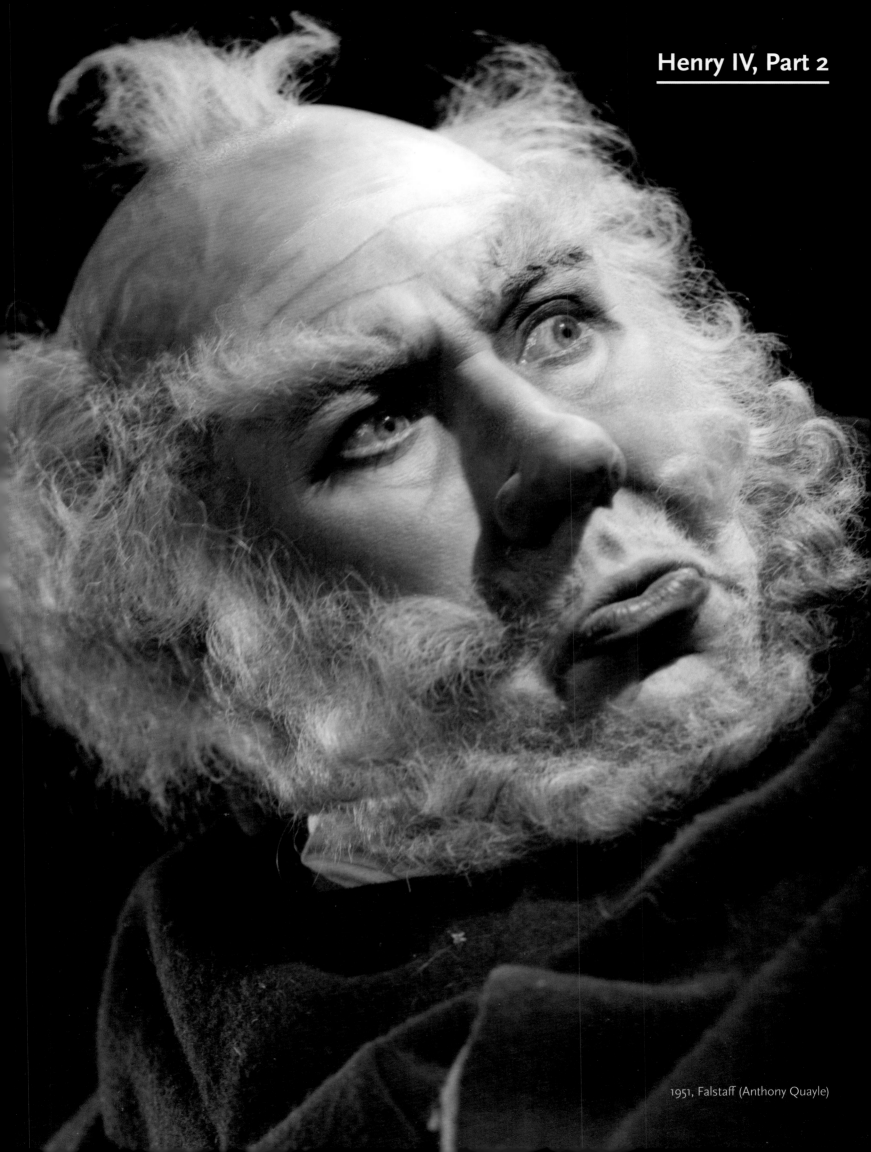

1951, Falstaff (Anthony Quayle)

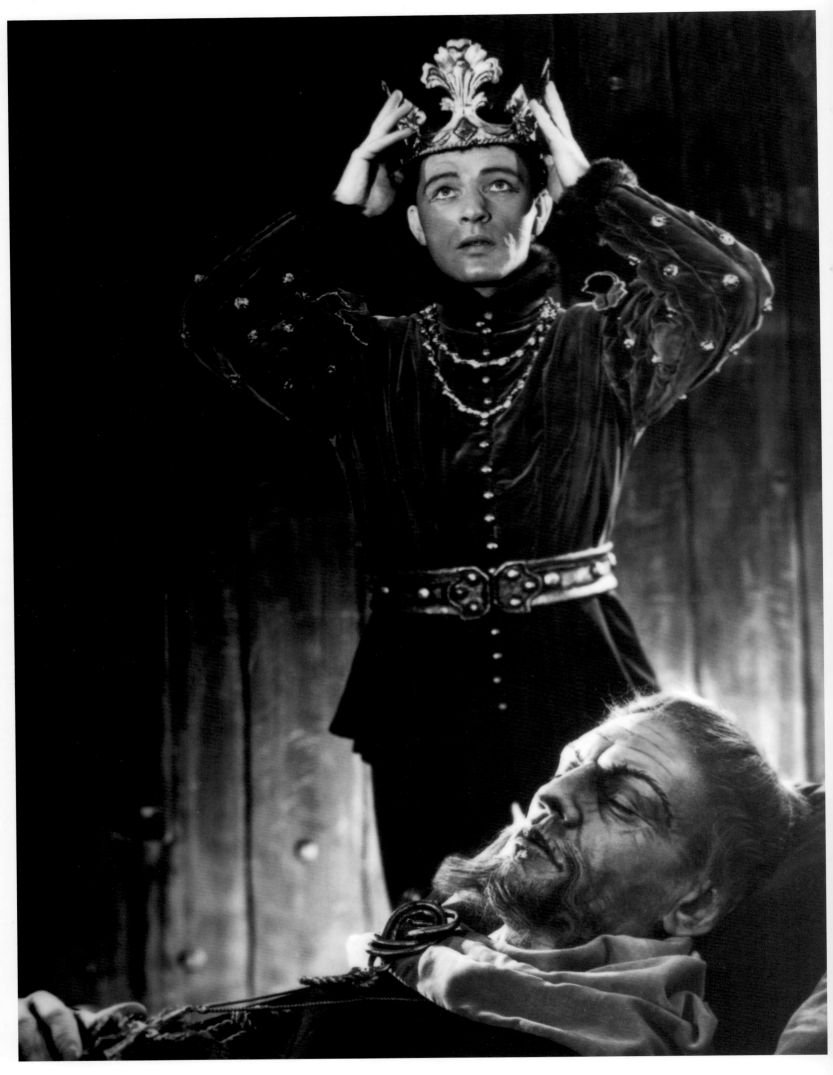

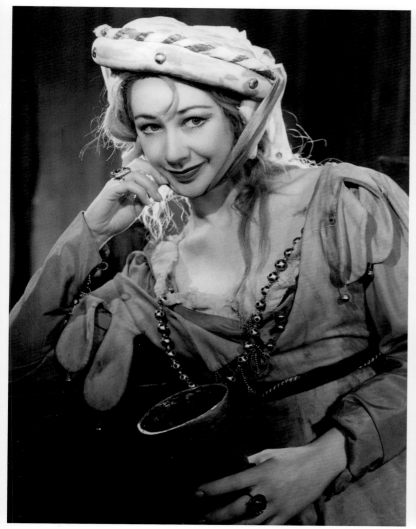

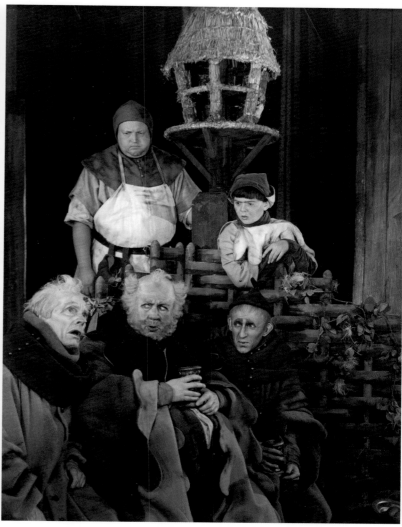

1951, II.4, Doll Tearsheet
(Heather Stannard)

III.2, Silence (William Squire),
Falstaff and Shallow (Alan Badel)
with Davy (Alexander Gauge) and
Robin the boy (Robert Sandford)

v.4, At Henry V's coronation

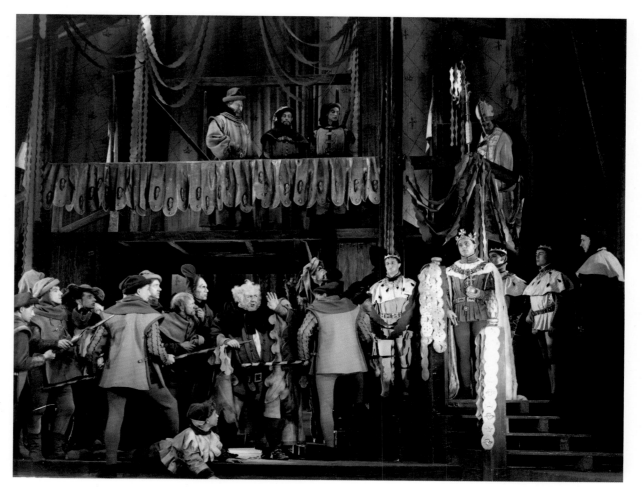

<

IV.5, Prince Hal (Richard Burton)
and Henry IV (Harry Andrews)

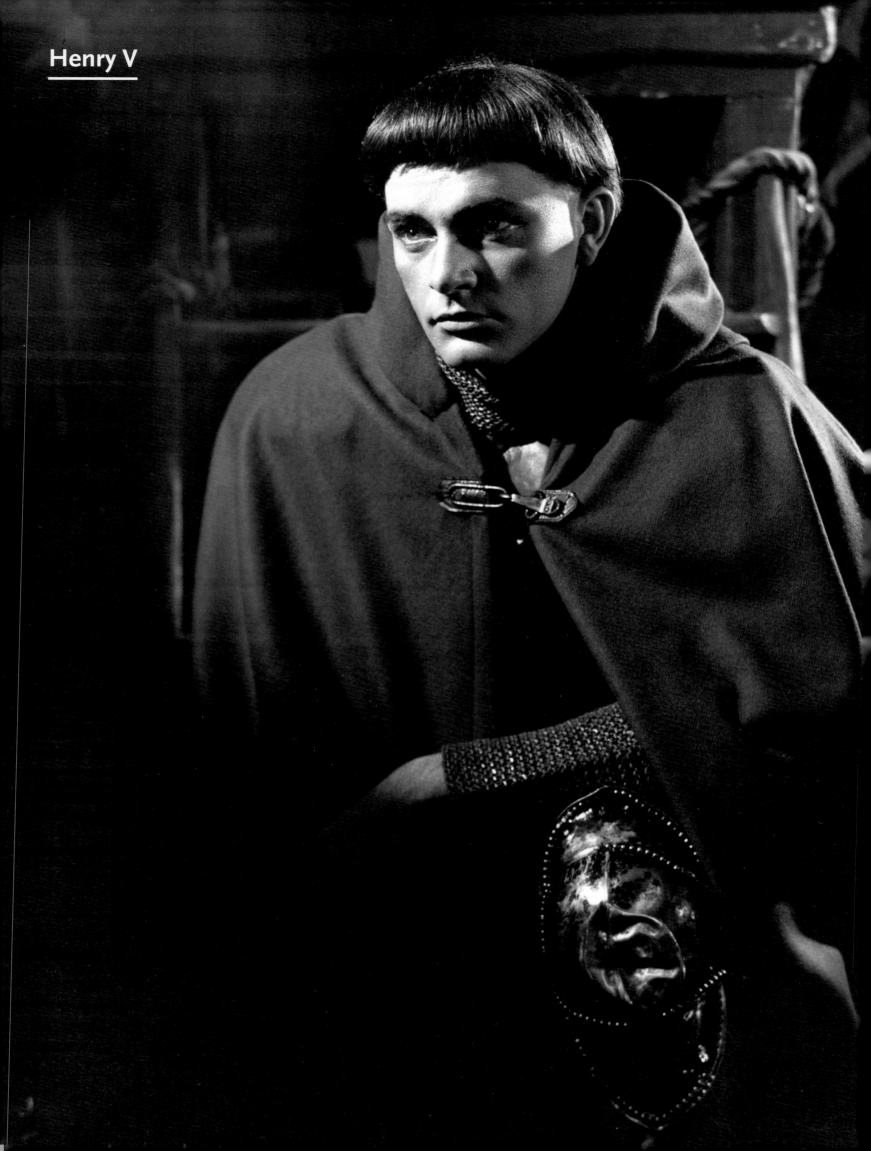

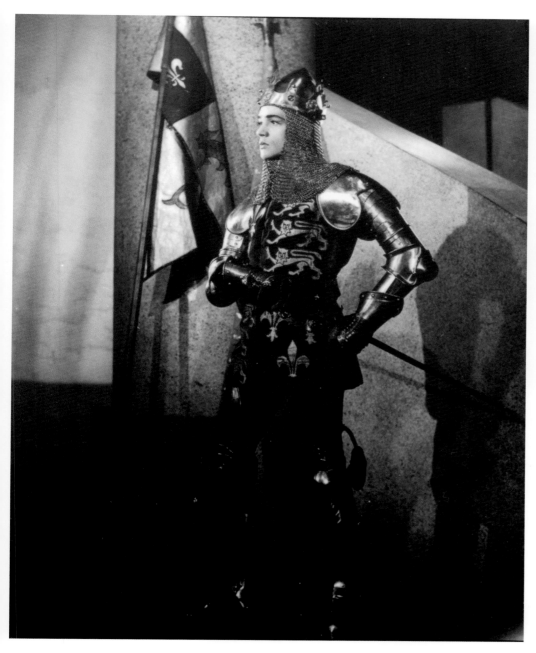

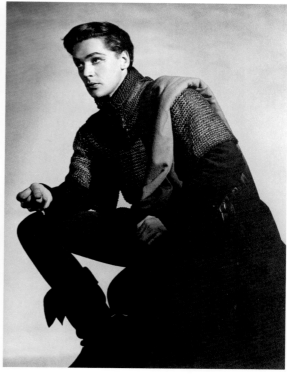

1946, III.1, King Henry (Paul Scofield)

IV.1 King Henry

1951, I.2, King Henry (Richard Burton)

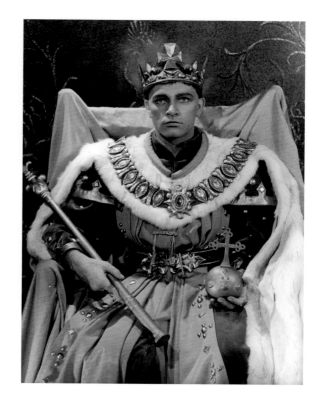

<

1951, IV.1, King Henry (Richard Burton)

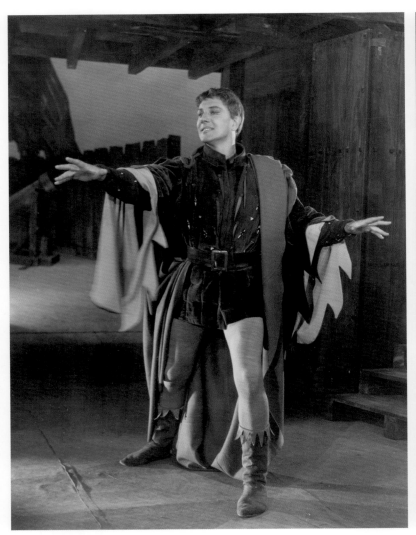

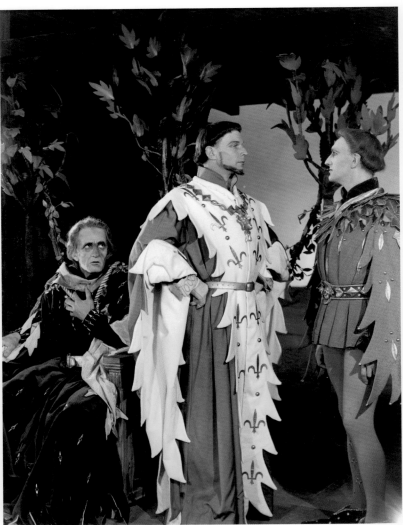

1951, II.3, Chorus (Michael Redgrave)

II.4, The King of France (Michael Gwynn), the Constable (William Fox) and the Dauphin (Alan Badel)

Scene change before IV.8

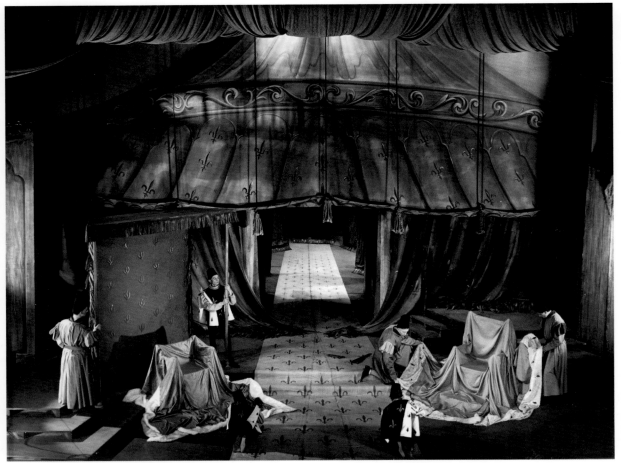

> V.2, Princess Katherine (Hazel Penwarden) and King Henry

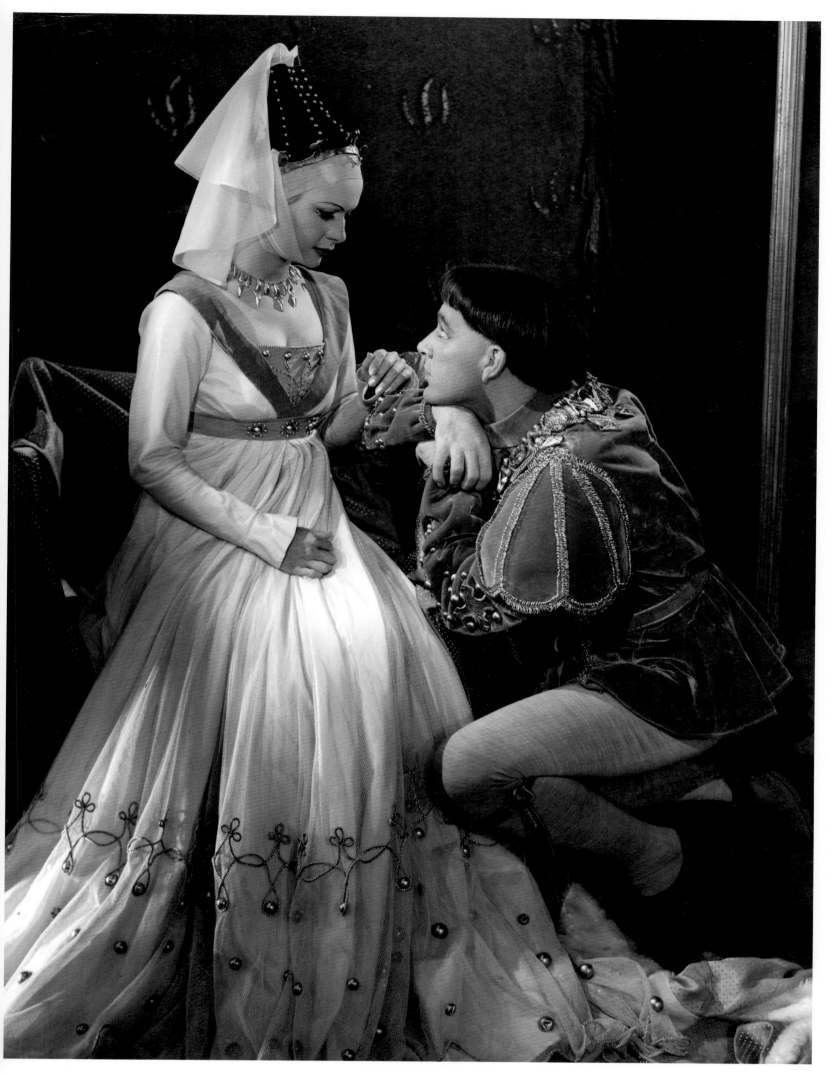

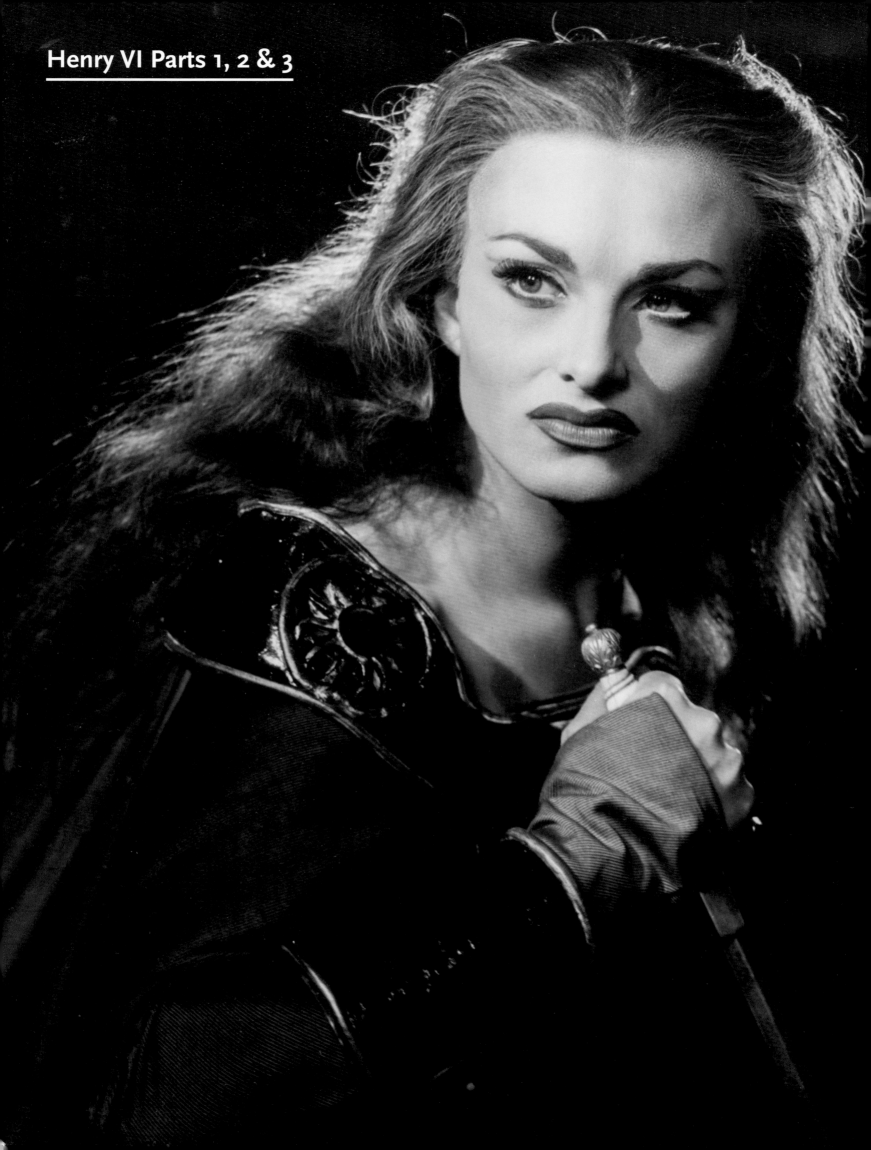

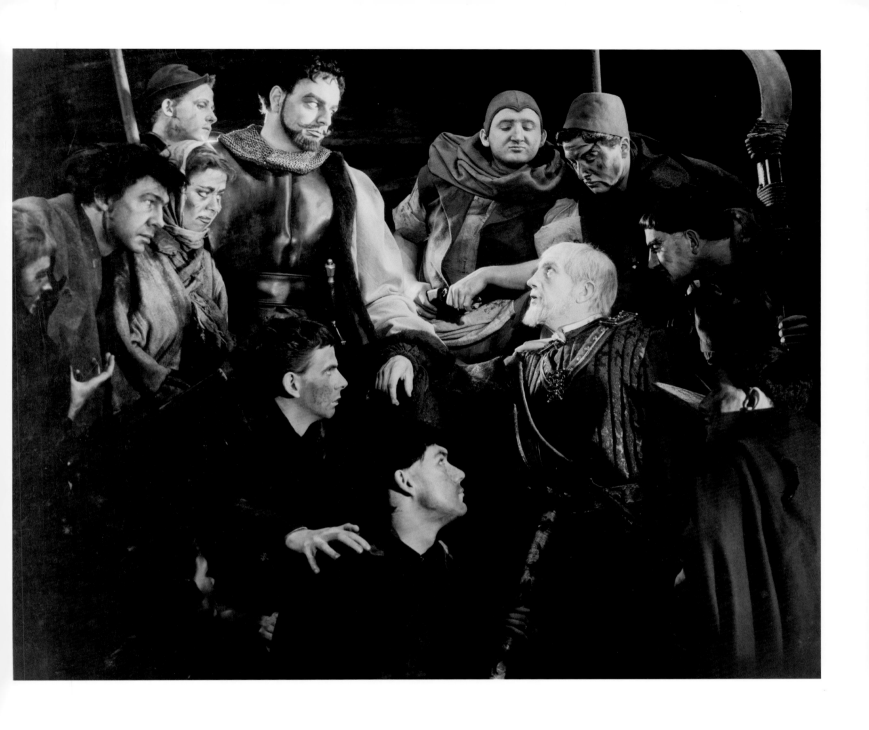

1957 (Old Vic)

Part 2, IV.7, Jack Cade (Derek Francis) and the rebels
with Lord Say (Charles West)

<

Part 3, I.4, Queen Margaret (Barbara Jefford)

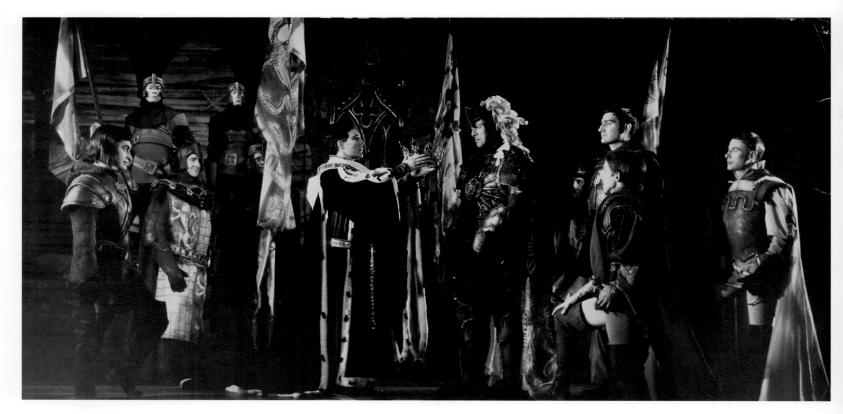

Part 3, I.1, Henry (Paul Daneman) names York
(John Arnatt) his heir

Part 3, I.4, Queen Margaret and her troops kill York

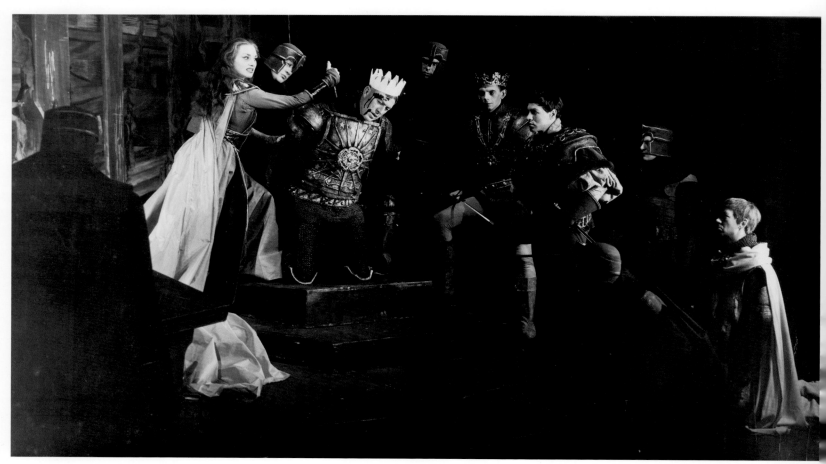

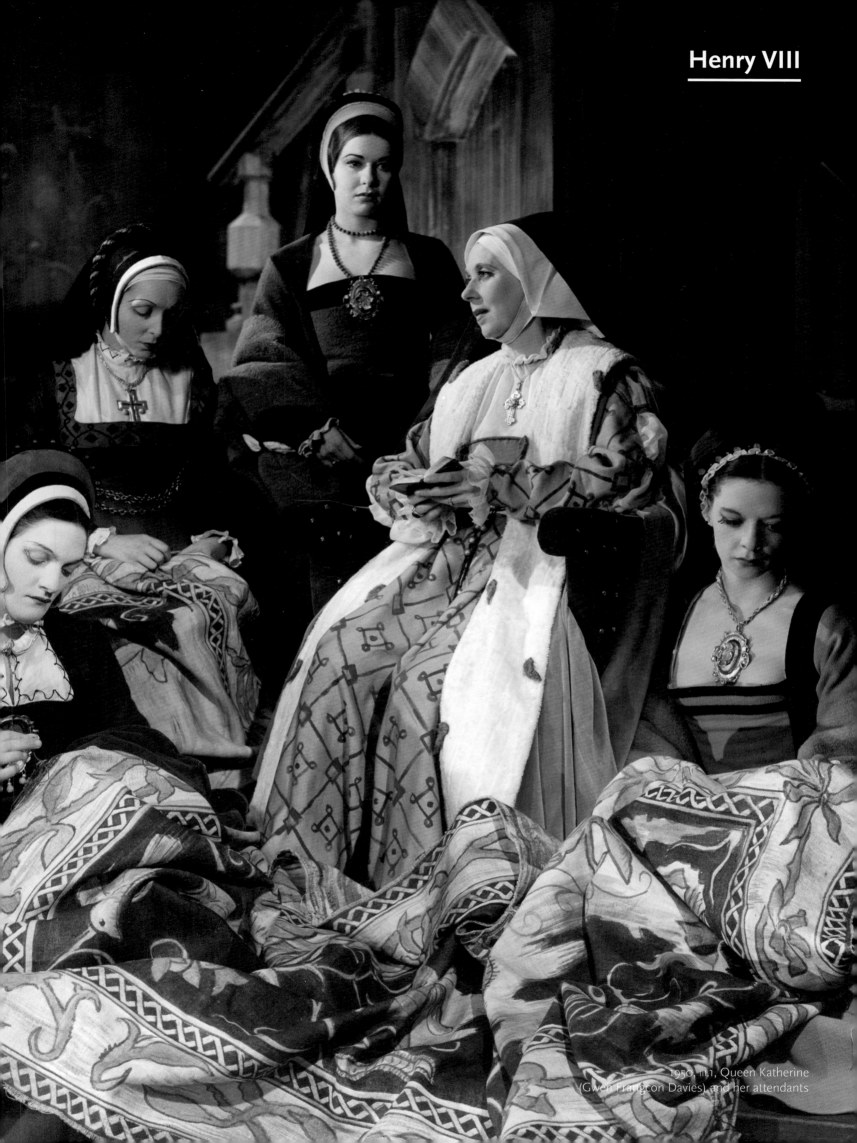

1950, III.1, Queen Katherine
(Gwen Ffrangcon Davies) and her attendants

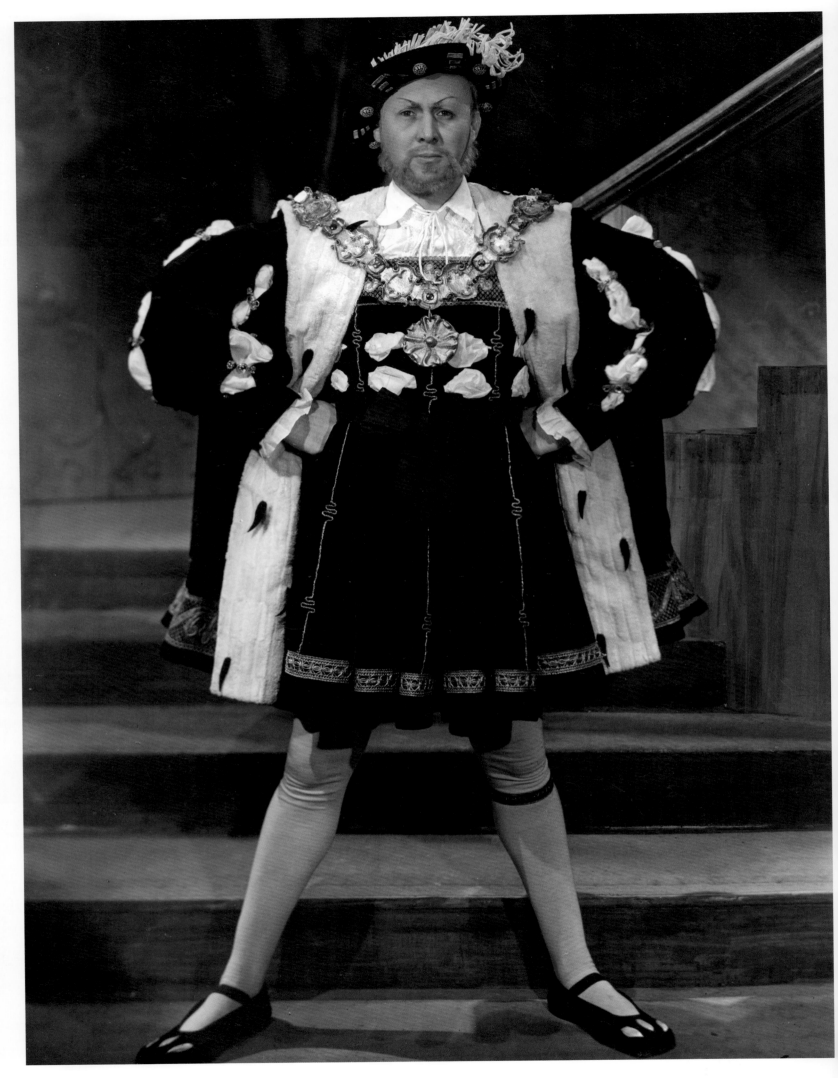

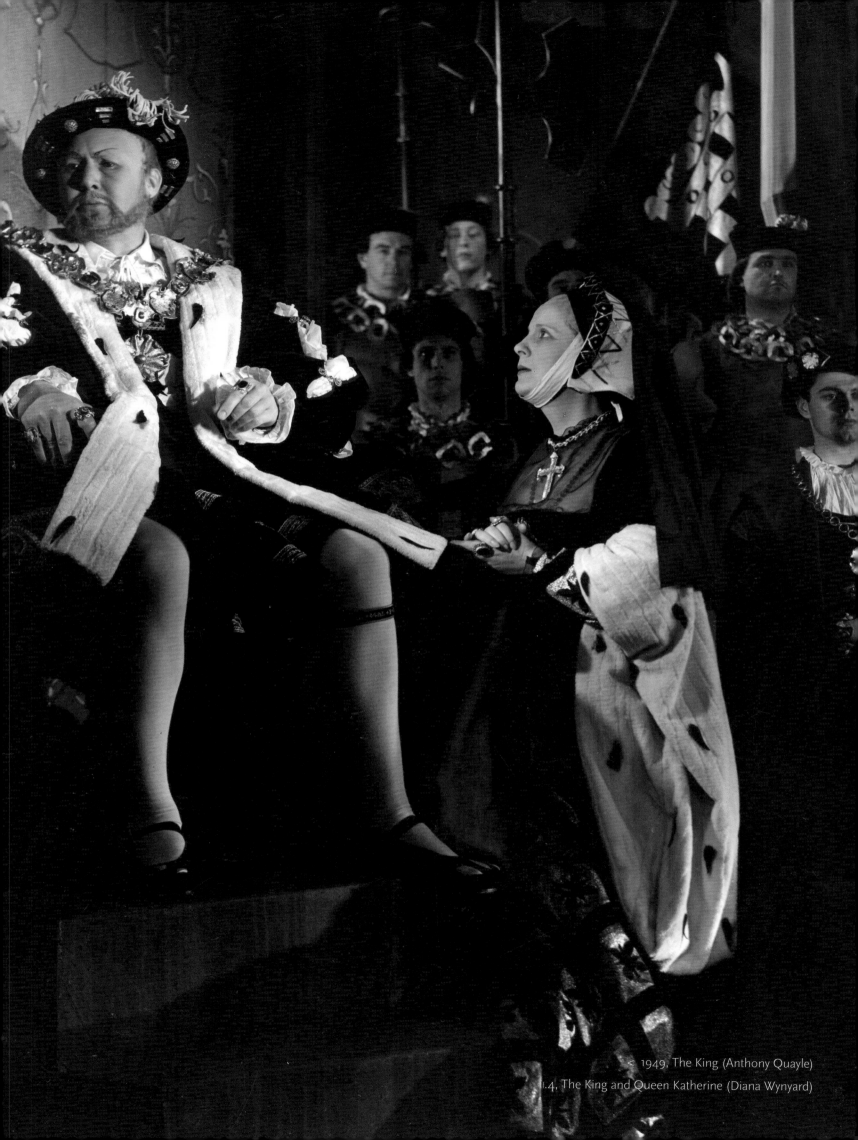

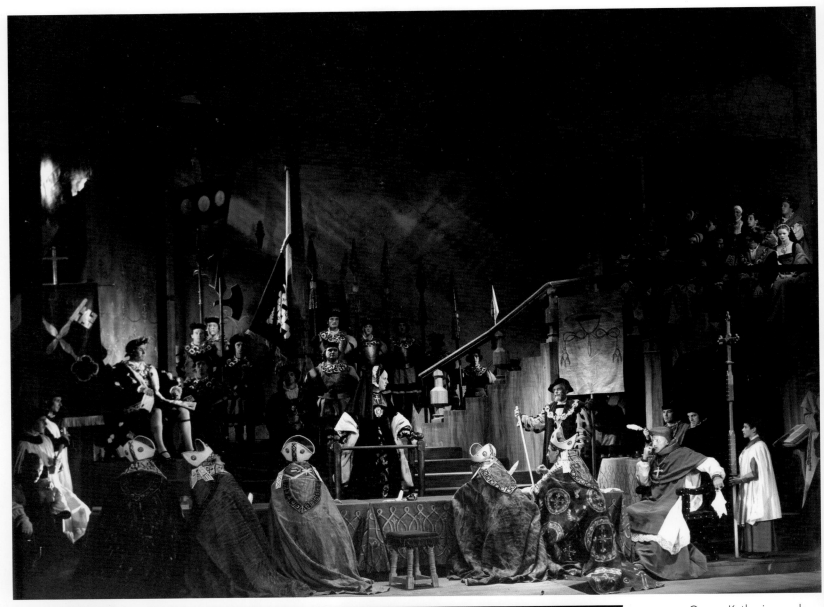

1949, II.4, Queen Katherine under examination

v.4, The christening of Princess Elizabeth

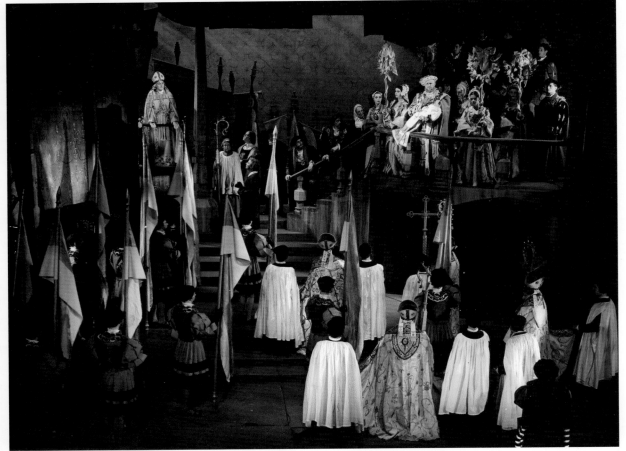

>

1950, Anne Bullen as Queen (Barbara Jefford)

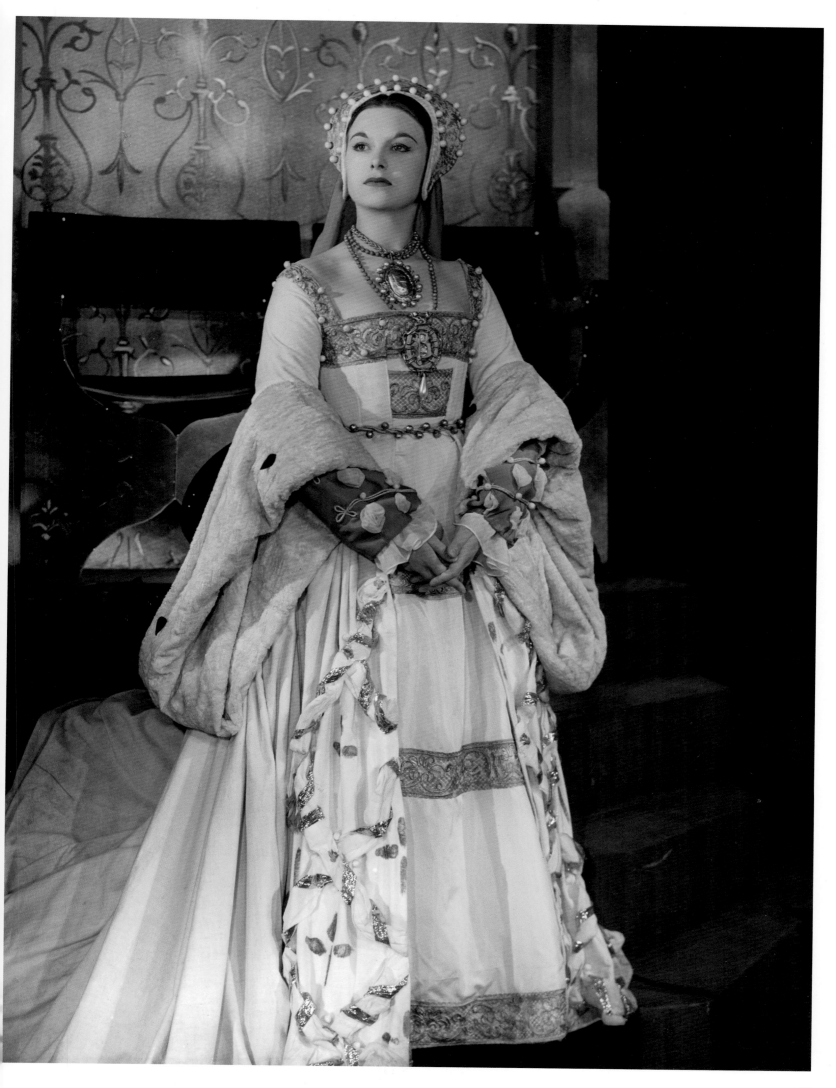

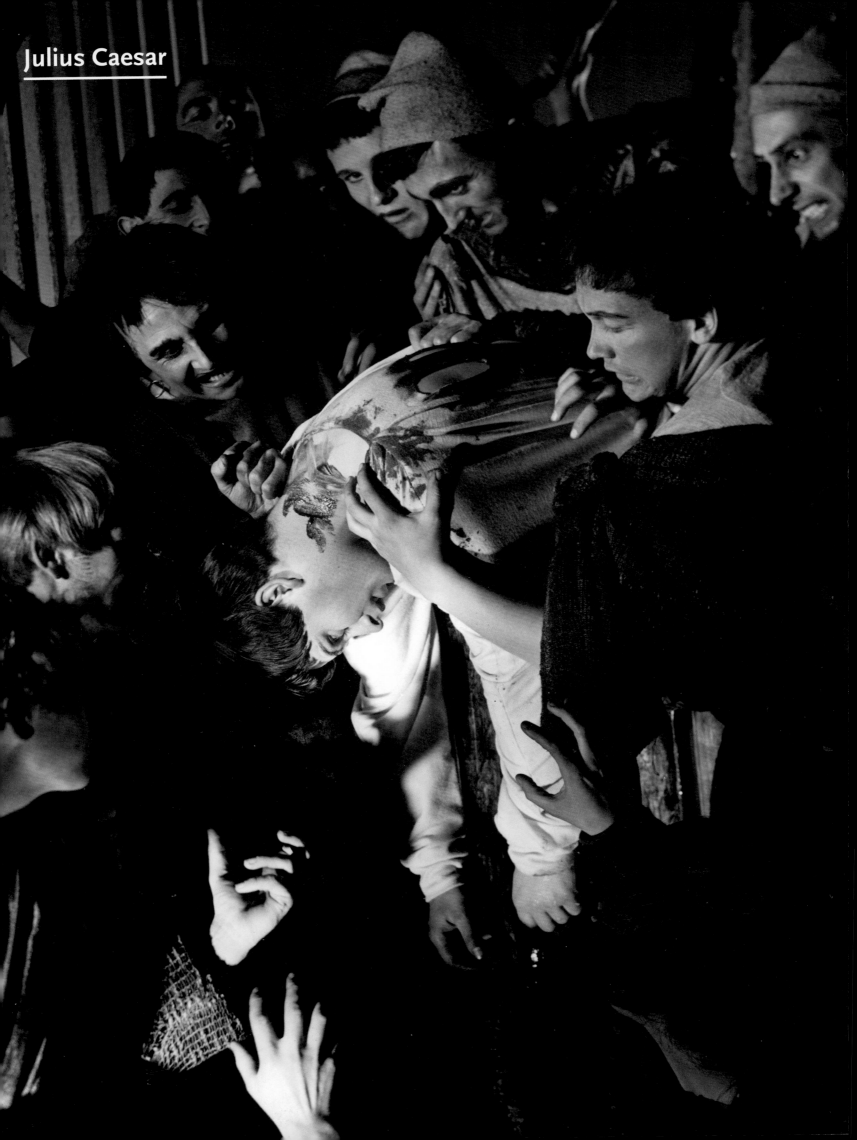

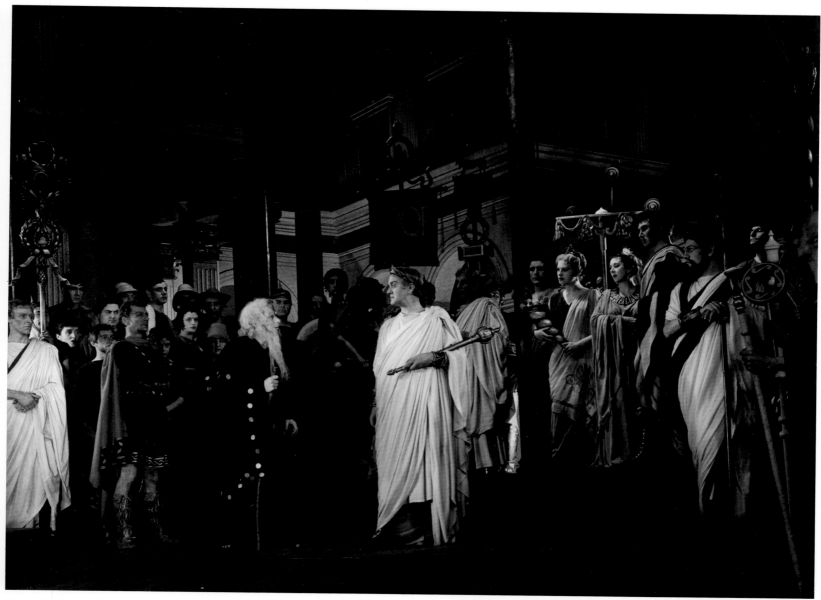

1950, I.2, The soothsayer (Timothey Bateson) warns
Caesar (Andrew Cruickshank)

III.1, The conspirators surround Caesar

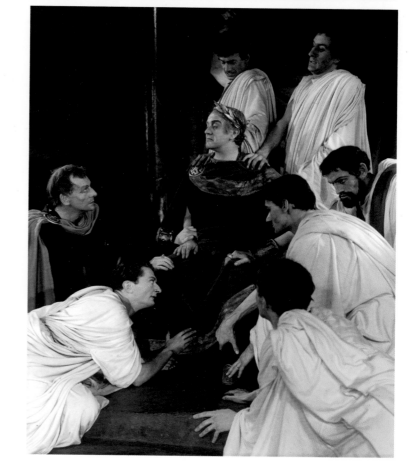

<

1957, III.3, The death of Cinna the Poet
(James Wellman)

FOLLOWING SPREAD

1950, IV.1, Mark Antony (Anthony Quayle)

IV.1, Brutus (Harry Andrews)

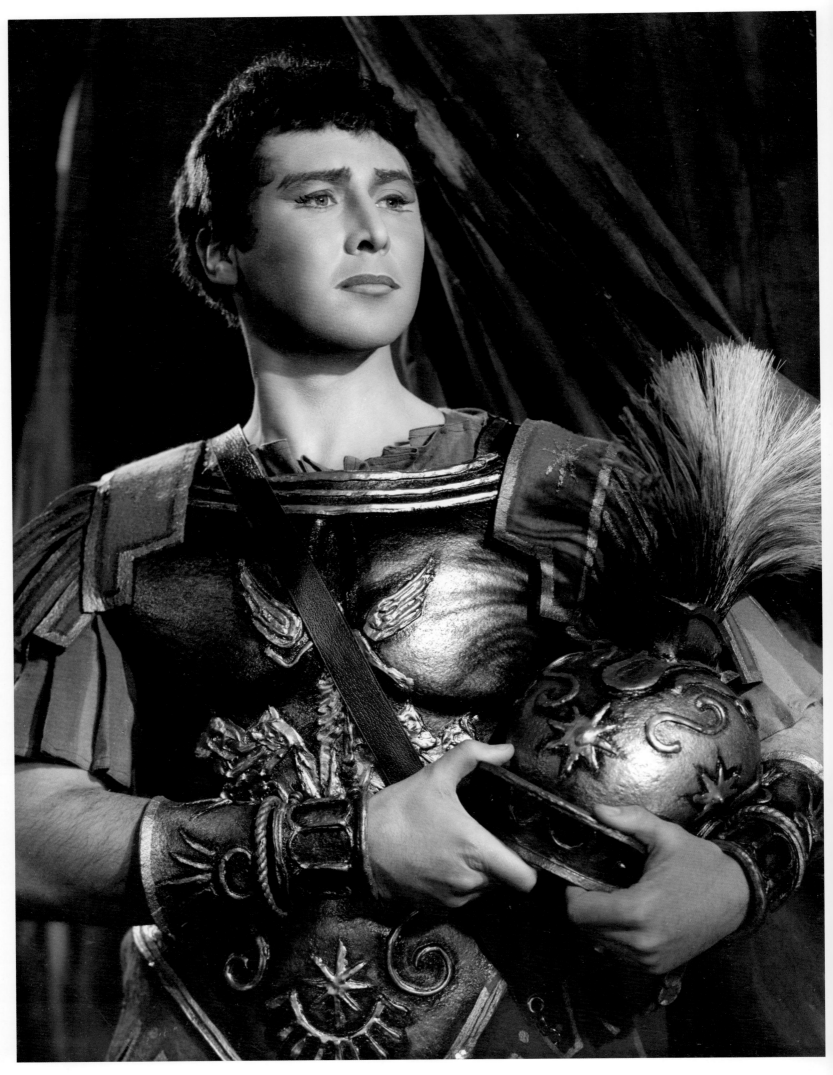

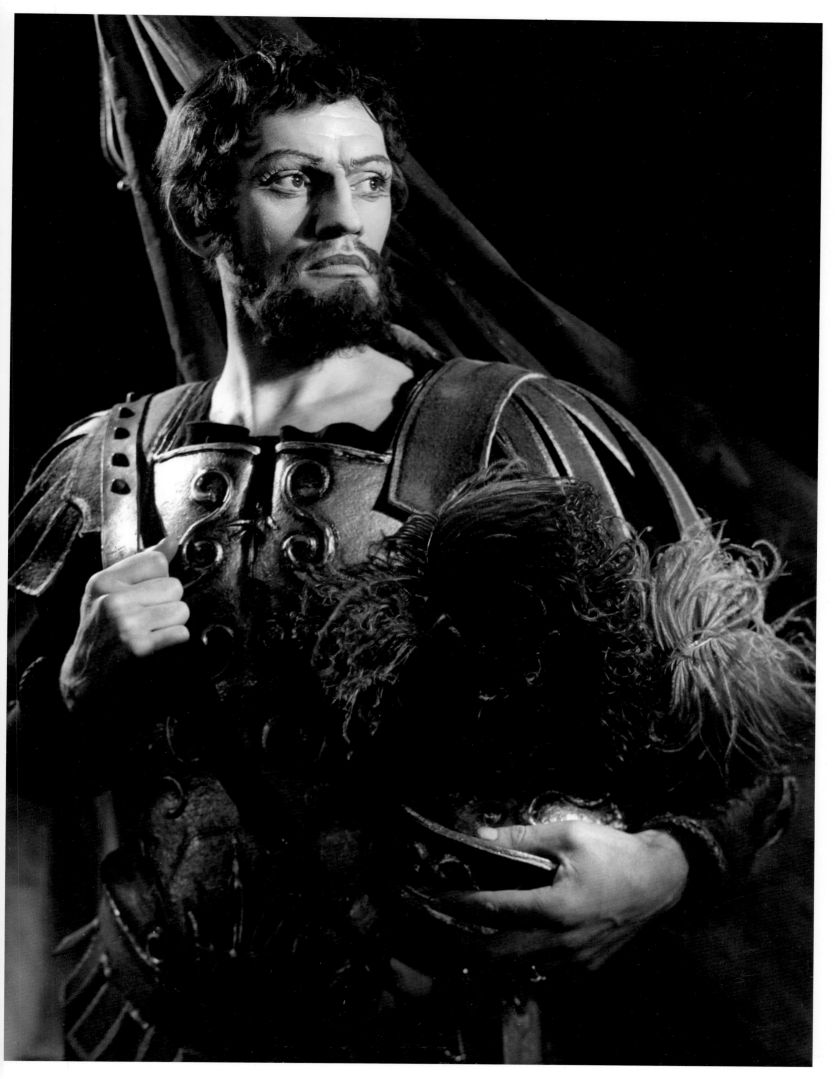

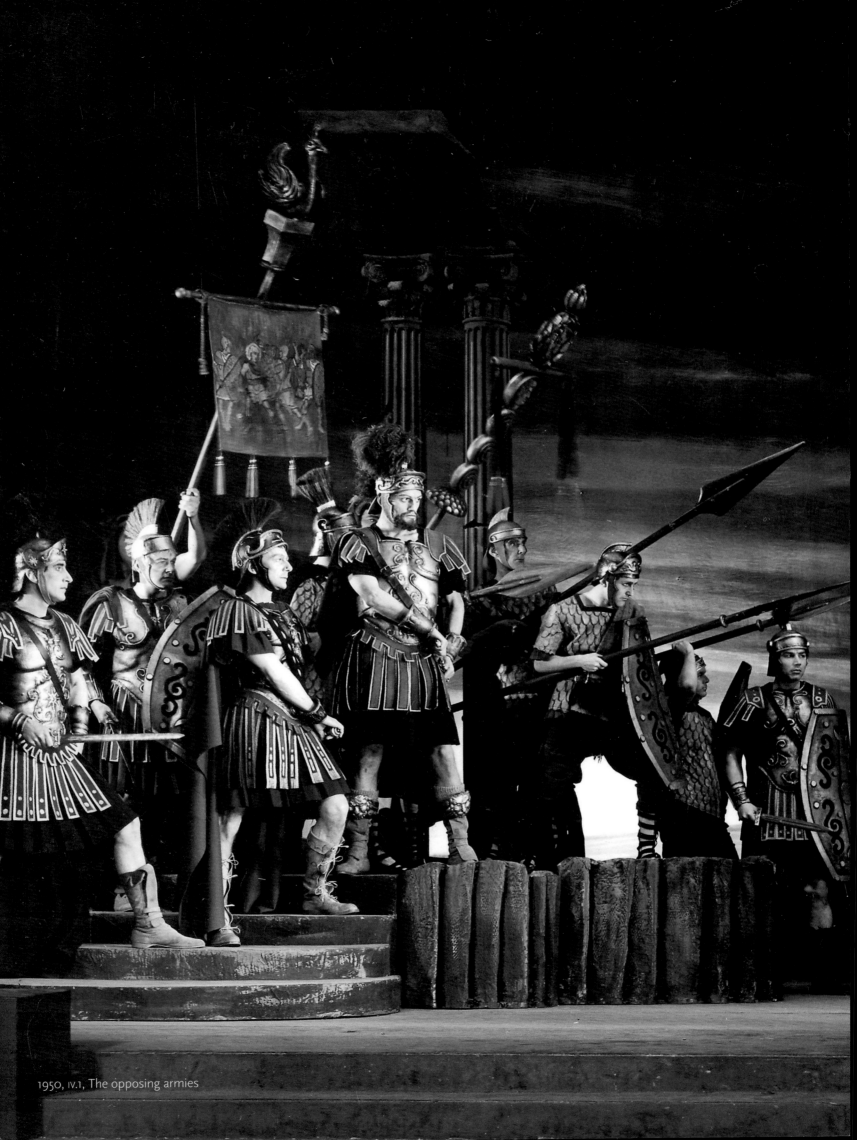

1950, IV.1, The opposing armies

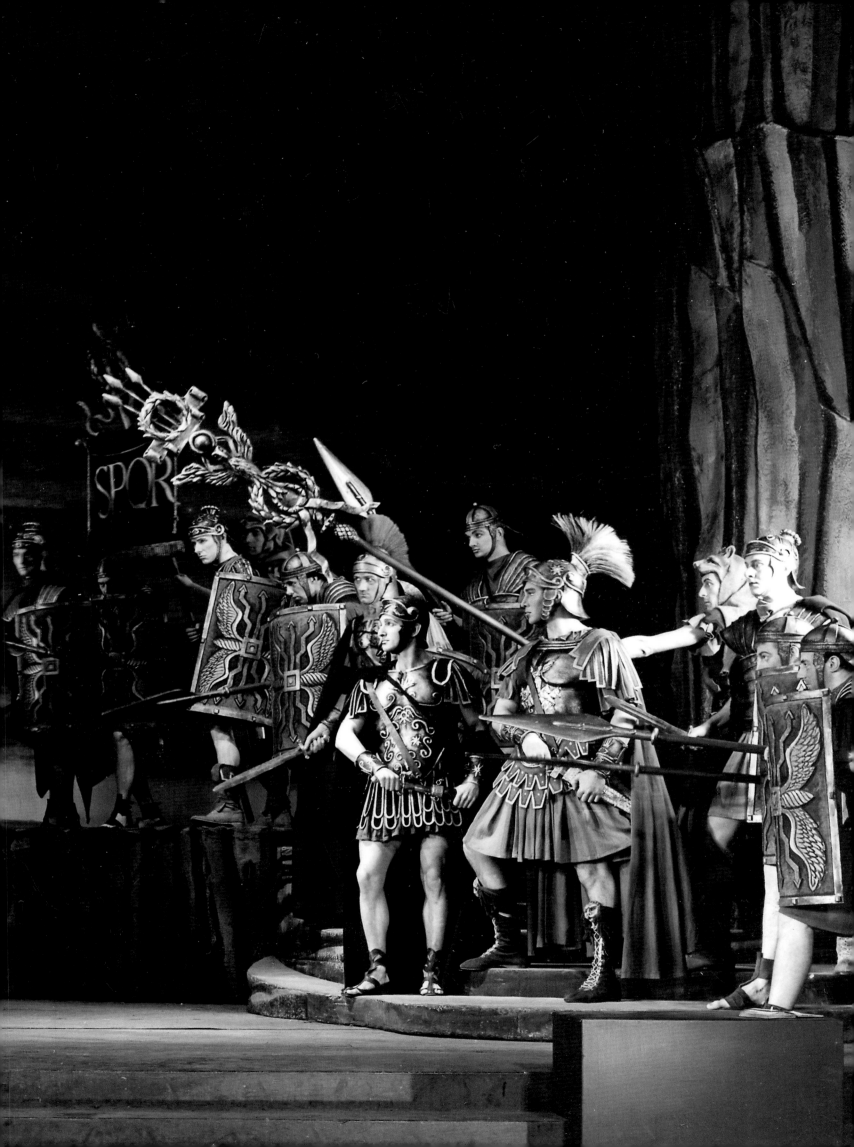

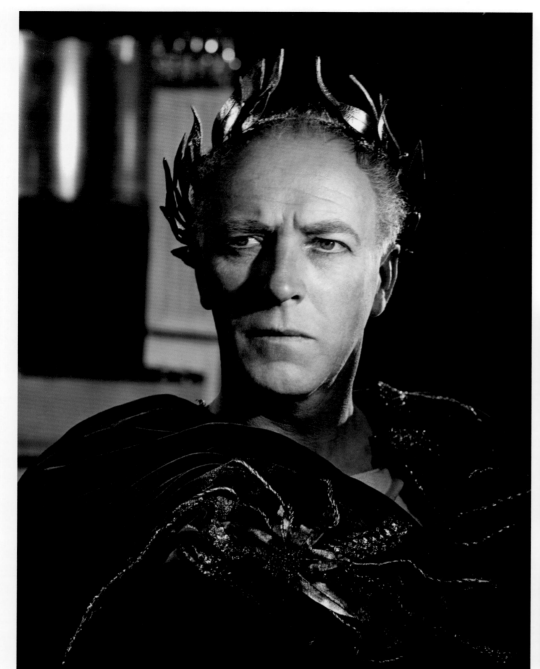

1957, III.1, Caesar (Cyril Luckham)

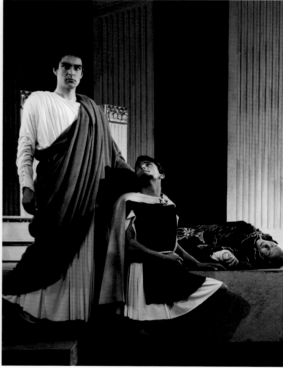

III.1, Mark Antony (Richard Johnson), his servant (Derek Mayhew) and Caesar's body

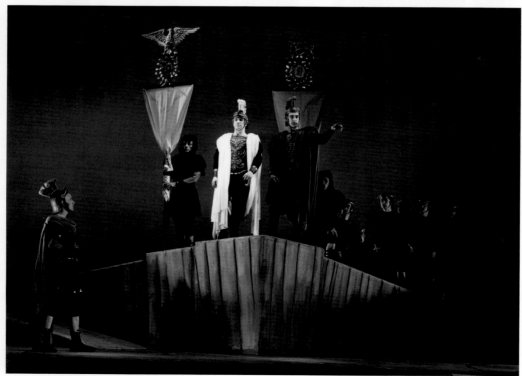

V.5, Octavius (Clive Revill) and Mark Antony with their army

>

IV.3, Brutus (Alec Clunes) and Lucius (Barry Warren)

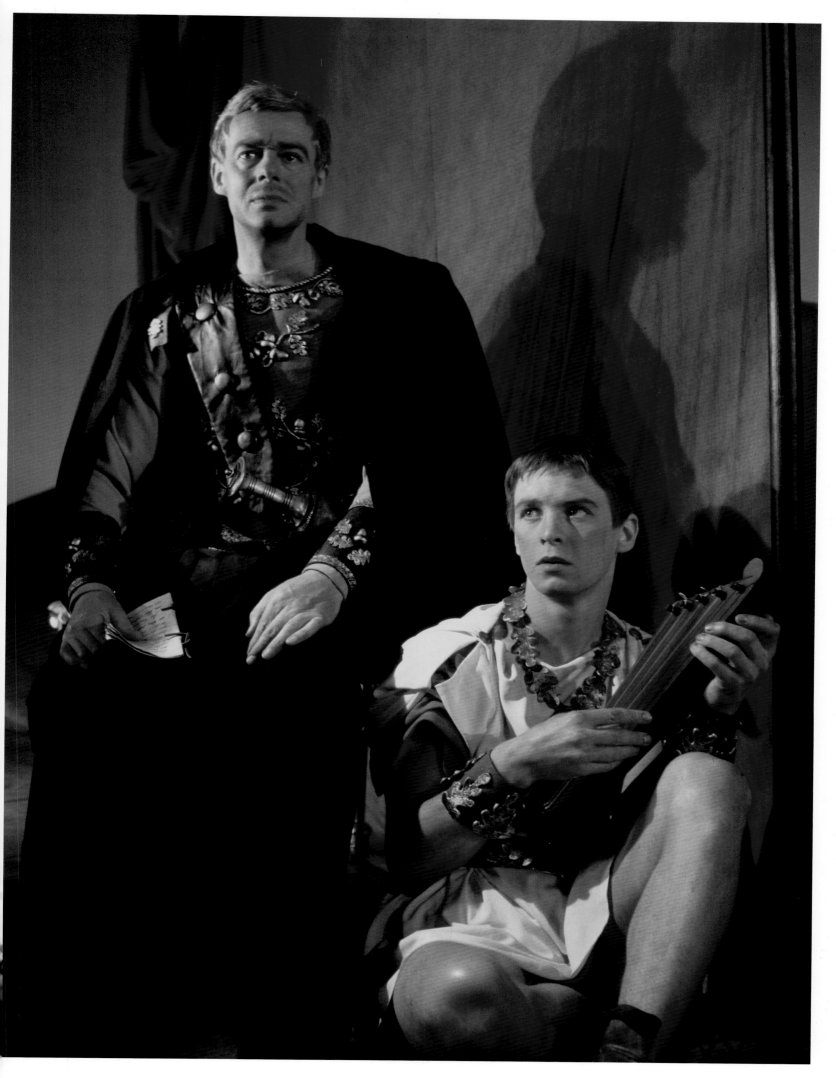

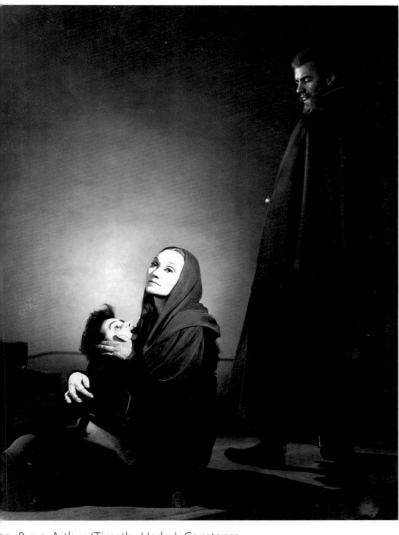

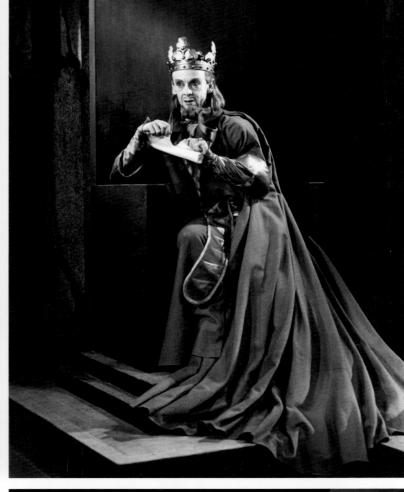

1948, III.1, Arthur (Timothy Harley), Constance (Ena Burrill) and Salisbury (Michael Gwynn)

v.2, King John (Robert Helpmann)

v.3, King John and his army

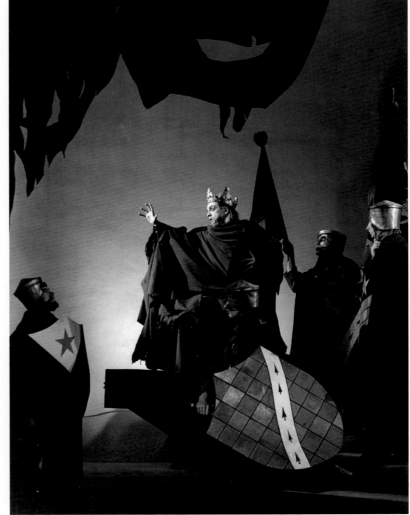

1957, IV.1, Hubert (Ron Hadrick) and Arthur (Christopher Bond)

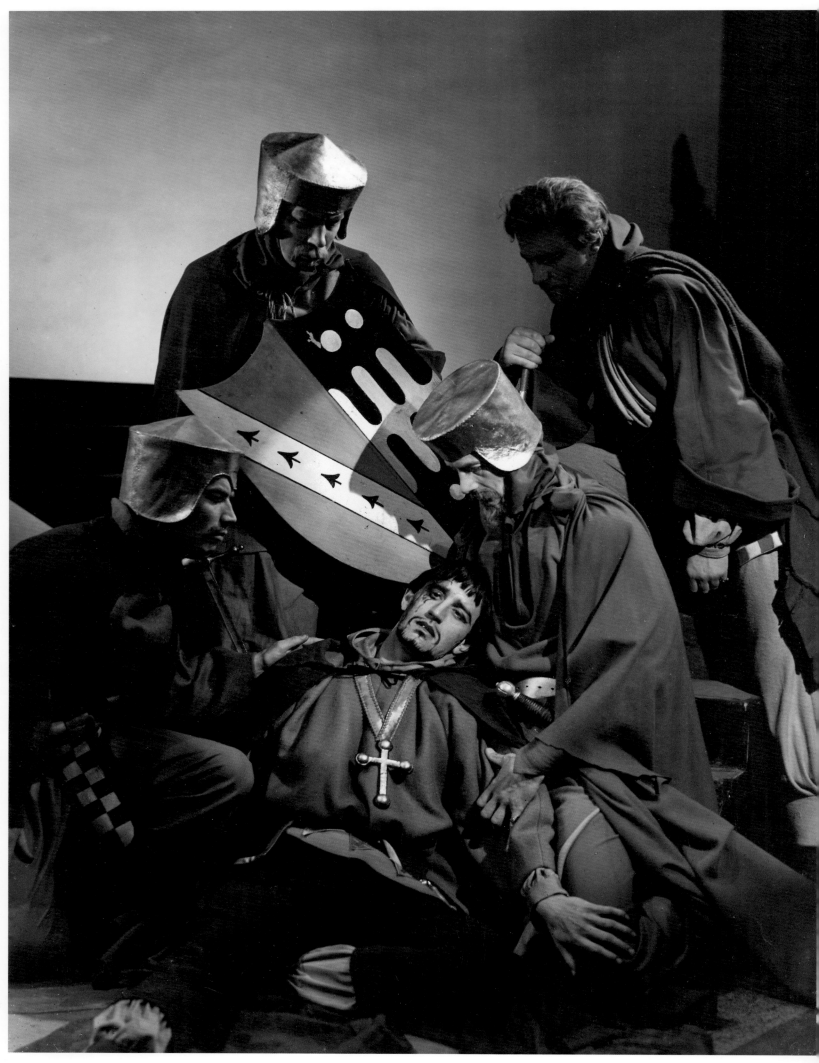

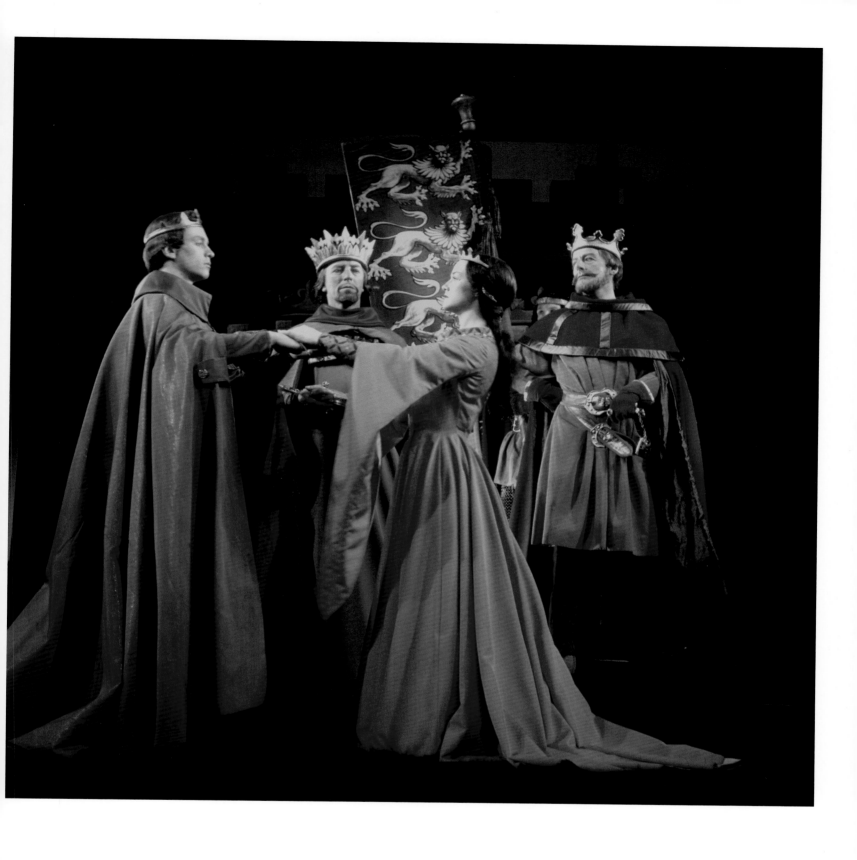

1948, v.4, Melun (Douglas Wilmer) is wounded

1957, III.1, The Dauphin (Barry Warren),
King Louis (Cyril Luckham), Blanch (Doreen Aris)
and King John (Robert Harris)

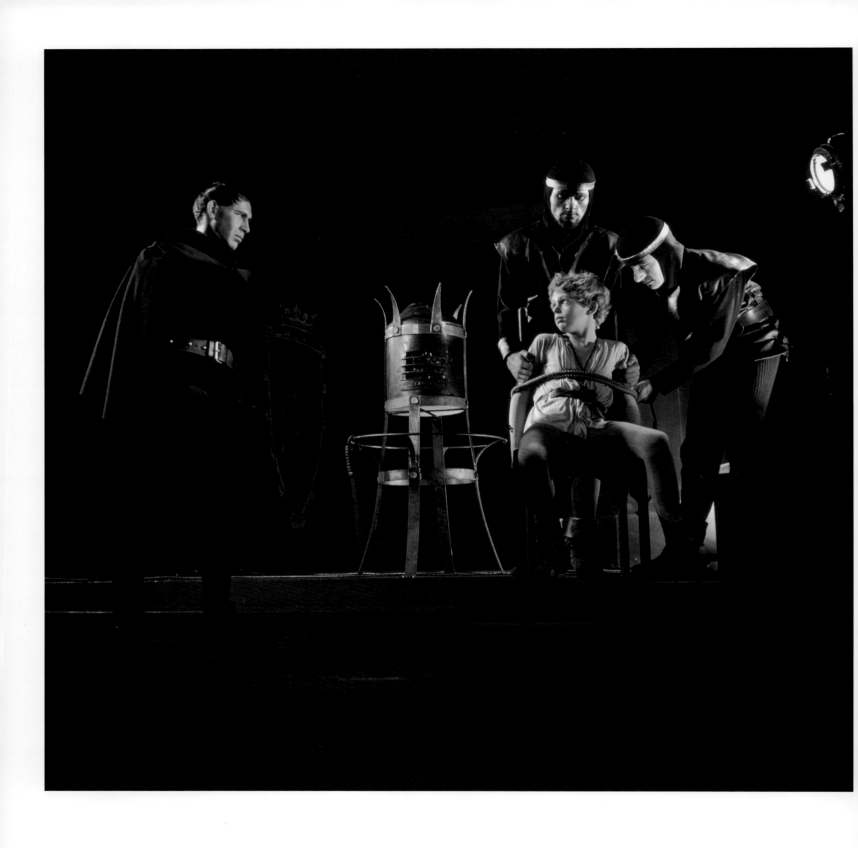

1957, IV.1, Hubert (Ron Hadrich) and
Arthur (Christopher Bond)

>

IV.2, King John (Robert Harris)

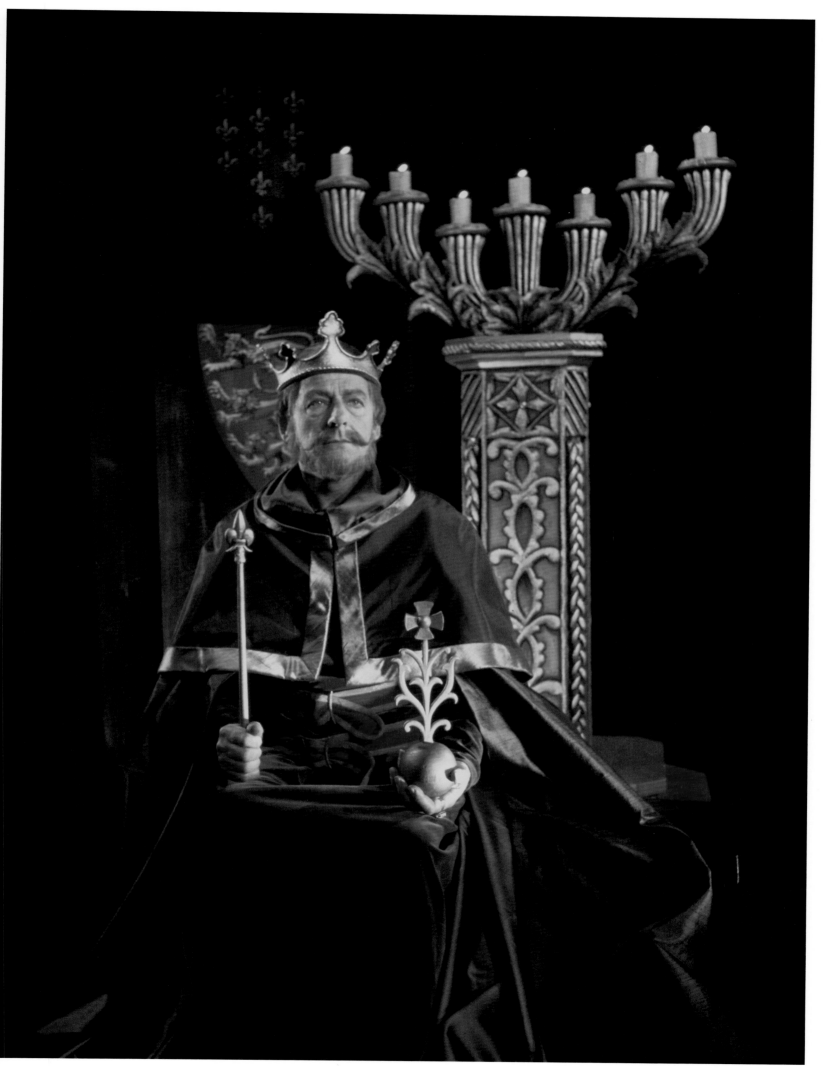

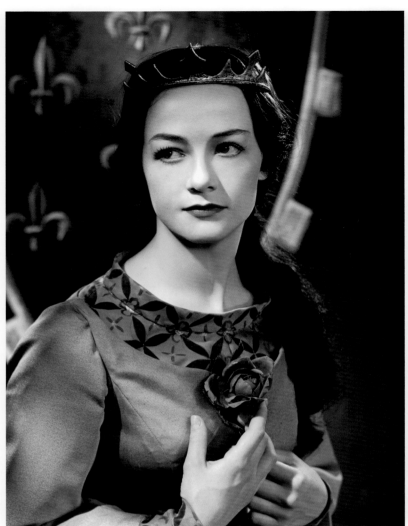

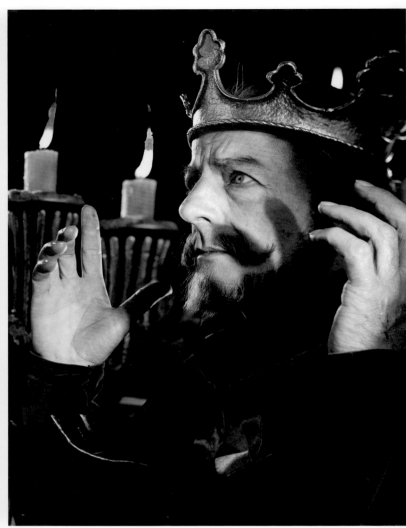

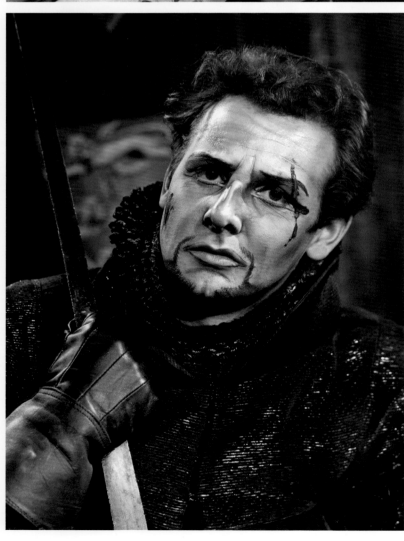

III.1, Blanch (Doreen Aris)

IV.2, King John

V.3, Melun (Toby Robertson)

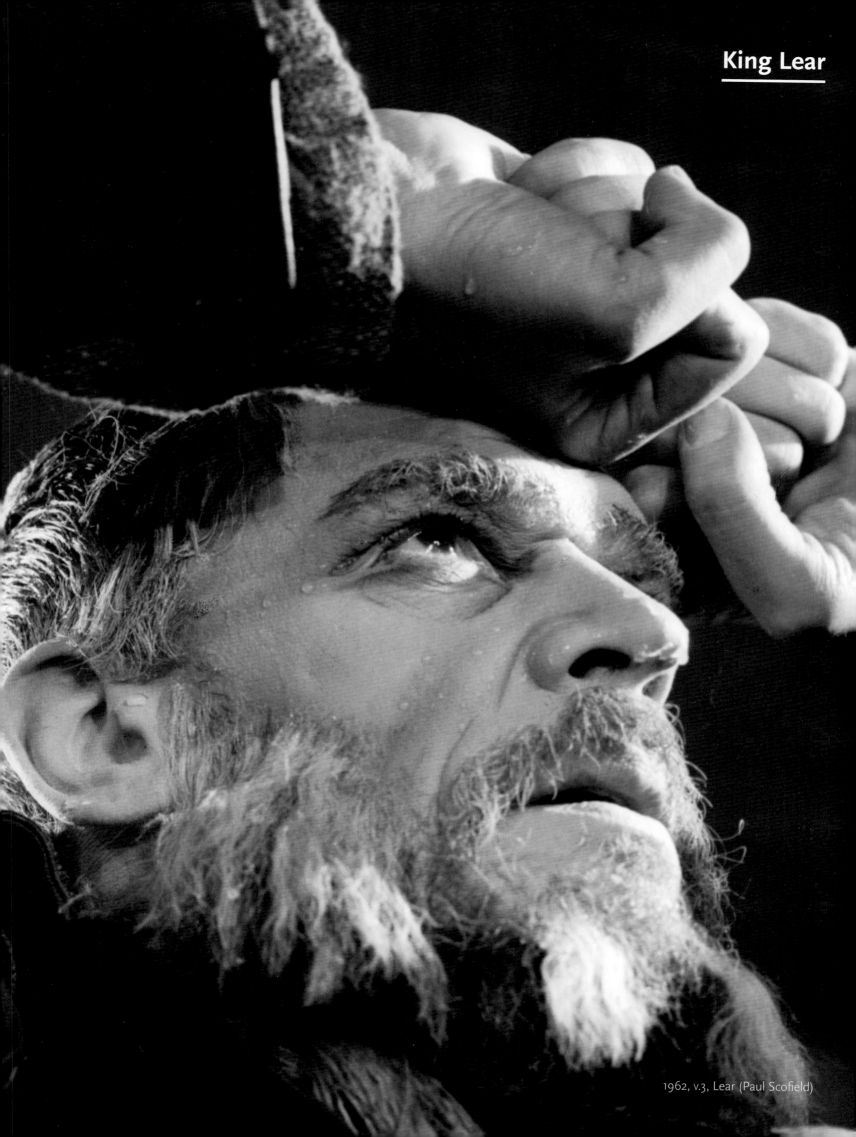

1962, v.3, Lear (Paul Scofield)

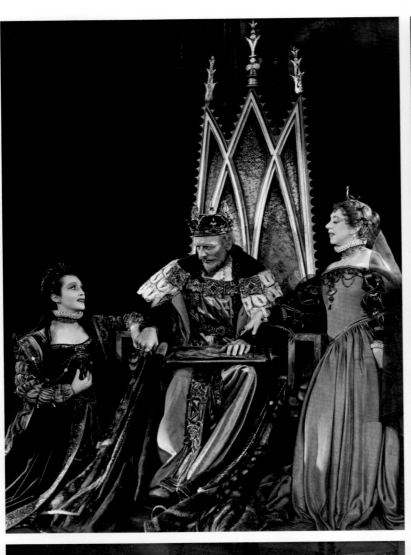

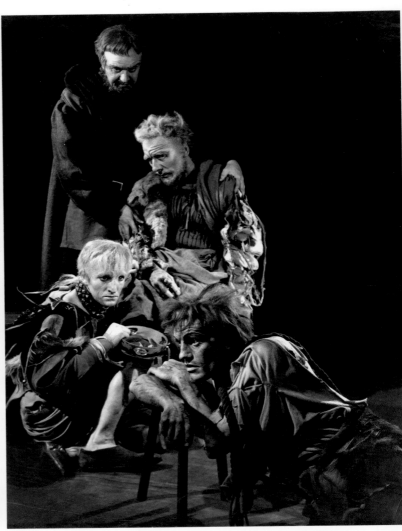

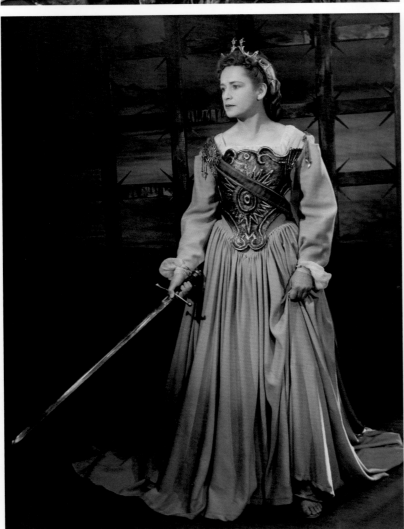

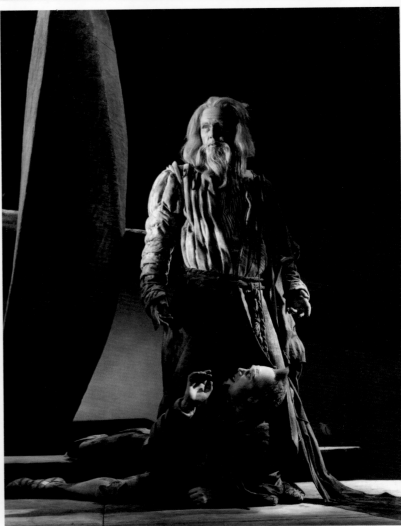

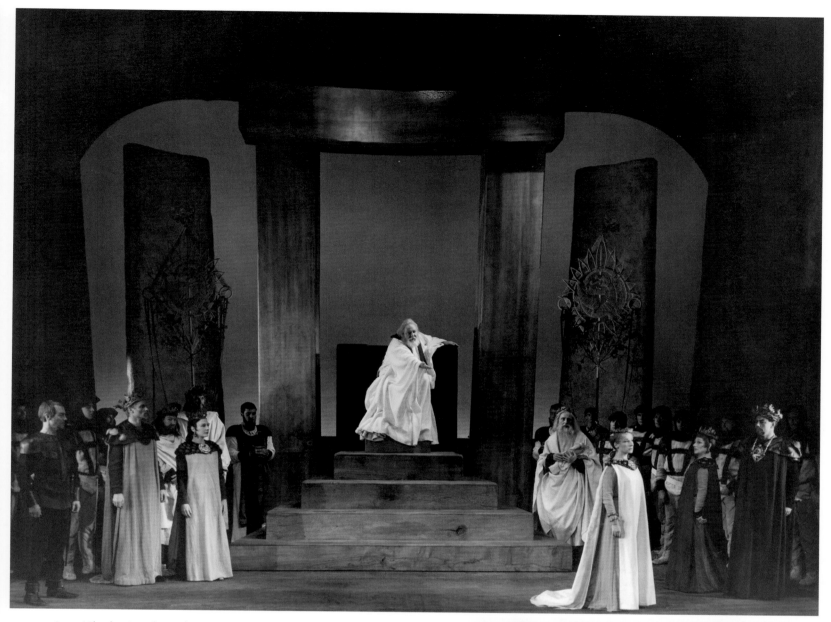

1959, I.1, Lear (Charles Laughton) berates Cordelia (Zoe Caldwell) before the court

III.4, Edgar (Albert Finney)

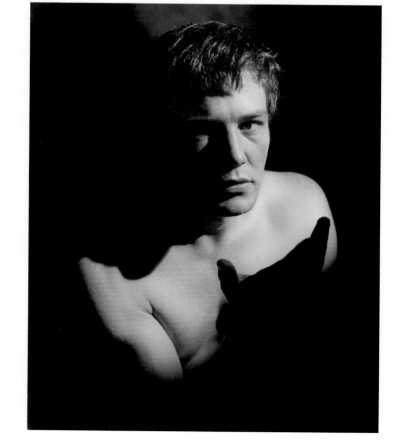

<

1950, I.1, Goneril (Maxine Audley), Lear (John Gielgud) and Regan (Gwen Frangcon Davies)

III.6, Kent (Andrew Cruickshank), Fool (Alan Badel), Lear and Poor Tom (Harry Andrews)

IV.4, Cordelia (Peggy Ashcroft)

1953, III.2, Lear (Michael Redgrave) and Fool (Marius Goring)

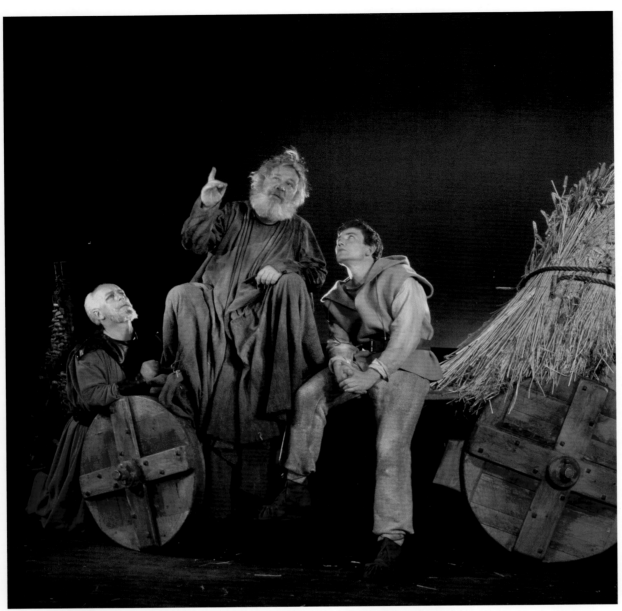

1959, IV.6, Gloucester
(Cyril Luckham), Lear and Edgar

IV.7, Lear and Cordelia

1962, I.1, Cordelia (Diana Rigg)

>

1962, I.1, Lear (Paul Scofield) asks
his daughters who loves him best

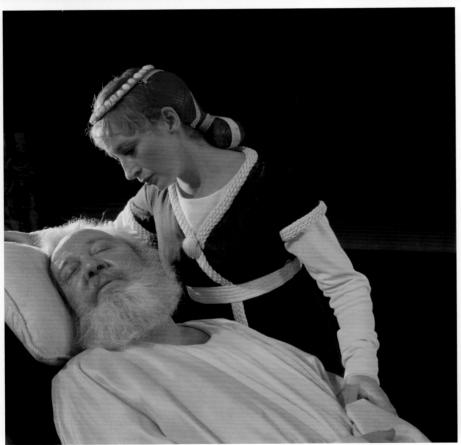

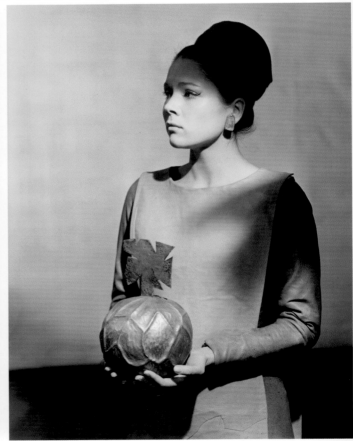

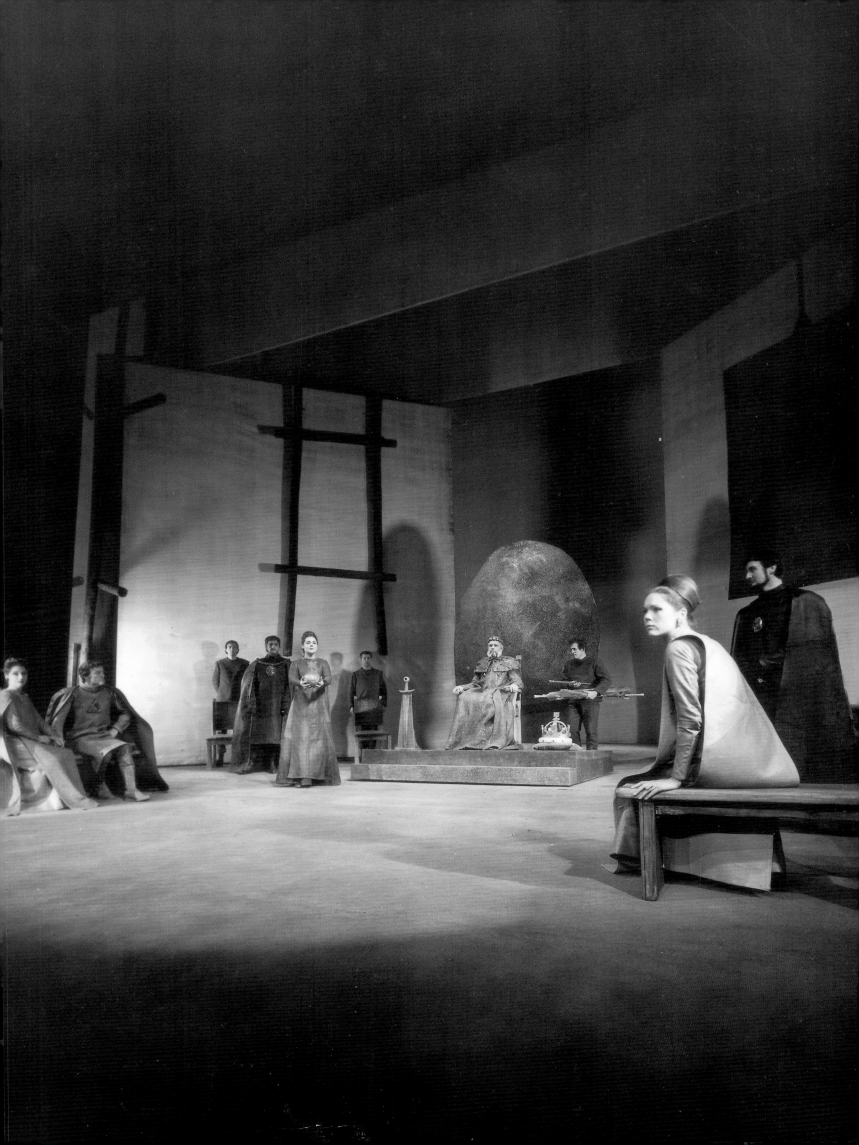

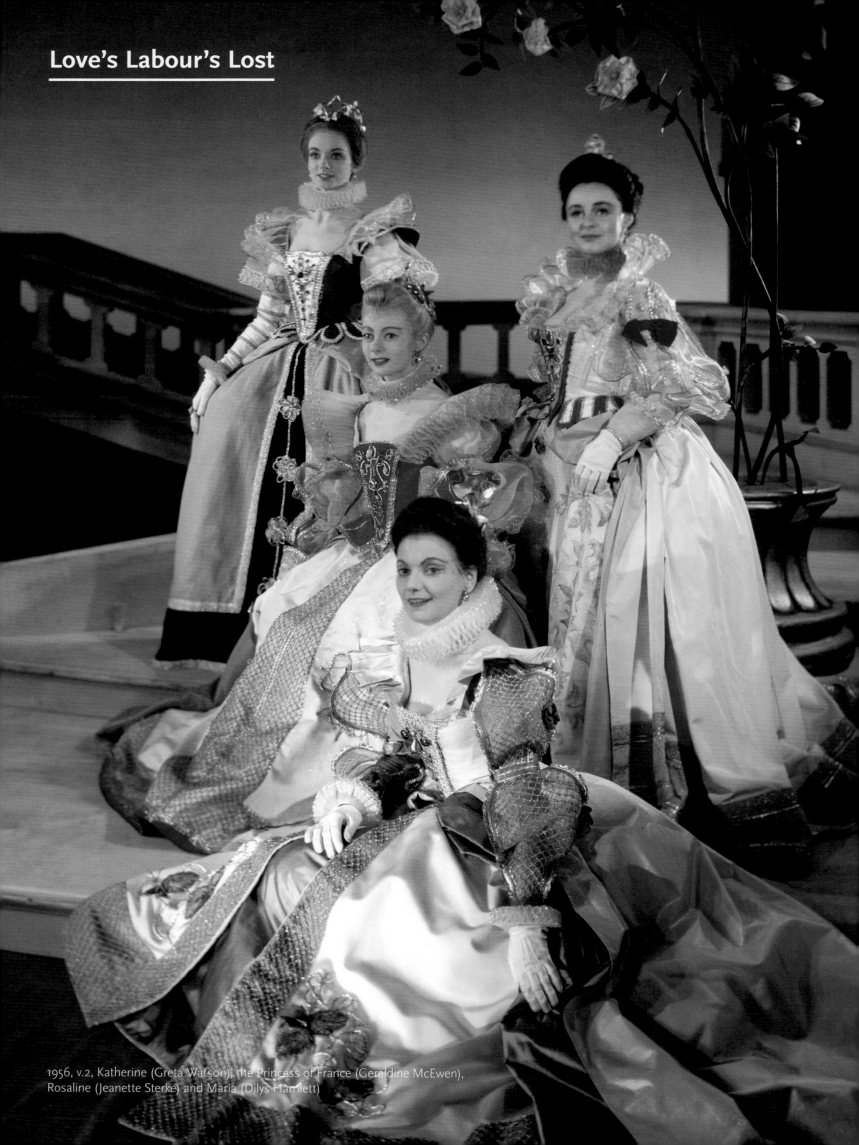

1956, v.2, Katherine (Greta Watson), the Princess of France (Geraldine McEwen), Rosaline (Jeanette Sterke) and Maria (Dilys Hamlett)

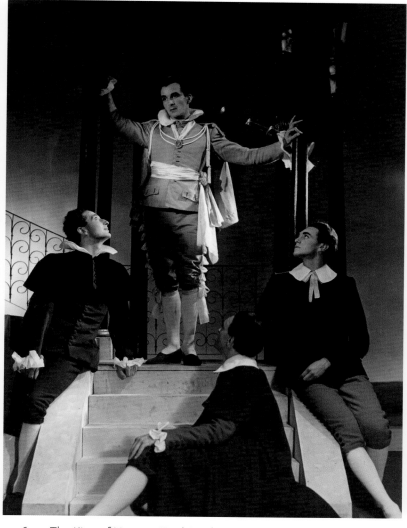

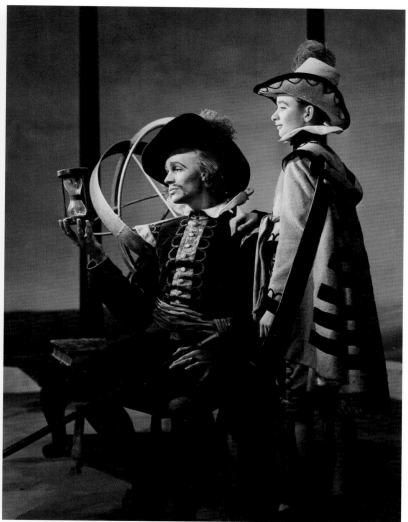

1946, I.1, The King of Navarre (Paul Stephenson),
Berowne (David King-Wood), Dumaine (Donald Sinden) and
Longaville (John Harrison)

I.2, Don Armado (Paul Scofield) and Moth (David O'Brien)

I.2, Moth, Costard (Robert Vernon) and Dull (Vernon Fortescue)

IV.1, The Princess of France (Valerie Taylor) and her entourage

FOLLOWING SPREAD

1956, I.1, The King of Navarre (Basil Hoskins)

V.2, The Princess of France

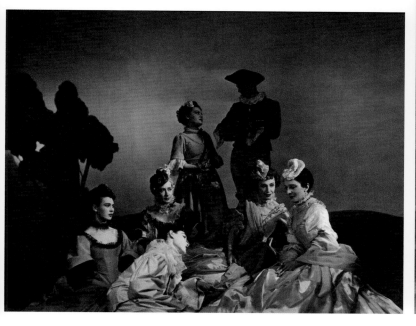

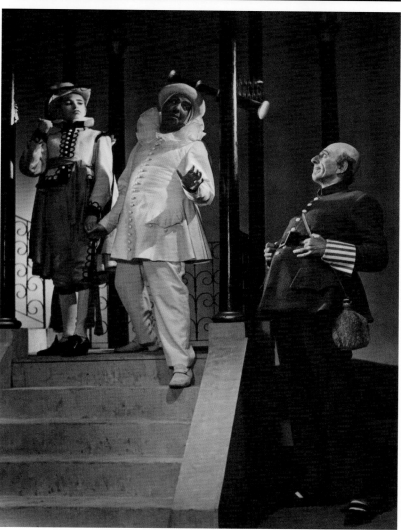

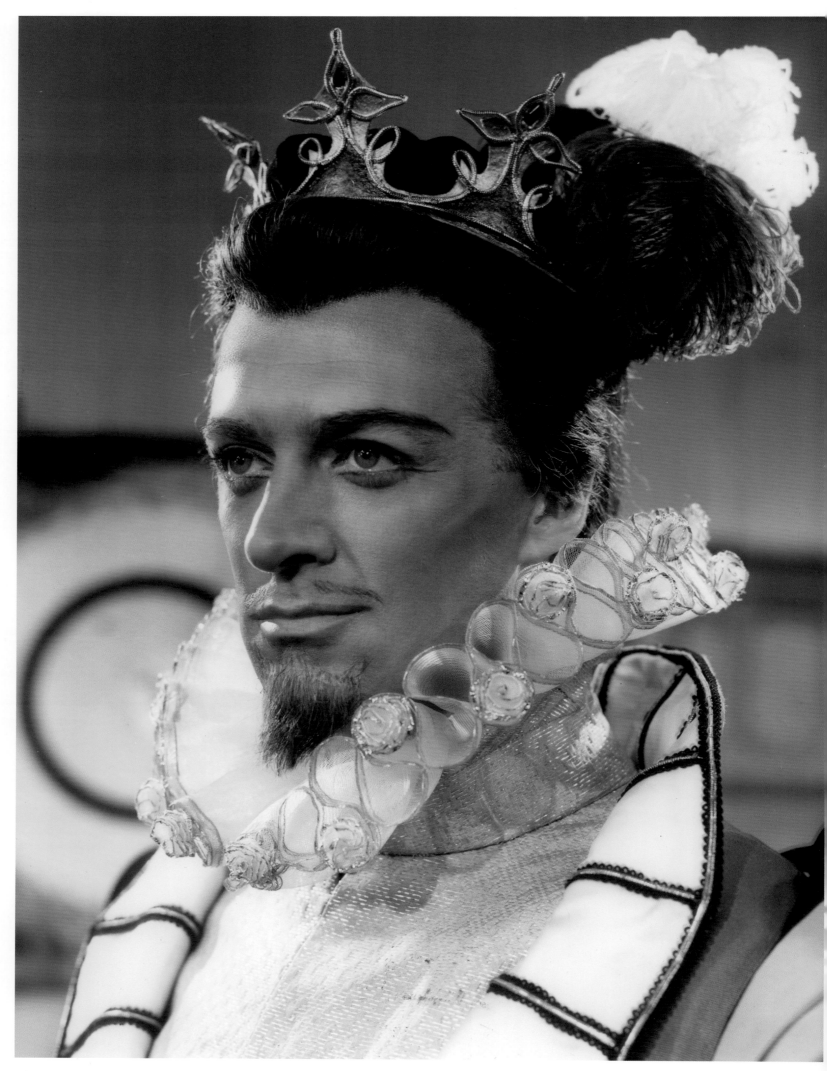

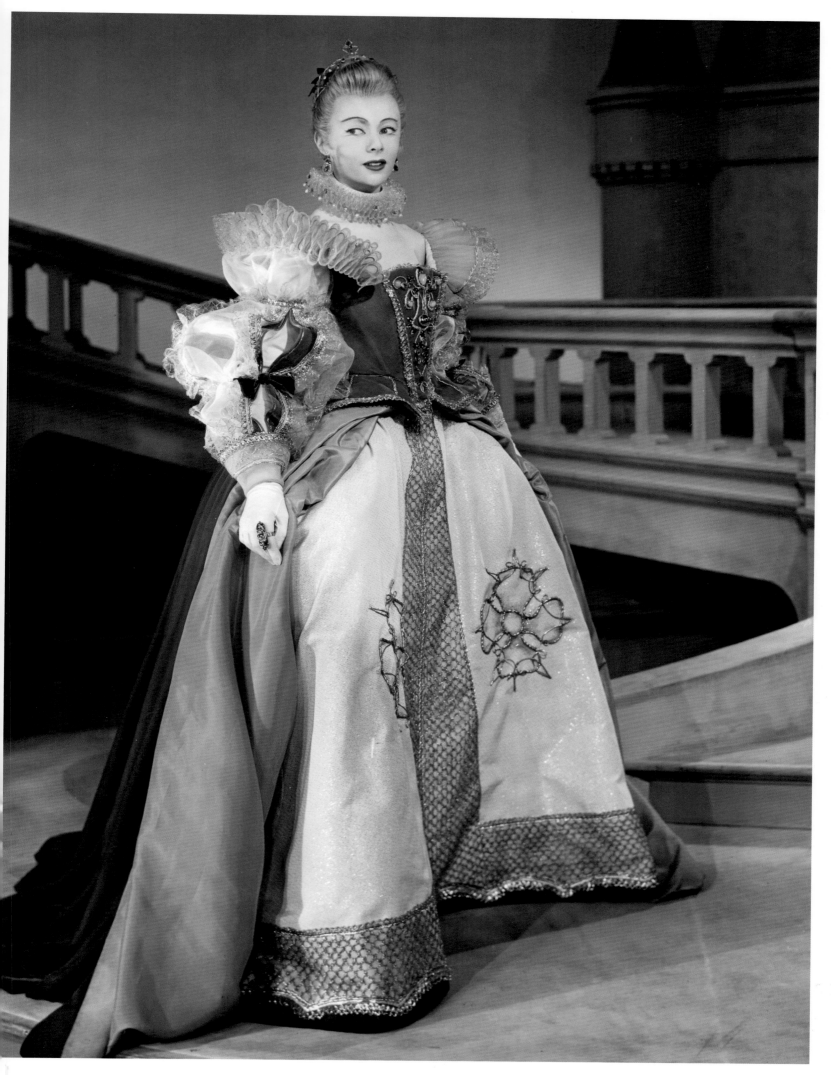

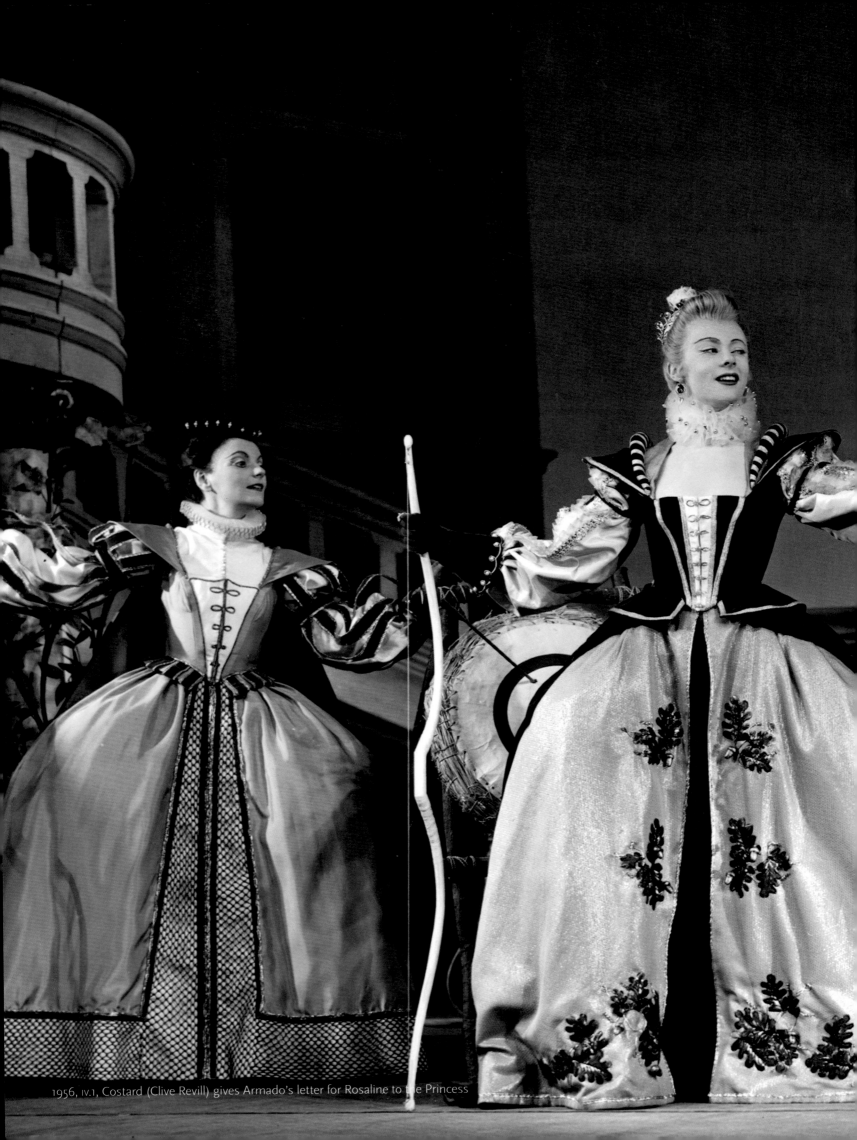

1956, IV.1, Costard (Clive Revill) gives Armado's letter for Rosaline to the Princess

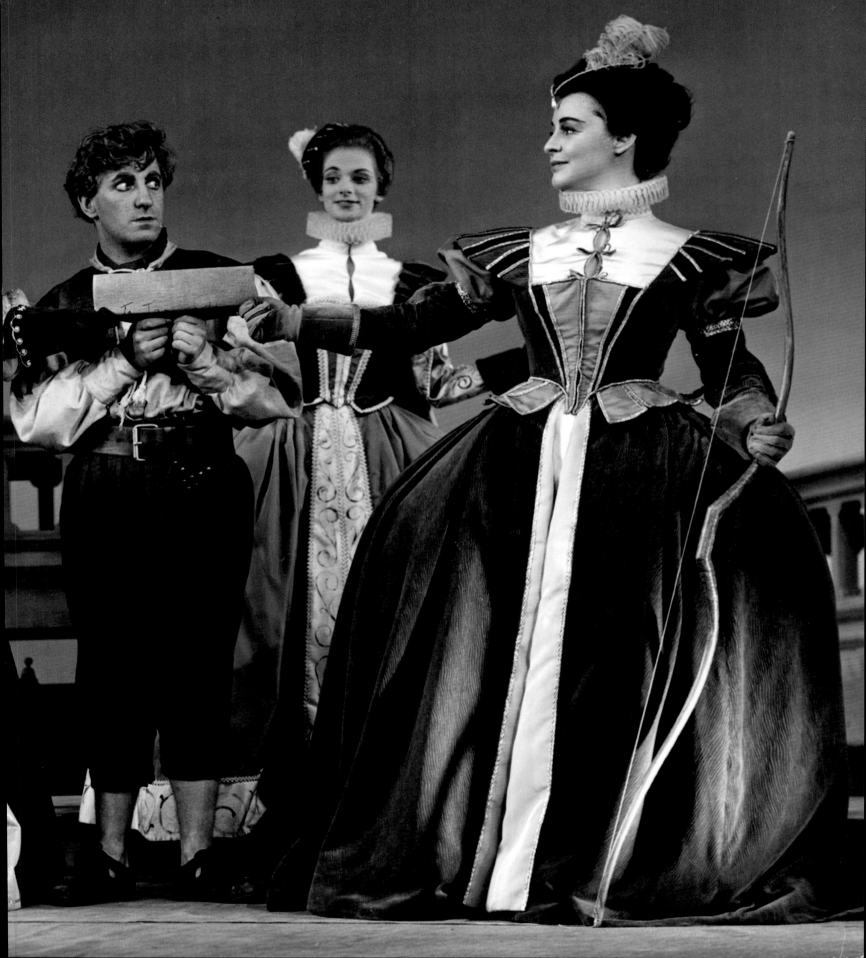

1956, v.2, Rosaline and Berowne
(Alan Badel)

v.2, the 'Muscovites'

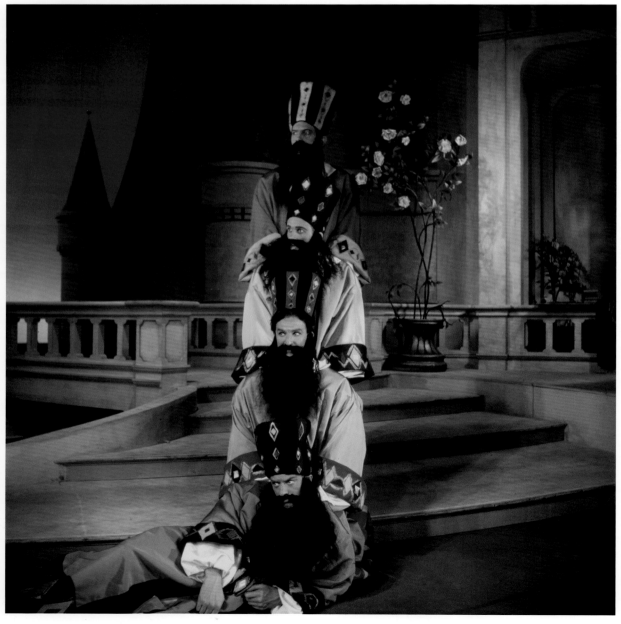

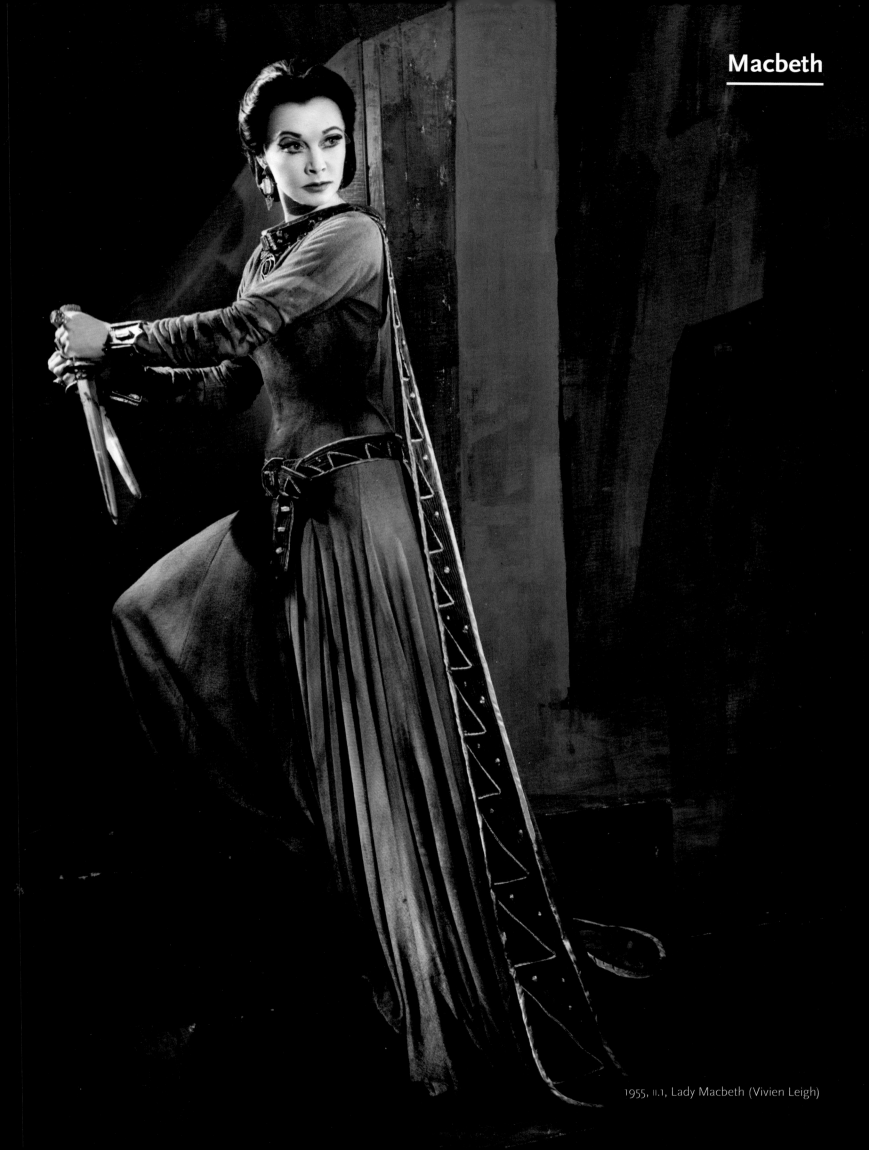

1955, ii.1, Lady Macbeth (Vivien Leigh)

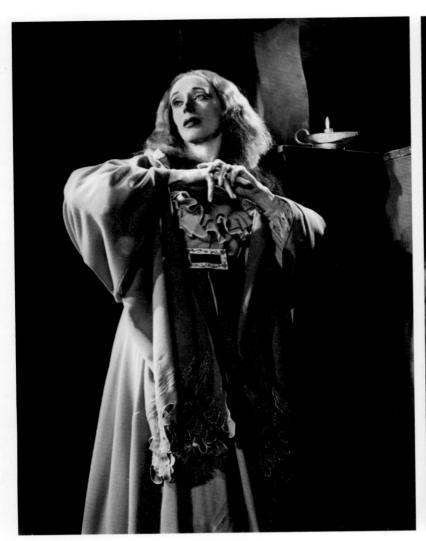

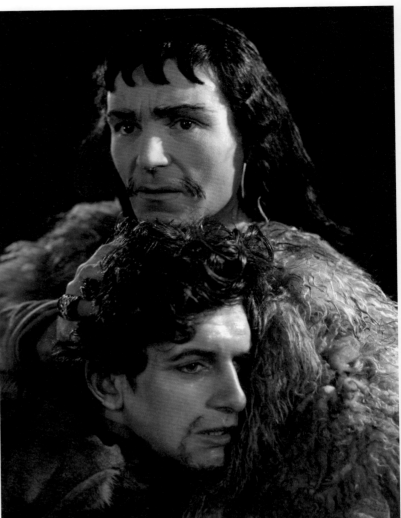

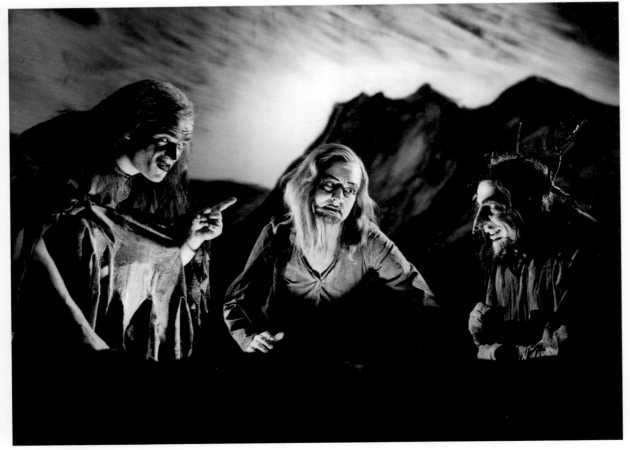

1946, I.1, Lady Macbeth
(Valerie Taylor)

1949, II.1, Donalbain (Philip Guard)
and Malcolm (Clement McCallin)

IV.1, The Witches (Dudley Jones,
Ruth Lodge and Hugh Griffith)

>

1952, I.3, Macbeth (Ralph
Richardson) and the Witches
(John Foster, Alexander Davion
and Richard Martin)

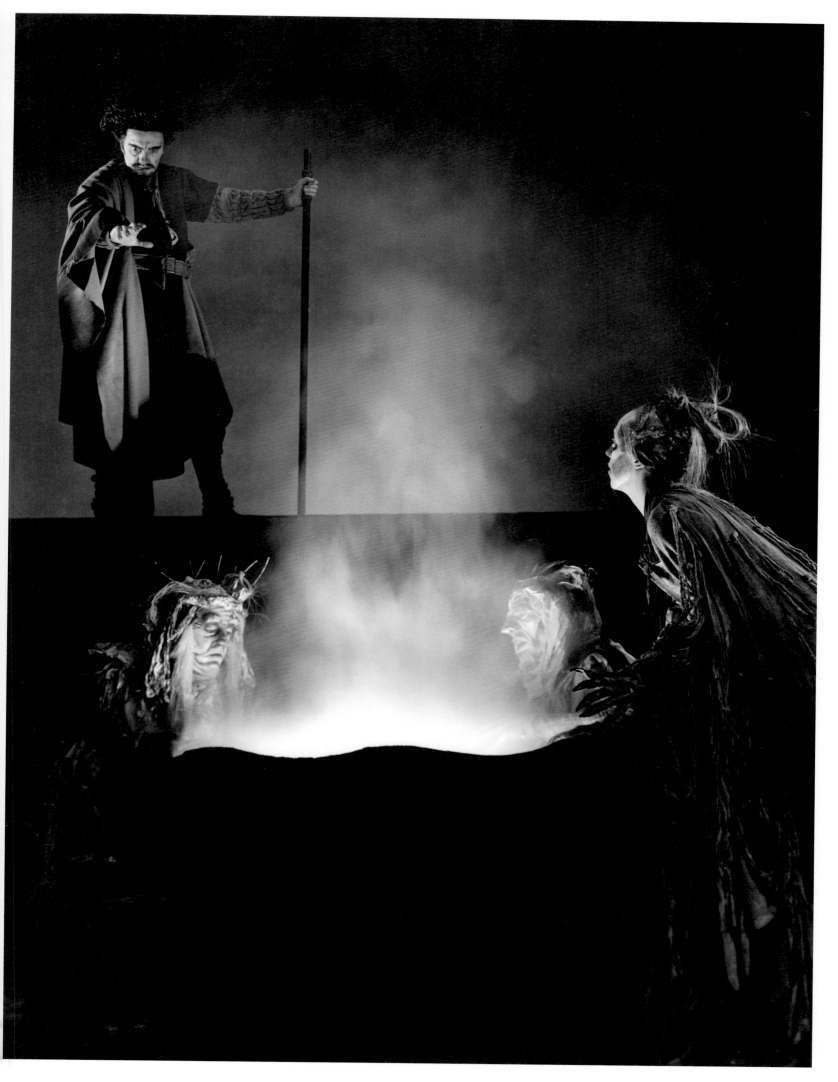

II.1, Malcolm (Laurence Harvey)

Macduff (Harry Andrews)

III.4, Macbeth sees the ghost of Banquo (Raymond Westwell)

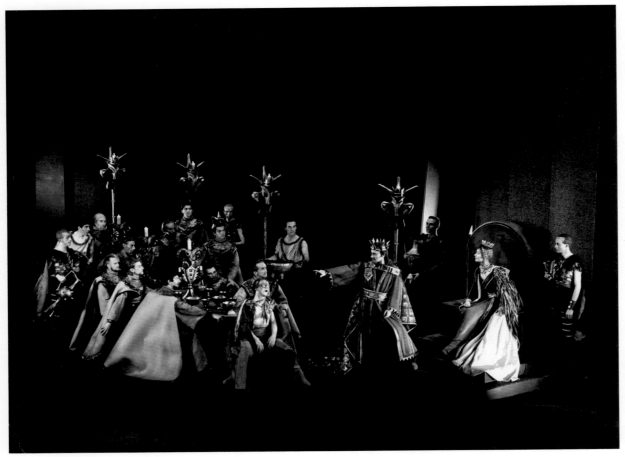

>

V.1, Lady Macbeth
(Margaret Leighton)

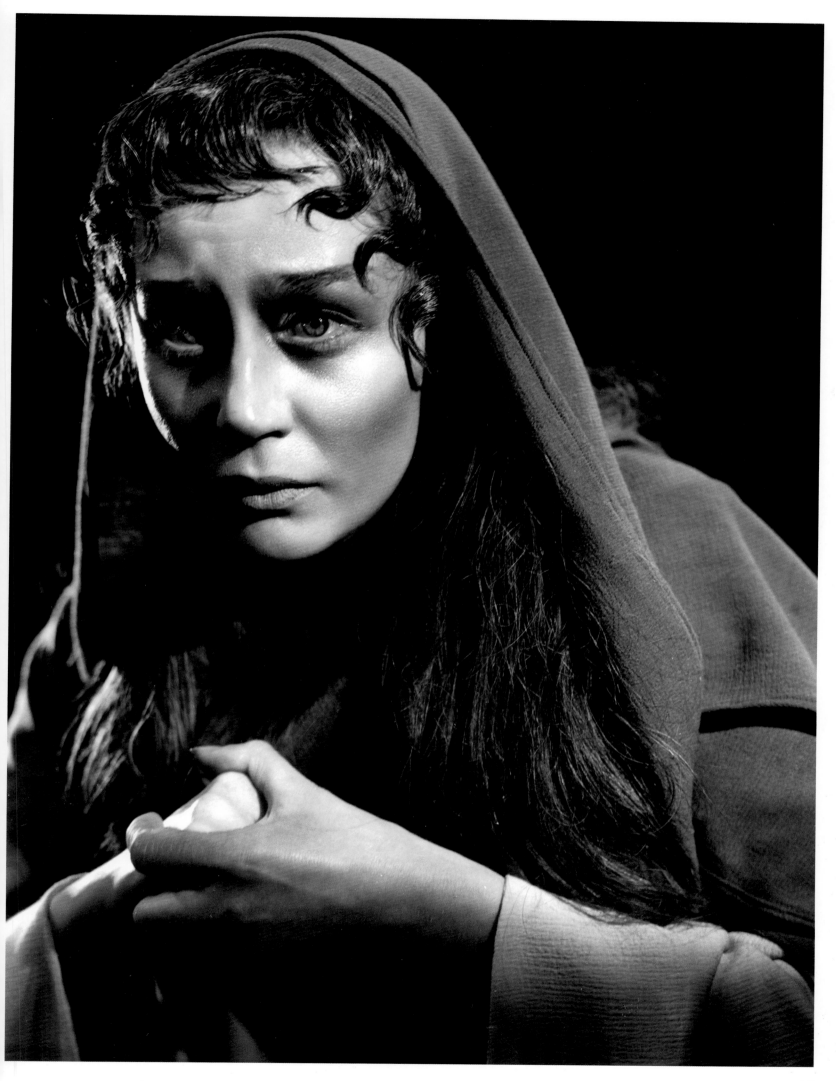

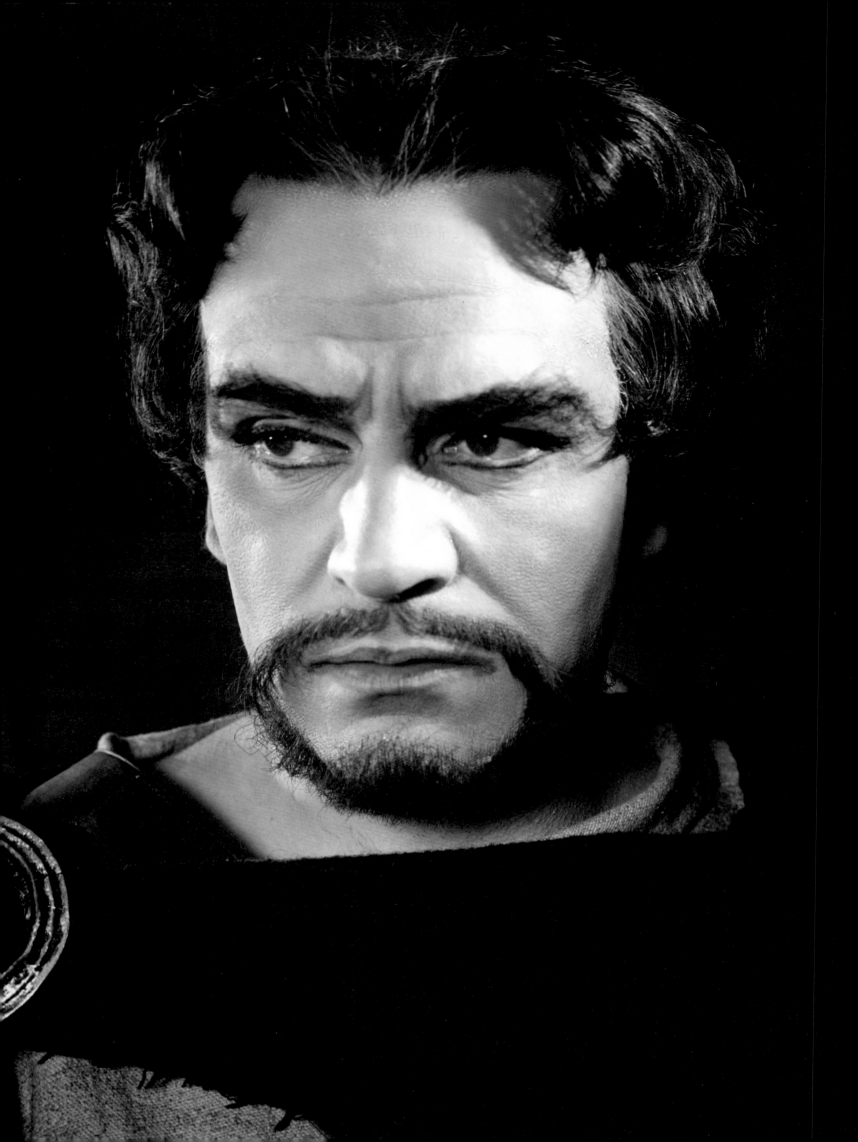

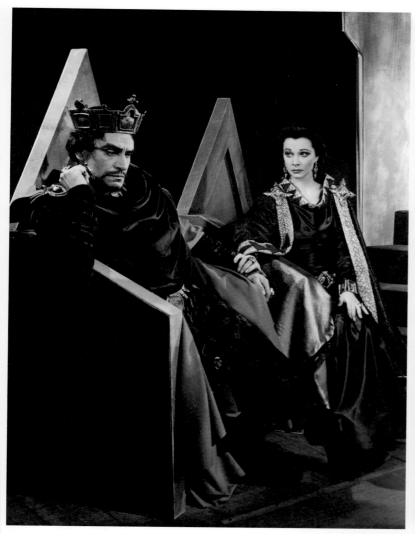

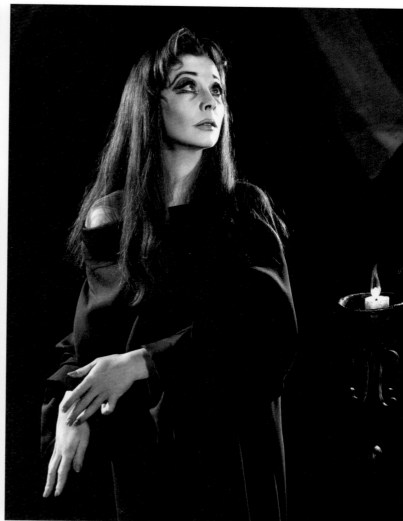

1955, Macbeth and Lady Macbeth
(Vivien Leigh)

v.1, Lady Macbeth

iv.2, Lady Macduff (Maxine Audley)
and her sons (John Rogers and
Kevin Miles)

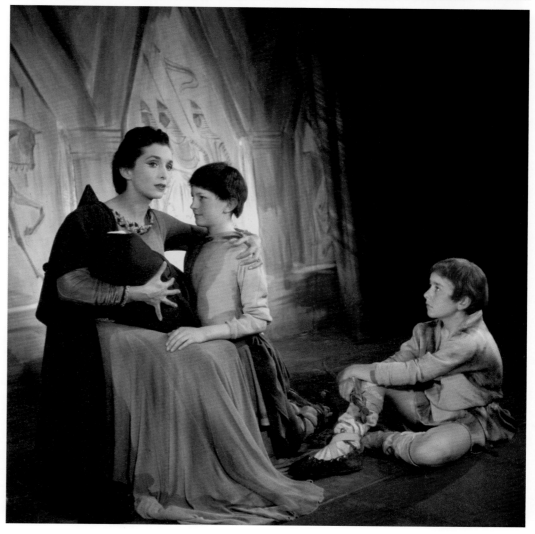

<

ii.1, Macbeth (Laurence Olivier)

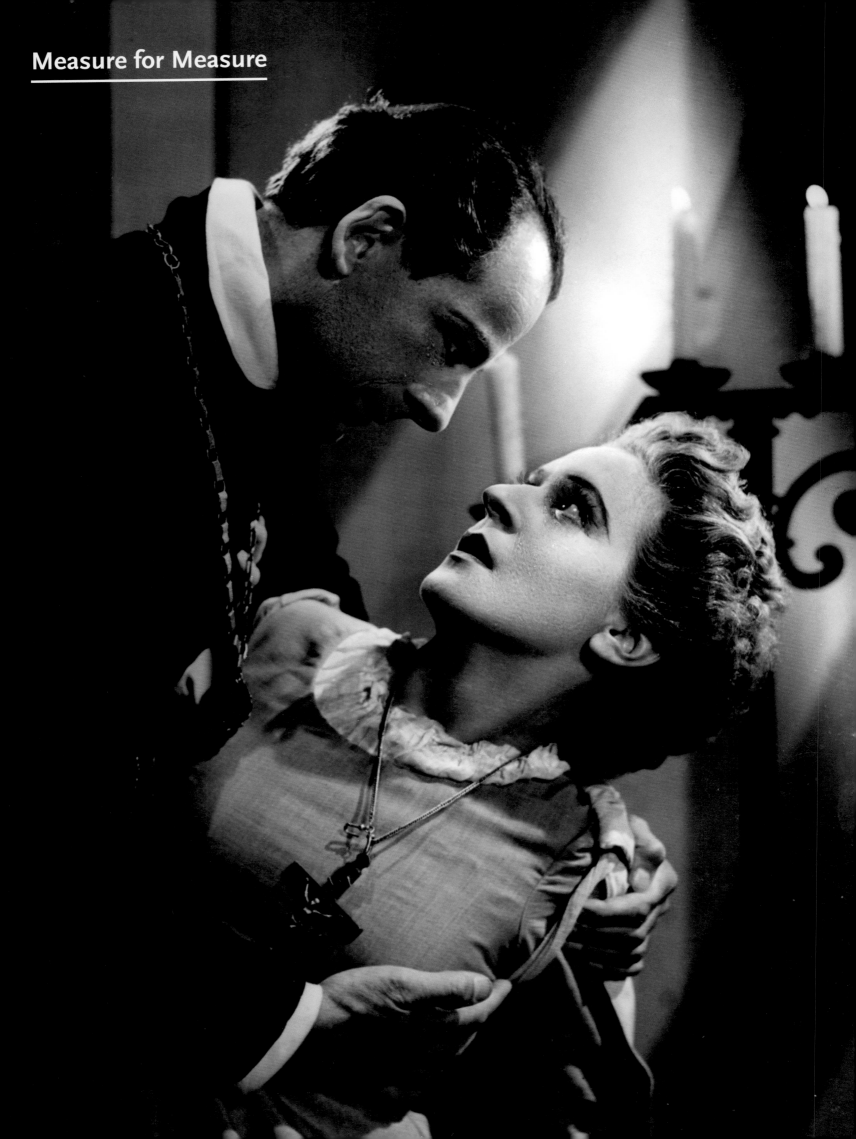

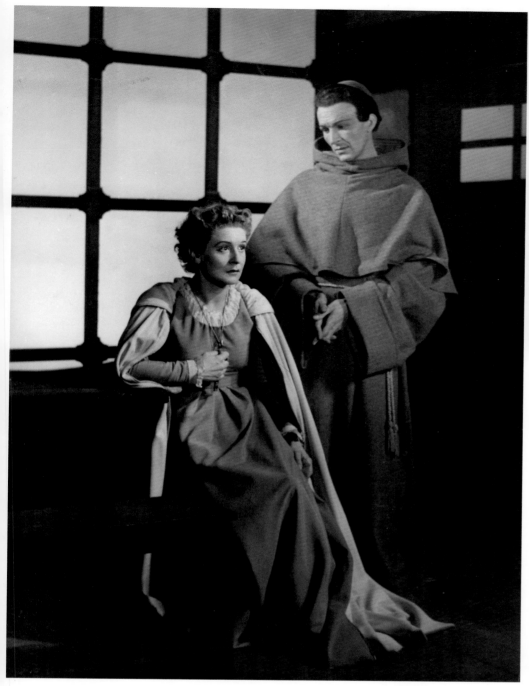

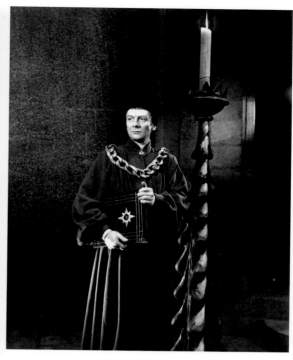

1946, III.1, Isabella and the Duke (David King-Wood)

1950, II.2, Angelo (John Gielgud)

III.1, The Duke (Harry Andrews) and Isabella
(Barbara Jefford)

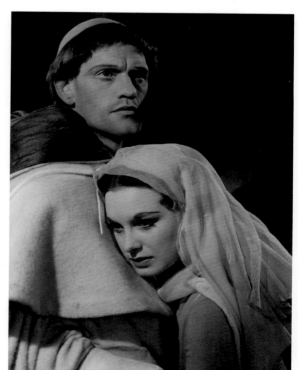

<

1946, II.4, Angelo (Robert Harris) and Isabella
(Ruth Lodge)

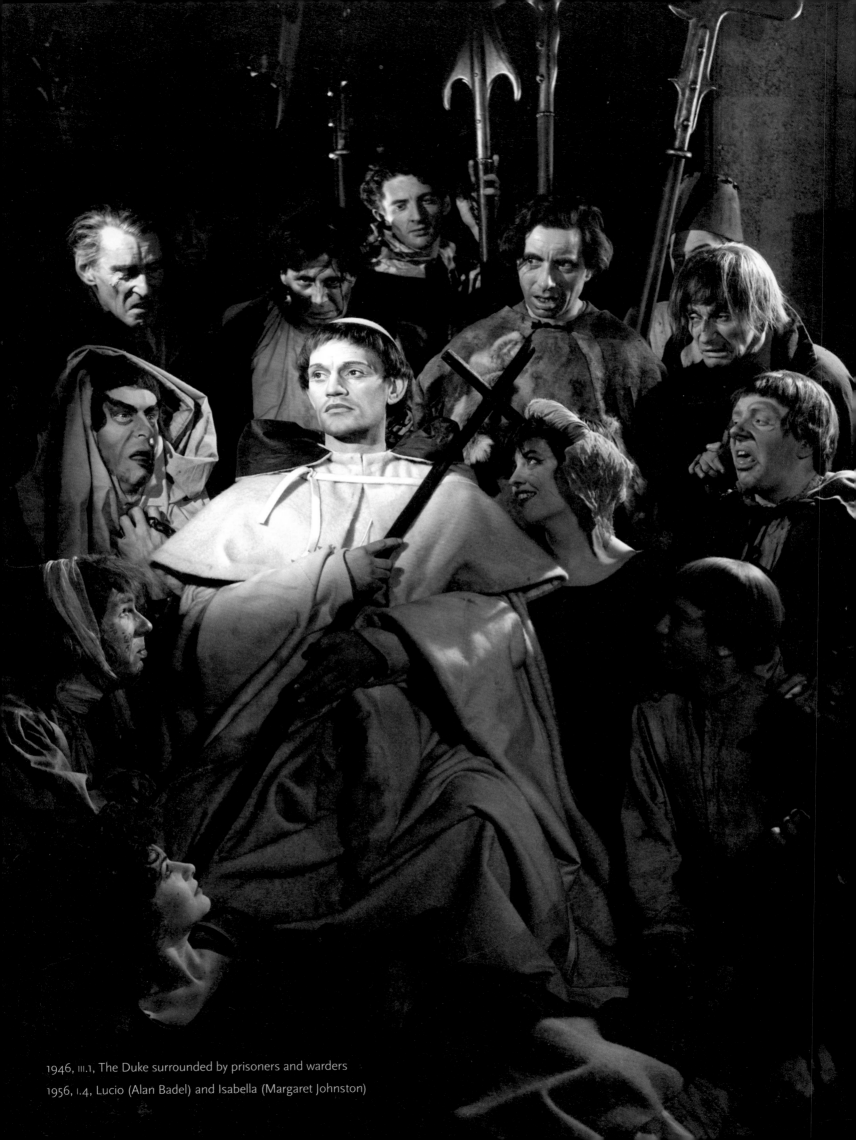

1946, III.1, The Duke surrounded by prisoners and warders

1956, I.4, Lucio (Alan Badel) and Isabella (Margaret Johnston)

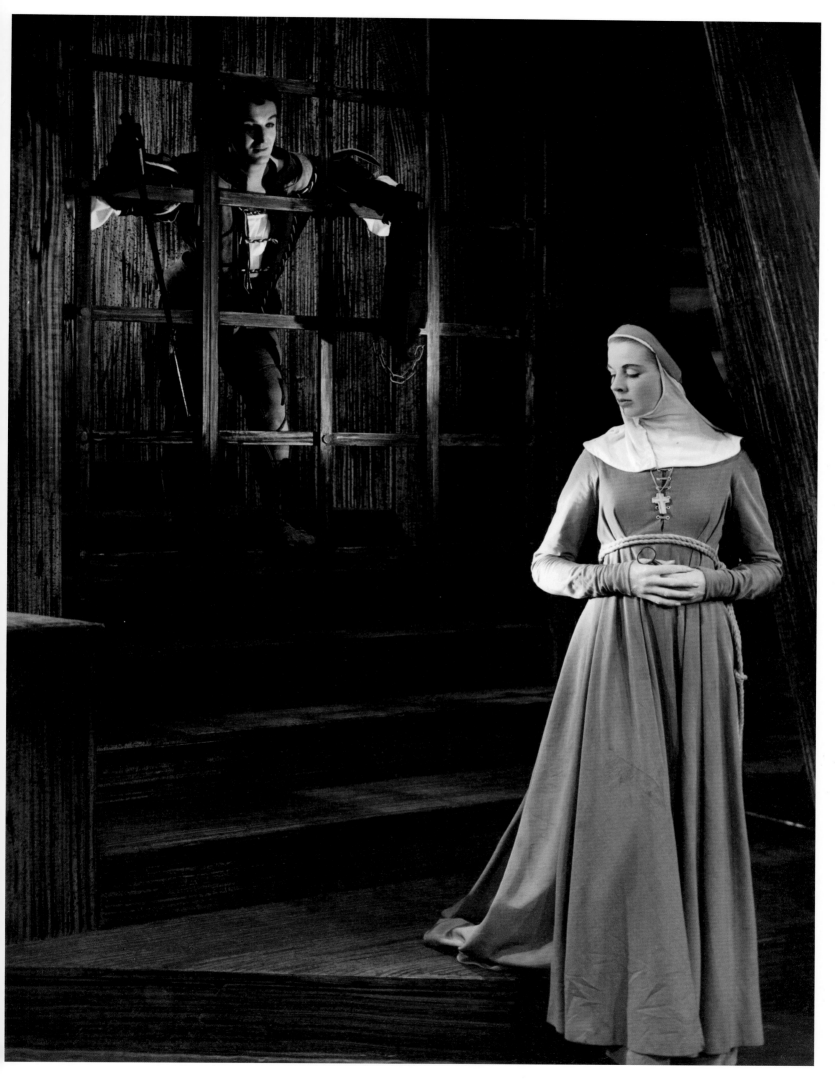

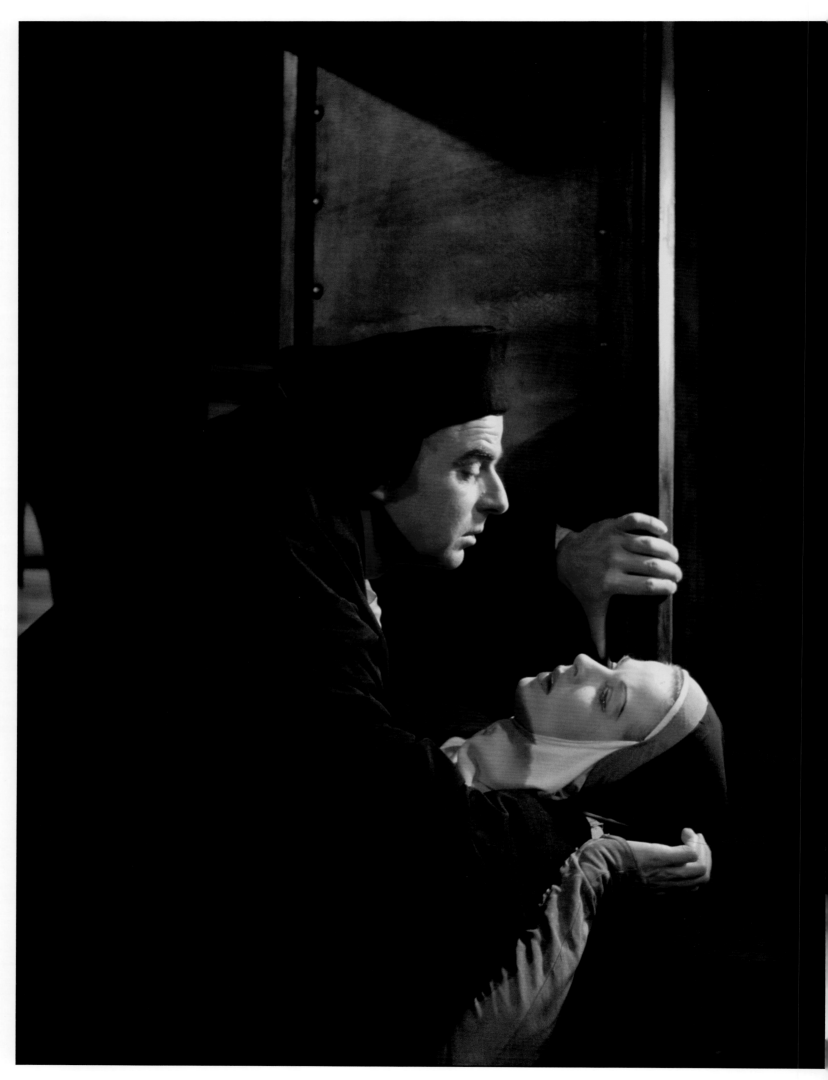

1956, II.4, Angelo (Emlyn Williams) and Isabella

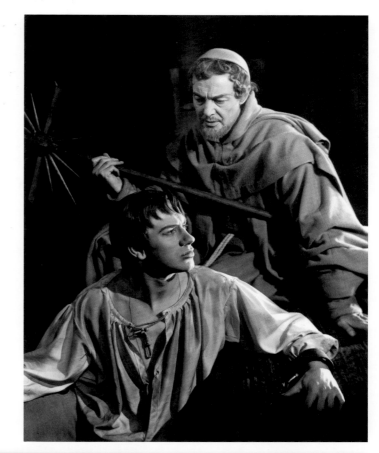

III.1, Claudio (Emrys James) and the Duke
(Anthony Mitchell)

IV.3, Pompey (Patrick Wymark), Barnardine
(Clive Revill) and Abhorson (Ron Haddrick)

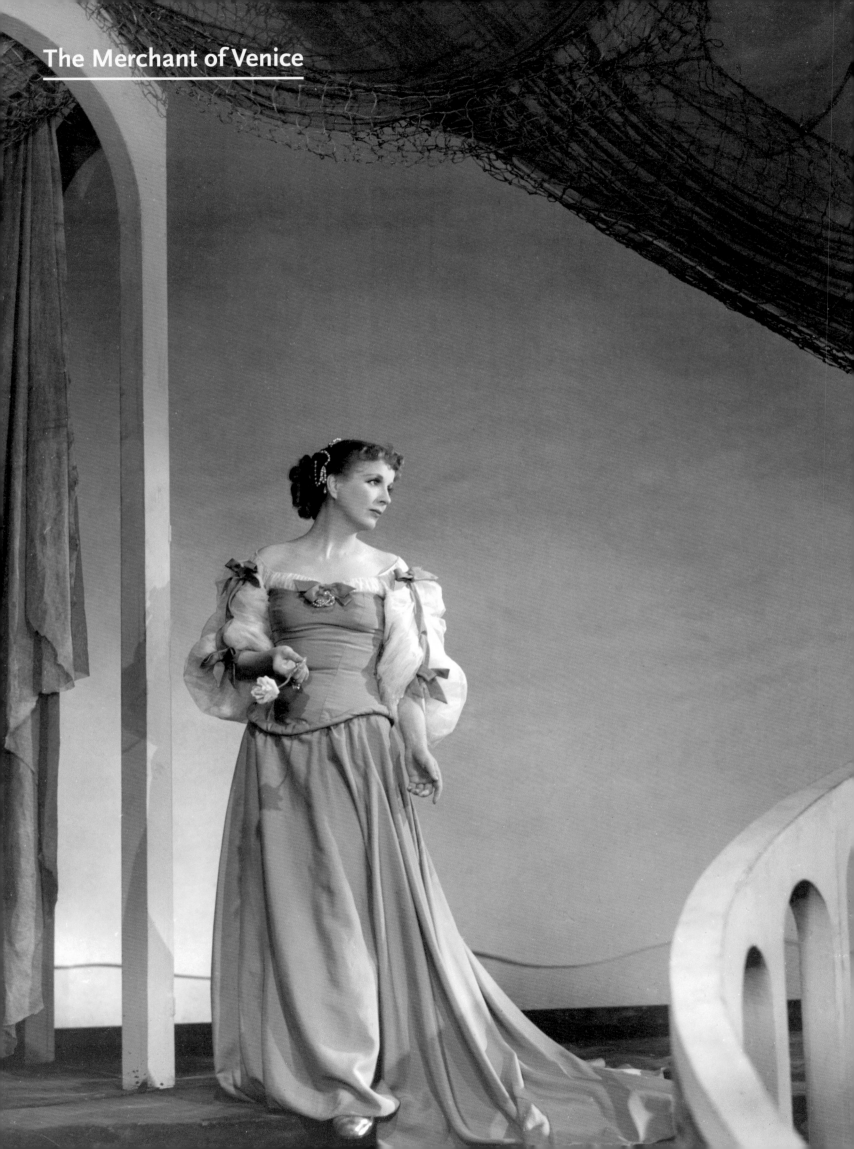

The Merchant of Venice

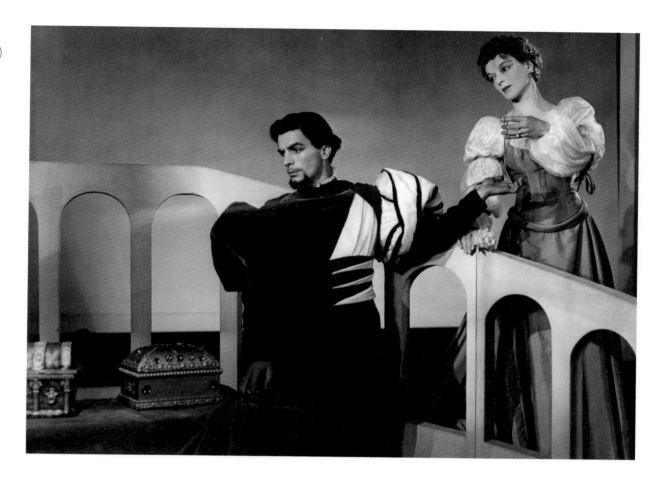

1948, II.7, Portia (Diana Wynyard)

1947, III.1, Bassanio (Laurence Payne) and Portia (Beatrix Lehmann)

v.1, Lorenzo (Donald Sinden) and Jessica (Joy Parker)

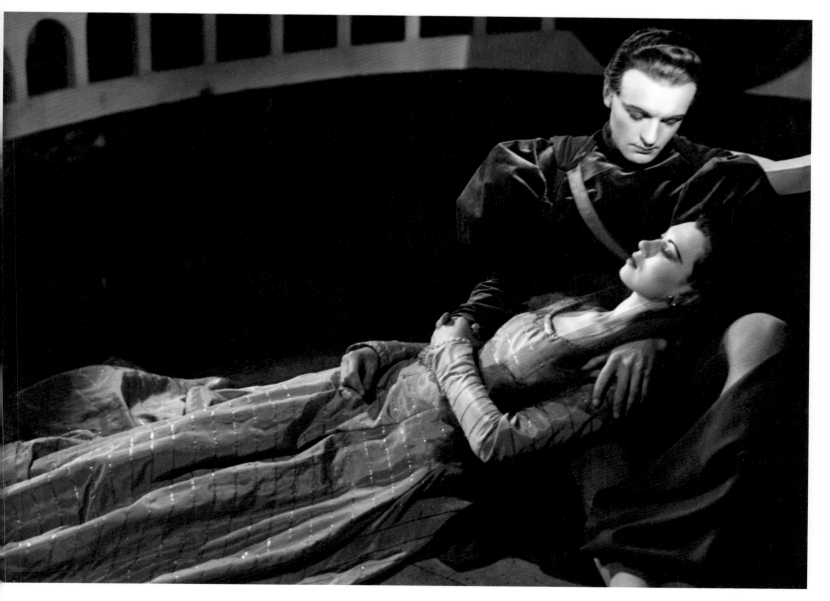

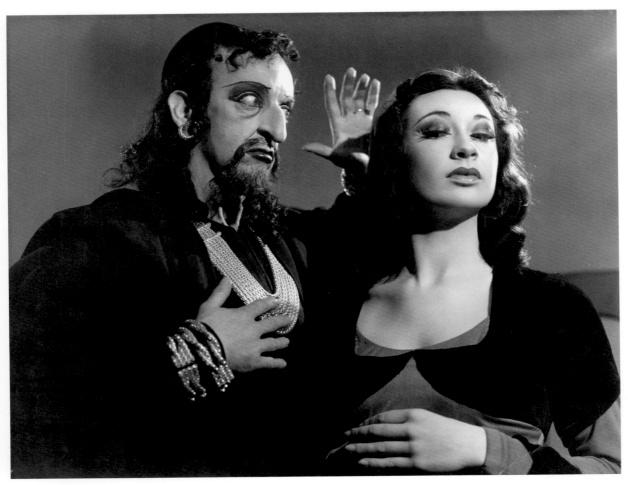

1948, II.5, Shylock (Robert Helpmann) and Jessica (Heather Stannard)

III.1, Bassanio (Paul Scofield) and Portia (Diana Wynyard)

1953, I.3, Bassanio (Tony Britton) and Shylock (Michael Redgrave)

>

1953, II.7, The Prince of Morocco (John Bushell) chooses his casket

II.7, Portia (Peggy Ashcroft)

III.2, Gratiano (Robert Shaw)

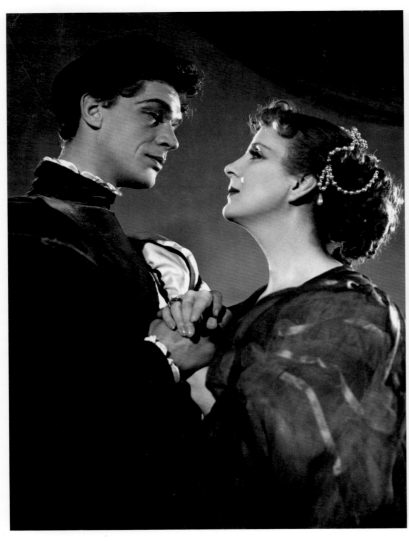

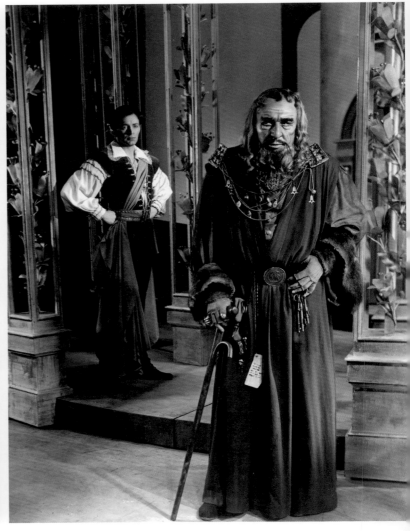

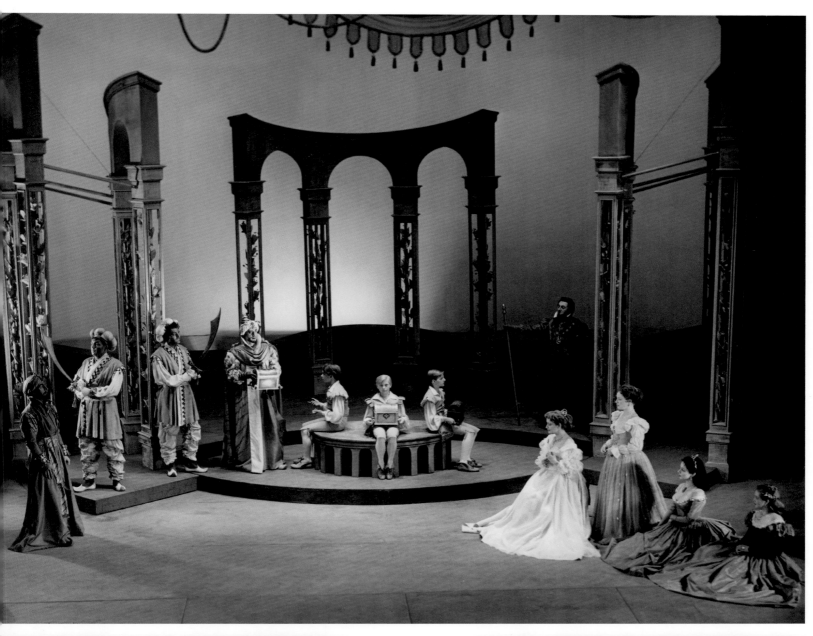

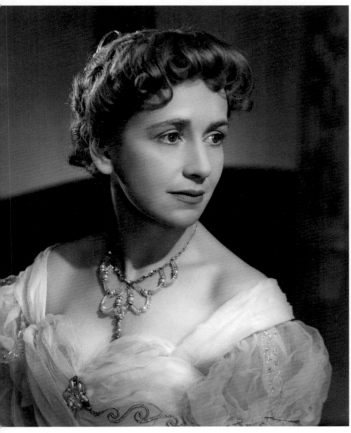

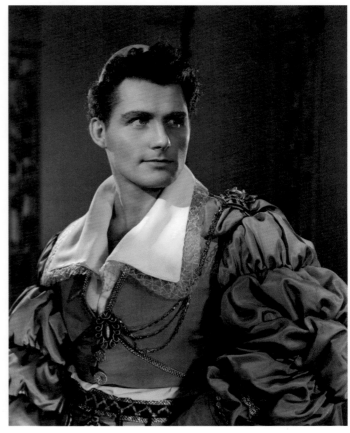

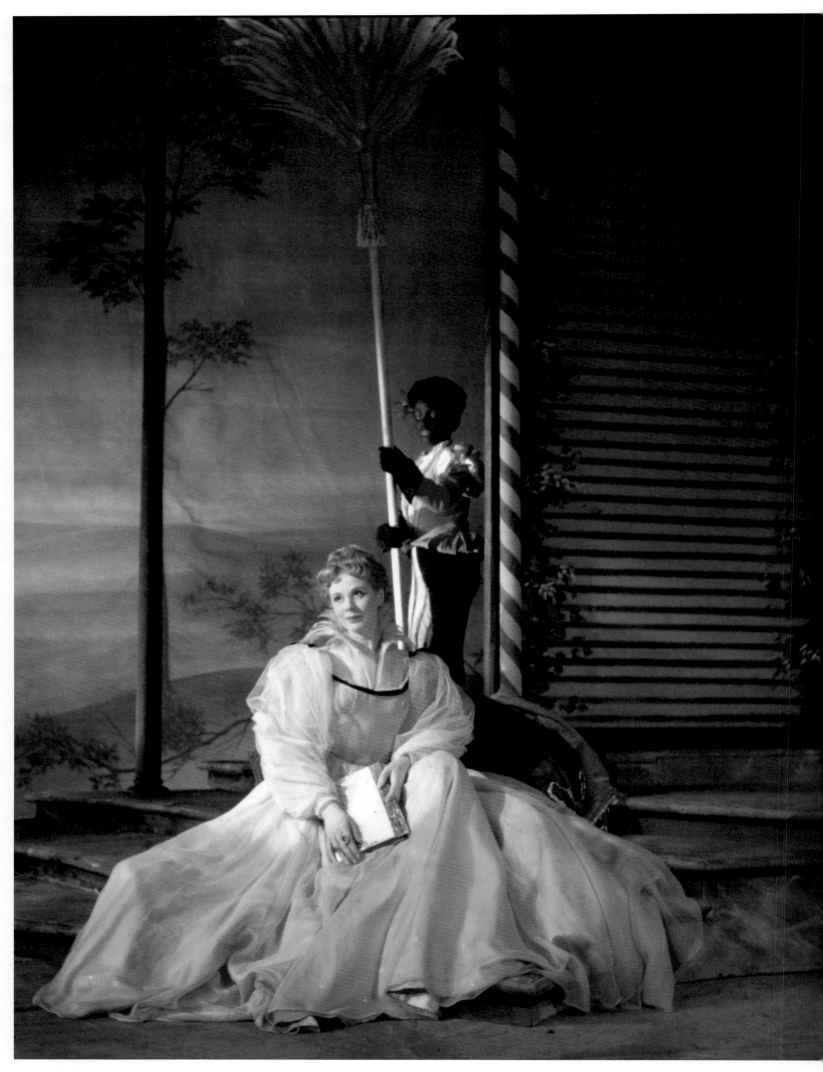

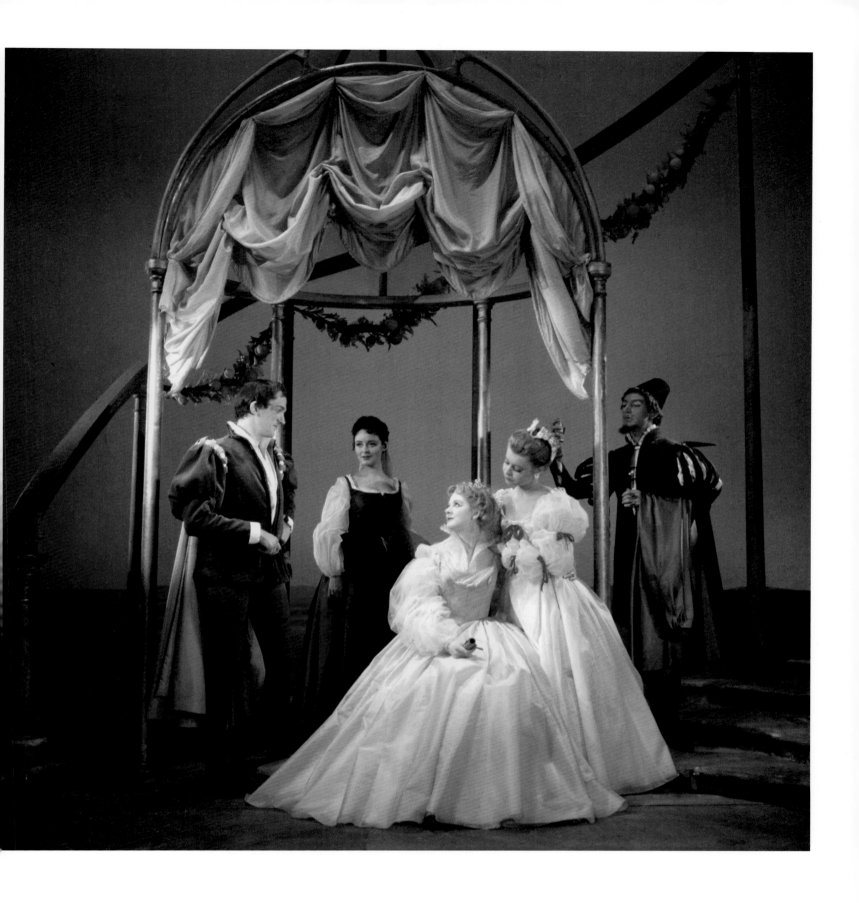

1956, II.7, Portia (Margaret Johnston) and her page
(Christopher Warby)

v.2, Lorenzo (David William), Jessica (Jeanette Sterke),
Portia, Nerissa (Prunella Scales) and Balthazar
(George Little)

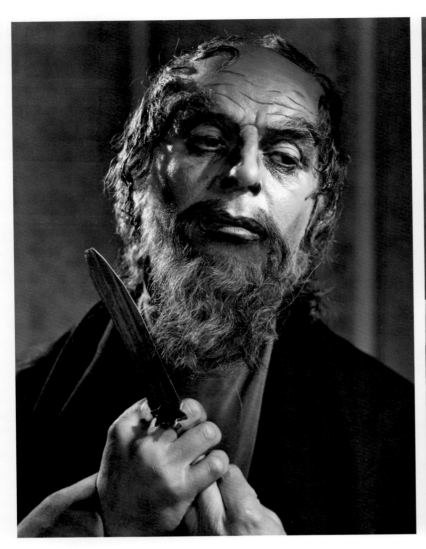

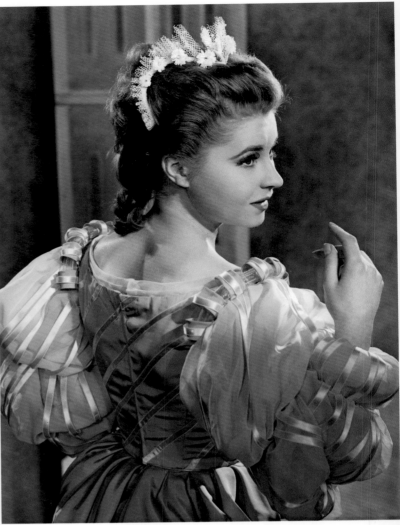

1956, IV.1, Shylock (Emlyn Williams)
Nerissa

1960, IV.1, The Duke (Tony Church)
is addressed in the court by Portia
(Dorothy Tutin)

1960, I.3, Shylock (Peter O'Toole)

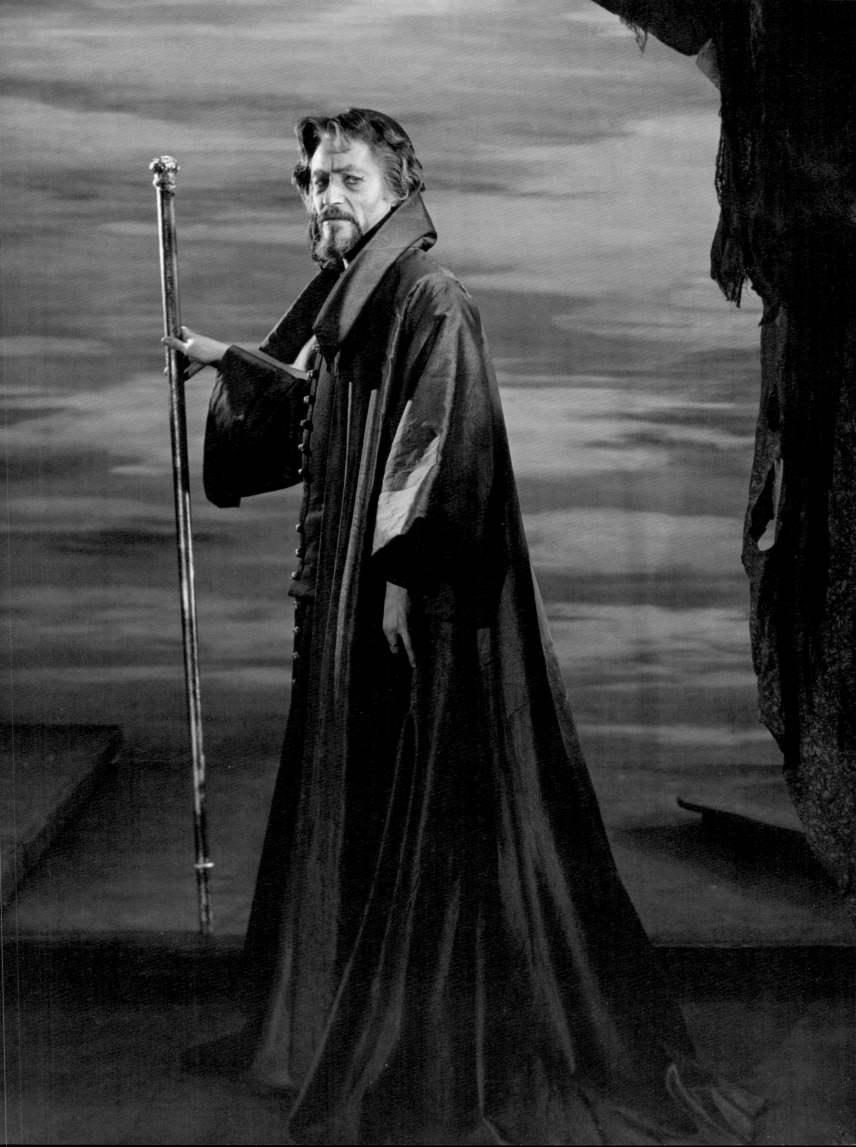

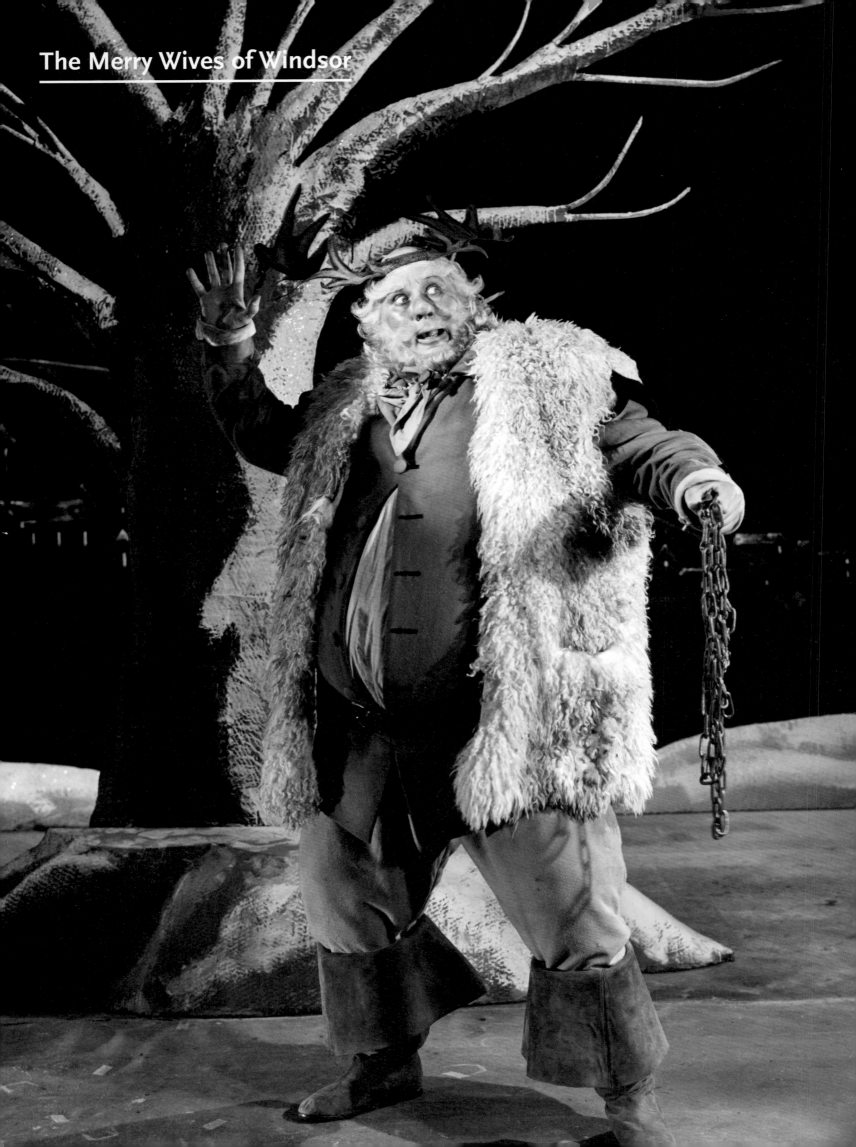

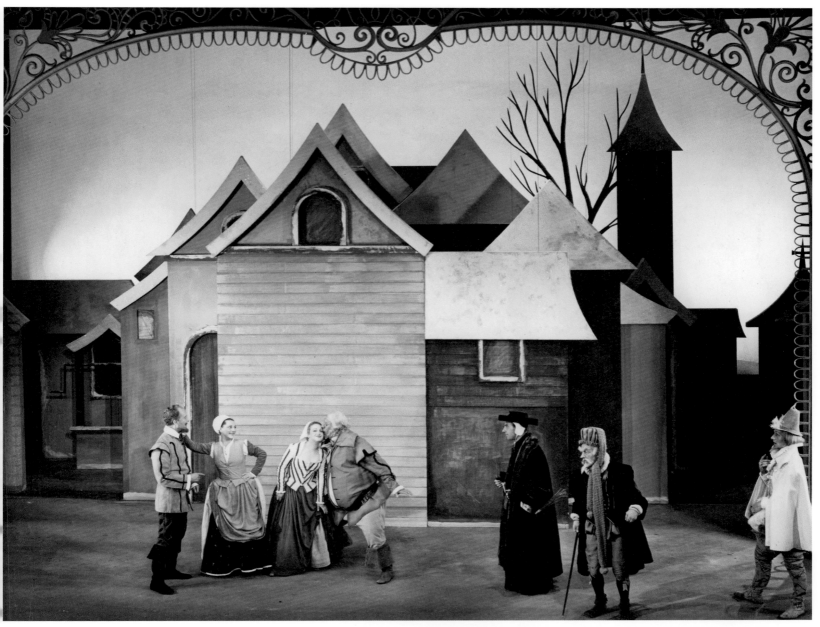

1955, I.1, Mistress Ford (Joyce
Redman), Falstaff (Anthony Quayle)
and company

III.1, Rugby (John Southworth) and
Dr Caius (Michael Denison)

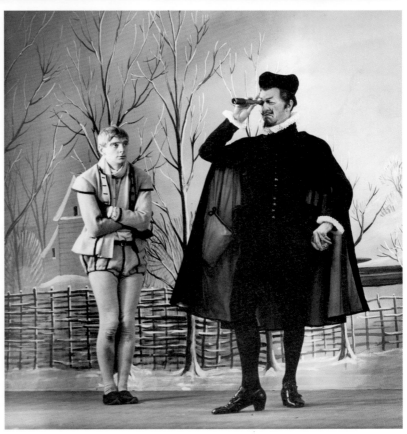

<
V.5, Falstaff (Anthony Quayle)

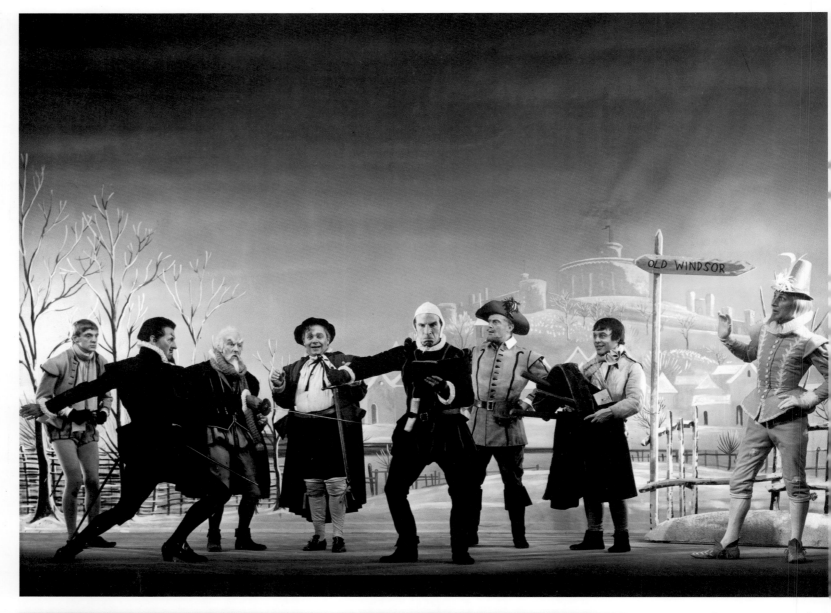

1955, III.1, Dr Caius prepares to duel with Evans (William Devlin)

The Bear interlude

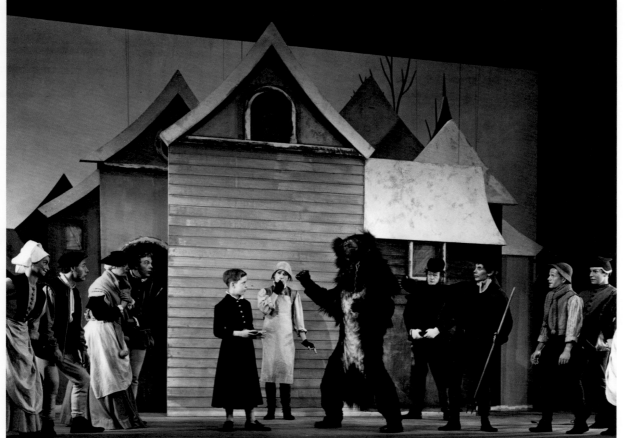

>
III.3, Mistress Ford and Mistress Page (Angela Baddeley)

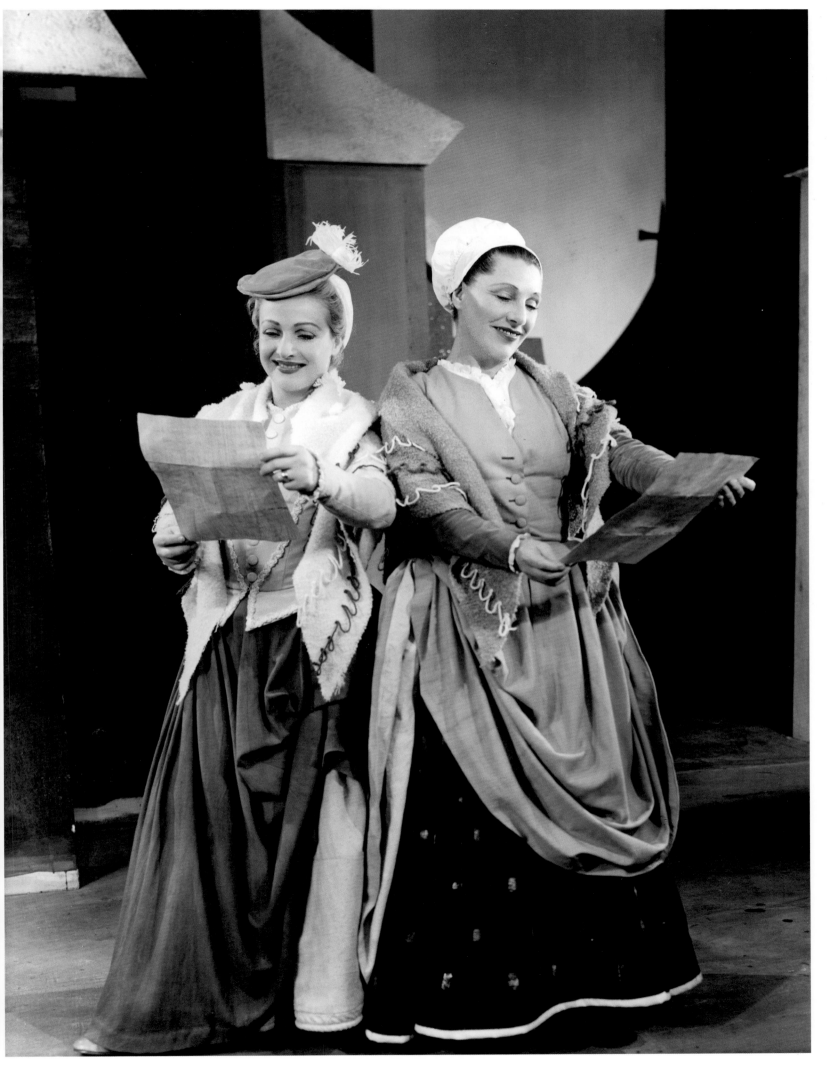

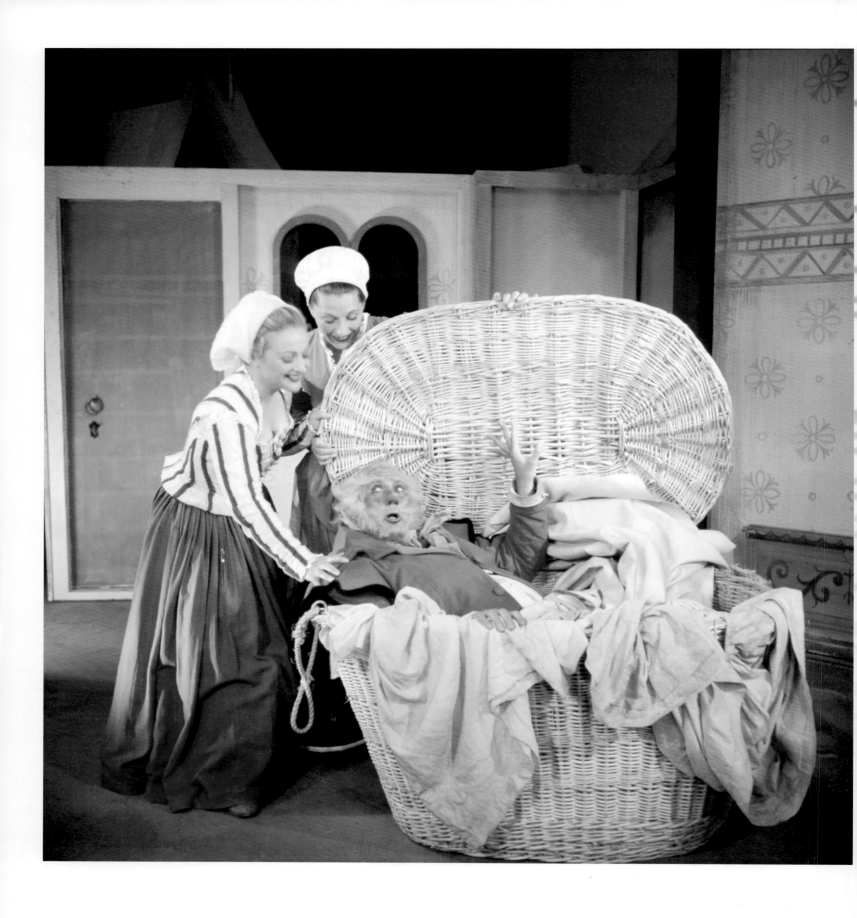

III.3, Mistress Ford, Mistress Page and Falstaff

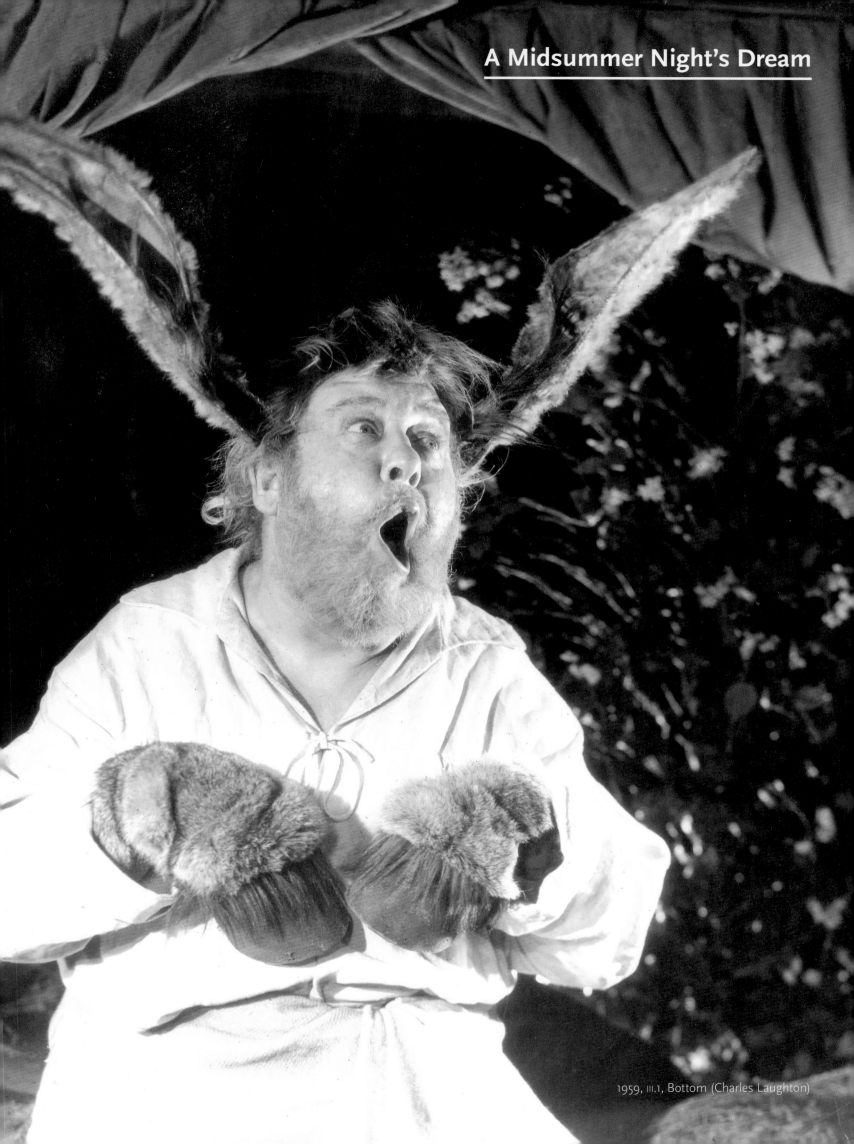

1959, III.1, Bottom (Charles Laughton)

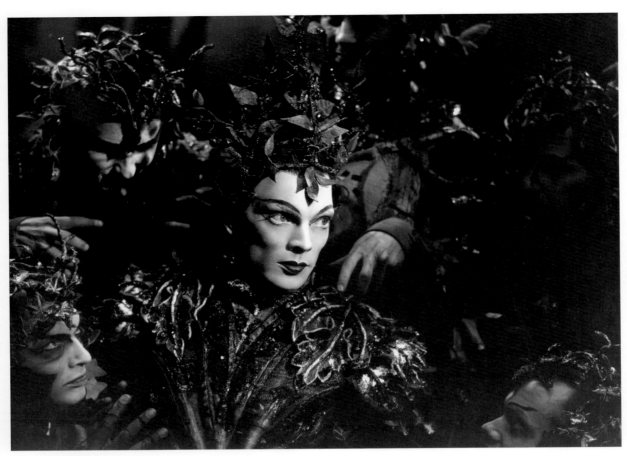

1949, II.2, Oberon (William Squire) and attendants

II.3, Titania (Kathleen Michael) and attendants

>

II.3, Helena (Diana Wynyard)

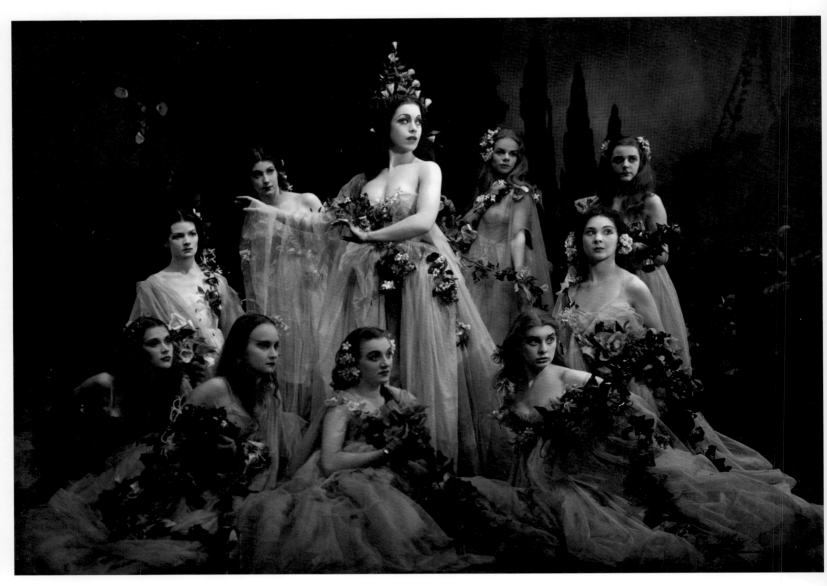

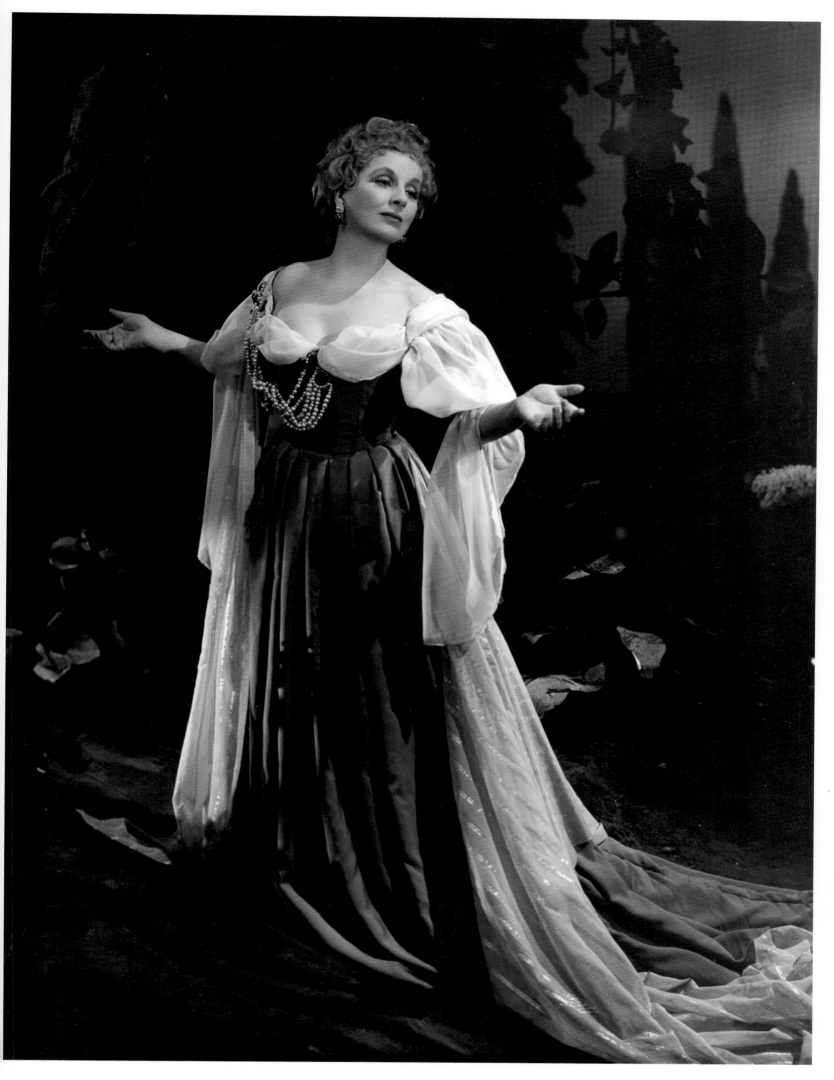

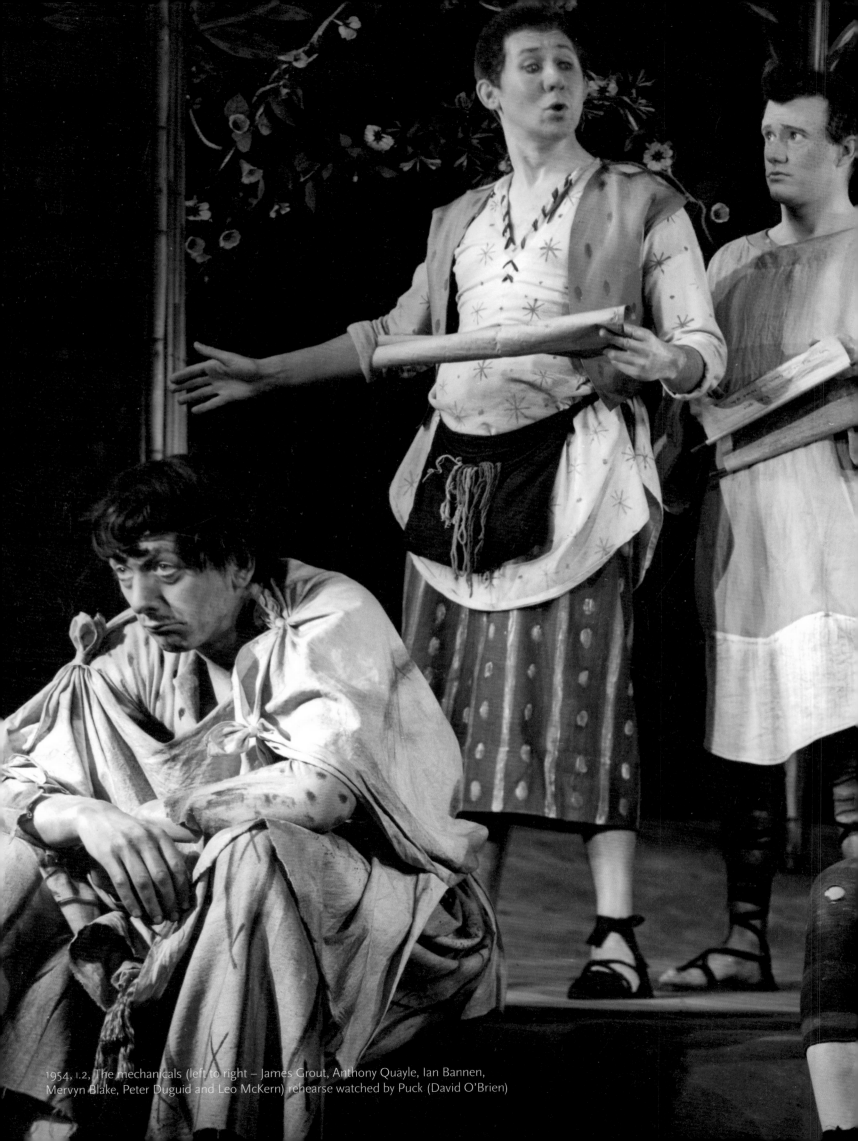

1954, I.2, The mechanicals (left to right – James Grout, Anthony Quayle, Ian Bannen, Mervyn Blake, Peter Duguid and Leo McKern) rehearse watched by Puck (David O'Brien)

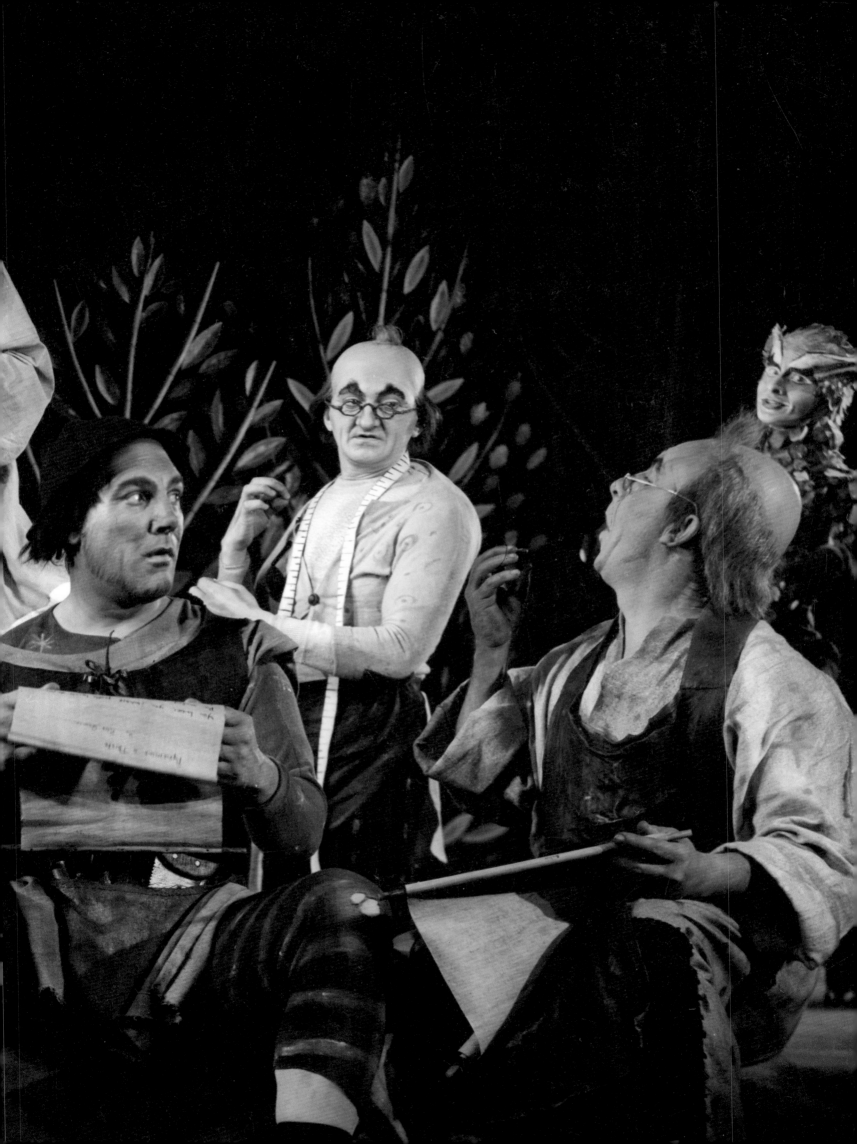

1954, IV.1, Puck

V.1, Bottom (Anthony Qyayle) as Pyramus and Flute (Ian Bannen) as Thisbe

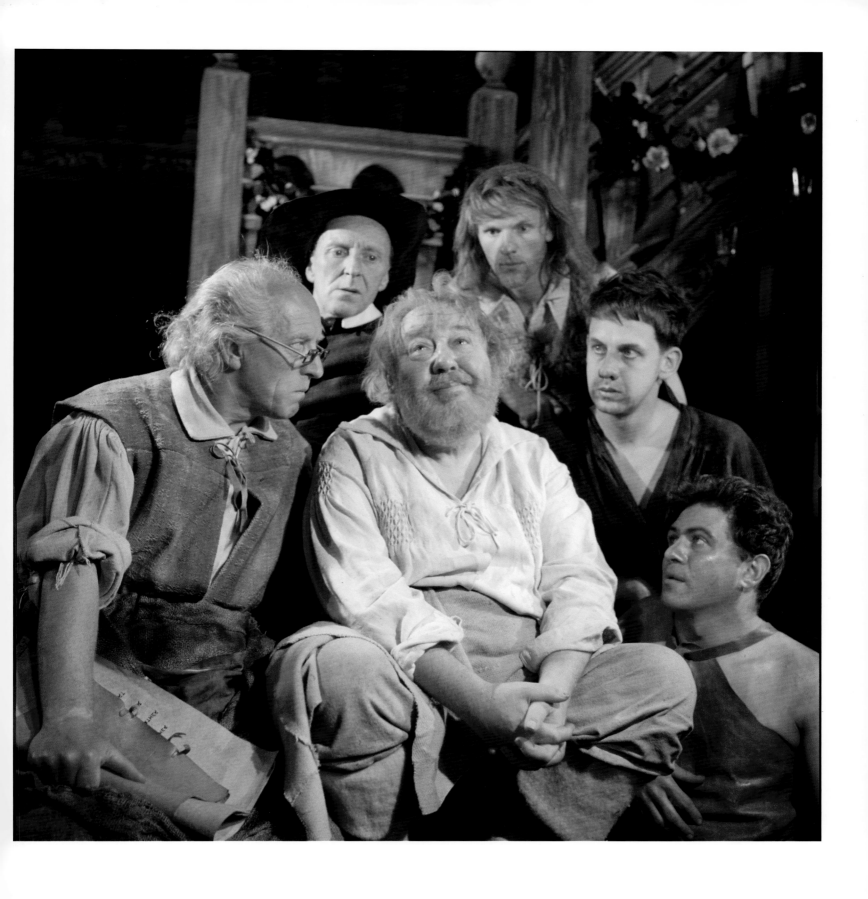

1959, I.2, Bottom surrounded by the mechanicals
(left to right – Cyril Luckham, Robert Eccles, Julian Glover,
Michael Blakemore and Peter Woodthorpe)

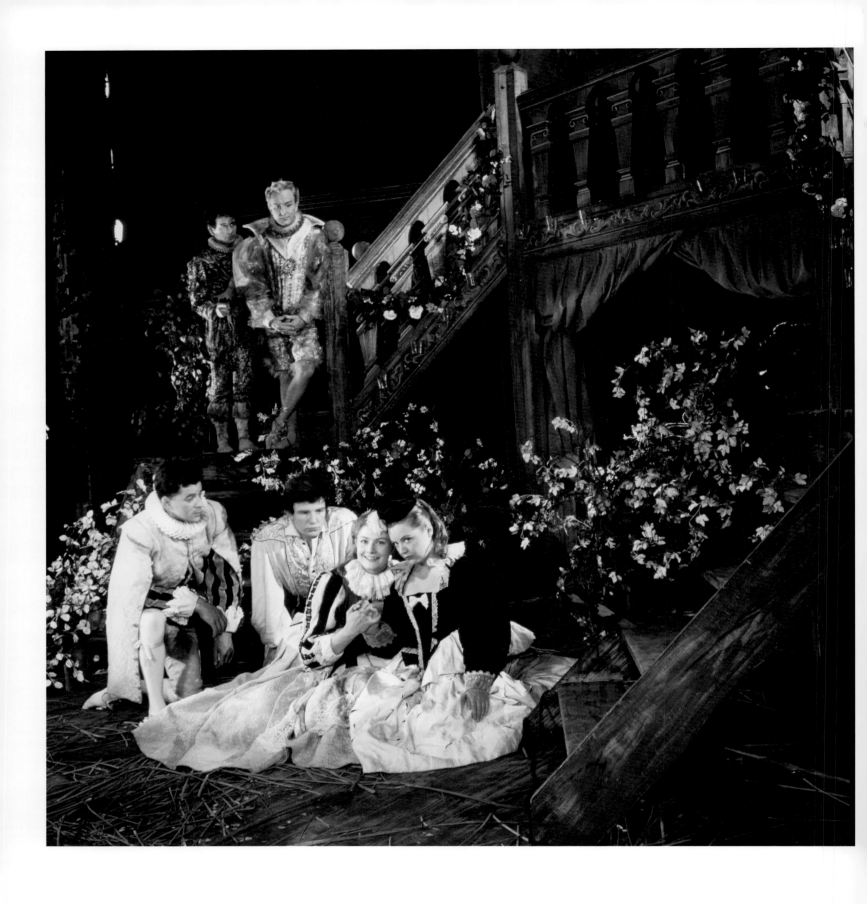

1959, III.2, Puck (Ian Holm) and Oberon
(Robert Hardy) observe the lovers

Hermia (Priscilla Morgan) and Lysander
(Albert Finney)

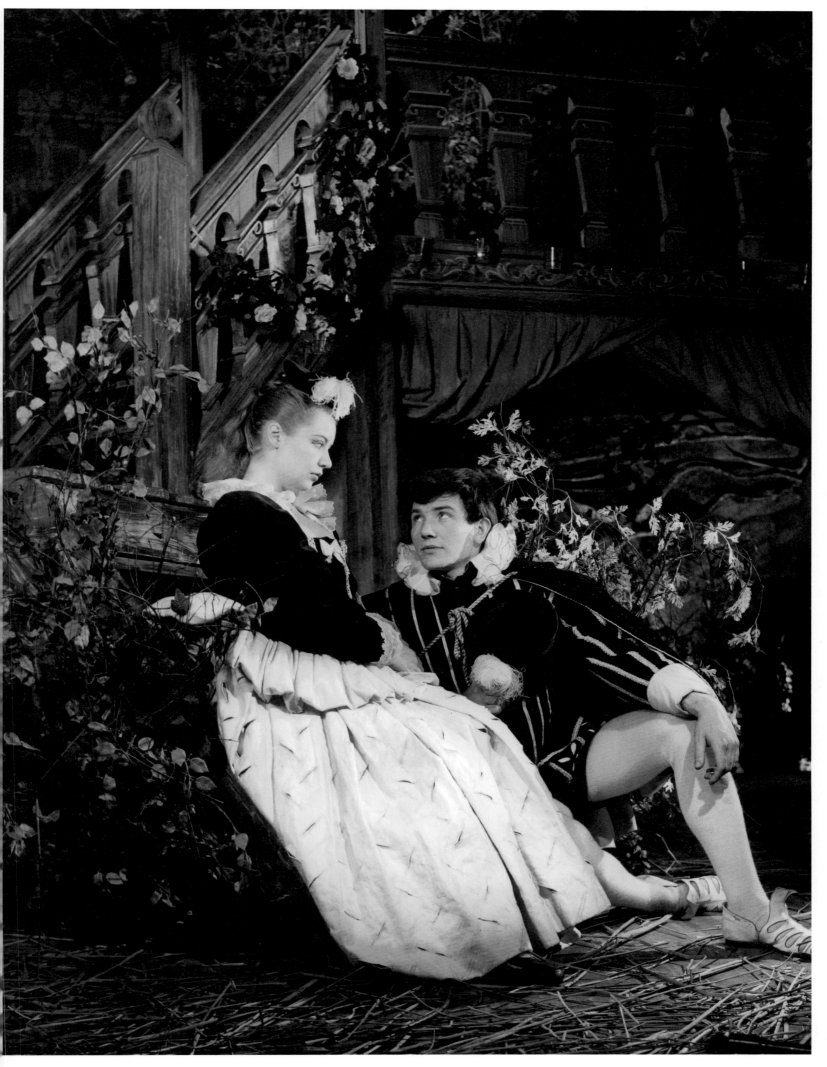

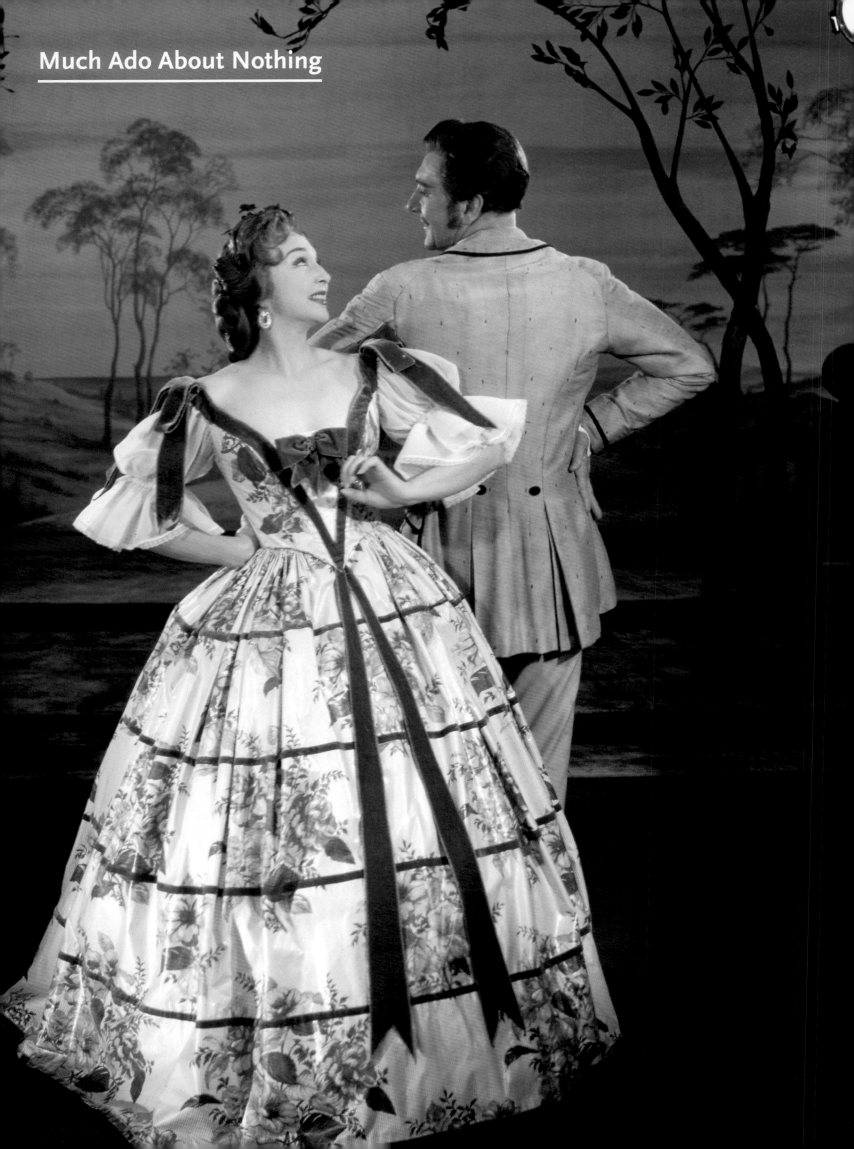

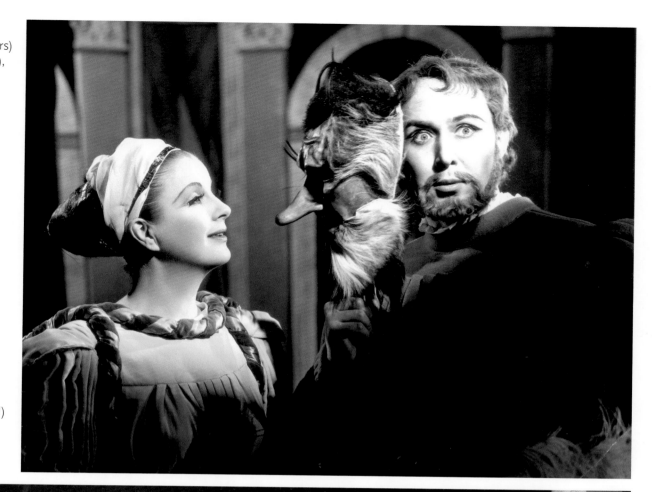

1959, v.2, Beatrice (Googie Withers)
and Benedick (Michael Redgrave),
note McBean's lamp

1949, II.1, Beatrice (Diana Wynyard)
and Benedick (Anthony Quayle)

II.2, Page (Robin Dowell)
and Benedick

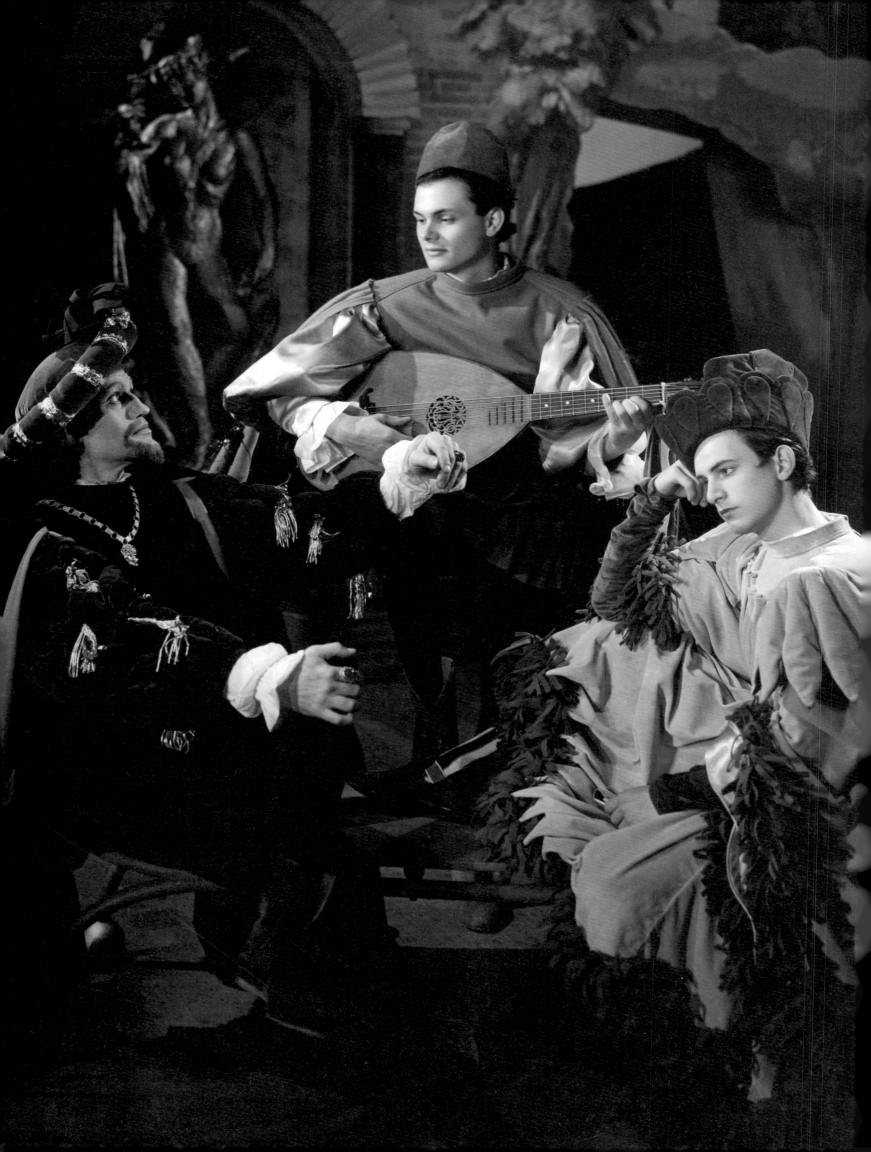

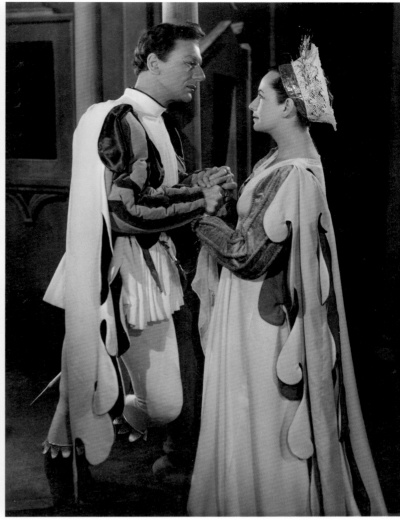

1950, III.4, Margaret (Mairhi Russell), Hero (Barbara Jefford) and Beatrice (Peggy Ashcroft)

IV.1, Benedick (John Gielgud) and Beatrice

V.2, Benedick, Claudio (Eric Launder) Balthazar (John York), Hero, Margaret, Ursula (Maxine Audley) and Beatrice

<

1949, II.3, Don Pedro (Harry Andrews), Balthazar (Paul Hansard) and Claudio (Philip Guard)

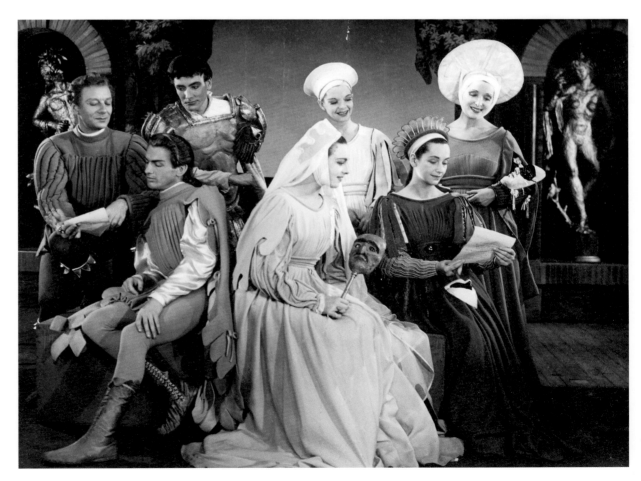

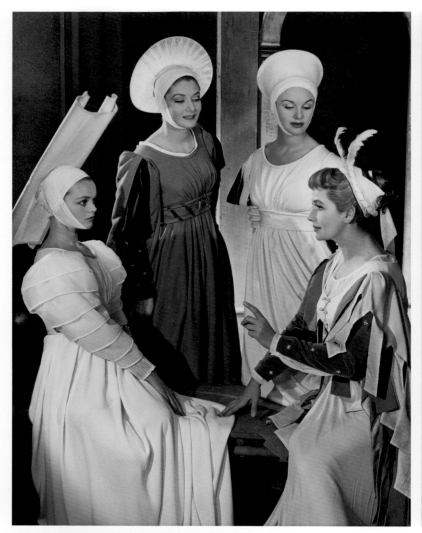

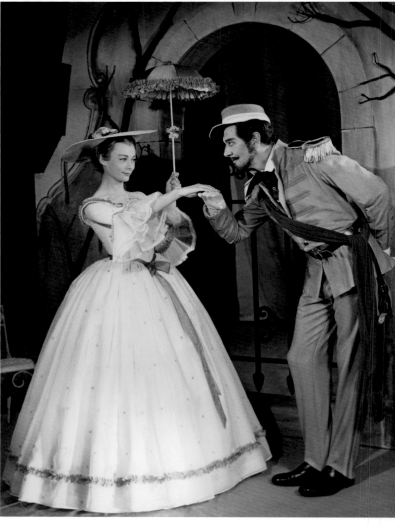

1955, III.4, Hero (Jeanette Sterke), Ursula (Helen Cherry), Margaret (Moira Lister) and Beatrice (Peggy Ashcroft)

1958, I.1, Hero (Geraldine McEwan) and Benedick (Michael Redgrave)

II.3, Leonato (Cyril Luckham), Don Pedro (Anthony Nicholls) and Claudio (Edward Woodward) gull Benedick

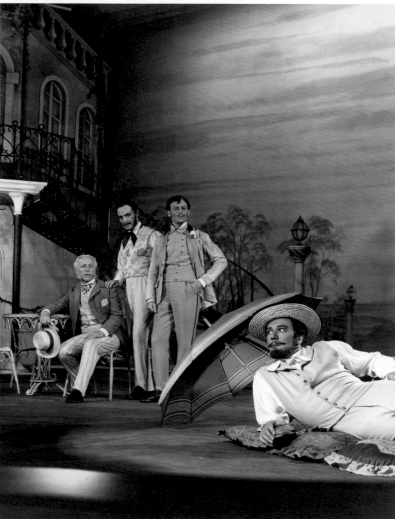

>

1958, III.3, Verges (Ian Holm), the Watch (John Salway, Eric Holmes, John Davidson and Anthony Brown) and Dogbery (Patrick Wymark)

III.4, Ursula (Rachel Kempson), Hero (Geraldine McEwan) and Margaret (Zoe Caldwell)

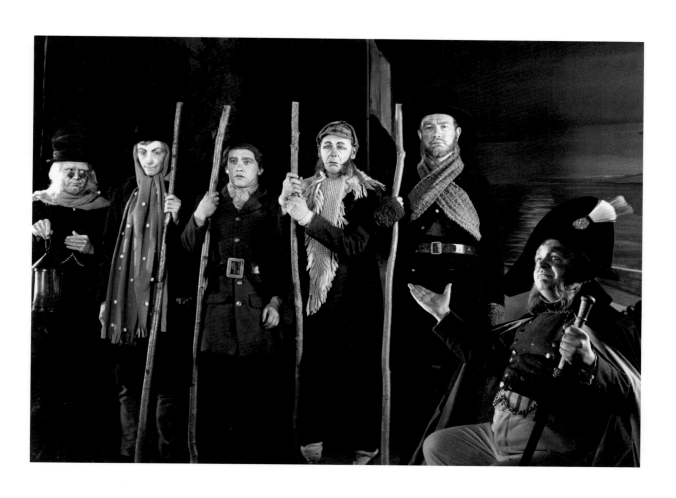

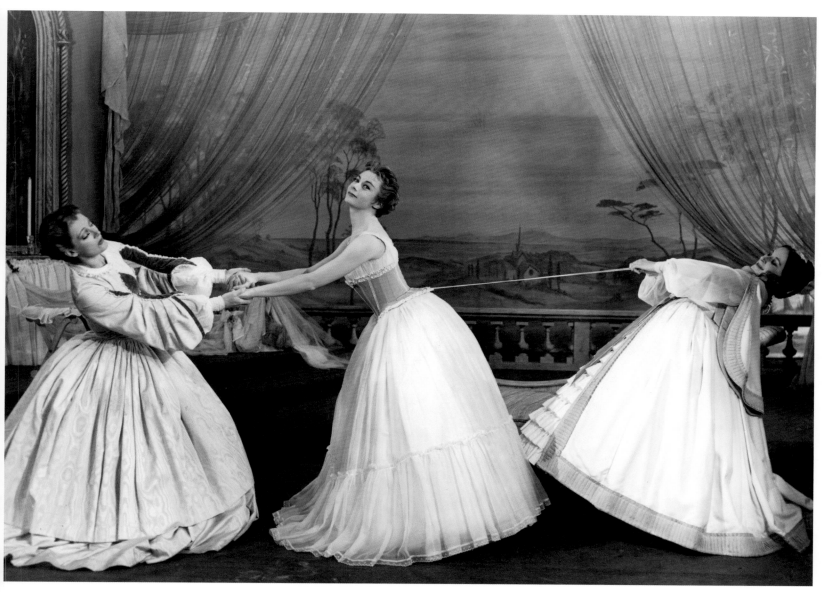

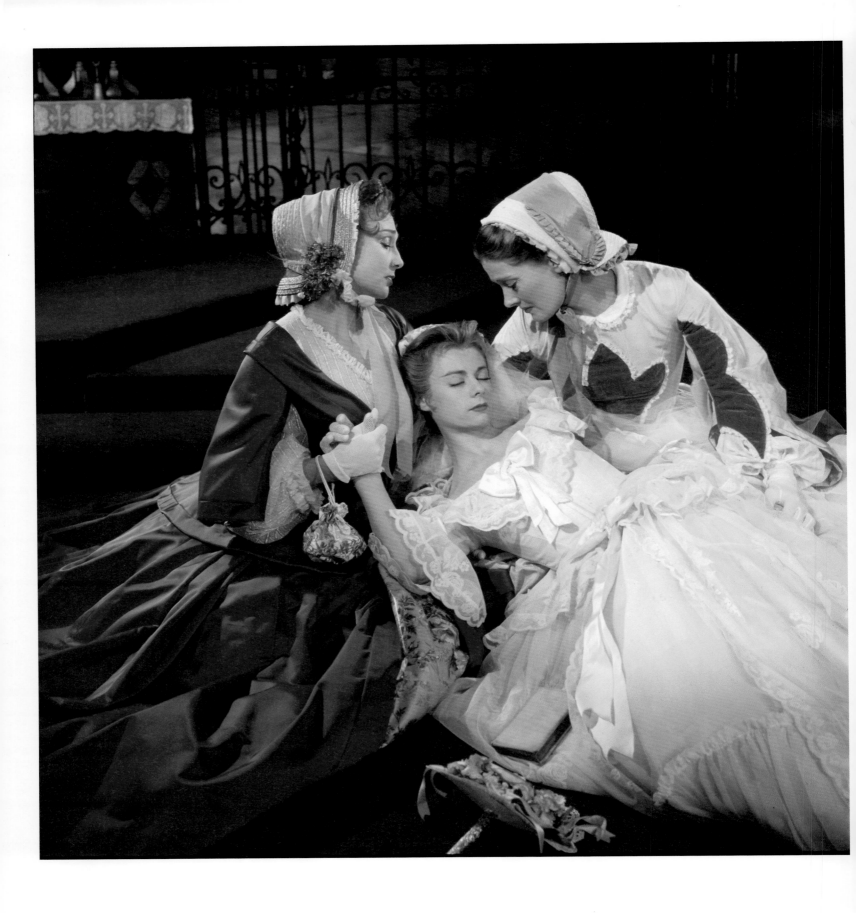

1958, IV.1, Beatrice, Hero and Ursula

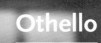

1959, II.3, Othello (Paul Robeson) and Iago (Sam Wanamaker)

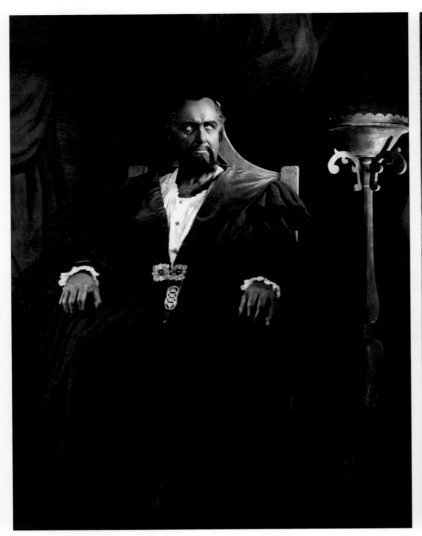

1949, Othello (Godfrey Tearle)

II.1, Desdemona (Diana Wynyard)

III.3, Iago (Anthony Quayle) and
Othello

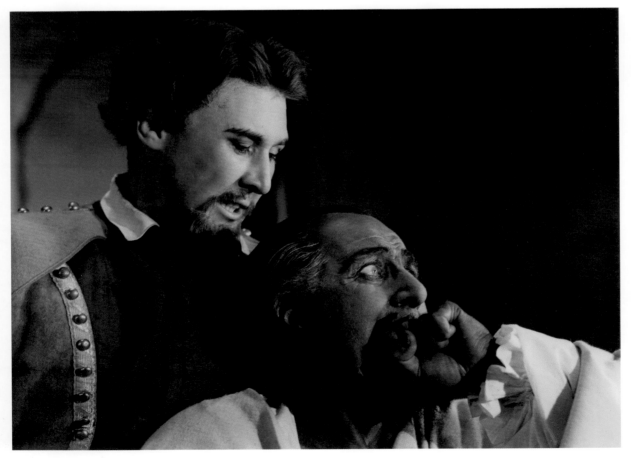

>
1954, II.1, Othello (Anthony Quayle)
and Desdemona (Barbara Jefford)

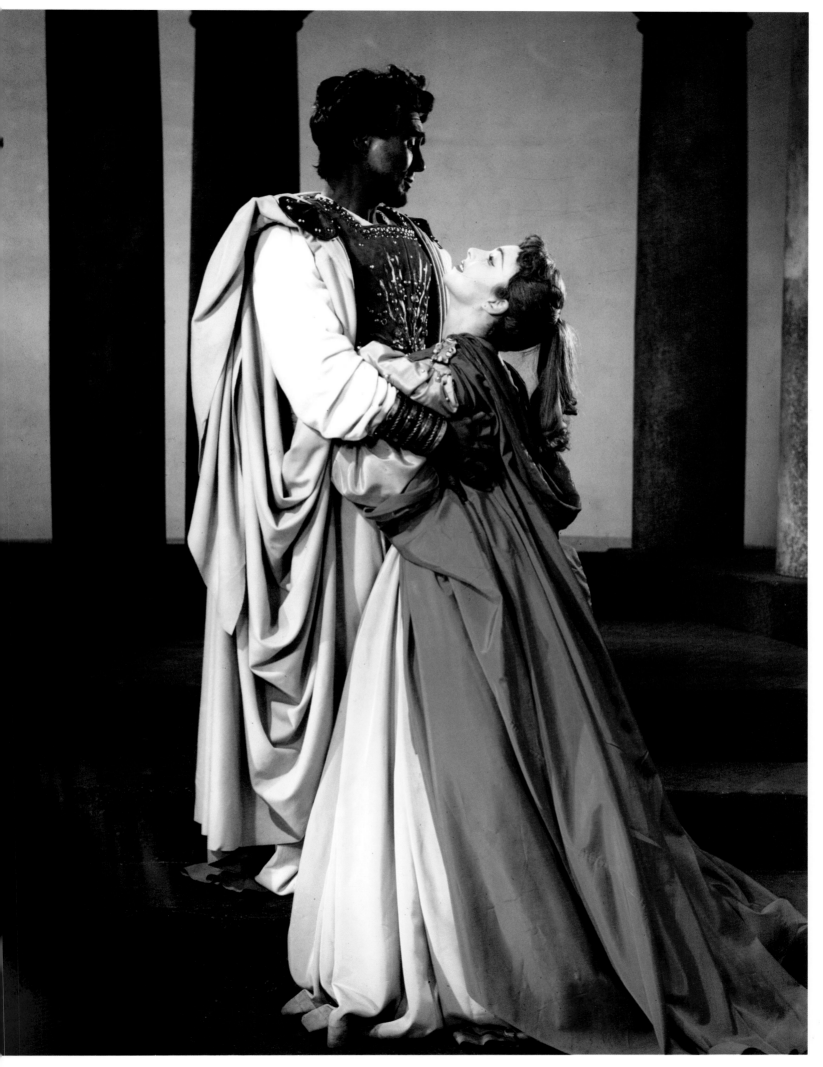

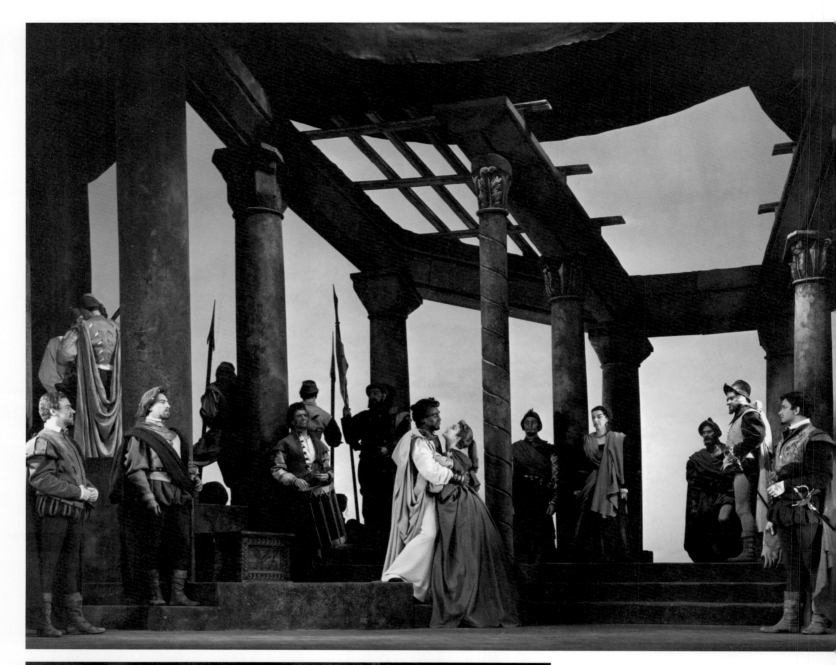

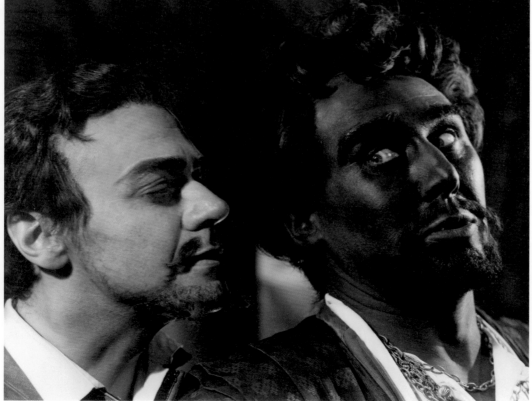

1954, II.1, Othello, Desdemona and company

II.3, Iago (Raymond Westwell) and Othello

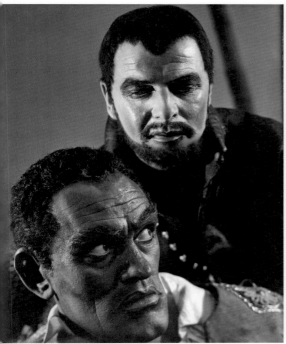

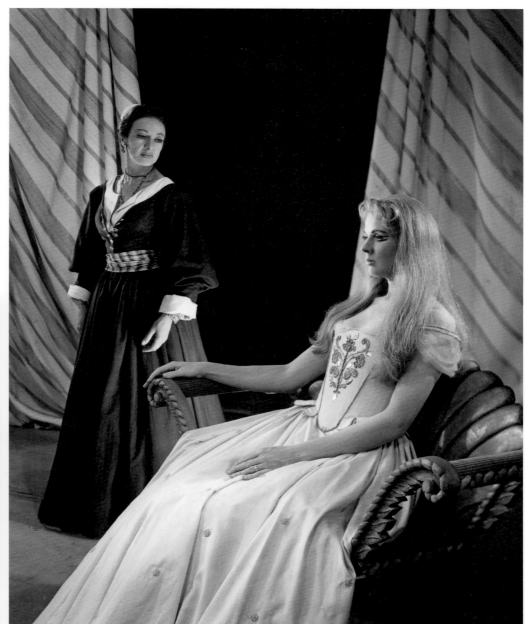

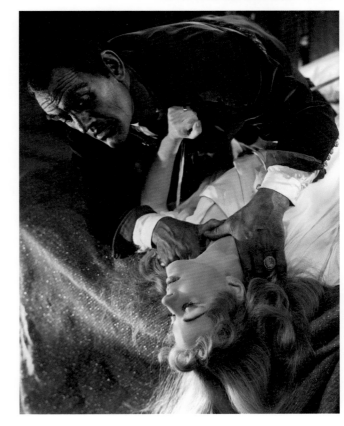

1956, II.3, Othello (Harry Andrews)
and Iago (Emlyn Williams)

v.3, Emilia (Diana Churchill) and
Desdemona (Margaret Johnston)

v.2, Othello and Desdemona

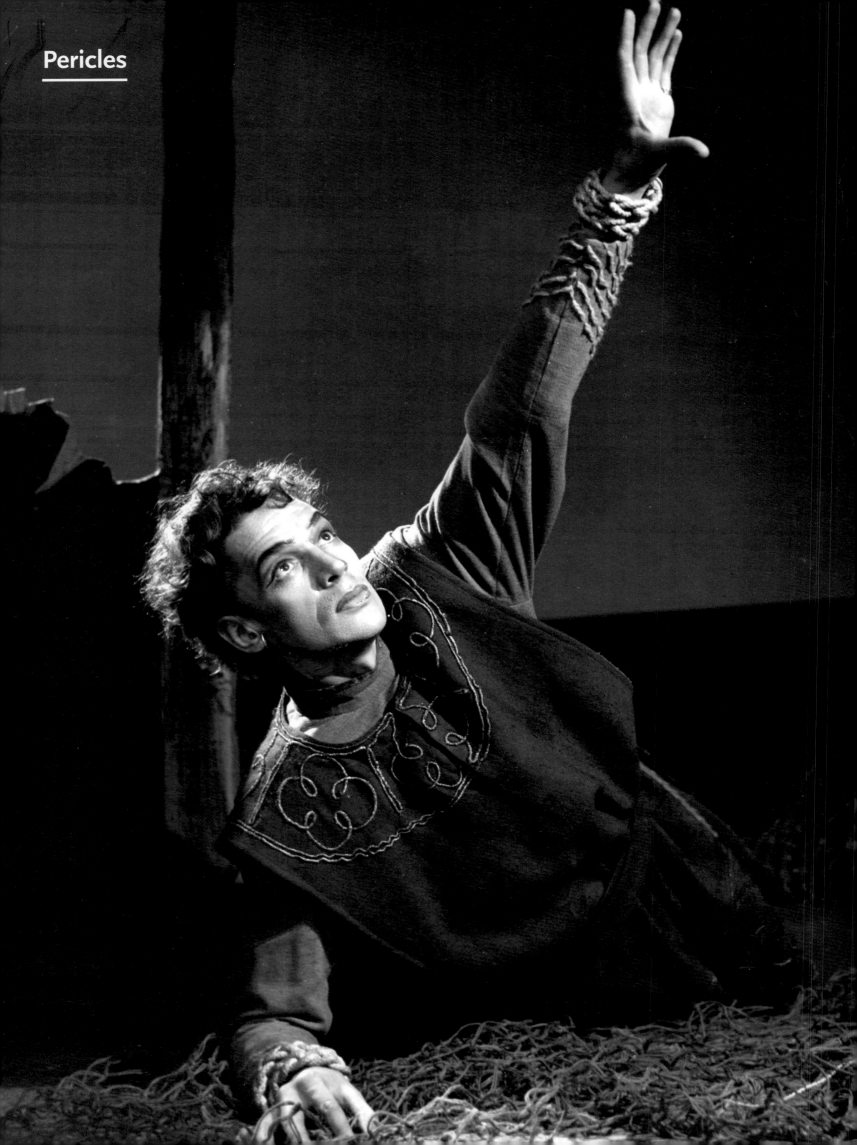

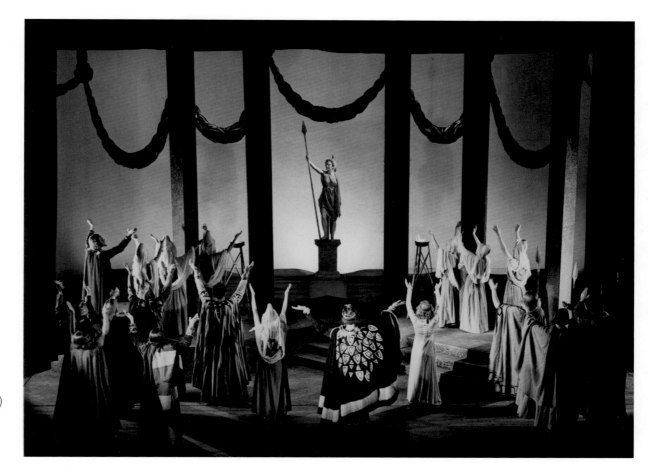

1947, II.1, Pericles (Paul Scofield)

1947, V.2, Pericles and attendants
arrive at the Temple of Diana

V.2, Pericles, Thaisa (Irene Sutcliffe)
and Marina (Daphne Slater)

1958, II.1 interlude, Gower
(Edric O'Connor) and the sailors

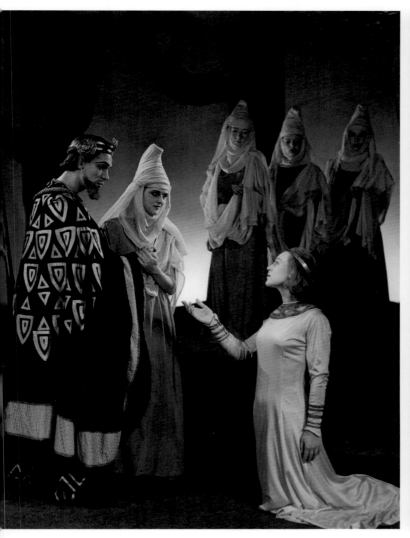

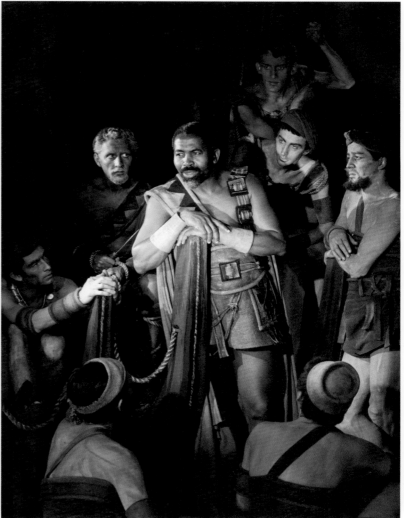

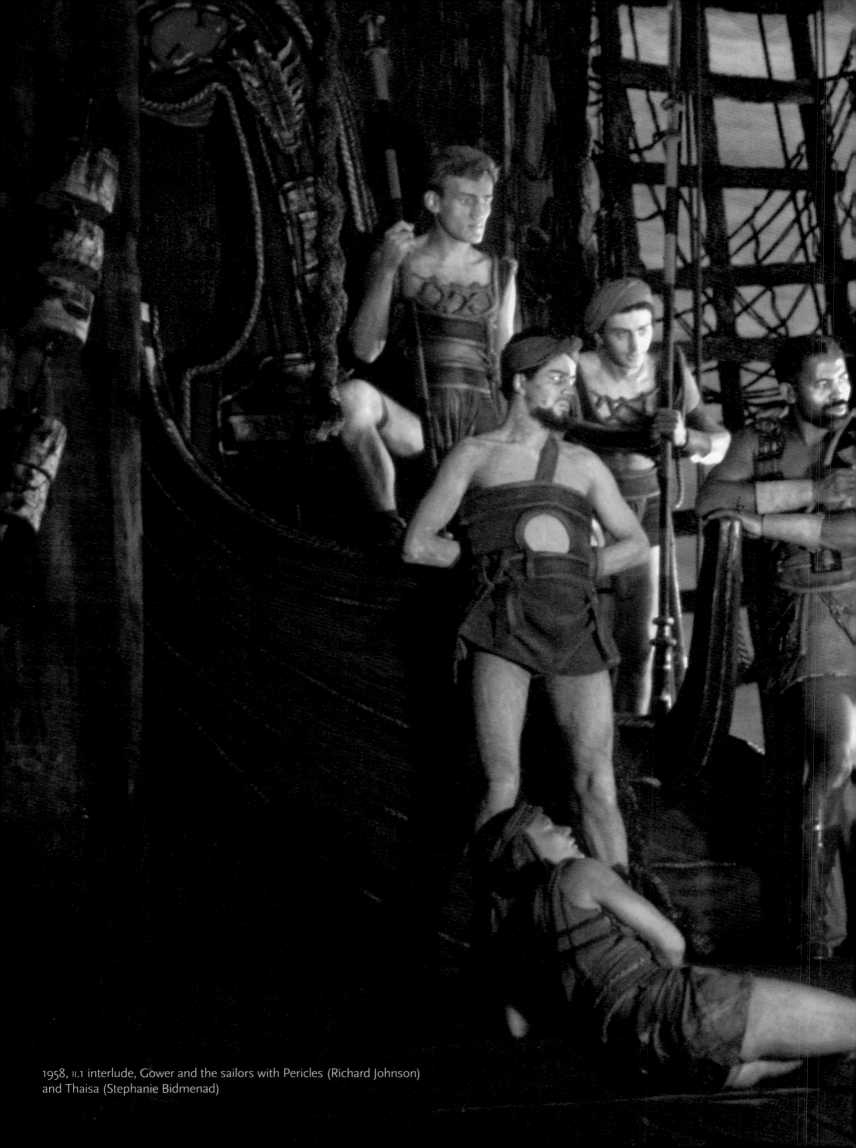

1958, ɪɪ.1 interlude, Gower and the sailors with Pericles (Richard Johnson) and Thaisa (Stephanie Bidmenad)

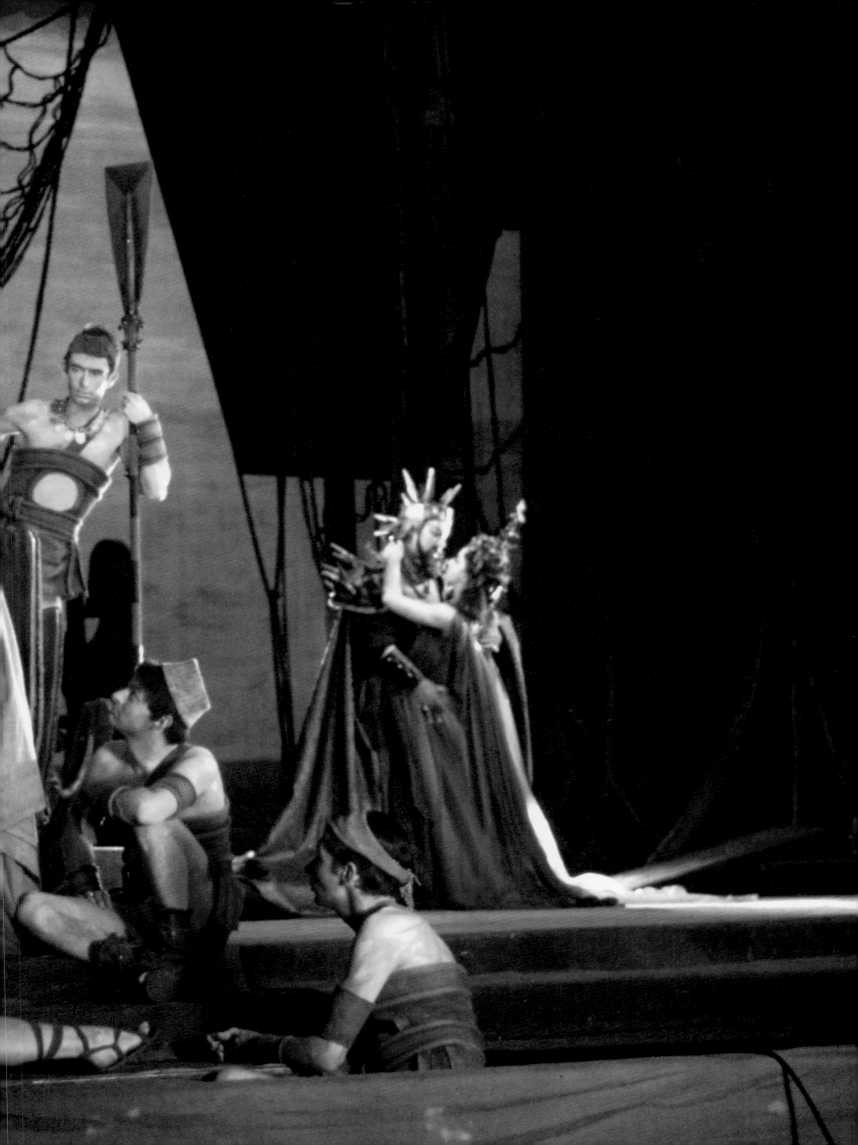

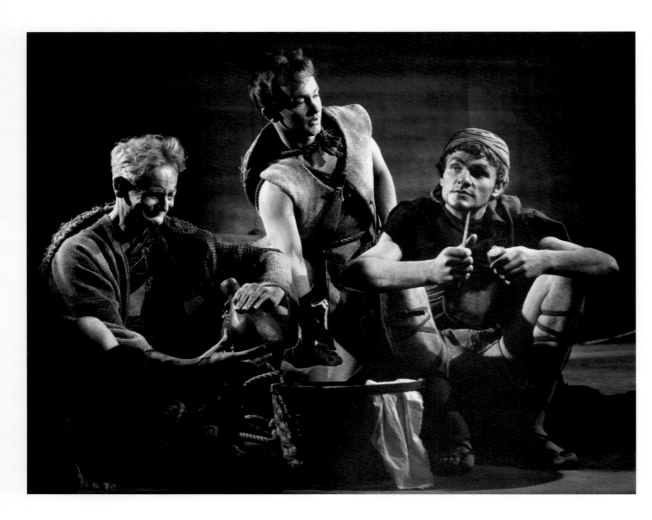

1958, II.2, The fishermen
(John Davidson, Eric Holmes and
Julian Glover)

III.1, Pericles and the body of Thaisa

IV.5, The Bawd (Angela Baddeley)

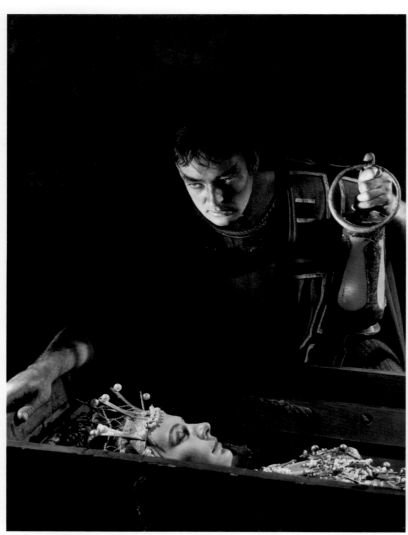

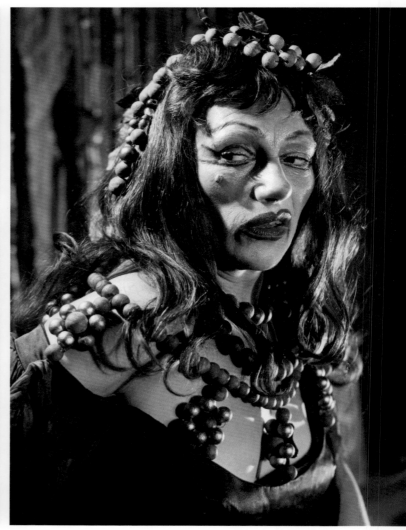

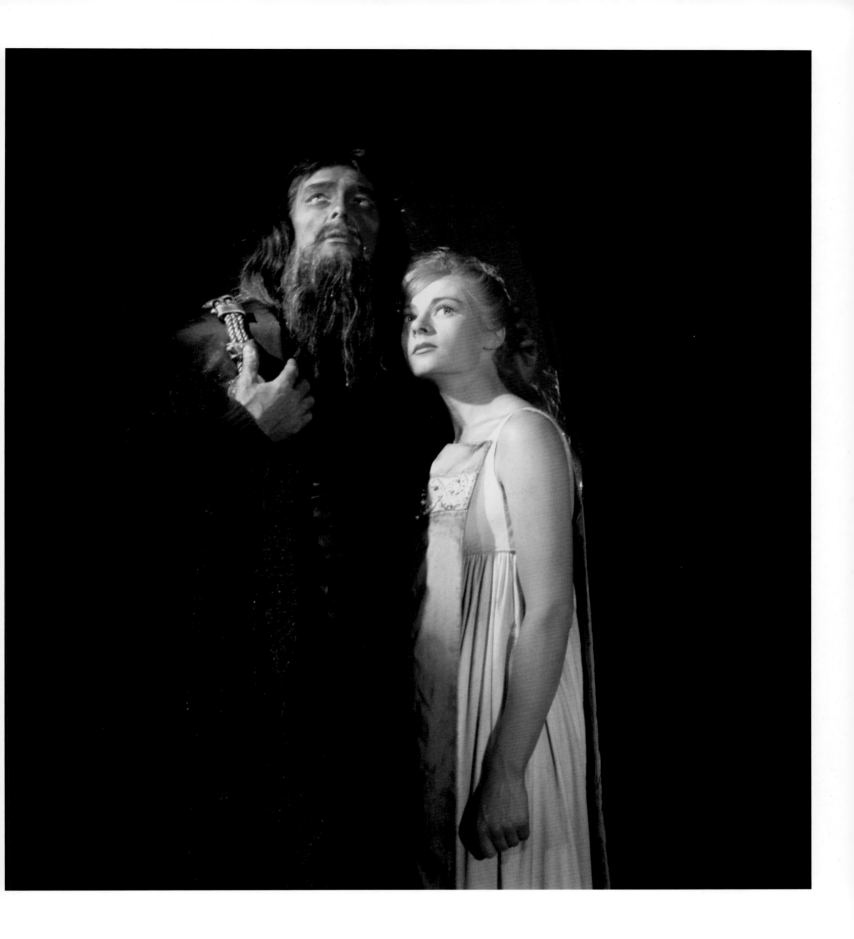

Pericles and Marina (Geraldine McEwan)

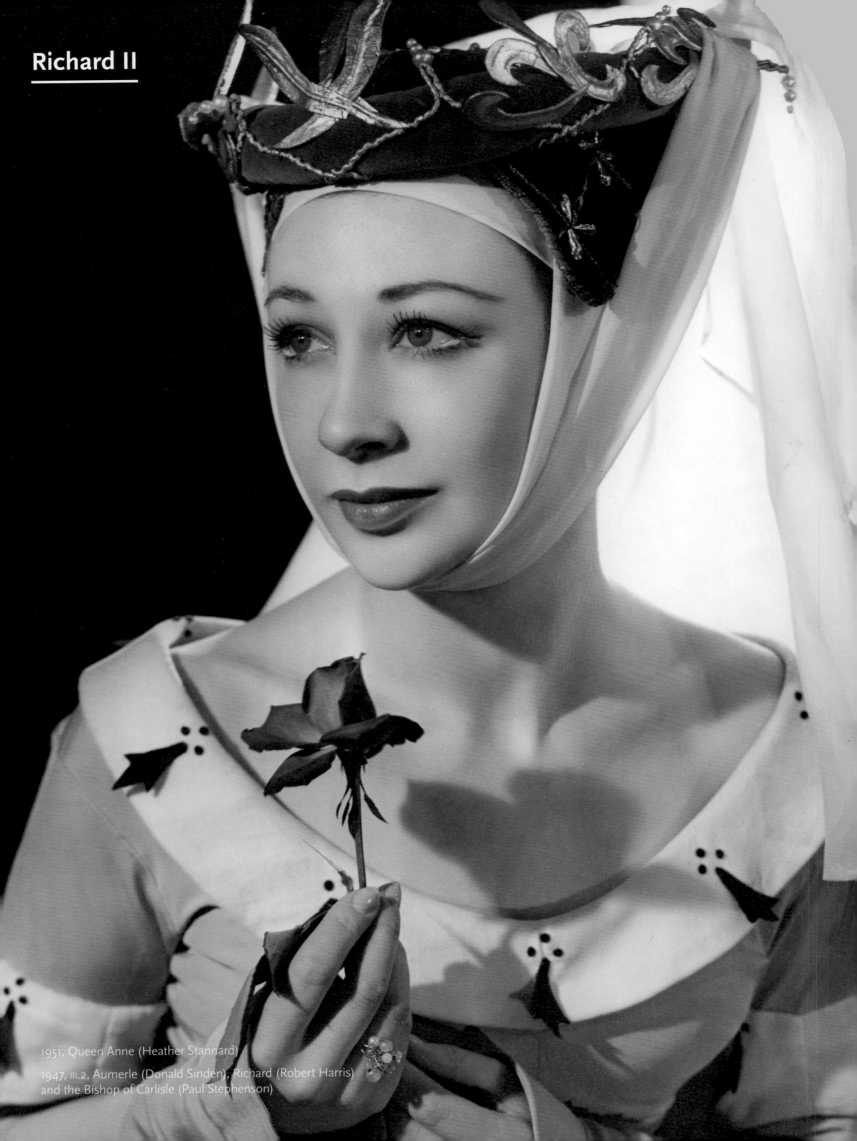

Richard II

1951, Queen Anne (Heather Stannard)

1947, III.2, Aumerle (Donald Sinden), Richard (Robert Harris)
and the Bishop of Carlisle (Paul Stephenson)

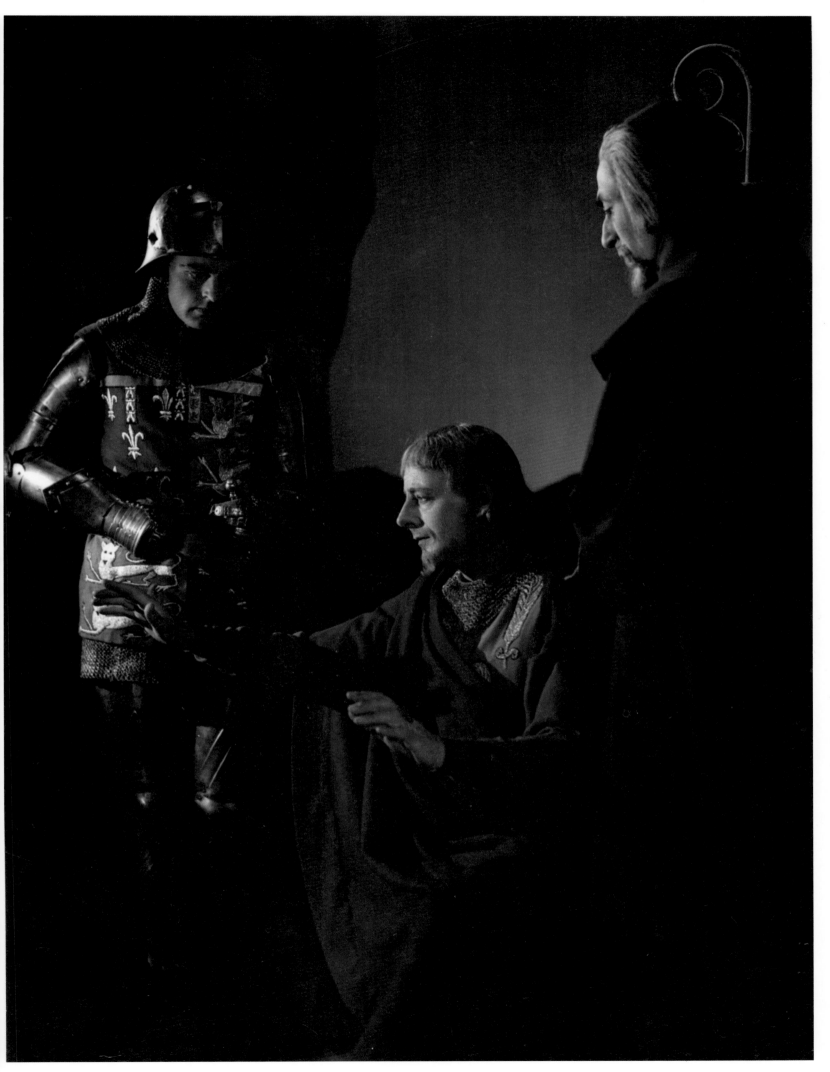

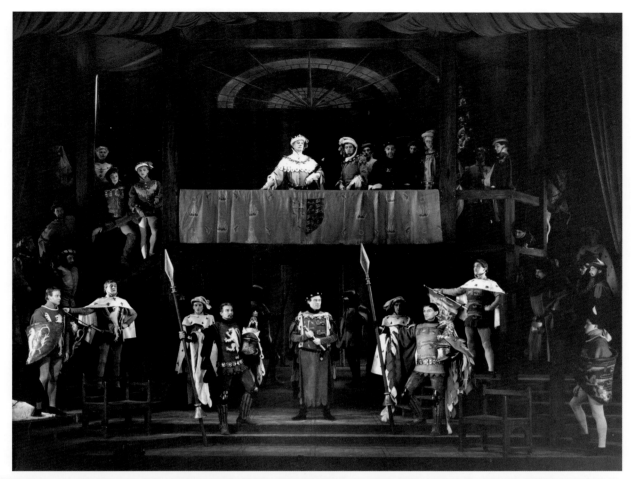

1947, v.1, Queen Anne (Joy Parker) and Richard

1951, i.3, Richard (Michael Redgrave) presides over the combat between Mowbray (William Fox) and Bolingbroke (Harry Andrews)

iv.1, Bolingbroke is given the crown by Richard

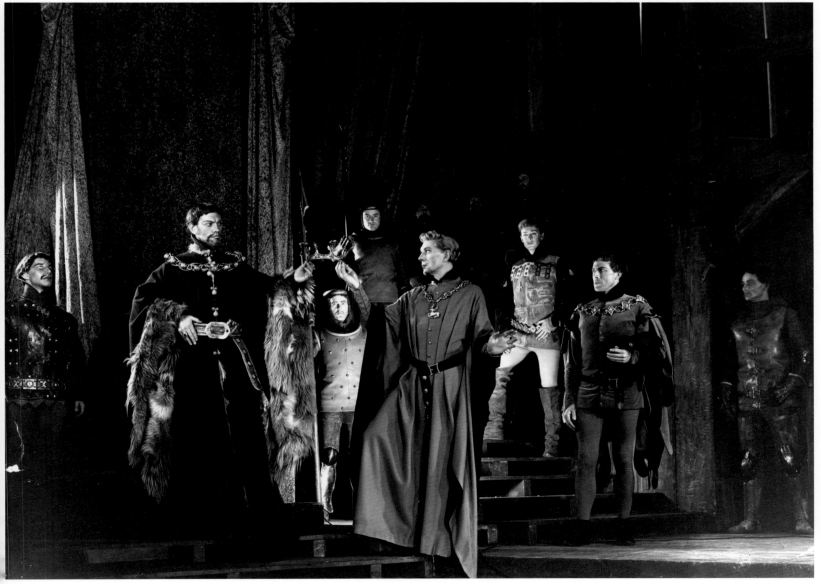

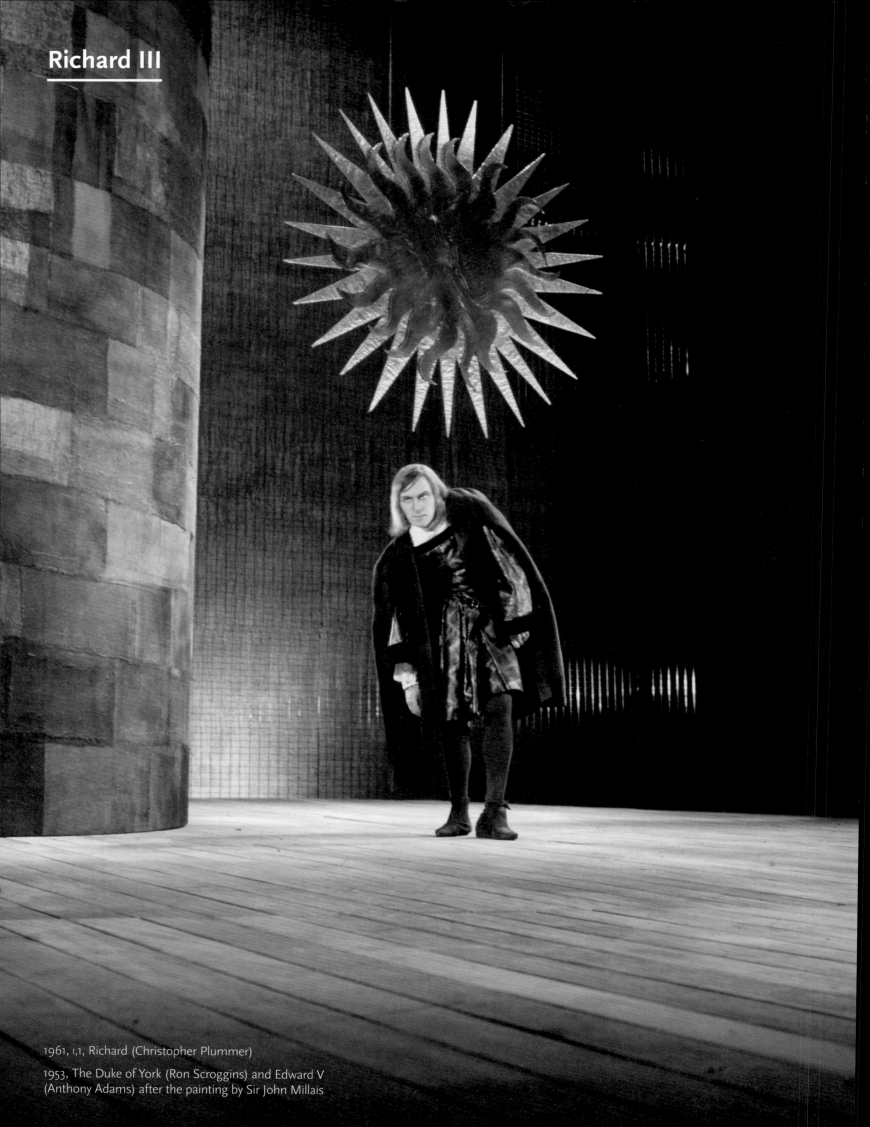

Richard III

1961, 1,1, Richard (Christopher Plummer)

1953, The Duke of York (Ron Scroggins) and Edward V
(Anthony Adams) after the painting by Sir John Millais

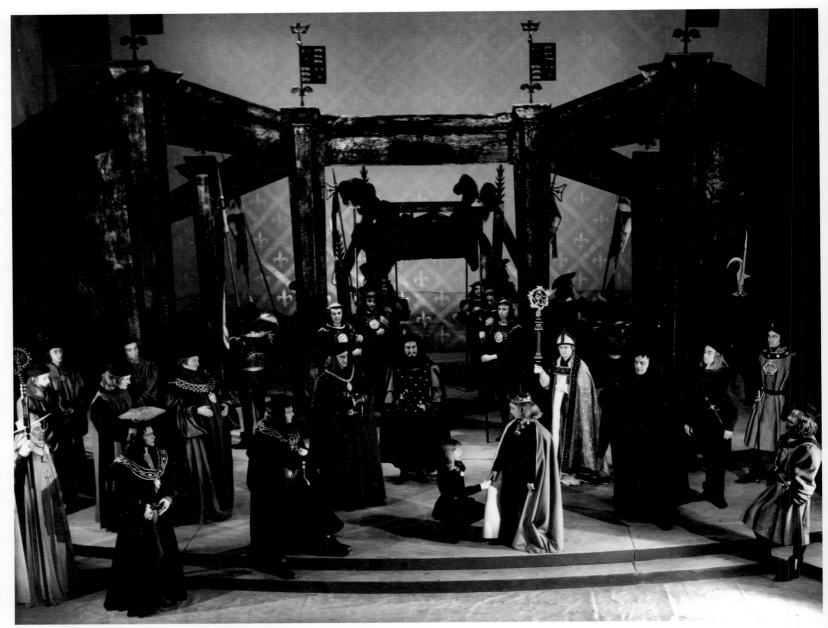

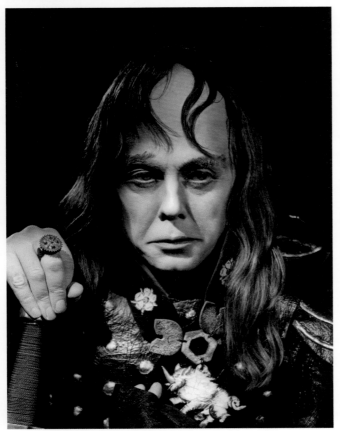

1953, III.1, The Duke of York kneels to his brother, Edward V

V.3, Richard (Marius Goring) on the eve of Bosworth

>

IV.2, Richard enthroned

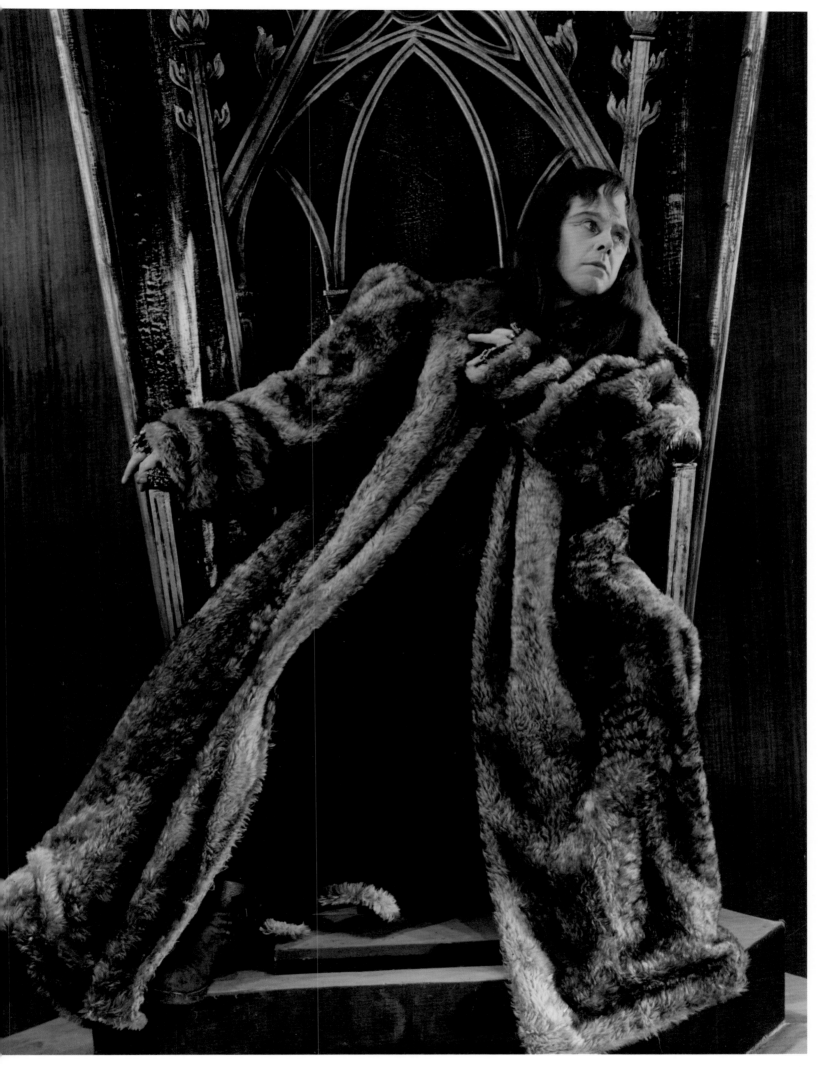

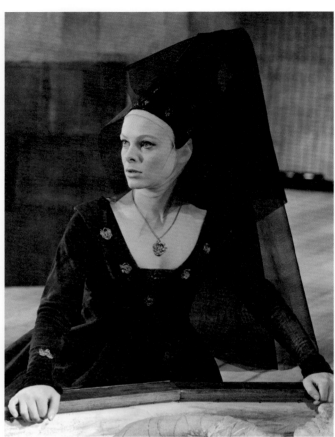

1961, I.2, Lady Anne (Jill Dixon)

I.2, Richard (Christopher Plummer) wooing Lady Anne

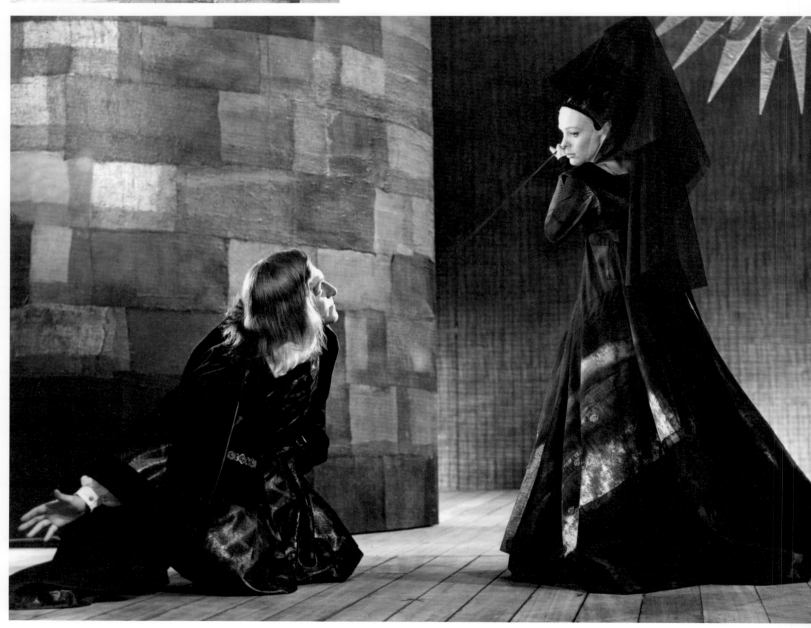

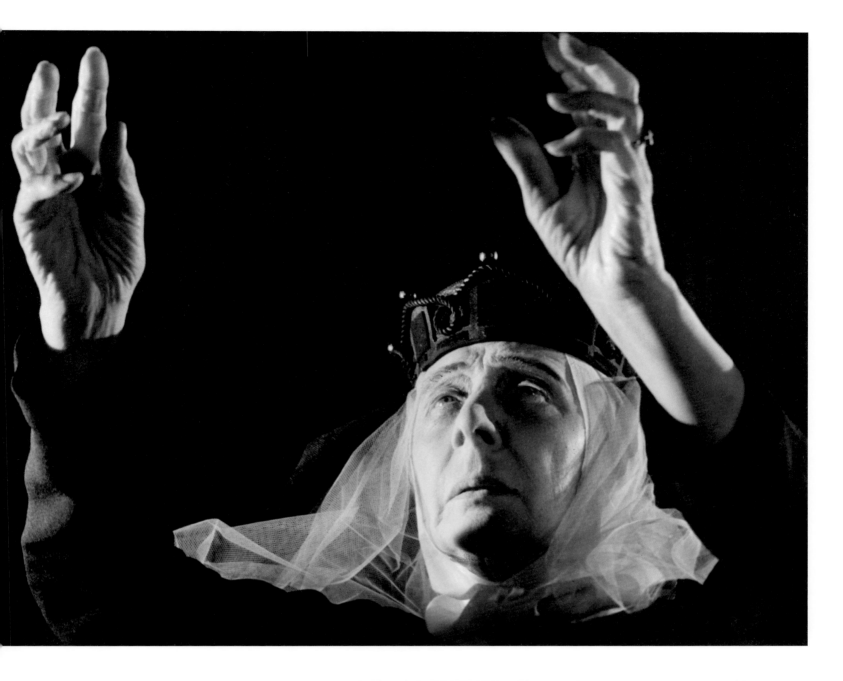

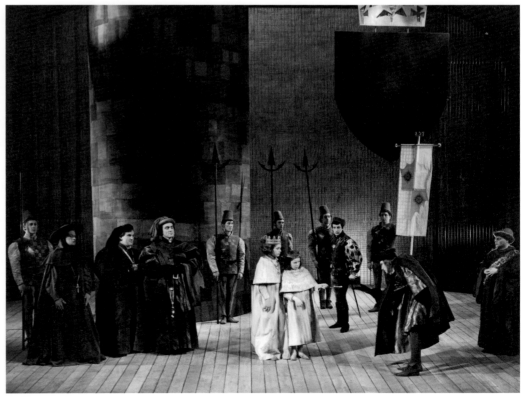

.3, Queen Margaret (Edith Evans)

I.1, Richard bows to Edward V (Richard Lewis)
and the Duke of York (Adrian Blount)

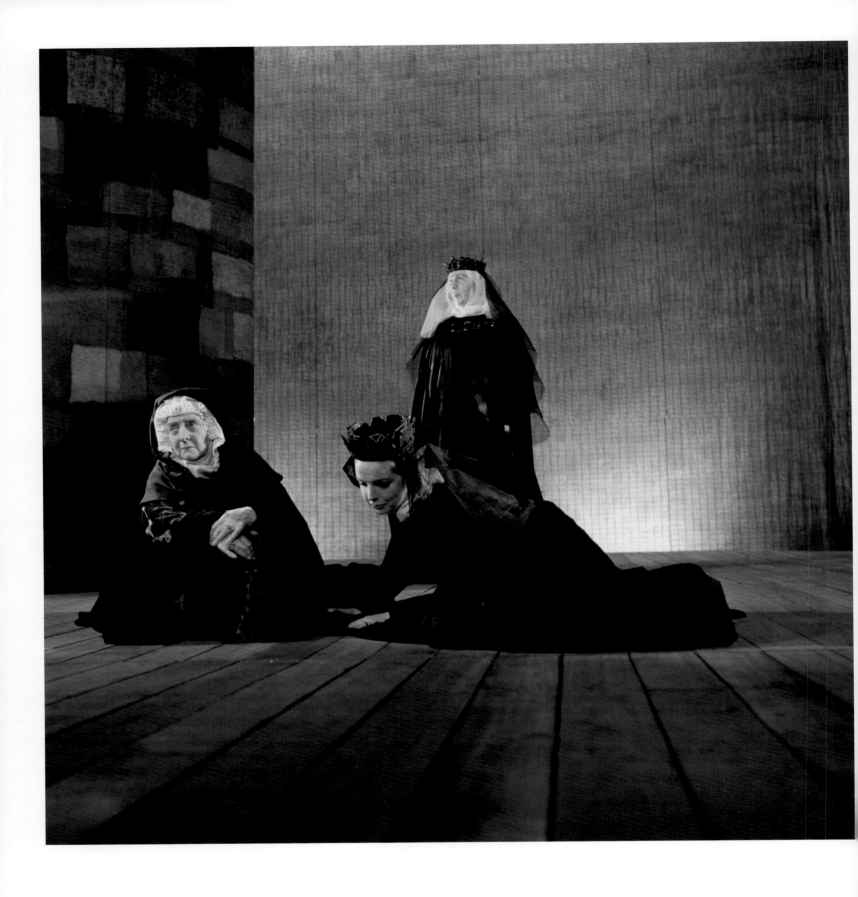

1961, IV.4, The Duchess of York (Esme Church)
Queen Elizabeth (Elizabeth Sellars) and Queen Margaret

V.5, Richmond (Brian Murray) kills Richard

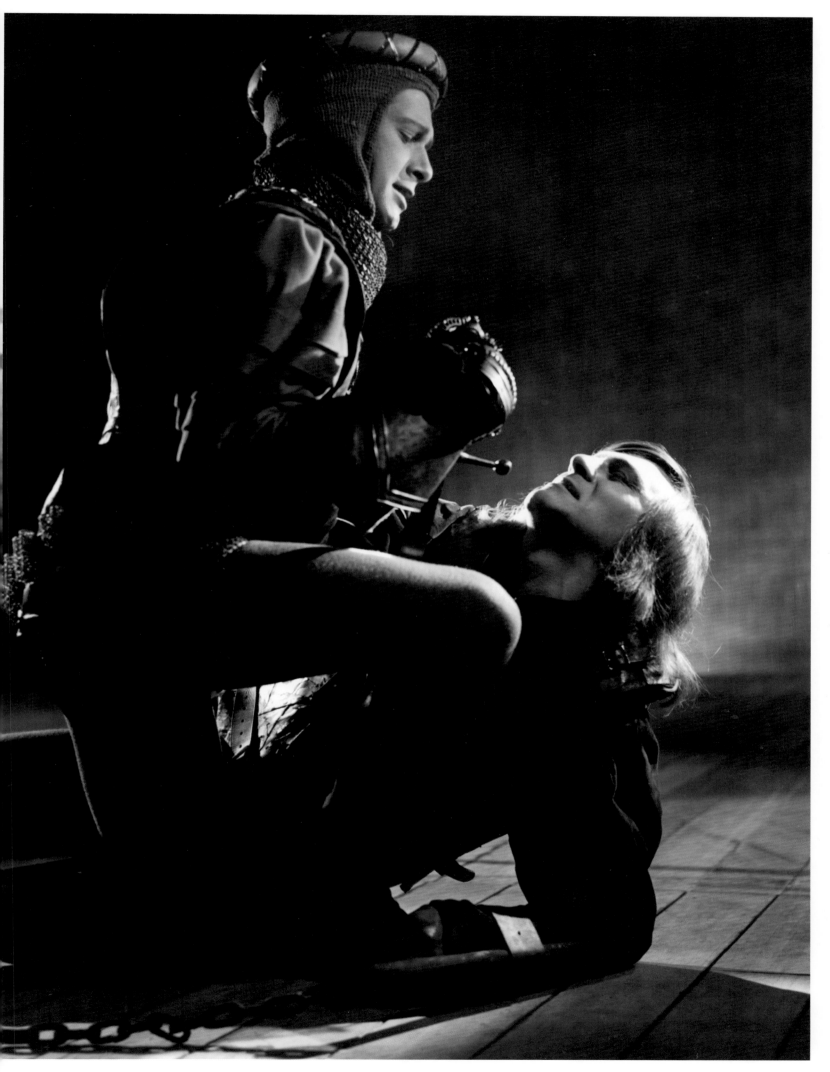

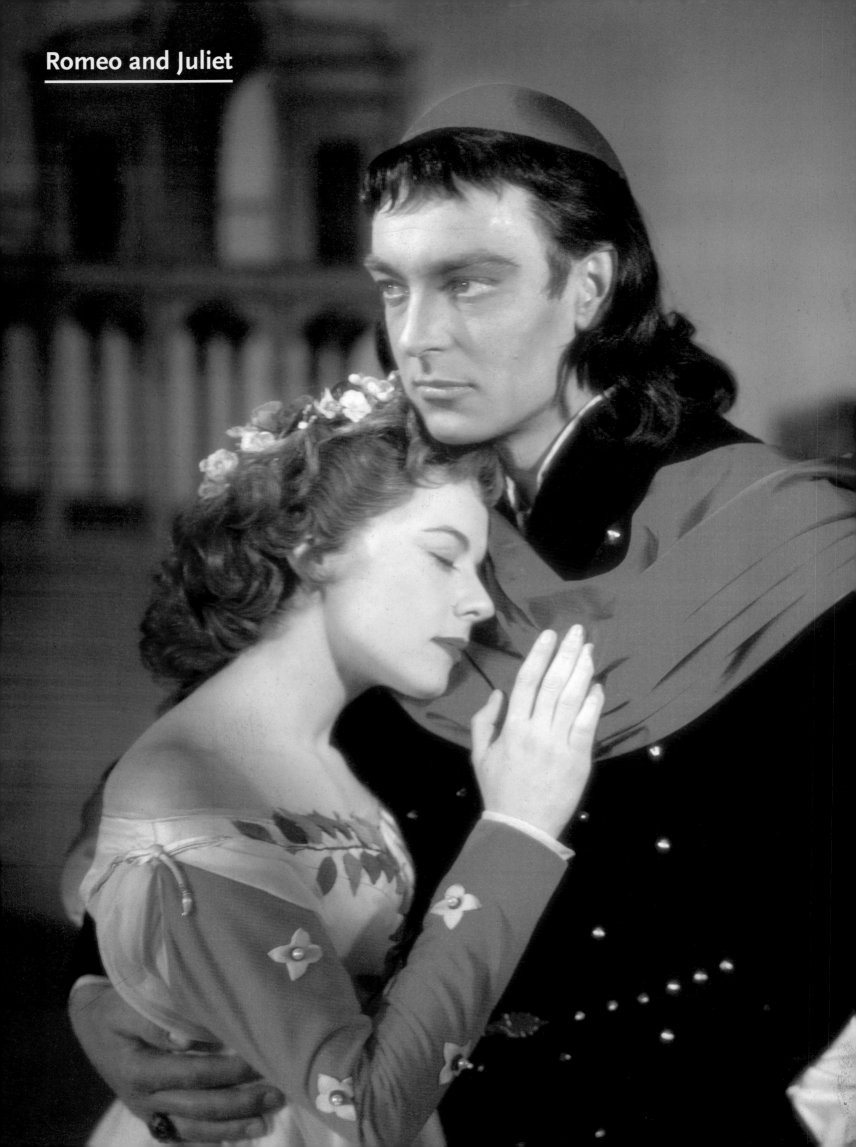

Romeo and Juliet

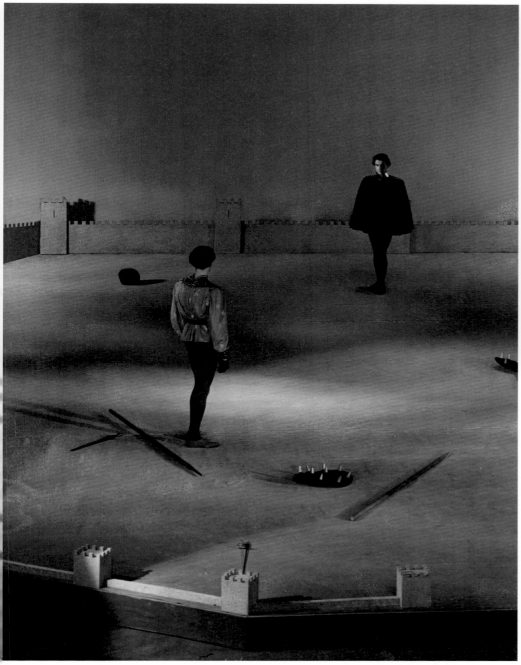

1947, I.1, Benvolio (John Harrison) and
Romeo (Laurence Payne)

IV.3, Juliet (Daphne Slater)

V.1, Romeo

<

1958, III.5, Juliet (Dorothy Tutin) and
Romeo (Richard Johnson)

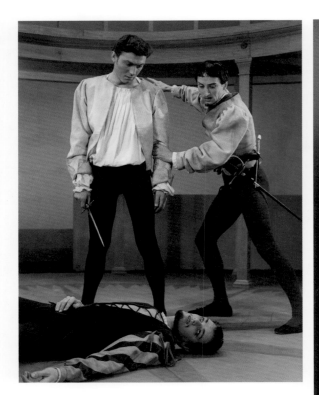

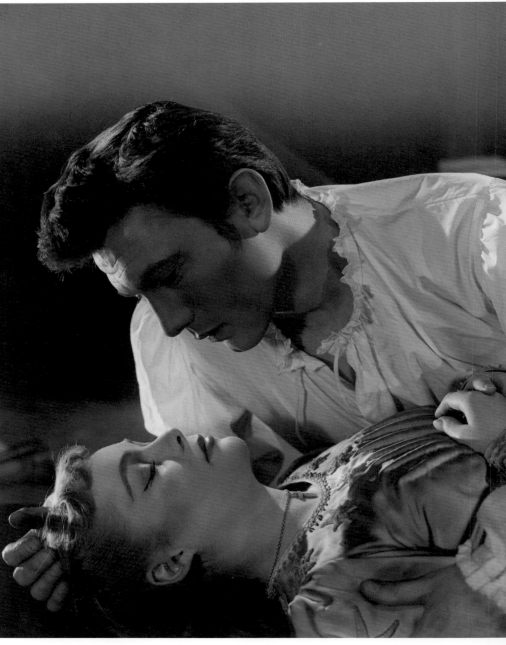

1954, III.1, Romeo (Laurence Harvey), Benvolio (Powys Thomas) and the body of Tybalt (Keith Michell)

v.3, Juliet (Zena Walker) and Romeo

1958, II.4, The Nurse (Angela Baddeley)

>

1958, III.5, Juliet (Dorothy Tutin)

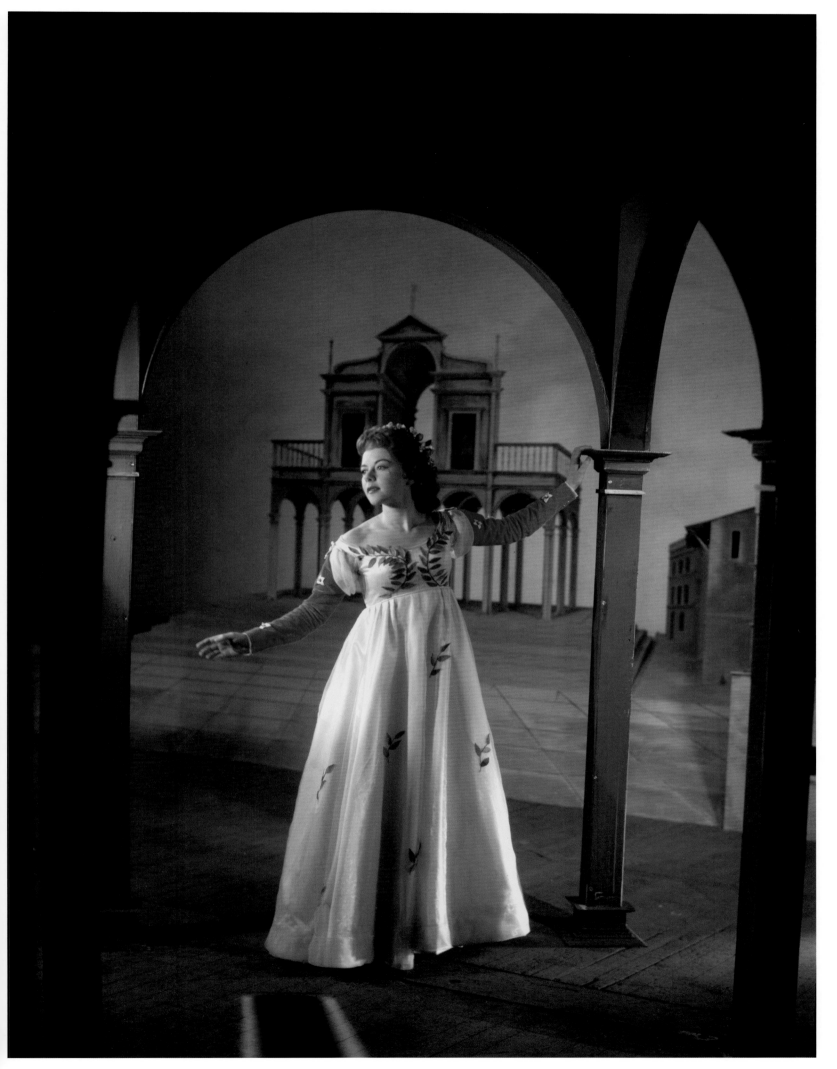

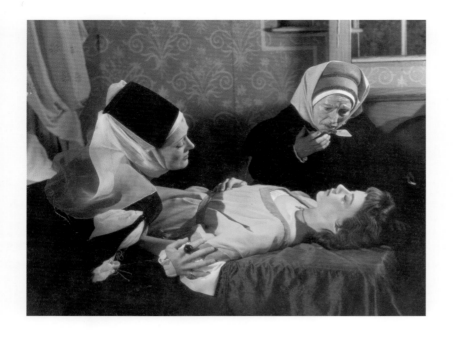

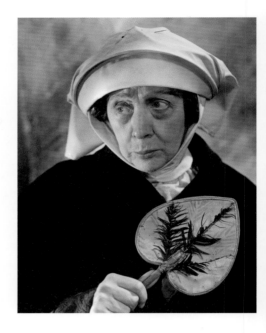

1958, IV.5, Lady Capulet (Rachel Kempson), Juliet and the Nurse

1961, II.4, The Nurse (Edith Evans)

III.1, Tybalt (Peter McEnery) and Mercutio (Ian Bannen) fight as Benvolio (Kerry James) and Romeo (Brian Murray) look on

1961, III.5, Juliet (Dorothy Tutin) and Romeo

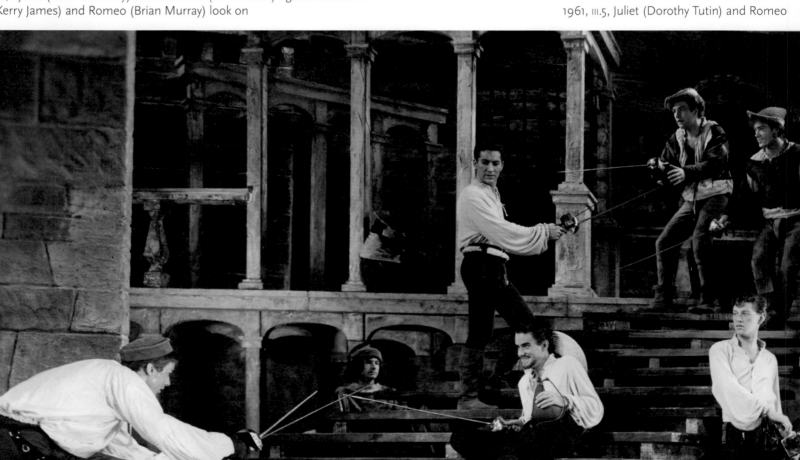

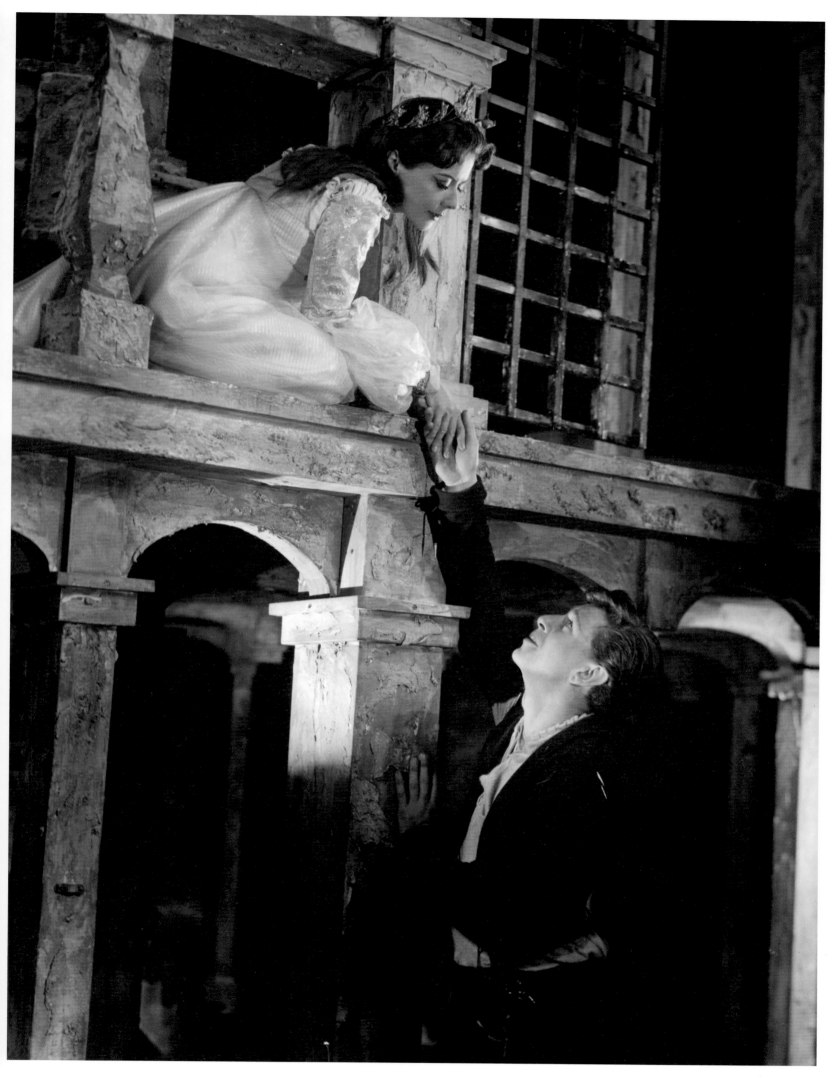

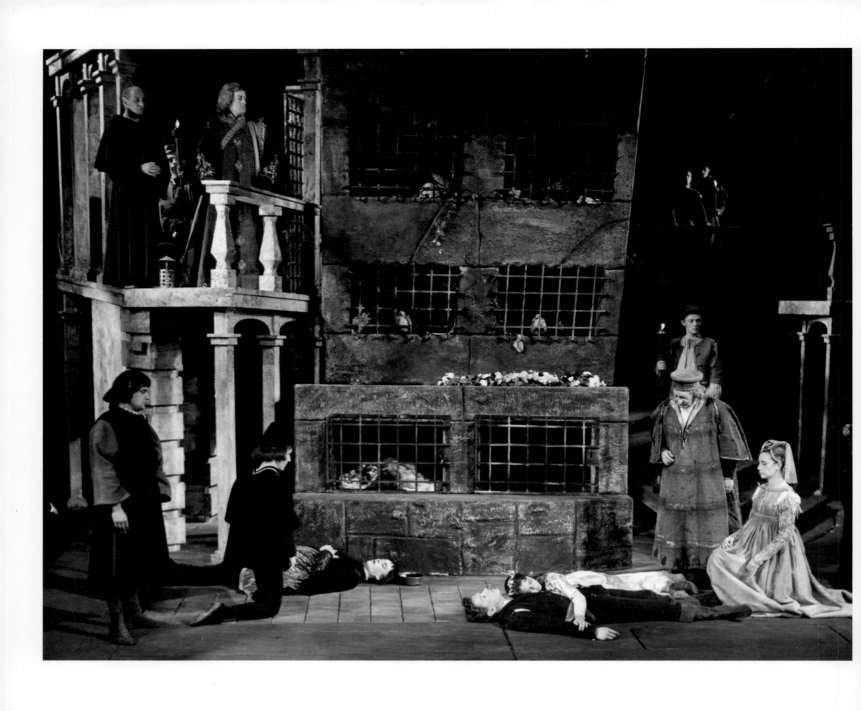

1961, v.3, The discovery of the dead lovers

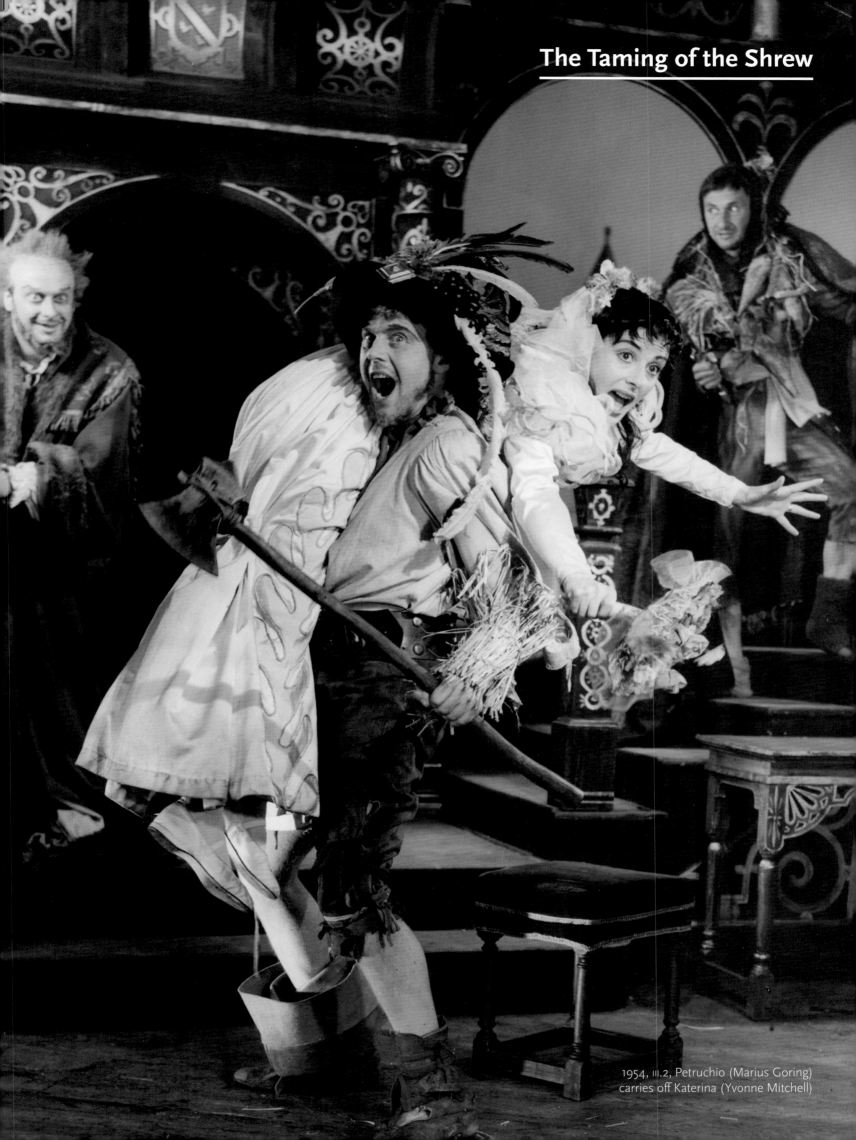

1954, III.2, Petruchio (Marius Goring) carries off Katerina (Yvonne Mitchell)

1947, II.1, Katerina (Diana Wynyard)

II.1, Hortensio (Michael Gwynn), Bianca
(Mairhi Russell) and Lucentio (Robert Urquhart)

>

1947, III.2, Grumio (Alfie Bass), Petruchio
(Anthony Quayle) 0and Katerina

1954, II.1, Katerina (Barbara Jefford) and Bianca
(Muriel Pavlow)

IV.1, Petruchio (Keith Michell) and Katerina

1960, IV.1, Petruchio (Peter O'Toole)

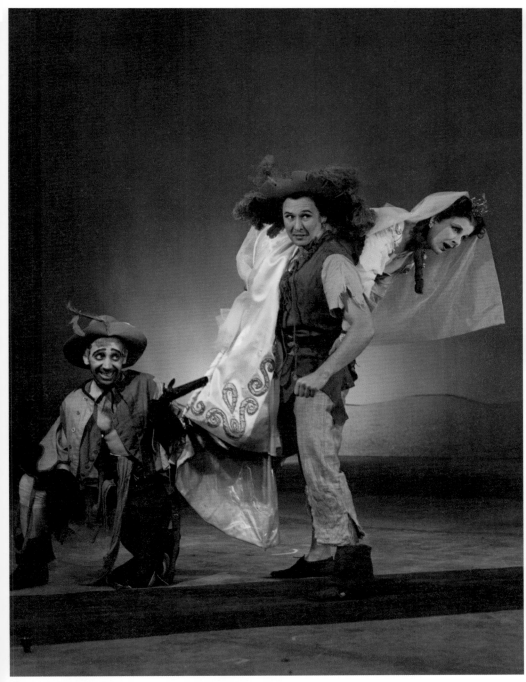

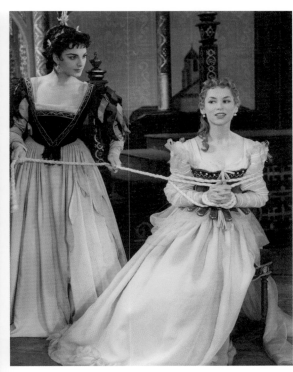

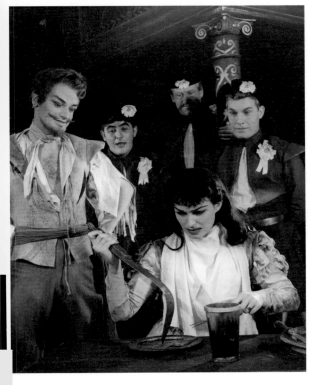

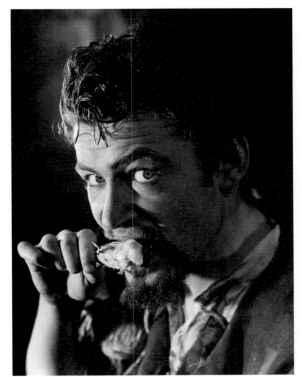

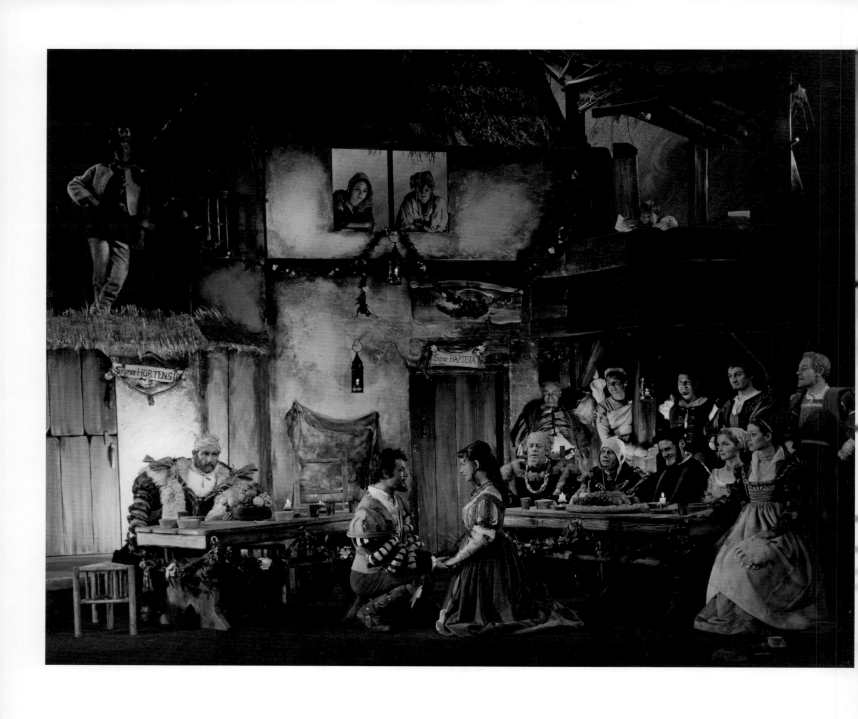

1960, v.2, Petruchio receives Katerina (Peggy Ashcroft)

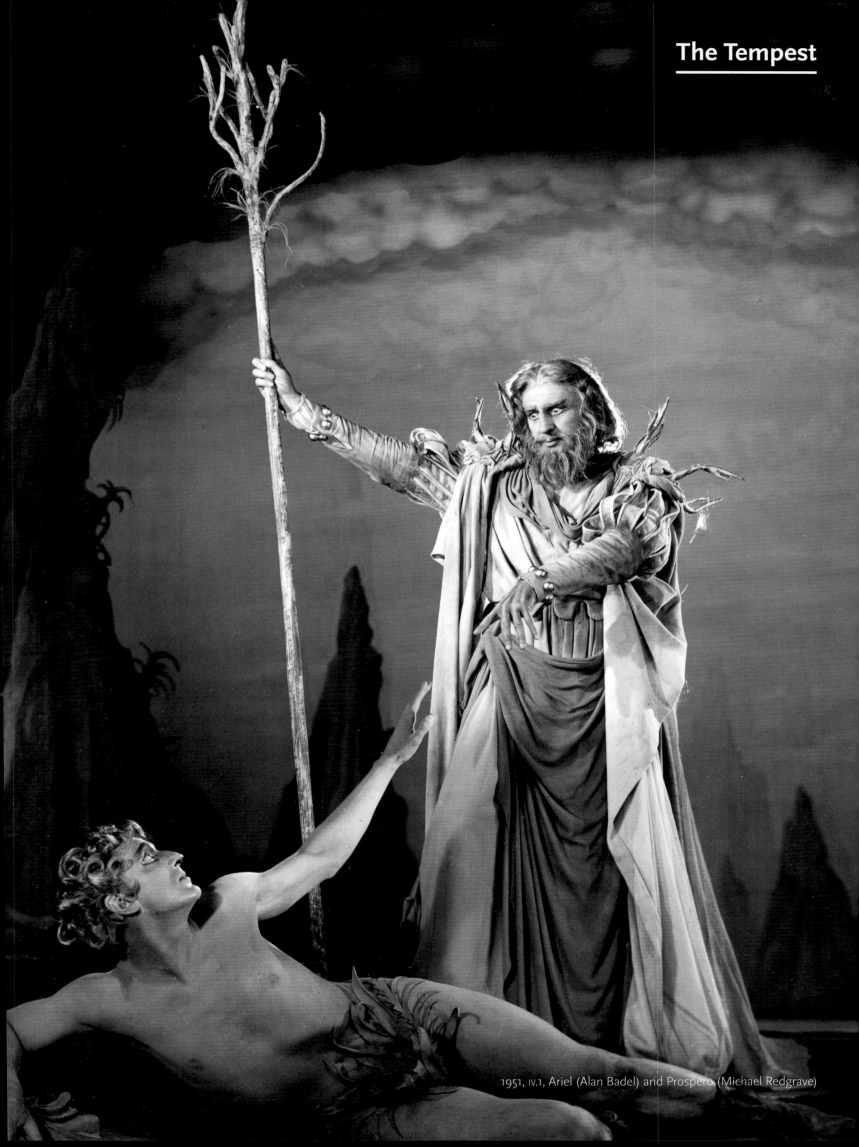

1951, IV.1, Ariel (Alan Badel) and Prospero (Michael Redgrave)

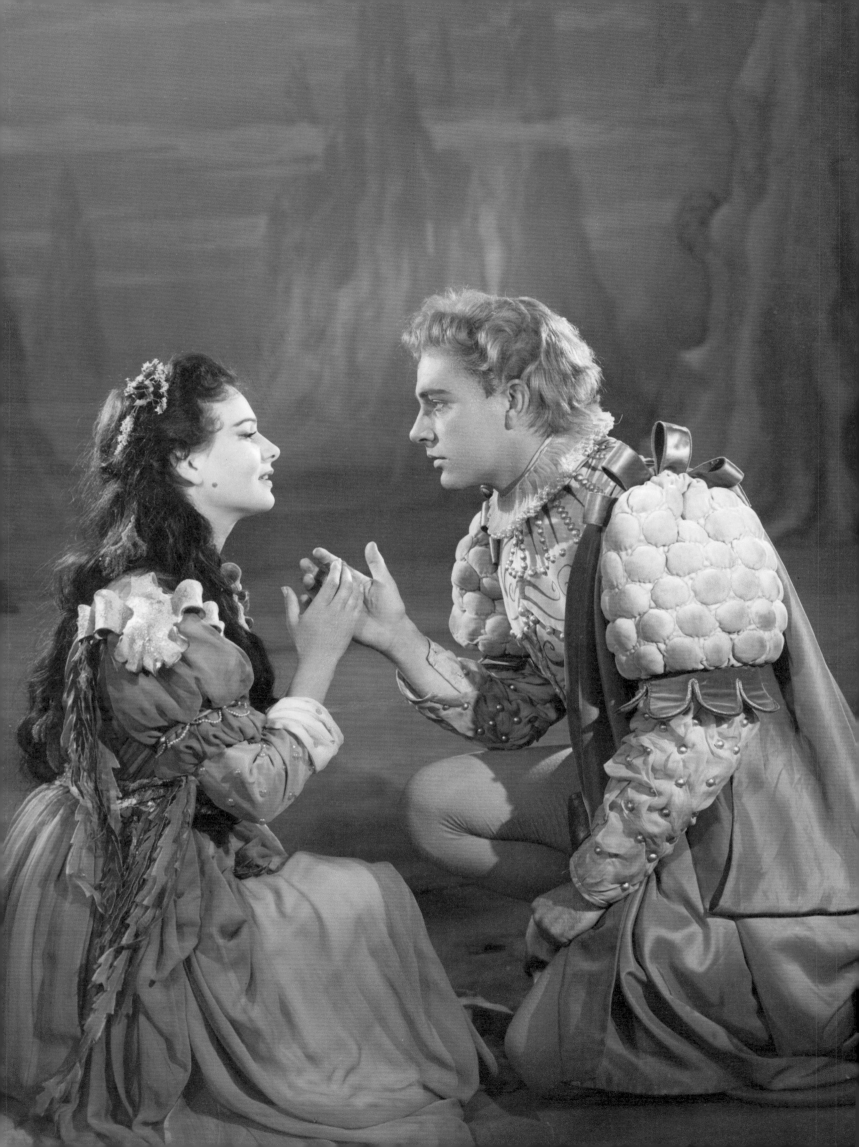

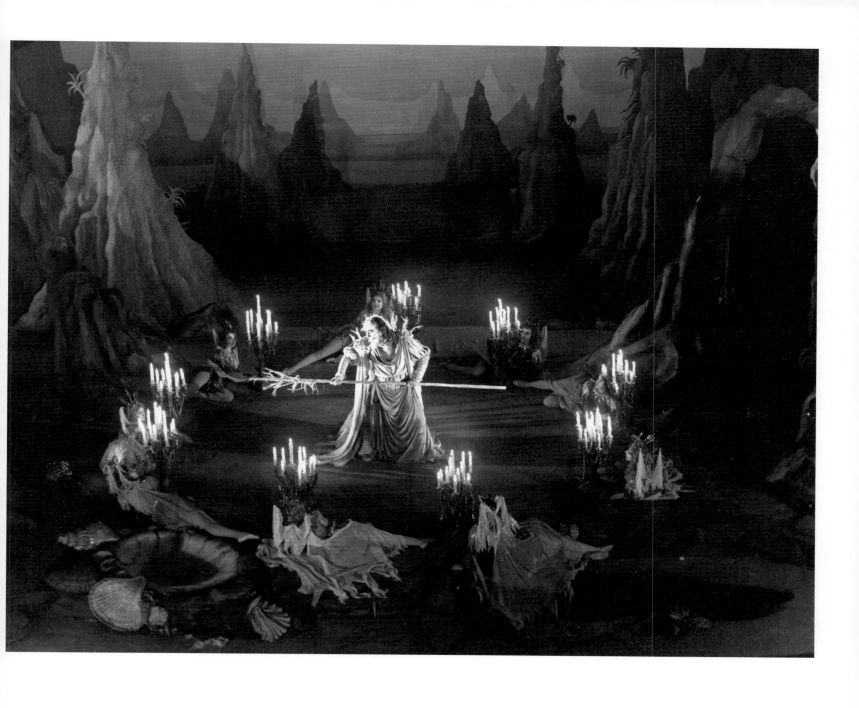

<

1951, III.1, Miranda (Hazel Penwarden) and Ferdinand
(Richard Burton)

IV.1, Prospero (Michael Redgrave) summons the spirits

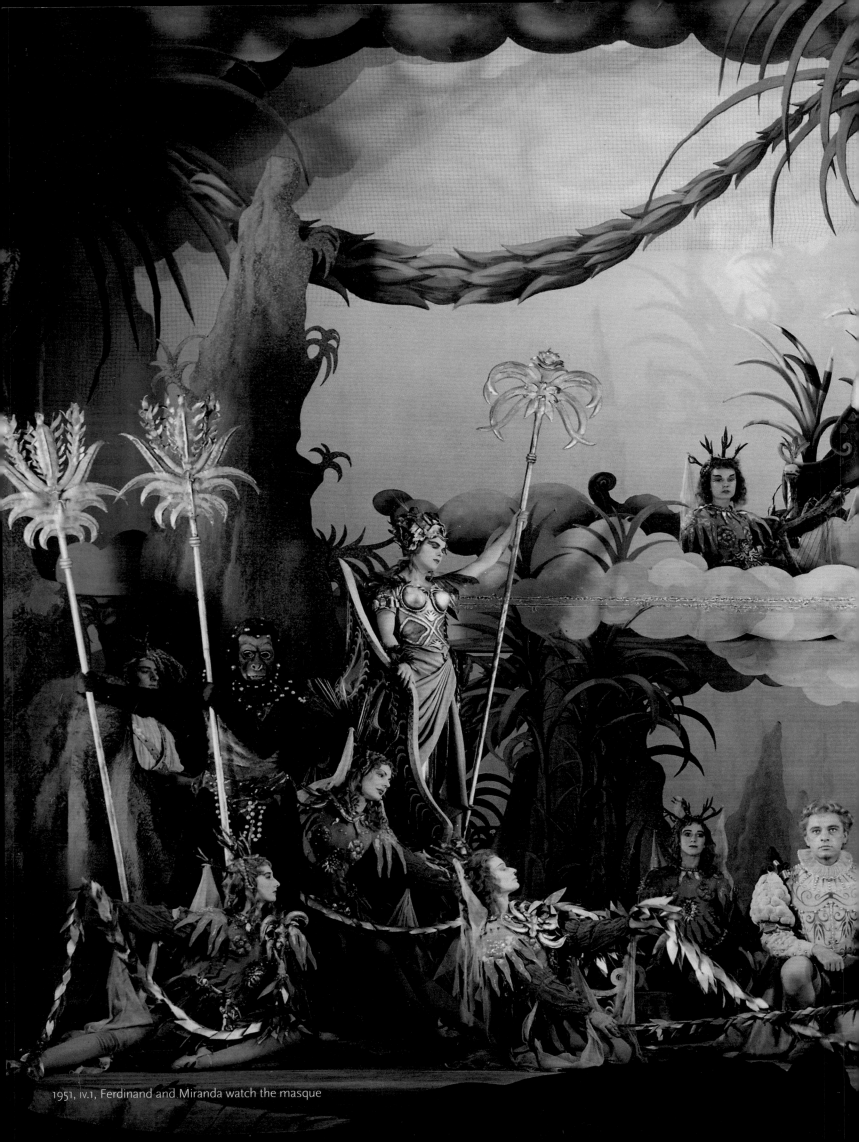

1951, IV.1, Ferdinand and Miranda watch the masque

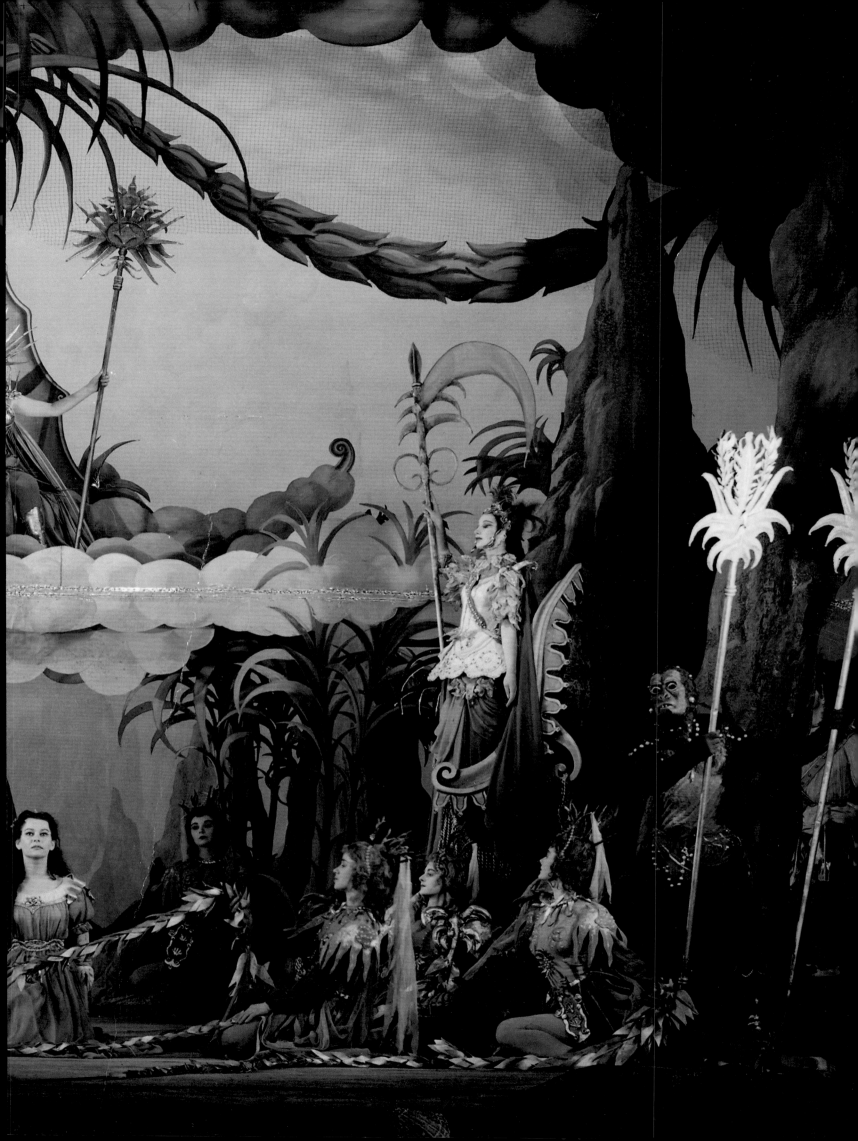

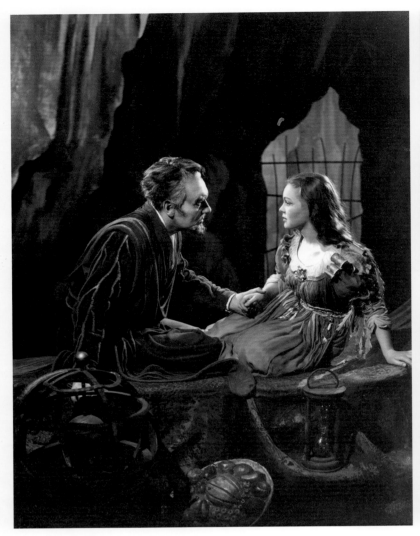

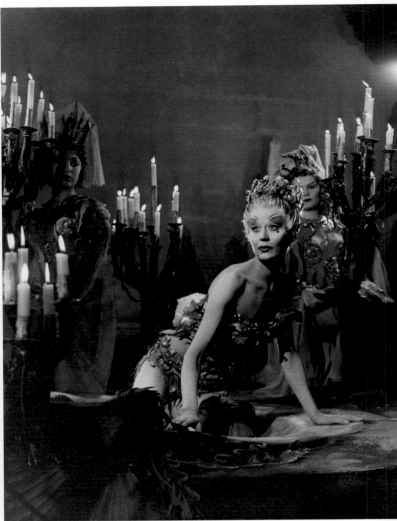

1952, I.2, Prospero (Ralph Richardson) and Miranda (Zena Walker)

Ariel (Margaret Leighton)

v.1, Prospero summons the spirits

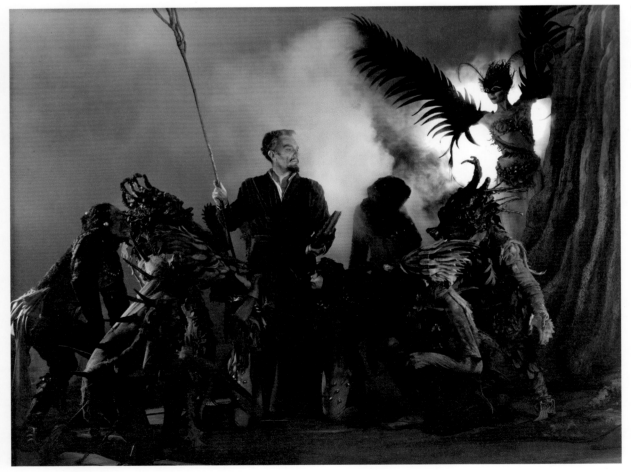

>

1957, I.2, Prospero (John Gielgud)

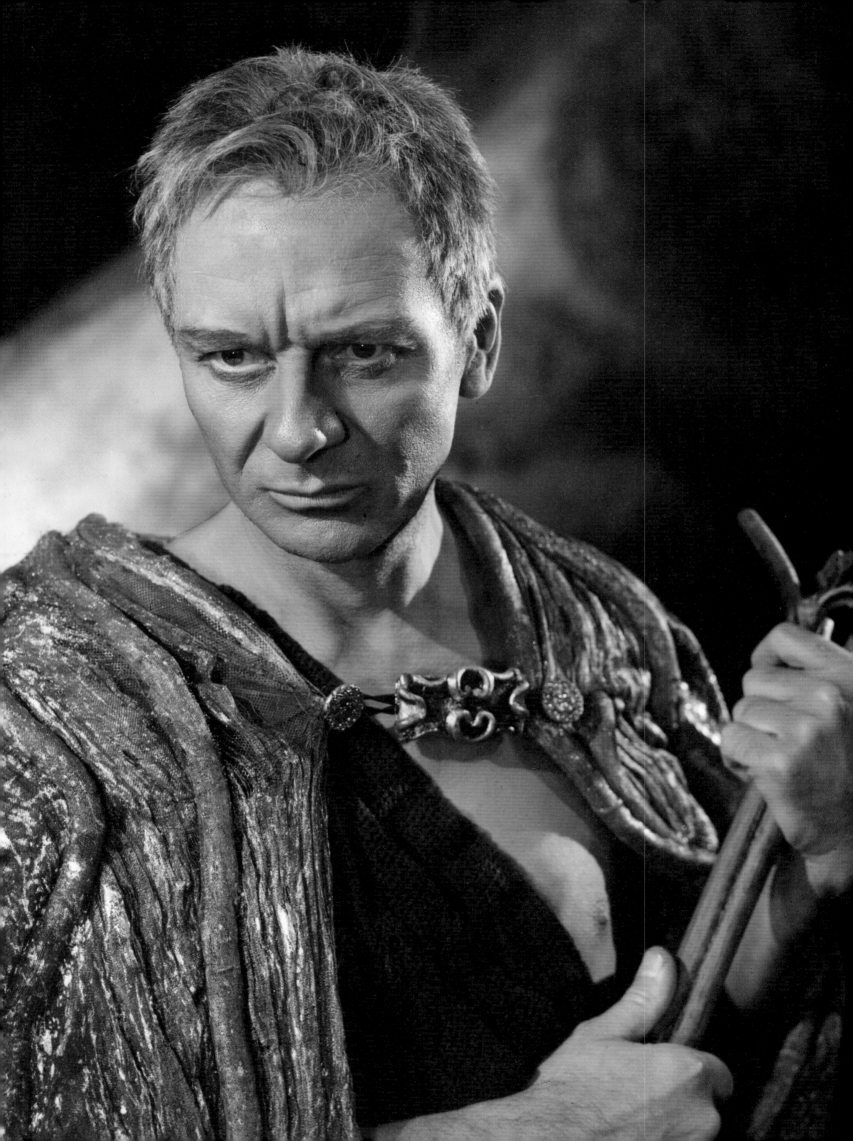

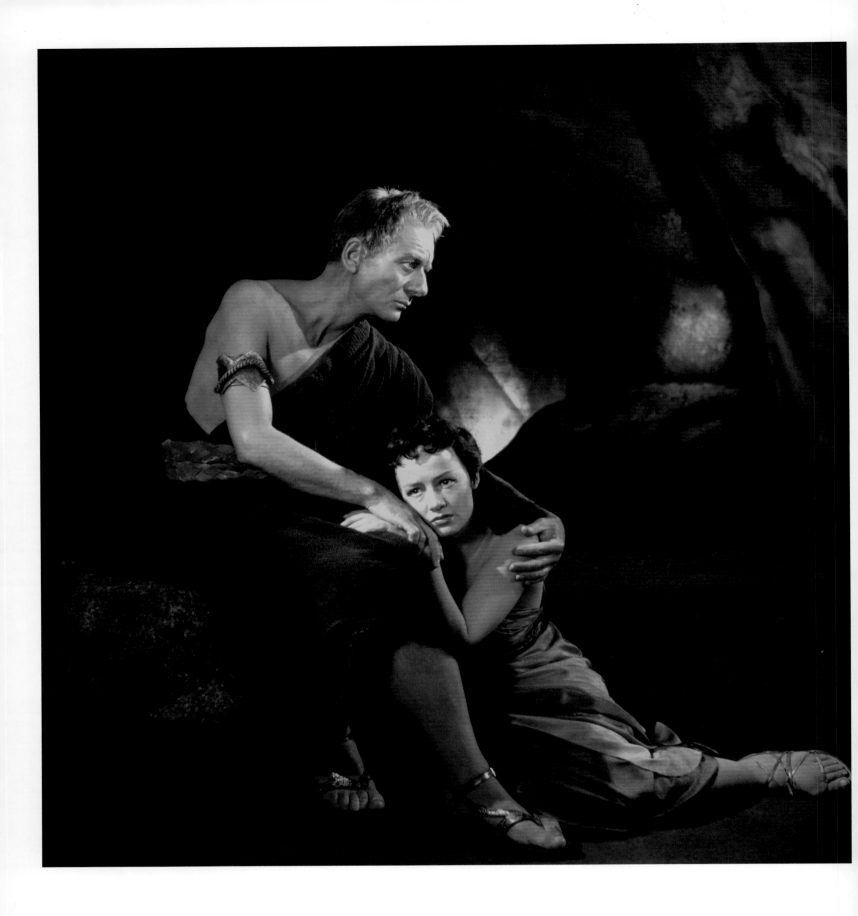

1957, I.2, Prospero and Miranda (Doreen Aris)

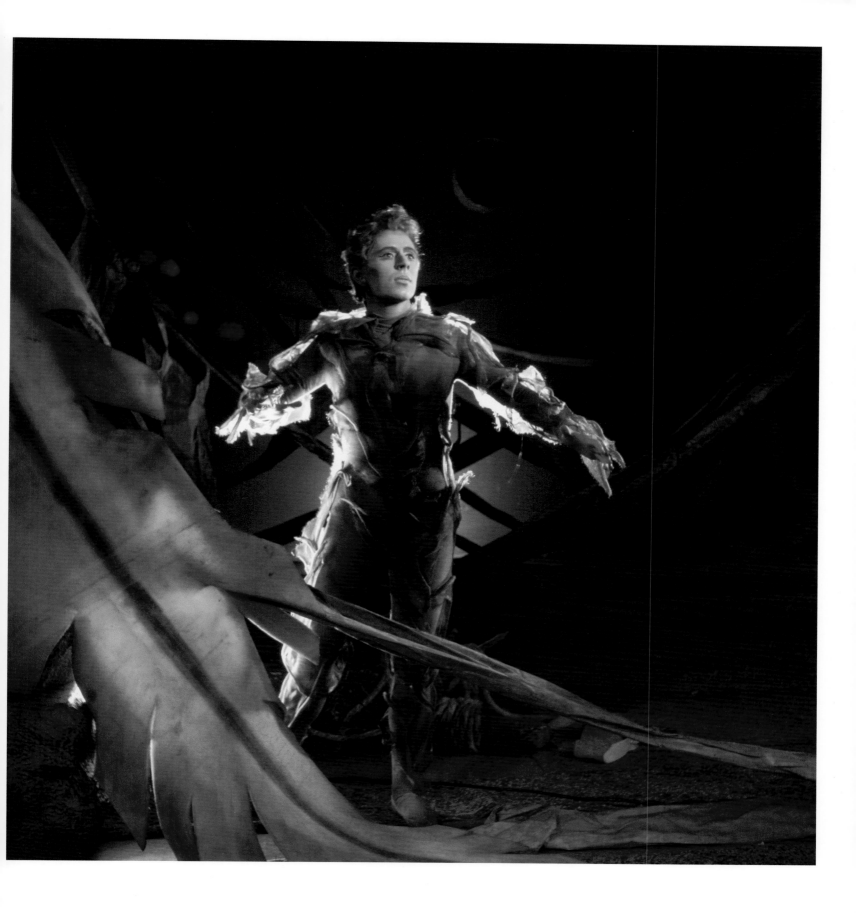

I.2, Ariel (Brian Bedford)

FOLLOWING PAGE

III.2, Ariel with Trinculo (Clive Revill),
Stephano (Patrick Wymark) and Caliban (Alec Clunes)

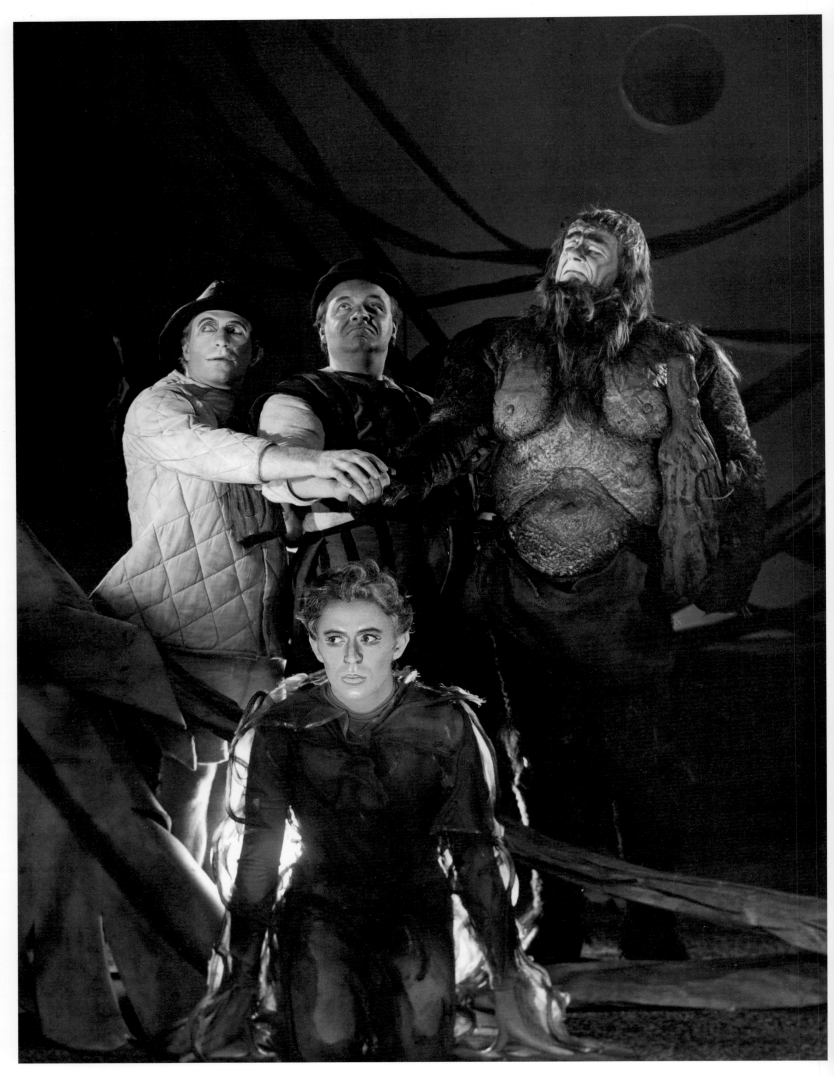

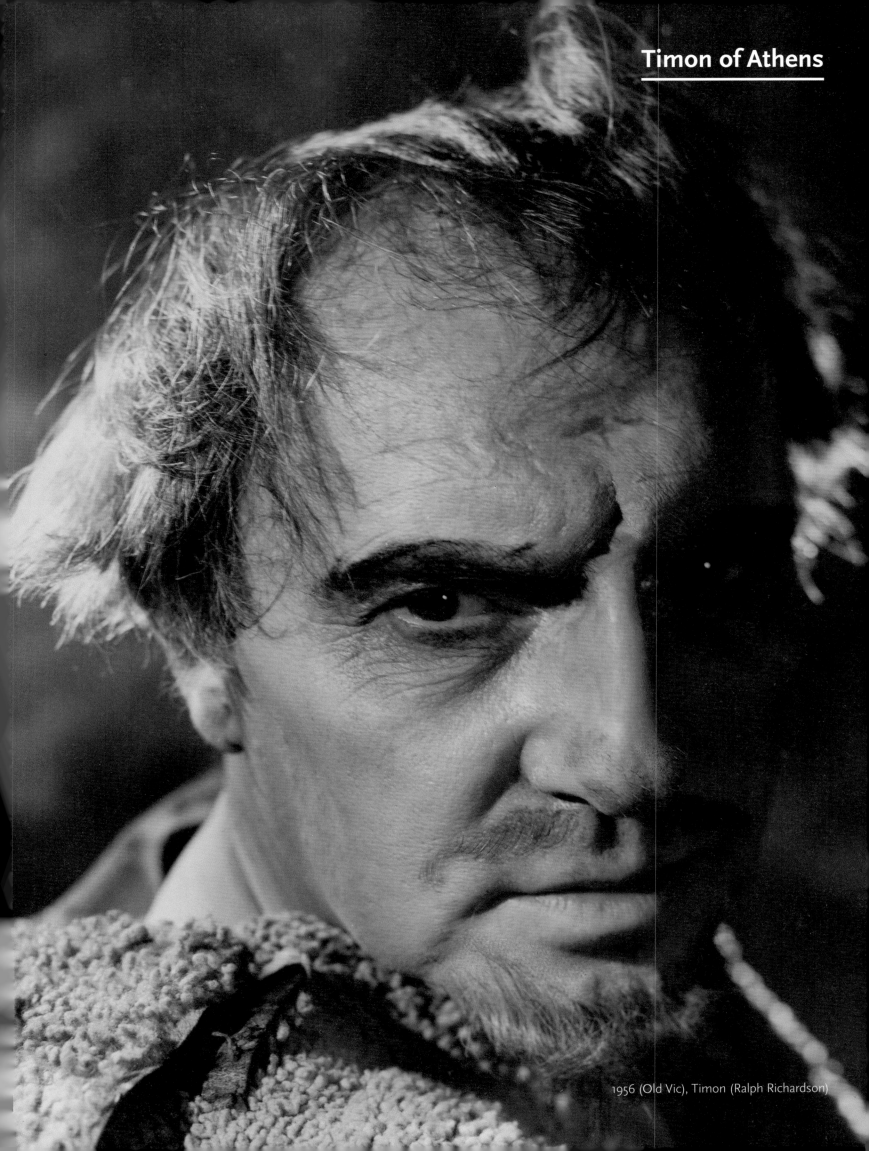

1956 (Old Vic), Timon (Ralph Richardson)

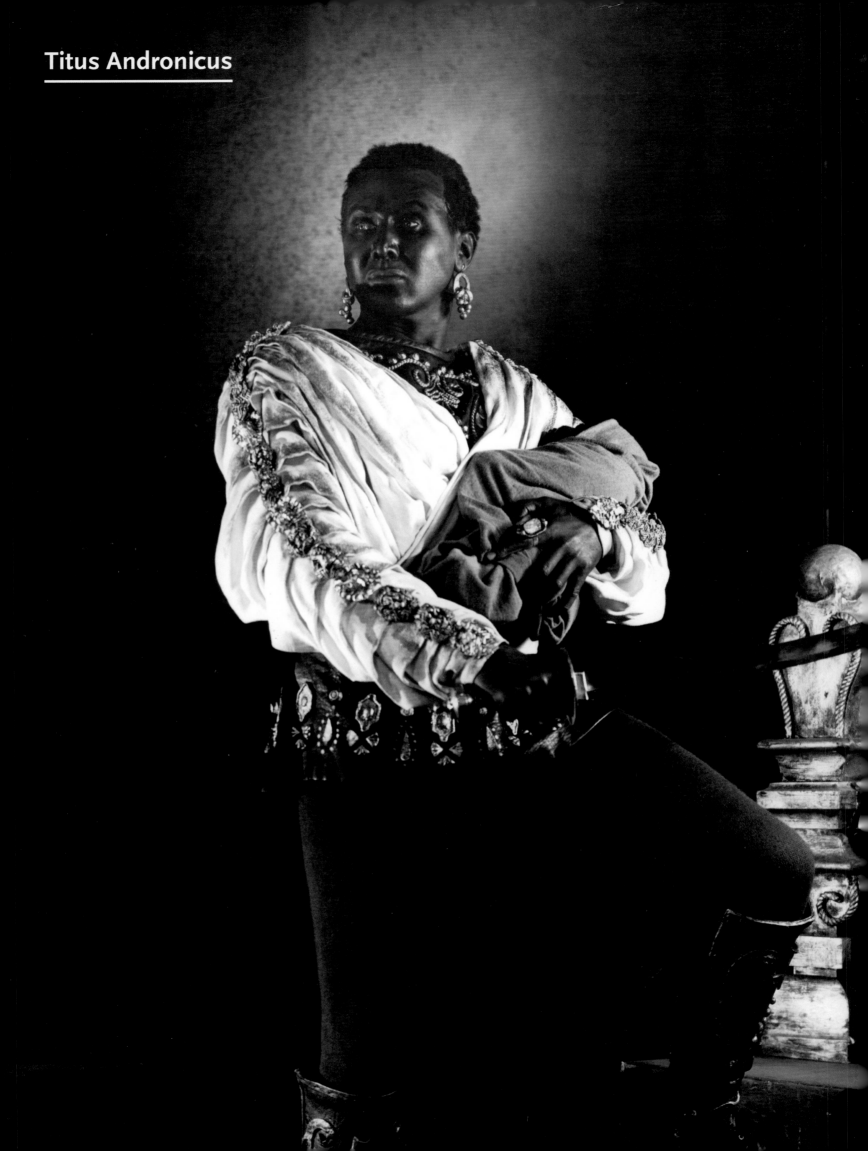

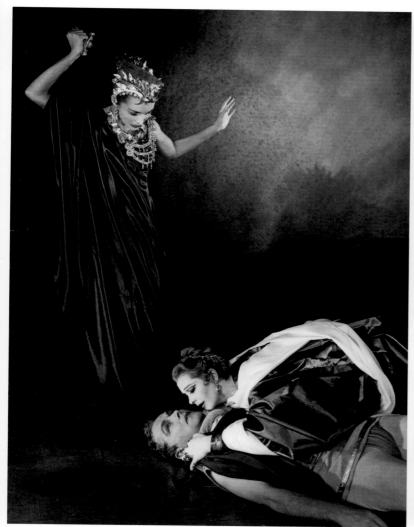

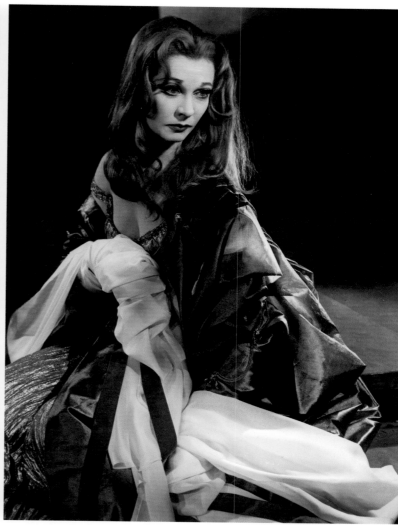

1955, II.3, Tamora (Maxine Audley)
Bassanius (Ralph Michael) and
Lavinia (Vivien Leigh)

IV.1, Lavinia

IV.1, Titus (Laurence Olivier)
and Lavinia

<
Aaron the Moor
(Anthony Quayle)

FOLLOWING PAGE
v.3, The banquet

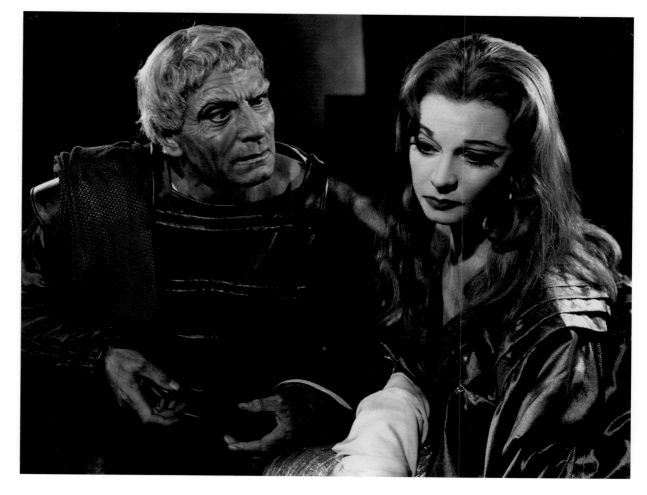

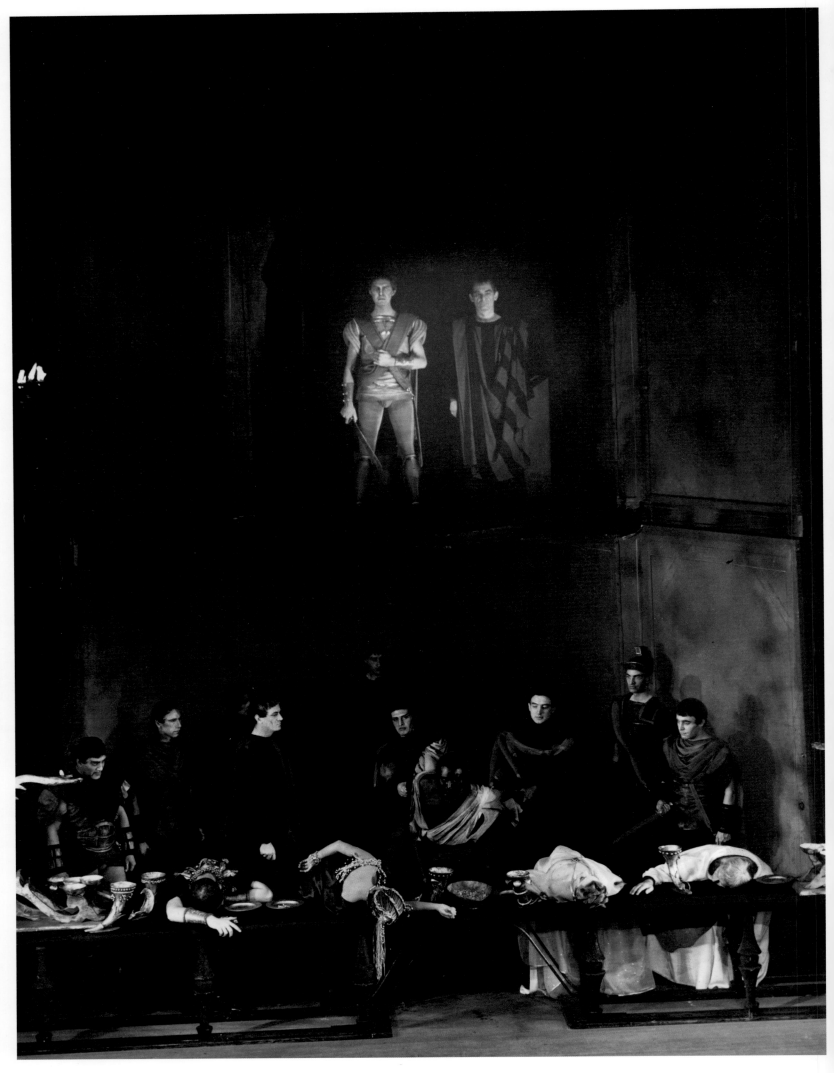

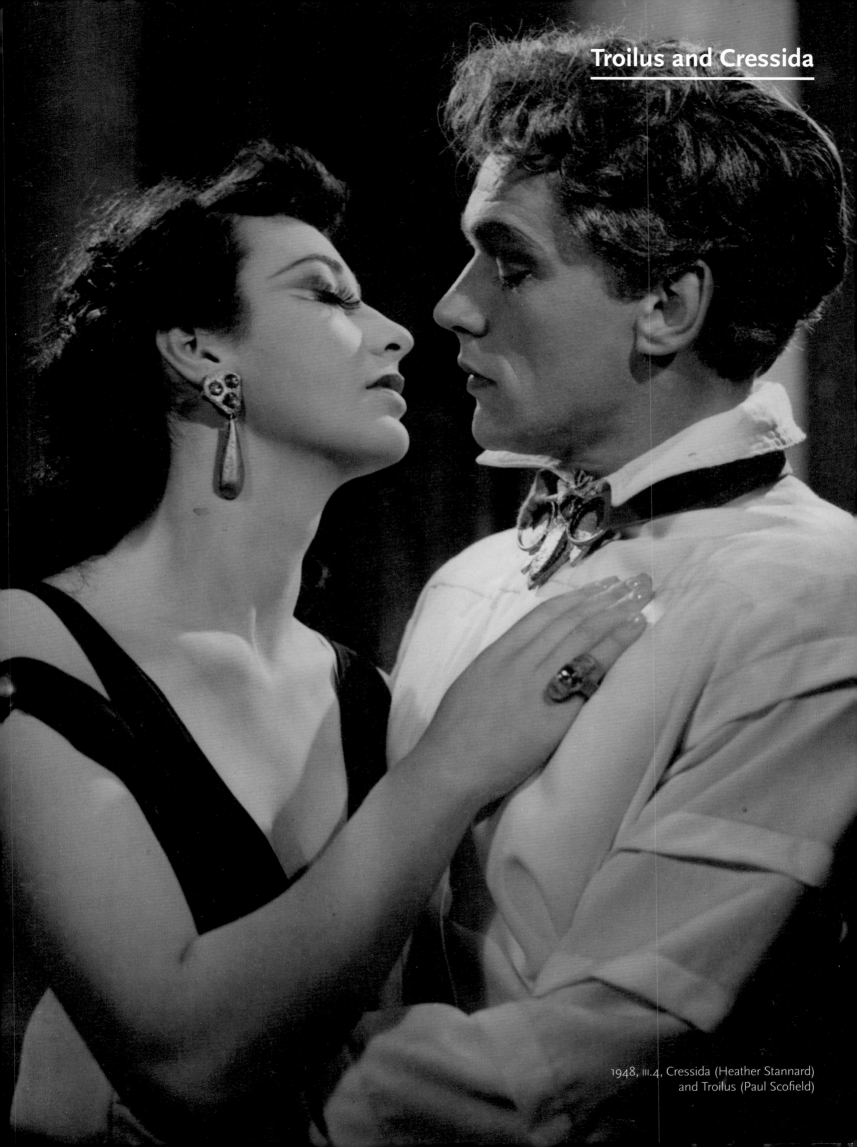

1948, III.4, Cressida (Heather Stannard)
and Troilus (Paul Scofield)

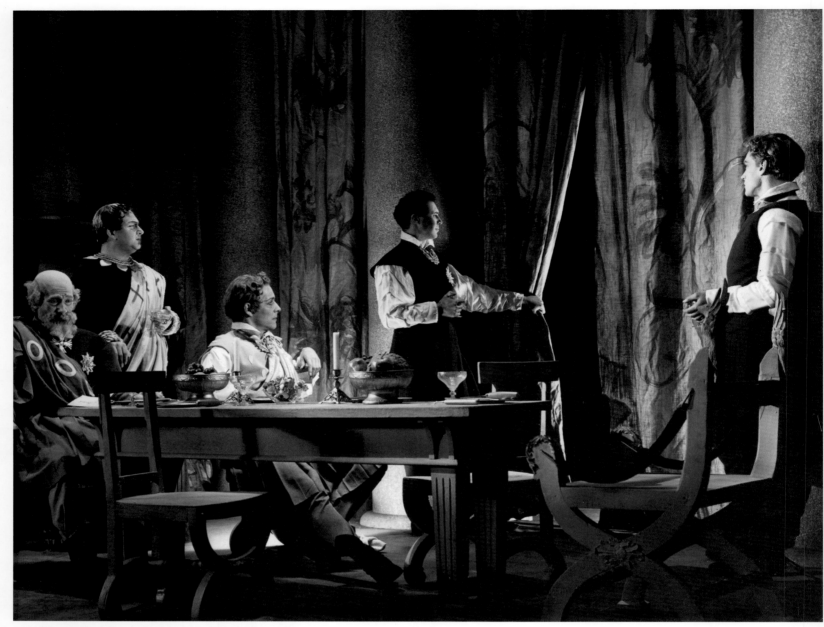

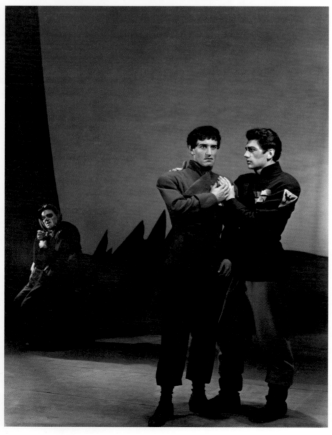

1948, II.2, The Trojan court

II.3, Thersites (Esmond Knight), Achilles
(Douglas Wilmer) and Patroclus (Edward Purdom)

1954, I.2, Cressida (Muriel Pavlow) and Pandarus (Anthony Quayle)

II.1, Pandarus sings to Helen (Barbara Jefford) and Paris (Basil Hoskins)

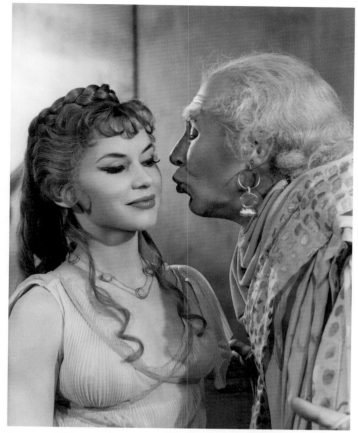

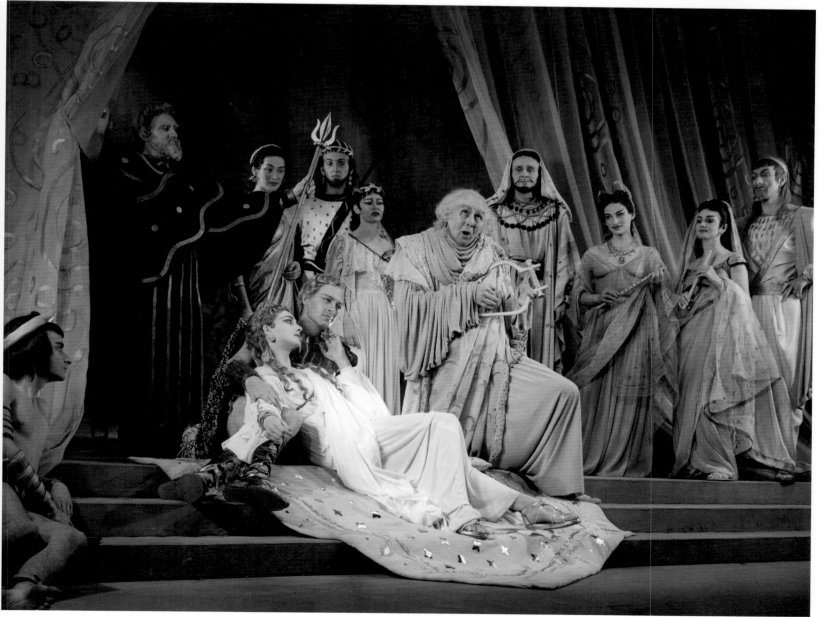

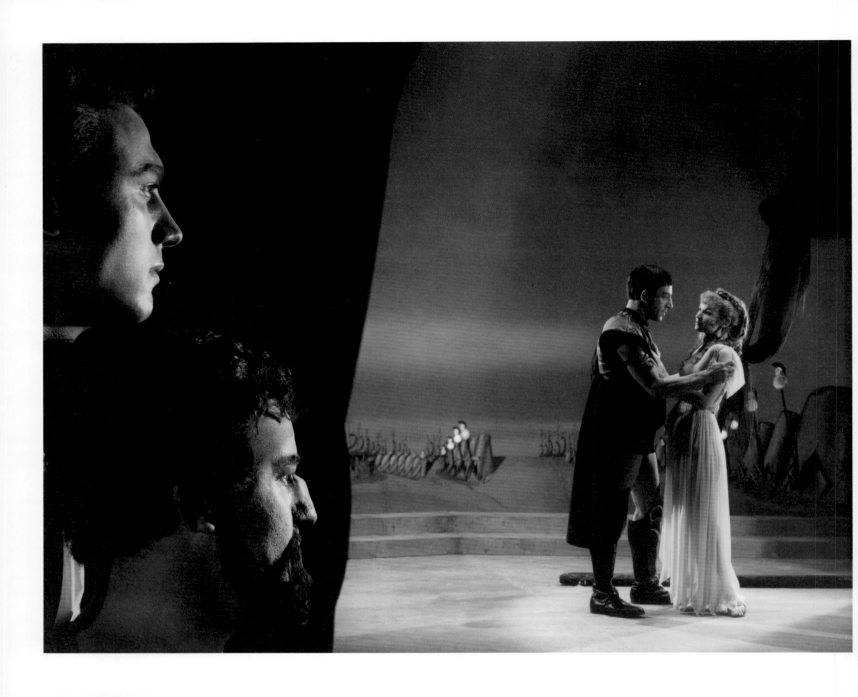

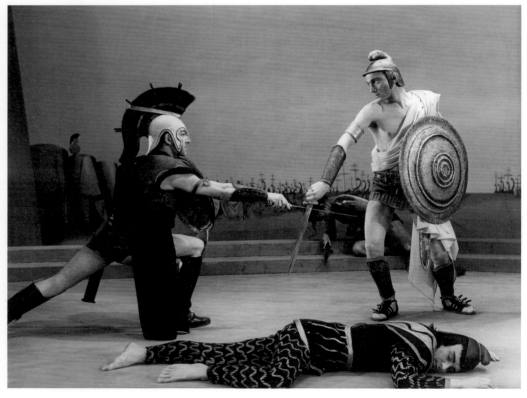

1954, v.2, Troilus (Laurence Harvey) and Achilles (Keith Michell) watch Diomedes (Bernard Kay) and Cressida

v.6, Diomedes and Troilus fight

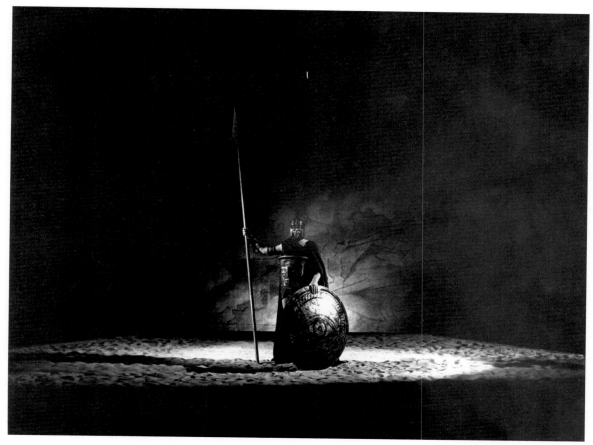

1960, Prologue (Paul Hardwick)
III.1, Pandarus (Max Adrian) and the
Trojan court

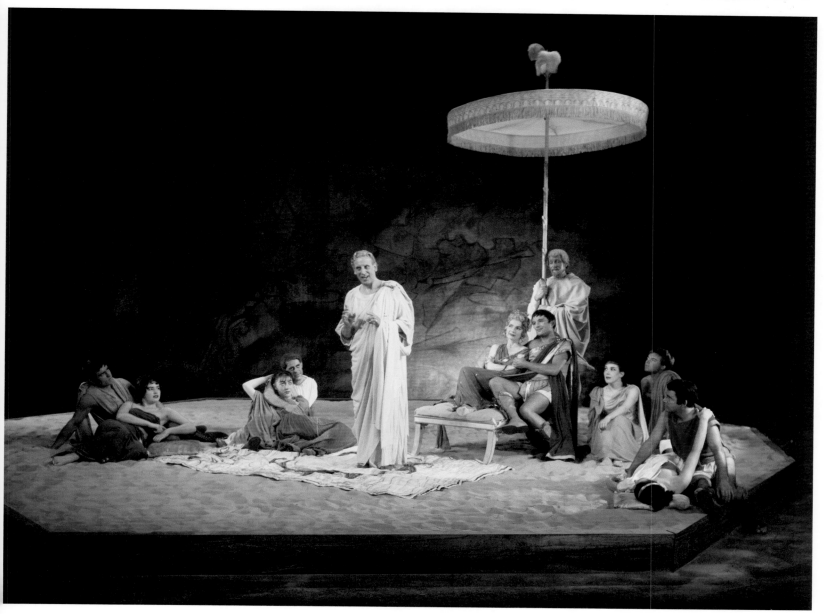

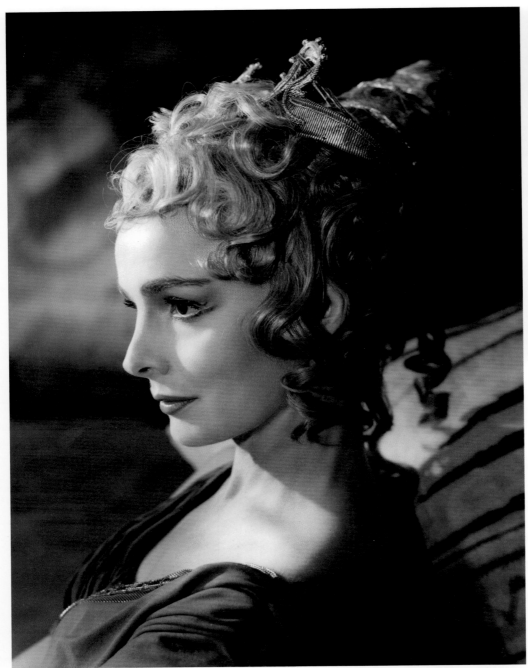

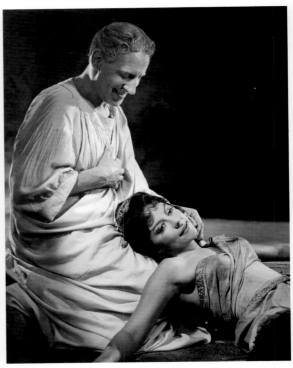

1960, Helen (Elizabeth Sellars)

III.1, Pandarus and Cressida (Dorothy Tutin)

III.2, Thersites (Peter O'Toole)

v.9, Achilles (Patrick Allen) and his men surround Hector (Derek Godfrey)

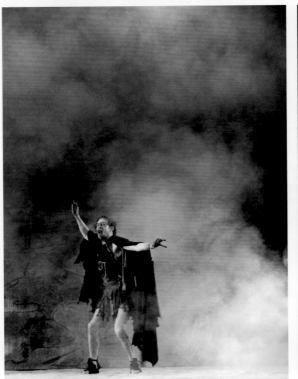

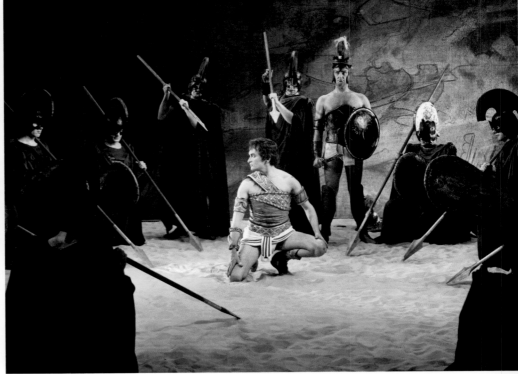

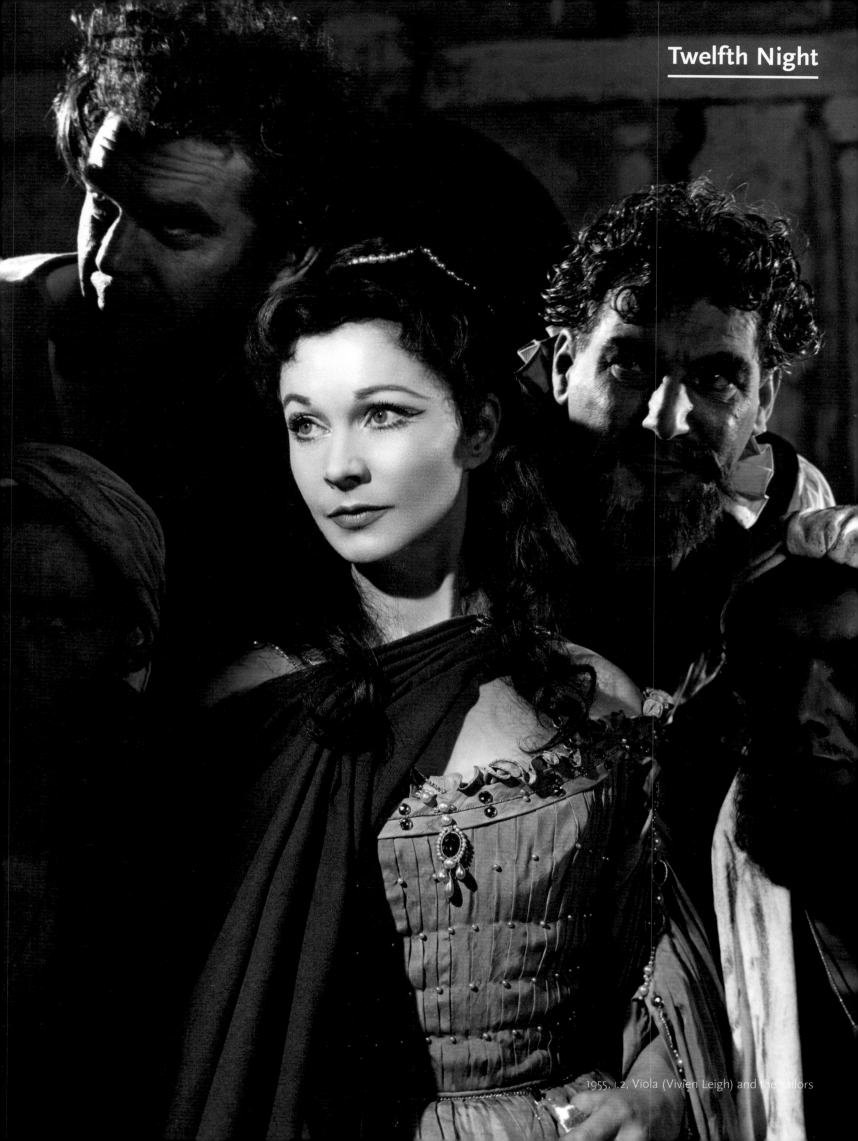

1955, i.2, Viola (Vivien Leigh) and the sailors

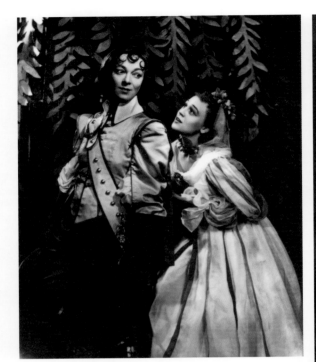

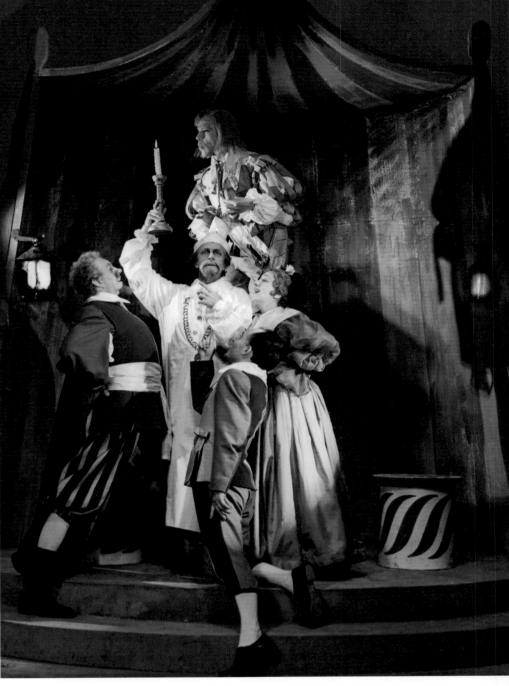

1947, III.1, Viola (Beatrix Lehmann) and Olivia
(Daphne Slater)

III.2, Malvolio (Walter Hudd) is disturbed by
Sir Toby Belch (John Blatchley) Sir Andrew Aguecheek
(Paul Scofield), Feste (Dudley Jones) and Maria
(Helen Burns)

v.1, Maria and Feste

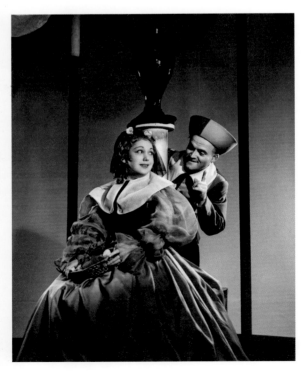

>

1955, II.2, Viola (Vivien Leigh) and Malvolio
(Laurence Olivier)

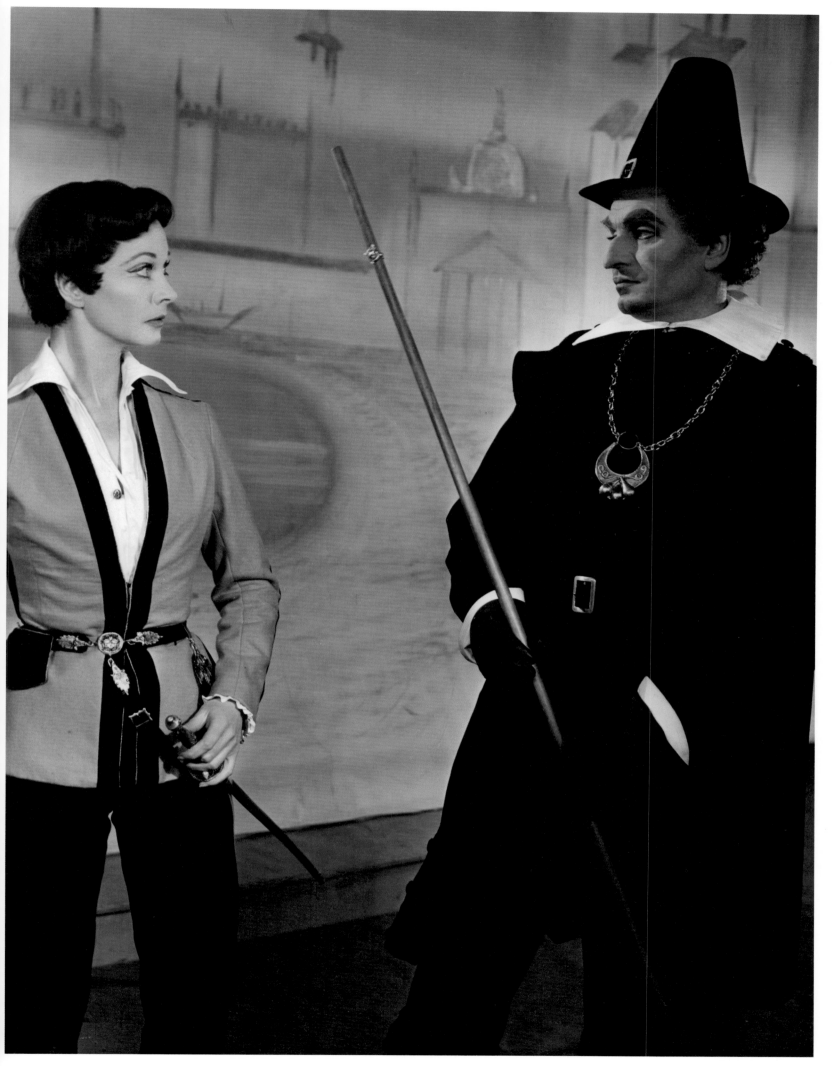

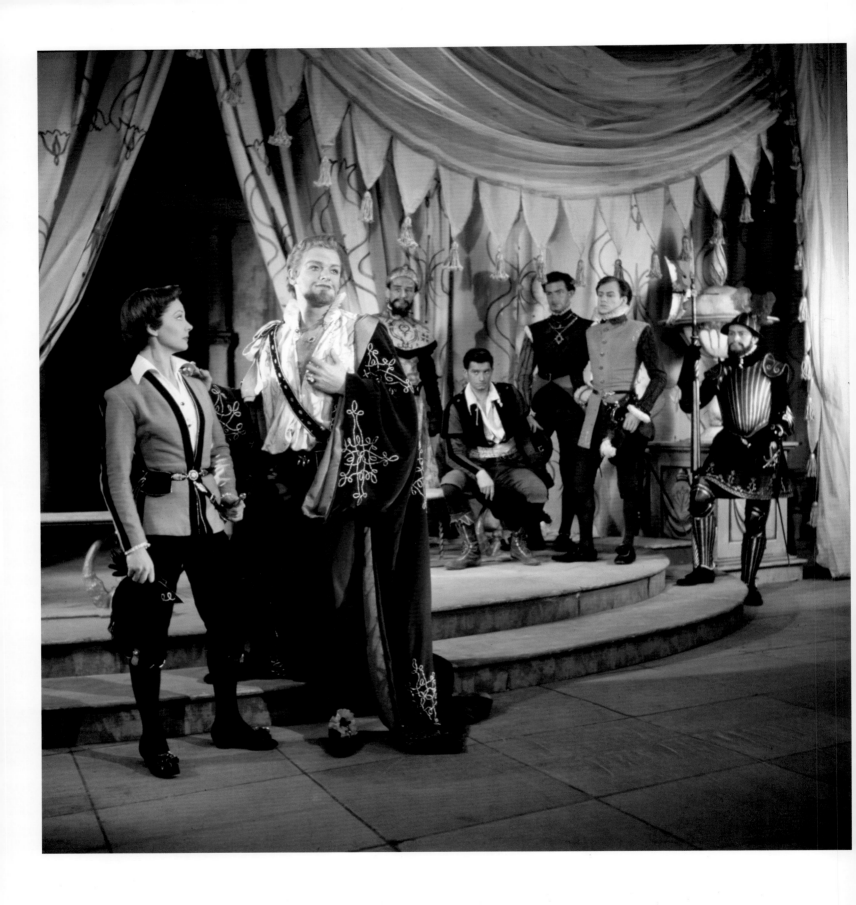

1955, II.4, Viola and Orsino (Keith Michell)

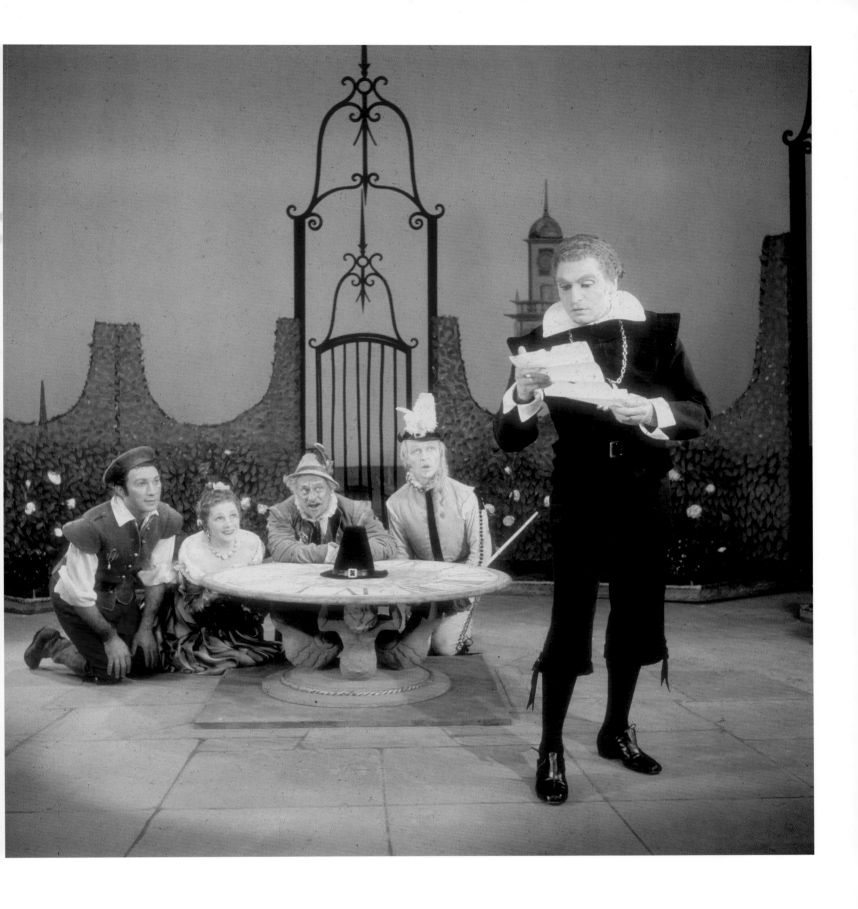

II.5, Malvolio reads the letter

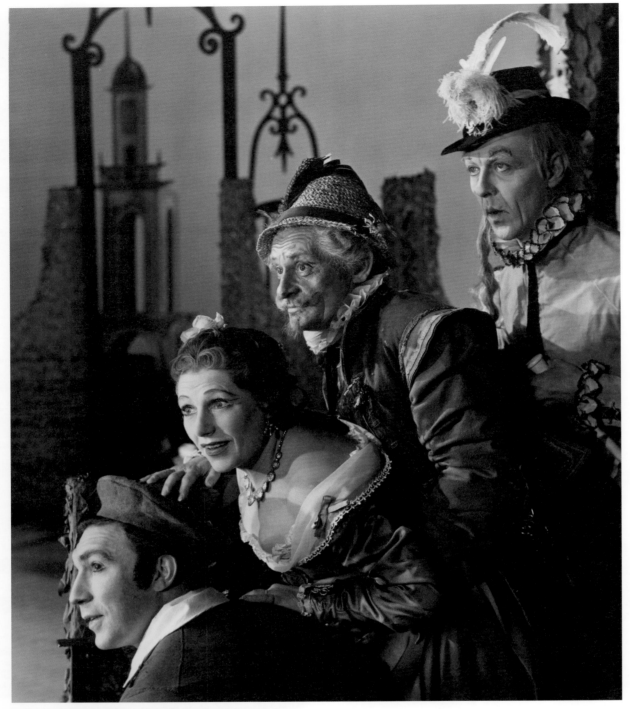

II.5, Fabian (Lee Montague), Maria (Angela Baddeley),
Sir Toby (Alan Webb) and Sir Andrew (Michael Denison)
observe Malvolio

III.2, Malvolio is disturbed

>

V.1, Viola

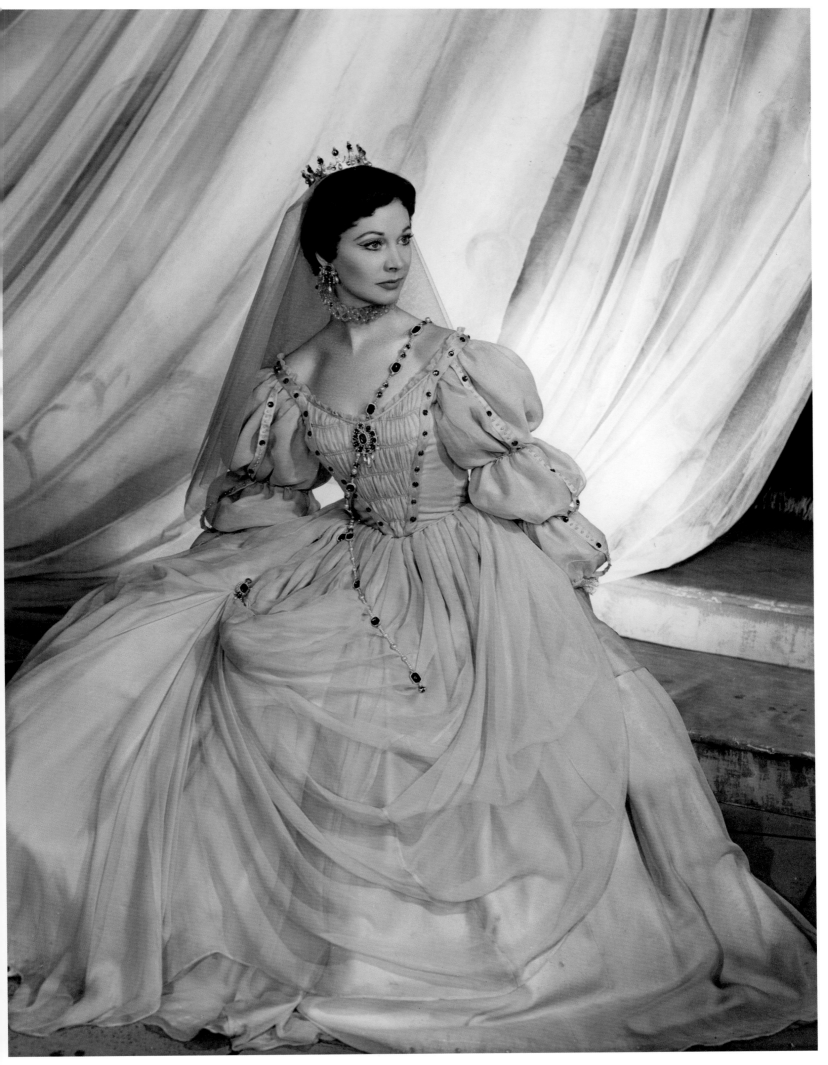

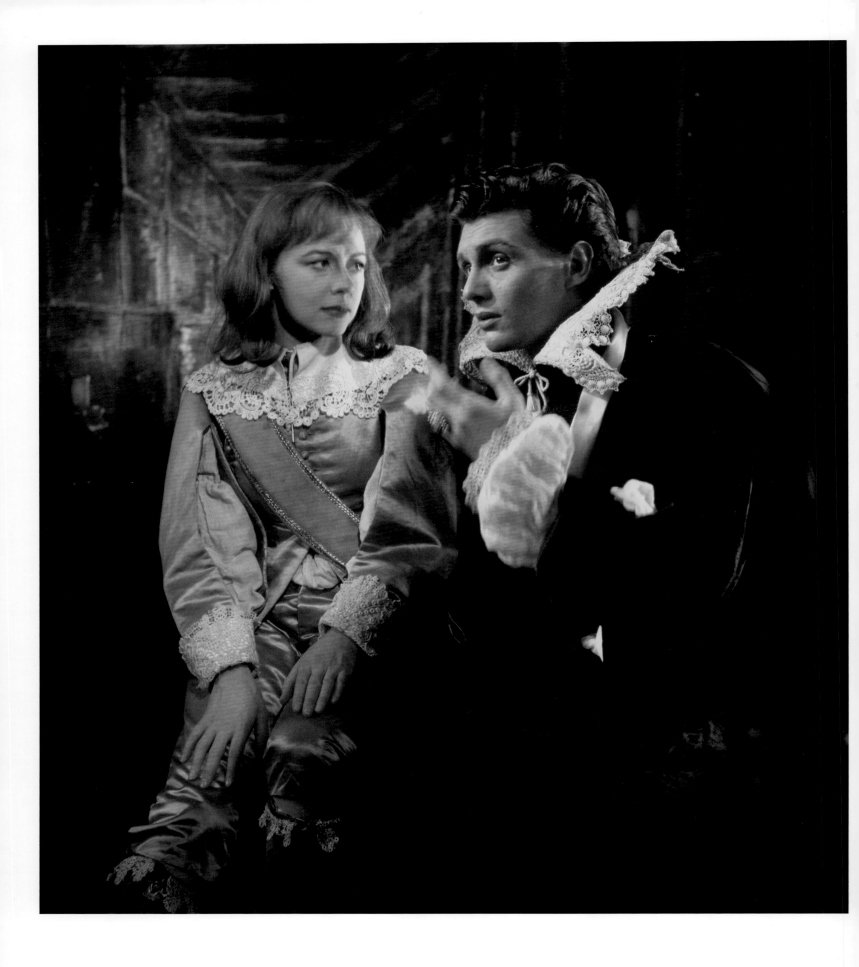

1958, II.4, Viola (Dorothy Tutin) and
Orsino (Michael Meacham)

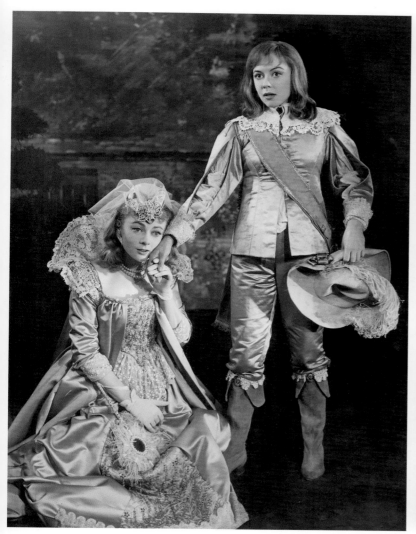

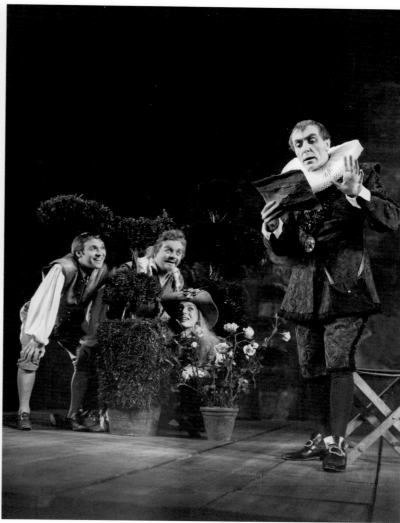

1958, II.1, Olivia (Geraldine McEwan) and Viola

1960, II.5, Malvolio (Eric Porter) is observed by Fabian (Dinsdale Landen), Sir Toby (Patrick Wymark) and Sir Andrew (Ian Richardson)

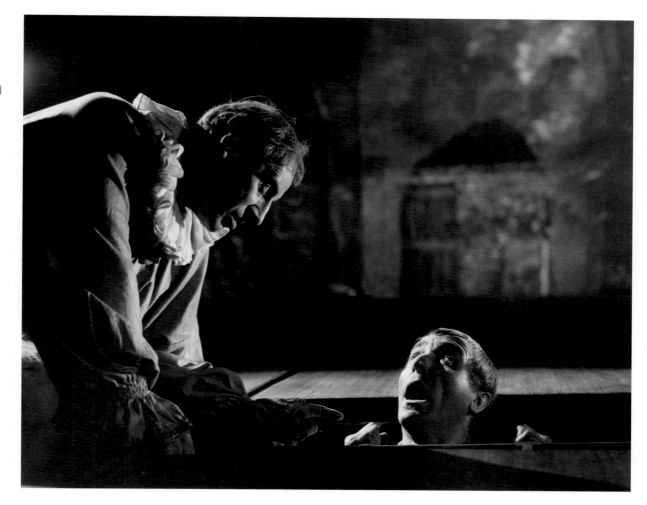

IV.1, Feste (Max Adrian) and Malvolio

The Two Gentlemen of Verona

1960, Launce (Patrick Wymark) with 'Crab'

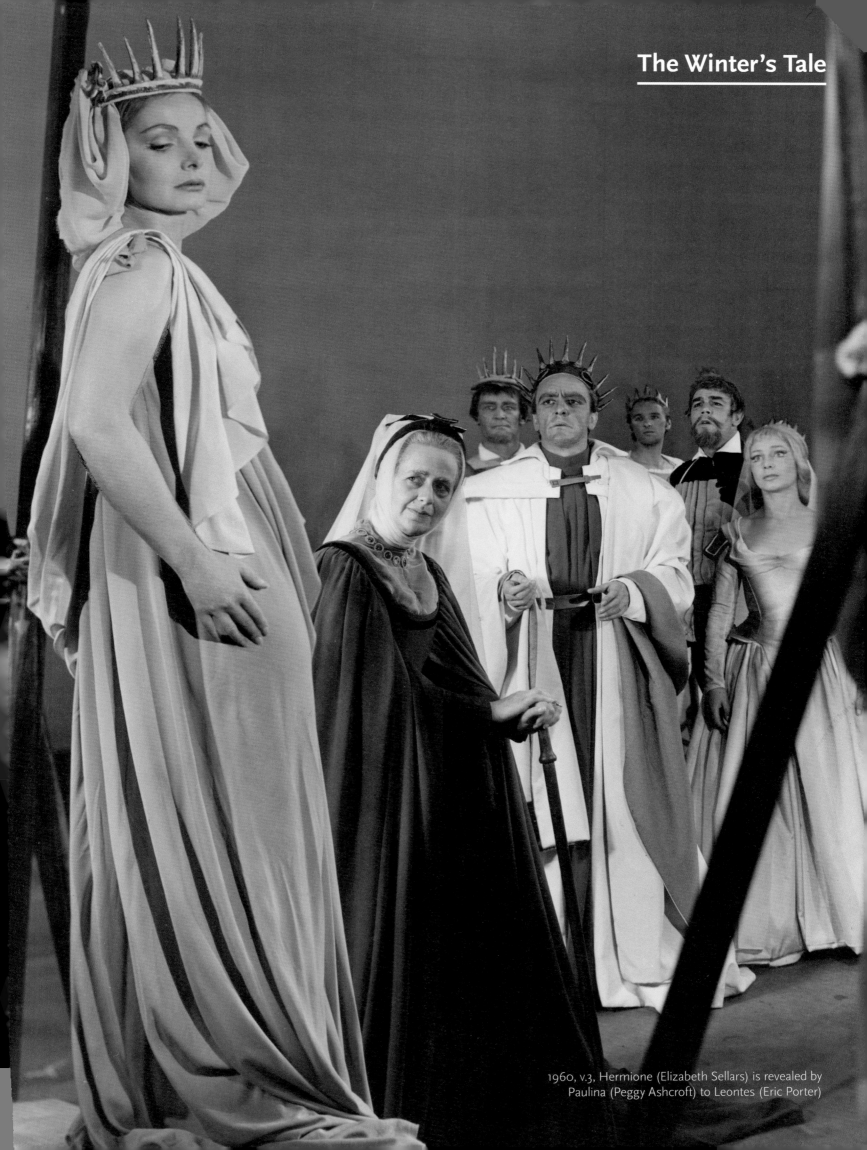

1960, v.3, Hermione (Elizabeth Sellars) is revealed by
Paulina (Peggy Ashcroft) to Leontes (Eric Porter)

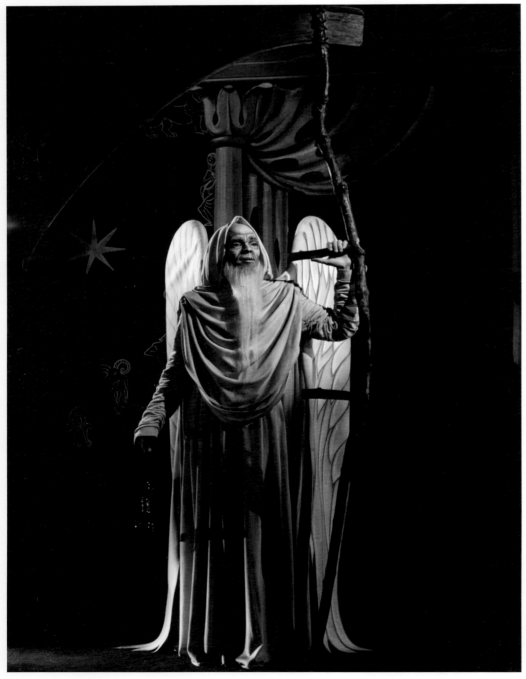

1948 I.2, Leontes (Esmond Knight) and Camillo (Julian Amyes)

I.3, Hermione (Diana Wynyard) and Mamilius (Timothy Harley)

IV prologue, Time (William Squire)

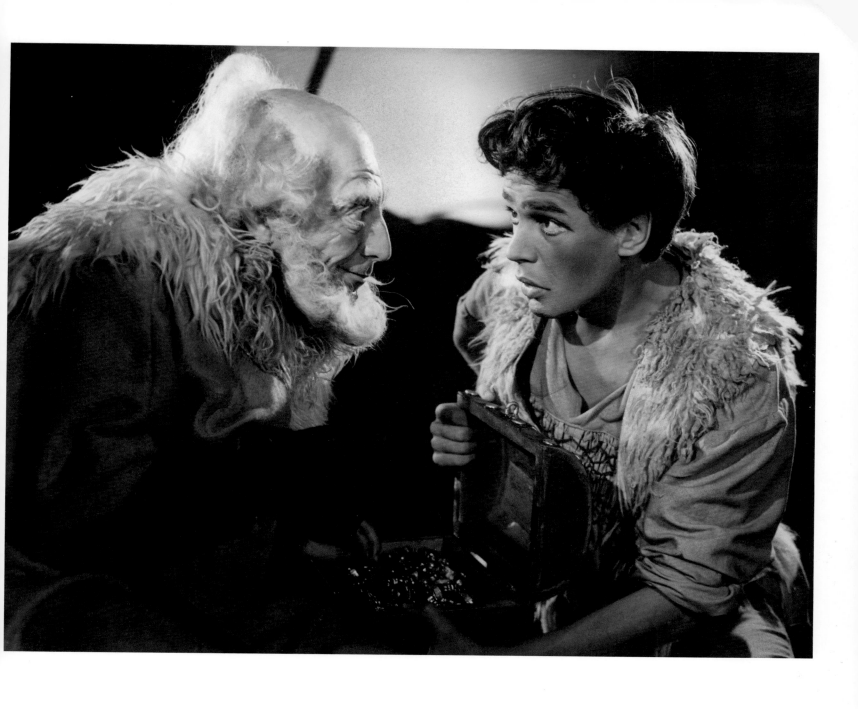

iv.3, The Old Shepherd (John Kidd)
and the Clown (Paul Scofield)

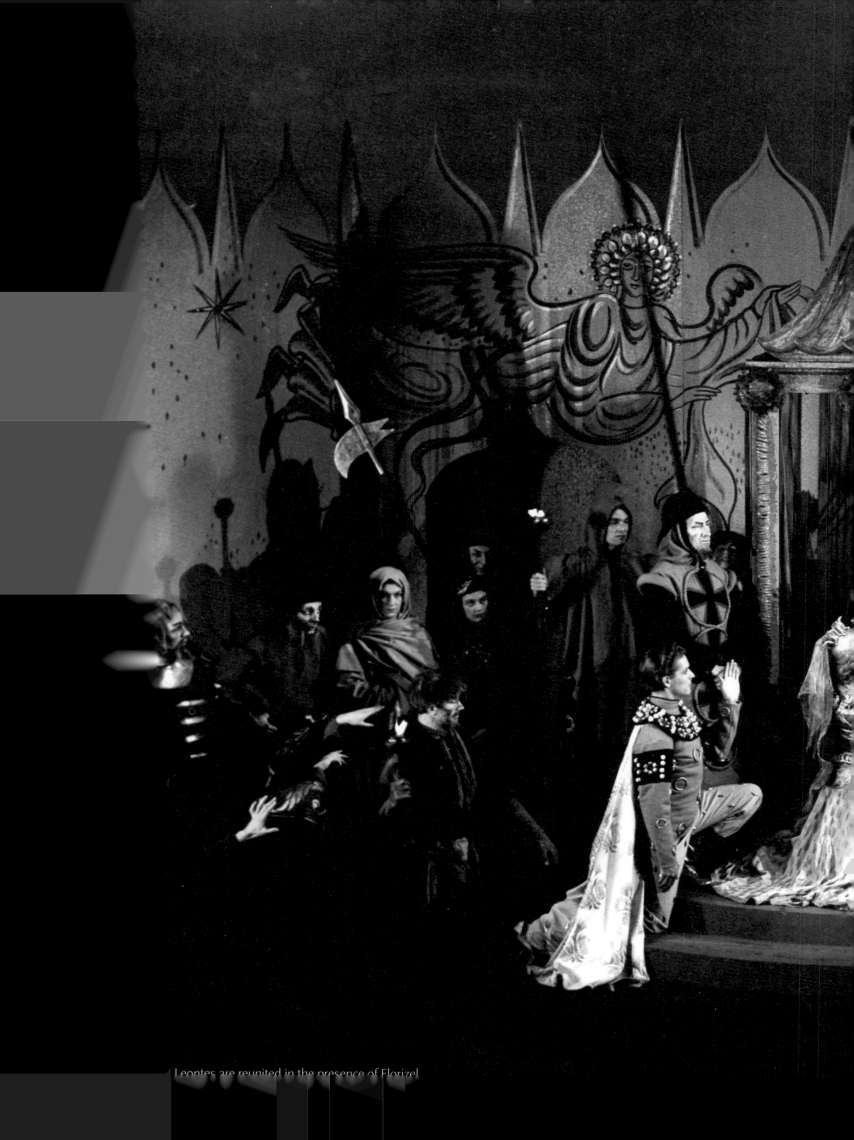

Leontes are reunited in the presence of Florizel

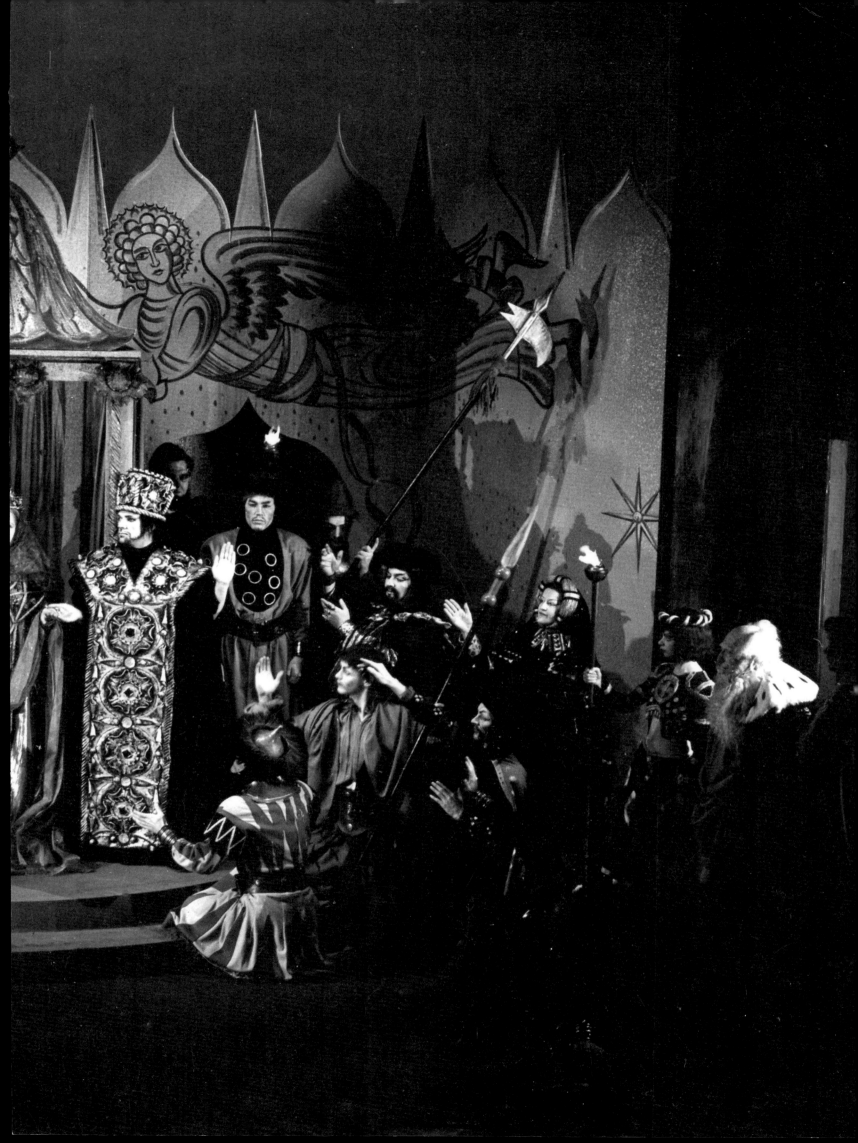

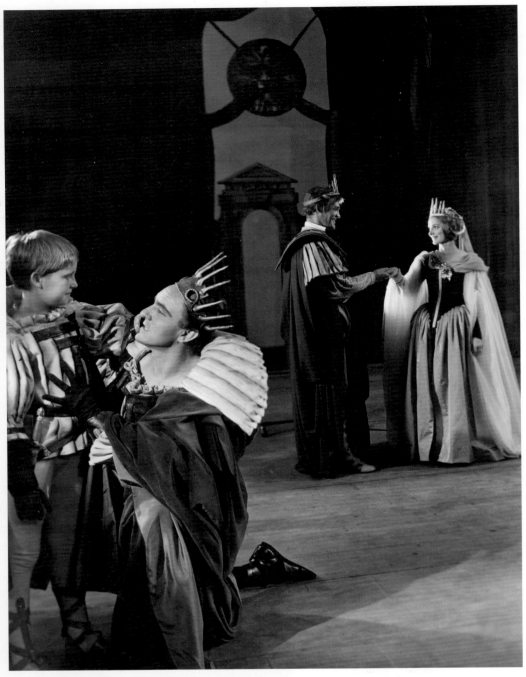

1960, I.2, Mamilius (Dennis Waterman), Leontes (Eric Porter), Polixenes (Patrick Allen) and Hermione (Elizabeth Sellars)

IV.2, Perdita (Susan Maryott) and Florizel (Dinsdale Landen)

☞ ☞
EXIT, pursued by a McBean